ROBERT BURNS

David Shepherd

July 2007

Books by Maurice Lindsay

PROSE

The Lowlands of Scotland: Glasgow and the North
The Lowlands of Scotland: Edinburgh and the South
The Scottish Renaissance
The Burns Encyclopedia
Clyde Waters
By Yon Bonnie Banks
The Discovery of Scotland
Environment: a Basic Human Right
The Eye is Delighted
Portrait of Glasgow
Robin Philipson
History of Scottish Literature
Scottish Lowland Villages
Francis George Scott and the Scottish Renaissance
The Buildings of Edinburgh (with Anthony F. Kersting)
Thank You for Having Me: A Personal Memoir
Unknown Scotland (with Dennis Hardley)
The Castles of Scotland
Count All Men Mortal: The Story of Scottish Provident
Victorian and Edwardian Glasgow
Edinburgh: Past and Present (with David Bruce)
Glasgow
An Illustrated Guide to Glasgow 1837

ANTHOLOGIES

Poetry Scotland 1–4 (4 with Hugh MacDiarmid)
No Scottish Twilight (with Fred Urquhart)
Modern Scottish Poetry: an Anthology of the Scottish Renaissance
John Davidson: Selected Poems, with a preface by T. S. Eliot and an
 introduction by Hugh MacDiarmid
A Book of Scottish Verse (with R. L. Mackie)
Scottish Poetry 1–6 (with George Bruce and Edwin Morgan)
Scottish Poetry 7–9 (with Alexander Scott and Roderick Watson)
Scotland: An Anthology
As I Remember: Ten Scottish Writers Recall How for Them Writing Began
Scottish Comic Verse

(with Joyce Lindsay)

The Scottish Dog
A Pleasure of Gardens
The Scottish Quotation Book
The Music Quotation Book
The Theatre and Opera-lovers' Quotation Book
The Burns Quotation Book
A Mini-Guide to Scottish Gardens

MAURICE LINDSAY

Robert Burns

The Man, His Work, The Legend

ROBERT HALE · LONDON

© *Maurice Lindsay 1954, 1968, 1971 and 1979*
This edition first published 1979
Reprinted 1988
This paperback edition 1994

ISBN 0 7090 5436 X

Robert Hale Limited
Clerkenwell House
Clerkenwell Green
London, EC1R 0HT

Printed and bound in Malta by Interprint Ltd

CONTENTS

To the memory of my parents,
Eileen Frances and Matthew Lindsay

PREFACE

The idea of a popular study of Burns and his work was first suggested to me by my friend and colleague the late James Pope-Henessy, when talking literature together to relieve the tedium of shared night-duty in London's War Office towards the end of 1944. The first edition of this book appeared in 1954; the second, revised and corrected, in 1968, reprinted in 1971; and the third, in 1979, reprinted in 1988, on which this edition is based.

The need for an easily assimilable account of Burns's life and work for the general reader, taking account of the latest advances of Burns scholarship, has not diminished during the forty years since this book first appeared. In specialist matters, there is, for example, R.D. Thornton's study of Burns's early biographer *James Currie: The Entire Stranger* (1963) and his *William Maxwell to Robert Burns* (1979) both revealingly fair-minded. The Sydney Goodsir Smith and James Barke limited edition of *The Merry Muses* (1966), though only partly by Burns, is now available on paperback bookstalls. Above all, James Kinsley's edition of *The Poems and Songs of Robert Burns* (1968) provides a definitive *ur-text*, as also does G. Ross Roy's *The Letters of Robert Burns* (1985). Useful, too, is Donald A. Low's anthology *Robert Burns: The Critical Heritage* (1974). For more detailed information about the characters in the Burns story, there is this writer's *The Burns Encyclopedia* (third edition, reprinted 1987).

On only two issues have my views substantially changed since writing this book. One is Burns's drinking. While heart disease, brought on by overwork as an adolescent, and not drink, as Currie suggested, was mainly responsible for Burns's early death, there is plenty of evidence to suggest that he drank too much for

the good of his uncertain health, latterly at the homes of the hard-drinking Dumfriesshire gentry rather than in taverns. The other is the teaching of Scottish Literature in Scottish schools. While by no means as general as it should be, it has advanced considerably in quantity and quality since 1954.

Burns remains Scotland's only widely read world poet. His range of interests far exceeds those of William Dunbar, while his passionate concern for ordinary humanity is a quality conspicuously absent in the work of Hugh MacDiarmid. Burns's story and achievement thus remain of unique interest to the people of Scotland and to poetry-lovers everywhere.

December 1993 MAURICE LINDSAY
 Milton, Dunbarton

Part I

The Author's Apology

BURNS'S work has been translated into more than eighteen tongues. In the catalogue of Burns books kept by the Mitchell Library of Glasgow, there are—or were on the poet's birthday, 1953, when I inspected it—three thousand five hundred titles. What possible reason, then, can there be for adding yet another title to a body of writing already so vast?

The strange truth is, however, that for a number of reasons which I hope presently to make plain, the majority of these titles are of books and pamphlets which nowadays have very little value. The posthumous reputation of Burns, more than that of any other British writer, was subjected to a process of falsification which, until the ruthless critical apparatus of twentieth-century scholarship was brought to bear upon it, succeeded in presenting to the world a distorted picture of the poet's earthly tenure. His first editor, the much-criticised Dr James Currie, a Liverpool physician, was a reformed drunkard, entirely out of sympathy with the character of the man with whose poems and letters he took such astonishing, though well-meaning, liberties, and through whose life-story he persistently laced a moral warning on the fate which awaits those who succumb to the temptations of strong drink. Dr Currie's unfortunate biography became the foundation upon which later biographies were built for at least half a century.

Meanwhile, a different kind of falsification was being woven in another quarter. Students of Scottish poetry are well aware of Allan Cunningham's attempts to palm off some of his own productions as genuine Galloway ballads. Most of these excursions into the realms of phoney balladry were detected, or at least suspected, during Cunningham's lifetime. Unfortunately, he also applied his imaginative talent towards colouring up what he had learned about Burns; firstly, for the benefit of John Gibson Lockhart, whose *Life of Robert Burns* appeared in 1828, and then, more ambitiously, for the enrichment of his own life of the poet which came out in 1834 as the preface to an edition of the works.

Many of Cunningham's fabrications are so obvious that even a moderately informed reader must experience doubt on encountering them. Unfortunately, this is not the case with Lockhart's fictions, because although he acknowledged the inclusion of 'little touches of novelty' (for which he claimed to be 'indebted to respectable authorities') in his extremely readable narrative, he constantly gives the impression that what he says has the hall-mark of absolute accuracy. Such is far from the case. Of all Burns's biographers, Lockhart is so far the only writer who has become the author of a classic. The prestige arising out of his great *Life of Scott* has been extended gratuitously to take in also his *Life of Robert Burns*. His Burns biography has been reprinted in the Everyman Library; it is thus the life of Scotland's national poet most commonly read today.

The authors of the important later Burns studies have mostly been foreigners. The first writer to draw a tolerably accurate picture of Burns in his *milieu* was the Frenchman Auguste Angellier. His two volumed *Robert Burns: la vie: les oeuvres* was published in Paris in 1893. Much fresh material has, of course, been discovered in the half-century or so that has passed since then. The next biography of value appeared in William Wallace's revised version of Dr Robert Chambers's *Life and Works*, which had first been published in 1851–2. Chambers was the earliest Burns scholar seriously to question the Currie-Lockhart-Cunningham fabrications. Wallace's revision, which amounted virtually to a complete rearrangement of the original material, appeared in 1896. *The Centenary Burns* of 1896–7, edited by the poet W. E. Henley and the historian T. F. Henderson, provided the best text of the poetry hitherto available, though Henley's zestful magnification of Burns's moral shortcomings, and his misreading of the significance of certain events of the later years, deprived the accompanying biography of objective value.

In 1901, O. Ritter published his *Quellenstudien zu Robert Burns 1773–1791*, which traces the poet's sources with Teutonic thoroughness.

The first of what might be called the modern standard lives was also the work of a German, *Robert Burns. Leben und Wirken des Schottischen Volksdichters*, by Hans Hecht, published in Heidelberg in 1919. An English translation by Jane Lymburn appeared in

Edinburgh in 1936, a second edition of which was published in 1950. Hecht has many admirers. His scholarship is sound, and from his German-viewpoint, he succeeds in portraying Burns as a figure of European literature. German critics have censured his book because, as one of them put it, Hecht 'does not examine in sufficient detail the philosophical implications of Burns's relationship with God'. (A very German criticism indeed of a 'shortcoming' for which most non-Teutonic readers may well be heartily thankful!) My own reservation about Hecht's book arises out of his tendency to gloss over happenings which seem to offend his sense of delicacy. He suffers, in fact, from Henley's tendency in reverse. More serious, however, is the awkwardness of his style, at any rate in the English version. Hecht's work does not read easily. Because of this, the image of a warm and living Burns does not come out of Hecht's pages.

Such an image certainly rises from the pages of Mrs Catherine Carswell's *The Life of Robert Burns* (1930). But she takes the romantic approach, incorporating scraps of unauthenticated gossip into her narrative without qualification.

By far the best Burns study is still *The Life of Robert Burns* by Franklyn Bliss Snyder, published in New York in 1932. Modified by a later article of Dr Snyder's,[1] it has already become the basis of subsequent Burns biographies. Of these, the most interesting is Professor De Lancey Ferguson's *Pride and Passion. Robert Burns 1759–1796*, also published in America,[2] in 1939. Neither of these books has so far been separately issued in this country. They may be consulted in libraries; but they cannot be bought, except occasionally and at a high price on the specialist's second-hand market. Nor are any comparable studies by British authors more easily available to Scottish or English readers. Hilton Brown's *There was a Lad* (1949) is not so much a biography as a consideration—though a penetrating and valuable one—of three of the outstanding riddles which perplex the Burns story. David Daiches, while he includes a modicum of biographical detail in his *Robert Burns* (New York 1950; London 1952 and 1966), is more concerned with critical matters.

[1] In the American 'Publications of the Modern Language Association' (1935).

[2] By the Oxford University Press, New York, though it was distributed by the O.U.P. in the United Kingdom.

Indeed, his examination of Burns's work is one of the fullest and fairest yet to be made, and is unlikely to be surpassed for a long time to come. Thomas Crawford's *Burns: A Study of the Songs and Poems* (Edinburgh and London 1960) is even more detailed, makes much use of Ritter's findings, and includes an Appendix dealing with 'Phonetic Values in Burns's Scots and Scots–English Poems and Songs'. To all these twentieth-century writers I am indebted.

In the realms of biography, however, the British reader, lacking Snyder and Ferguson, has only the admirable but cold and constrained Hecht; the warm but over-credulous Mrs Carswell; the specializing Hilton Brown; or—John Gibson Lockhart. The conclusion I drew from all this, when I first examined the position, was that, incredible as it may seem in theory, in practice there *is* room for a fresh biographical study in narrative form, the primary object of which is neither to extend the bounds of Burns scholarship, nor to try to better the excellent and exhaustive critical researches of Dr David Daiches and Mr Thomas Crawford, but simply to re-tell a human tale that is of absorbing interest, at the same time relating the man to his poetry, and both to the country from whose traditions they grew.

This book, then, is principally intended for the general reader, though I hope the scholar will find it neither inaccurate nor undocumented. I have not burdened my pages with unnecessary references to the numbering of the letters given in Professor De Lancey Ferguson's excellent edition which I have used throughout, since the dates of their composition are usually indicated in my text. Nor have I thought it necessary to detail the sources of generally-accepted information, since such sources should be familiar to all Burns scholars, and of little interest to the general reader. But I have indicated sources of information of a controversial or relatively unfamiliar nature.

The book is laid out in two parts, the first taking the Burns story up to the poet's departure for Edinburgh, the second completing it. An interlude, which need not be read by those more interested in the man than his work, deals with the Kilmarnock poems, and a postlude examines the Burns legend.

1

Alloway and Mount Oliphant

I

HIGH above the brawl of the North Sea, Dunnottar Castle stands
on a cliff top on the coast of Kincardineshire, in the north-east of
Scotland. In the second decade of the eighteenth century, the last
Earl Marischal of Scotland still lived there awaiting the call to arms.
One of those whom he employed to soften the severities of his
northern garden, in accordance with the up-and-coming fashion of
the times, may have been a certain Robert Burnes. But while this
garden was a pleasant place of relaxation for the Earl Marischal's
leisure moments, these were becoming increasingly few and far
between. A loyal Jacobite, 'the Cause' occupied much of his time
and most of his thought. When at last the call came in 1715—
a faltered call it proved to be—the Earl Marischal immediately
raised a force of his tenants and retainers to serve under the
banner of the Old Pretender. Robert Burnes may or may not
have ridden out with that futile little band. The poet, his grand-
son, liked to think that Robert Burnes had, in fact, been 'out'
in the '15, though there is no evidence whatever to prove that this
was so.

So far as this particular corner of Kincardineshire was concerned,
the main outcome of the Jacobite sally was that the lands of Dunnot-
tar were attainted, and the Earl Marischal had to flee to the Con-
tinent. The young gardener Burnes, having thus lost his job, shortly
afterwards took a wife and the farm at Clochanhill, and settled down
to the serious business of living. On 11th November 1721 a son,
William, was born to him. There were other children too, but they
do no more than fringe upon the Burns story.

At first Robert Burnes prospered, to the extent of being able to
substitute silver spoons at his table in place of the more usual horn
ones. But he had ambitions, this tenant-farmer, which could not

easily be satisfied under the disadvantageous farming system of the age. The soil of his sixty-odd acres was poor and thin. The old-fashioned plough still commonly in use required several oxen or horses to make it scrape out furrows, slowly and painfully, over a mere half-acre a day. The land itself was held by him under the ruinous two-year lease system, whereby the farmer had no security of tenure. If he yielded to the persuasion of his landlord, and took to cultivating the new root crops which were then being imported into Scotland, or perhaps enclosed his acres with hedges in the Dutch manner, he might find that at the end of his tenure the rent had been raised because the ground had become more valuable. In any case, it took capital to overcome the exhausting effects on the soil of the run-rigg system; and capital to buy the new-fangled equipment, including the smaller, more efficient plough, which was needed to put the land in better heart. Robert Burnes had very little capital.

So, in due course, the inevitable happened. Burnes lost his fight with circumstance, and would have become bankrupt there and then had not his credit been sufficiently good to enable him secure a loan from a neighbouring landowner, a Provost of Aberdeen. With this borrowed money behind him, Burnes then took the only practical course open to him. He added to his burdens two small farms adjacent to his own, desperately hoping that the extra acreage would at least enable him to put his agricultural economy on a sound basis. But hardly had he settled on his new course before the second Jacobite rising flared up, and swept ruin over himself and his acres. The war caused panic and its attendant instability, which led in turn to a general rise in prices. And Burnes, though now a douce, hardworking farmer, striving to make up for lack of capital with his own failing energies and anxious only to be left in peace, had to overcome the handicap of having once been an employee of the leading local Jacobite nobleman.

By 1748, his struggle was over. Burnes was a landless man mainly dependent for the rest of his days on the charity of his children. The eldest son, James, was already a promising wright in Montrose. For the other two sons, William, who also had skill as a gardener, and Robert, a mason, there was no alternative but to seek their fortunes

in the south. They parted on a hill-top, as Gilbert Burns (1760–1827) later recorded.[1]

> On the confines of their native place, each going off his several way in search of adventures, and scarcely knowing whither he went. My father undertook to act as gardener and shaped his course to Edinburgh, where he wrought hard when he could get work, passing through a variety of difficulties. Still, however, he endeavoured to spare something for the support of an aged parent, and I recollect hearing him mention his having sent a bank-note for this purpose, when money of that kind was so scarce in Kincardineshire that they hardly knew how to employ it when it arrived.

Fortunately for William Burnes, quite a number of the Edinburgh gentry were anxious to have their gardens 'landscaped', and when this private work became scarcer, William found employment in the laying-out of 'The Meadows', still a pleasant green expanse near the heart of the city. By 1750, however, William Burnes could get no more work in the Capital, so he travelled west into Ayrshire, perhaps on the strength of an invitation or a promised order, to work first in the garden of the Laird of Fairlie, and afterwards for the Crawford family at Doonside.

William Burnes was now over thirty, and still a bachelor. But he had ambitions both to set up as a nurseryman and to marry. He may well have met his future wife Agnes Broun (1742–1820), the chestnut-haired daughter of an Ayrshire farmer of Covenanting stock, at the annual Maybole fair, in 1756. At any rate, while still working as gardener to a wealthy retired London-Scottish medico who had become Provost of Ayr, Dr William Fergusson of Doonholm, William Burnes proceeded to build with his own hands a two-roomed cottage of clay and thatch on the seven and a half acre holding at Alloway he had rented from Dr Campbell of Ayr. On 15th December 1757 the thirty-six-year-old gardener married, and brought his wife home to his new cottage, within the whitewashed walls of which she bore him her first child, Robert, on 25th January 1759.

[1] This, and subsequent quotations of Gilbert Burns, come from 'Gilbert's Narrative', a letter originally written to Mrs Dunlop, and printed in full in the Scott Douglas edition of *The Poems and Prose of Robert Burns* (1877–9).

No time was lost in baptizing the baby, since under the tenets of the prevailing Calvinism, the soul of an unbaptized infant who might be unfortunate enough to die would thereafter be confined to the endless torments of hell-fire. When Robert was one day old the ceremony was performed by the Reverend William Dalrymple of the Established Church in Ayr, a minister whose Calvinism was tinged with a faint whiff of liberalism. Robert's surname was entered in the register as Burns, without the 'e', in accordance with the Ayrshire pronunciation.

A few days later a north-west wind raged. It damaged the cottage so badly that mother and child had to be carried into the night to seek shelter under a neighbour's roof. Gilbert, who was born the following year, gave Dr Currie a detailed account of what he had been told had happened.

> When my father built his 'clay biggin', he put in two stone jambs, as they are called, and a lintel, carrying up the chimney in his clay gable. The consequence was, that as the gable subsided, the jambs, remaining firm, threw it off its centre; and, one very stormy morning, when my brother was nine or ten days old, a little before daylight, a part of the gable fell out, and the rest appeared so shattered, that my mother, with the young poet, had to be carried through the storm to a neighbour's house, where they remained a week, till their own dwelling was adjusted.

This time, William's adjustment was of such a permanent nature that his 'clay biggin' still stands to this day.

Twenty-six years after the event, the 'young poet' himself light-heartedly commemorated the incident which has seemed to many later writers to have been a portent of the tempestuous career ahead of him.

> Our monarch's hindmost year but ane
> Was five-and-twenty days begun,
> 'Twas then a blast o' Janwar win'
> Blew hansel[1] in on Robin.

Apart from this incident and the particulars of the baptism, we

[1] The first gift received.

have very little authenticated information about the early years of
Robert's childhood. Other children were born into the family:
Gilbert (1760–1827), Agnes (1762–1834), Anabella (1764–1832),
William (1767–90), John (1769–85), and Isabella (1771–1858).
Doubtless they played on the tree-fringed banks of the near-by
River Doon, or watched their mother as she went about the dairy:
for she was a hard-working woman, rarely to be seen idle, except
when listening to the homilies of the husband she respected and
adored. Beasts and humans shared the same roof-tree, and the
smoky atmosphere of the living-room must often have reeked of the
pungent odours of steaming cattle. Agnes Broun had a good singing
voice, and a rich store of folk-snatches which the children, especially
Robert, would listen to eagerly. One of them certainly impressed
itself strongly on his imagination—

> Kissin' is the key o' love
> An' clappin' is the lock,
> An' makin' o's the best thing
> That e'er a young thing got.

—a strange if frank sentiment for a mother to be imparting to a
child of less than six years! But then Agnes Broun, for all her chest-
nut hair and her volatile spirits, could not read. Probably it was the
old tunes that attracted her, the words for which had so often been
altered in passing from mouth to mouth that they had frequently
been reduced to meaningless jingle, spiced with a flavour of honest,
earthy obscenity. She could hardly have guessed, as she went sing-
ing about her daily duties, that one day her eldest son would lift
Scots folk-song once and for all out of the decadent slough into
which it had so deeply sunk.

Another favourite with Robert was an old chap-book ballad
voicing the eternal sadness of those who labour, 'The Life and Age
of Man', which had been popular with Agnes's poor old uncle, a
farmer who had died blind. Its sonorous refrain, 'Ah! man was made
to mourn!', carrying overtones of the hopeless poverty and stoical
endurance of the working classes in a feudalistic society, also made a
strong impact on the boy's imagination. Agnes's store of folk-songs
was augmented by those of her cousin's widow, old Betty Davidson,

who came now and again to help Agnes about the house and the byre, and who sometimes stayed for a month at a time, being otherwise dependent on the charity of her daughter. Robert later said of her that she had 'the largest collection in the country of tales and songs concerning devils, ghosts, fairies, brownies, witches, warlocks, spunkies, kelpies, elf-candles, dead-lights, wraiths, apparitions, cantraips, enchanted towers, giants, dragons and other trumpery', some of which she may well have related to 'Alloway's auld haunted kirk'. 'This,' Robert adds, 'cultivated the latent seeds of poesy.'

William Burnes, though doubtless he scorned such womanish fripperies as Betty Davidson's, also had an interest in the kirk at Alloway. For him, its ruined shell held a melancholy fascination. Tradition avers that he even helped to replace the fallen stones of the walls which guard it. Certainly, it was in the ancient quiet of its deserted cemetery that he wished eventually to be laid to rest; a peaceful consummation which his severely religious temperament must often have led him to contemplate as the years laid heavier and heavier burdens upon his shoulders.

William Burnes impressed his religious fervour on his eldest son at an early age. Robert, in later years, said of himself at the age of five or six, that he was 'by no means a favourite with anybody. I was a good deal noted for a retentive memory, a stubborn, sturdy something in my disposition, and an enthusiastic idiot-piety. I say idiot-piety, because I was then but a child.'

Apart from his dour religious convictions, however, Burnes had other characteristics not unrelated in eighteenth-century Scotland: a passionate urge to be independent, and an equally passionate respect for learning, especially for his children so that they too might be independent. Education was not altogether easy to come by in Robert's boyhood. By Acts of Parliament of 1633 and 1643, public schools were supposed to have been set up in every Scottish parish. But in an age when the belief prevailed amongst the gentry that education merely encouraged the labouring classes to aim to rise above their God-intended stations, money to maintain these schools was often not forthcoming, even after the passing of a further Act in 1696, which legislated on the salary and living accommodation that

teachers were to receive. A school-teacher, dependent on fees from parents of about a shilling a quarter for each pupil, had to fall back upon all sorts of subsidiary jobs if he was not to starve. Even then, his position was insecure, because he might easily find himself dismissed from his school on the slightest of pretexts. In these conditions, there was naturally a shortage of competent school-teachers, and many worthless persons found their way into the profession. In 1765, 'a person by the name of Campbell' was, according to Dr Currie, the schoolmaster at Alloway Mill. During the early months of that year Robert and Gilbert made the daily journey over the mile which separated their home from the school, where they learned the rudiments of English. Soon after, however, Campbell abandoned his position at Alloway in favour of a more remunerative post as master of the Ayr Workhouse. There was then a danger that no successor would be found, or that, as was apparently rumoured, the choice might fall on a person of little ability.

William Burnes therefore took the lead in finding a new schoolmaster who could give instruction nearer home, probably in a convenient barn. Two of the masters of Ayr Academy with whom he was on friendly terms recommended a certain John Murdoch, so Burnes instructed the candidate to meet him in Ayr at Simpsons's Tavern, by the 'Auld Brig', and to bring his writing-book with him. The interview proved satisfactory, and Murdoch was accepted as the new master.

When he came to Alloway, Murdoch was almost twelve years older than his famous pupil. He had been born in Ayr in 1747, where he had received most of his education, though he had been 'finished' at a school in Edinburgh. That he was a ponderous young man can be seen from his own account of the terms of his engagement:

> In the month of May following, I was engaged by Mr Burnes, and four of his neighbours, to teach, and accordingly began to teach the little school at Alloway, which was situated a few yards from the argillaceous fabric above-mentioned. My five employers undertook to board me by turns, and to make up a certain salary, at the end of the year, provided my quarterly payments from the different pupils did not amount to that sum.

The argillaceous fabric was, of course, Burnes's clay cottage, which Murdoch also called elsewhere the 'mud edifice' and the 'tabernacle of clay'. In spite of his unwillingness to use a simple word if a complicated phrase could be devised, Murdoch appears to have had a real flair for teaching. He saw to it that his pupils mastered the rudiments of English, learned poems by heart, and made a study of the Old and New Testaments, a knowledge of which in the eyes of many Scots was still the true end of education. He insisted that every clause must be understood before it was memorized. His own description of the methods he followed and the results he obtained during his two and a half years at Alloway shows, amongst other things, that the brightest boys do not always become the most intelligent or gifted men.

My pupil, Robert Burns, was then between six and seven years of age; his preceptor about eighteen. Robert, and his younger brother Gilbert, had been grounded a little in English before they were put under my care. They both made a rapid progress in reading, and a tolerable progress in writing. In reading, dividing words into syllables by rule, spelling without book, parsing sentences, and etc., Robert and Gilbert were generally at the upper end of the class, even when ranged with boys by far their seniors. The books most commonly used in the school were, the 'Spelling Book', the 'New Testament', the 'Bible', 'Mason's Collection of Prose and Verse', and Fisher's 'English Grammar'. They committed to memory the hymns, and other poems of that collection, with uncommon facility. This facility was partly owing to the method pursued by their father and me in instructing them, which was, to make them thoroughly acquainted with the meaning of every word in each sentence that was to be committed to memory. By the by, this may be easier done, and at an earlier period, than is generally thought. As soon as they were capable of it, I taught them to turn verse into its natural prose order; and sometimes to substitute synonimous expressions for poetical words, and to supply all the ellipses. These, you know, are the means of knowing that the pupil understands his author....

Gilbert always appeared to me to possess a more lively imagina-

tion, and to be more of a wit, than Robert. I attempted to teach them a little church-music. Here they were left behind by all the rest of the school. Robert's ear, in particular, was remarkably dull, and his voice untunable. It was long before I could get them to distinguish one tune from another. Robert's countenance was generally grave, and expressive of a serious, contemplative, and thoughtful mind. Gilbert's face said, 'Mirth, with thee I mean to live'; and certainly, if any person who knew the two boys, had been asked which of them was most likely to court the muses, he would surely never have guessed that Robert had a propensity of that kind.

Like many a school-teacher before and since, Murdoch clearly preferred the docile and obedient Gilbert to his more spirited, though also more moody, brother.

Robert himself, writing of these earlier days in the autobiographical letter which he addressed to Dr John Moore on 2nd August 1787, noted the first conscious impact which English art-literature made upon him.

> The earliest thing of composition that I recollect taking pleasure in was 'The Vision of Mirza' and a hymn of Addison's, beginning, 'How are thy servants blest, O Lord'. I particularly remember one half stanza which was music to my boyish ears—
>
>> Far though in dreadful whirls we hung,
>> High on the broken wave—
>
> I met with these pieces in 'Mason's English Collection', one of my school-books.—The two first books I ever read in private, and which gave me more pleasure than any two books I ever read again, were 'The Life of Hannibal', and 'The History of Sir William Wallace'.—Hannibal gave my young ideas such a turn, that I used to strut in raptures up and down after the recruiting drum and bag-pipe, and wish myself tall enough that I might be a soldier; while the story of Wallace poured a Scottish prejudice into my veins which will boil along there till the flood-gates of life shut in eternal rest.

The school books were solid enough stuff. Apart from the Bible, the one which had the greatest influence on Robert was Arthur Masson's *Collection of Prose and Verse*. This was an anthology selected from the poetry of Shakespeare, Milton, Dryden, Thomson, Gray and such lesser eighteenth-century poets as Akenside and Shenstone; and from miscellaneous prose pieces including a number of Mrs Elizabeth Rowe's *Moral Letters*. The pomp in which Mrs Rowe draped her sanctimonious sentiments became for a time Robert's criterion of a good prose style, while the poets filled his mind with good and bad work in the English tradition.

Indeed, the foundations of that dichotomy which all his life led him to alternate uneasily between the vernacular tradition of Scots literature and the genteel traditions of Augustan literature, may be traced back to his earliest schooling. Murdoch, for all his gentle pedagogic worthiness and for all the good the poet undoubtedly derived from him, was a wholehearted apostle of English literary gentility. Robert's mother and poor unloved Betty Davidson, with their broad folk-songs, were, on the other hand, the apostles of Scotland's peasant past, then already falling into disrepute with the 'gentles' of the upper classes. Even *The History of Sir William Wallace*, which poured the 'Scottish prejudice' into Robert's veins, was not Blind Harry's rough Middle Scots original, but a smooth Anglicized version modernized from the original by Allan Ramsay's friend and verse-correspondent, William Hamilton of Gilbertfield. The wonder is that with Murdoch and his father so strongly on the side of the angels (William Burnes apparently did his best to speak 'correct English'!), the Scots folk-tradition should have asserted itself in Robert's imagination as strongly as it did. Even so, it was not until many years later, when he had already taken to writing poetry, that he made his first genuine contact with Scottish art-literature as opposed to folk-song.

The *Life of Hannibal* which fired his soldiering ambitions has never with any certainty been traced. Whoever the author may have been, the copy which Robert read was probably borrowed from Murdoch. The wish to be a soldier was a common enough escapist dream to poor men in the eighteenth century, and one which seemed theoretically inviting to Robert during various later crises in his life.

In the end, the wish was to have ironic fulfilment: he was given a military funeral!

One other book featured in the Alloway scheme of instruction. This was the *Manual of Religious Belief*, a dialogue between father and son supposed to have been composed by William Burnes himself, though no doubt Murdoch, in whose handwriting it survives, had a share in polishing the style. The son asks the questions, while the father, after the manner of the biblical patriarch (on whom so many Calvinistic fathers modelled their preposterous domestic behaviour) supplies the answers. Even so, the mere idea of a son questioning his father would not have been countenanced by many a stricter contemporary of William Burnes.

With his children's education proceeding satisfactorily, Burnes had also to consider their future. The nursery garden had not been a success. Worked in conjunction with his job as Provost Fergusson's gardener, it yielded a scant living, but hardly enough on which to complete the upbringing of a growing family that kept on increasing. In addition, the cottage was becoming too small to hold the children. Most important of all, Burnes wanted to be sure that his two oldest boys did not have to be fee'd out to work on a farm, perhaps some distance away, when they reached the age of nine or so, a fate which would certainly have befallen them if their father had not decided to turn farmer himself. No doubt, too, he felt a hankering after the ancient craft of his ancestors, though none of them had been conspicuously successful farmers.

At any rate, towards the end of 1765, Burnes approached his master with the proposal that he should lease the seventy acre farm of Mount Oliphant, two miles east of Alloway, which Dr Fergusson owned, and which had just then fallen vacant. Fergusson not only accepted the proposal, but offered to advance his gardener the sum of three hundred pounds so that he should have enough ready capital to set himself up, his own limited capital being tied up in the Alloway holding. The new lease was for a period of twelve years with the option of a break at six. Burnes had the rights over the soil from Martinmas 1765, though he was not to move his family into the farmhouse with the attic rooms until Whitsun 1766. The boys still went down to Murdoch's school until the early part of 1768.

But the greater distance to and from their home, and the ever-increasing demands which the farm made upon all the family, combined to make their attendance less regular.

It soon became apparent that the farm was a bad bargain. Gilbert went so far as to call it: 'Almost the very poorest soil I know of in a state of cultivation.' No servants were employed, butcher meat was for several years a rarity upon the table, and few came to visit the Burneses in their relative isolation on the hill-top with its fine view of the sea two miles or so away. No doubt, as the spring of 1768 came round, Robert and Gilbert were making the journey to Alloway less and less frequently. Two of Murdoch's other four patrons had also moved out of the district; so not unnaturally, the dominie decided to accept a better-paid appointment in the southern half of Carrick when the opportunity arose.

He climbed up the rough road to the bleak little farm to make a farewell visit. The journey involved staying the night, and during the evening, as Gilbert relates, a strange incident took place.

> He brought us a present and memorial of him, a small compendium of English Grammar, and the tragedy of 'Titus Andronicus', and by way of passing the evening, he began to read the play aloud. We were all attention for some time, till presently the whole party was dissolved in tears. A female in the play (I have but a confused recollection of it) had her hands chopt off, and her tongue cut out, and then was insultingly desired to call for water to wash her hands. At this, in an agony of distress, we with one voice desired that he would read no more. My father observed that if we would not hear it out, it would be needless to leave the play with us. Robert replied that if it was left he would burn it. My father was going to chide him for this ungrateful return to his tutor's kindness, but Murdoch interposed, declaring that he liked to see so much sensibility. . . .

The tutor took the offending play away with him in his pocket, leaving with the nine-year-old boy instead, the scarcely less unsuitable translation of a French play, *The School for Love*. One wonders what the stern William Burnes really thought of such literature as

Titus and *The School for Love*.[1] Secretly he must surely have disapproved. Probably he only reprimanded Robert out of courtesy to his guest.

II

When Murdoch had gone for good and their Alloway link was thus finally severed, the boys had little company other than that of their father. He at once made himself responsible for their further education. If the textbooks which Murdoch used were dull, most of those upon which William relied must have seemed almost unreadable to boys of Robert's and Gilbert's tender years—Thomas Salmon's *New Geographical and Historical Grammar* (published in 1749) and the rather livelier outline, the *New Geographical, Historical and Commercial Grammar* by William Guthrie (1771); William Derham's *Physico-Theology* and *Astro-Theology* (1713 and 1715 respectively), two works got from a 'book society in Ayr' which set forth the then-popular teleological arguments (the arguments from design) in favour of the existence of God; Thomas Stackhouse's *New History of the Holy Bible* (1767), a colourful re-telling of 'the Buik o' the Word' in up-to-date prose, which William Burnes took by subscription in parts, and from which, according to Gilbert, 'Robert collected a competent knowledge of ancient history'; John Ray's *The Wisdom of God Manifested in the Works of Creation* (1691); and —strangely out of place amongst those lofty tomes—the *Ready Reckoner and Tradesman's Sure Guide*.

To leaven this weighty intellectual diet a little, a brother of Mrs Burnes's was sent in to Ayr to buy a *Complete Letter-Writer*. Luckily, Gilbert says,

in place of 'The Complete Letter-Writer', he got by mistake a small collection of letters by the most eminent writers, with a few sensible directions for attaining an easy epistolary style. This book was to Robert of the greatest consequence. It inspired him

[1] This has never been traced, though Hecht suggests it may have been William Whitehead's *School for Lovers* (London, 1762), based on 'a plan' of de Fontenelle's.

with a strong desire to excel in letter-writing, while it furnished
him with models by some of the finest writers in our language.

The book in question, which Robert called 'a collection of letters by
the Wits of Queen Anne's reign', has never been satisfactorily
identified, though it evidently contained letters by, amongst others,
Bolingbroke and Pope. In any case, both the high-minded theo-
logical authors, and the stiff and formal 'Wits of Queen Anne's
reign' who favoured sentences balanced antithetically, brought
further moulding English influences to bear on Robert.

As he entered his 'teens, Robert began to take upon his shoulders
more of the physical burdens of the farm. Indeed, by the summer of
1772, he and Gilbert had become so useful to their father that when
Burnes had decided to send his sons to the parish school at
Dalrymple during the summer quarter in the hope of improving
their handwriting, they could only be spared week about. But the
sacrifice turned out to be worth while, for both brothers acquired a
similar style of hand, small and neat.

That autumn, Murdoch returned to Ayr as an English master in
the burgh school, and although Robert had by now become his
father's principal labourer, without hesitation Burnes sent his
oldest son to Ayr for three weeks during the summer of 1773.
Robert shared Murdoch's bed, and not a minute of their time to-
gether was wasted. Murdoch relates—

> Robert Burns came to board and lodge with me, for the pur-
> pose of revising English grammar, etc., that he might be better
> qualified to instruct his brothers and sisters at home. He was now
> with me day and night, in school, at all meals, and in all my
> walks. At the end of one week I told him, that, as he was now
> pretty much master of the parts of speech, etc., I should like to
> teach him something of French pronunciation, that when he
> should meet with the name of a French town, ship, officer, or the
> like, in the newspapers, he might be able to pronounce it some-
> thing like a French word. Robert was glad to hear the proposal,
> and immediately we attacked the French with great courage.

Just how well qualified Murdoch really was to teach French is more

than a little doubtful. Four years later he ruined himself by alleging, while in his cups, that the Reverend Dr William Dalrymple (who had baptized Robert and who had passed some minor criticisms on Murdoch's work) was as revengeful as Hell, as false as the Devil, and a liar and a hypocrite. For this outspokenness Murdoch was promptly relieved of his job by the magistrates. He then betook himself to London, where for a time he undertook to teach, amongst other languages, French; he even wrote some French textbooks. But after the French Revolution, refugees to the native manner born flocked to the English megalopolis, and monopolized most of this work. Probably they managed to get their pupils to pronounce sounds rather nearer to the sounds of French than Murdoch was ever able to do. At any rate, although Robert was very proud of his French and made a habit of spicing his letters—particularly those to Peggy Chalmers, who seems to have had some untraceable con-nexion with the language in Robert's mind—with rather obvious French phrases, the rhyming use to which he sometimes put French words makes one wonder about the nature of his pro-nunciation.

Whilst embarked upon the study of French with Murdoch, Robert also picked up a smattering of Latin from Murdoch's close friend Robinson, the 'established writing-master' in Ayr. With the Latin tongue, however, Robert made little progress.

Not the least important advantage of the Ayr visit was his meeting and mixing with boys of his own age, though above his own station in life. Young noblemen, Robert later observed, are not at the age of fourteen as conscious of 'the immense distance between them and their ragged playmates' as they become later; they lent him books and helped him with his studies.

He carried back with him to Mount Oliphant not only the mem-ory of this first independent savouring of the outside world, but also a French dictionary—his letters show that he must clearly have continued his study of French on his own, for three weeks' tuition would hardly even have made him master of the range of tags he later used—a grammar, and Fènelon's *Aventure de Télémaque*, as well as Thomas Ruddiman's *Rudiments of the Latin Tongue*. His English reading was also extended about this time to take in

Richardson's sentimental novel *Pamela*, which was borrowed from
a 'bookish acquaintance' of his father's and 'those excellent new
songs', as Gilbert called them, 'that are hawked about the country in
baskets, or exposed on stalls in the streets'. These songs would
almost certainly be in Scots, as are the best pieces in Allan Ramsay's
Tea-Table Miscellany, which also seems to have first come Robert's
way about this time.

Once he was home again, however, Robert could have found little
immediate time for study, for the harvest had to be reaped, and
there were no hands to spare. Yet out of that harvest, Robert reaped
the experience which suddenly caused his creative gifts to germinate.

You know our country custom of coupling a man and a woman
together as Partners in the labors of Harvest.—In my fifteenth
autumn, my Partner was a bewitching creature who just counted
an Autumn less,—My scarcity of English denies me the power
of doing her justice in that language; but you know the Scotch
idiom, She was a bonie, sweet, sonsie lass.—In short, she al-
together unwittingly to herself, initiated me in a certain delicious
Passion, which in spite of acid Disappointment, gin-horse
Prudence and bookworm Philosophy, I hold to be the first of
human joys, our dearest pleasure here below.—How she caught
the contagion I can't say; you medical folks talk much of infec-
tion by breathing the same air, the touch, etc., but I never
expressly told her that I loved her.—Indeed I did not well know
myself, why I liked so much to loiter behind with her, when
returning in the evening from our labors; why the tones of her
voice made my heart-strings thrill like an Eolian harp; and par-
ticularly, why my pulse beat such a furious ratann when I looked
and fingered over her hand, to pick out the nettle-stings and
thistles.—Among her other love-inspiring qualifications, she
sung sweetly; and 'twas her favorite reel to which I attempted
giving an embodied vehicle in rhyme.—I was not so presumptive
as to imagine that I could make verses like printed ones, com-
posed by men who had Greek and Latin; but my girl sung a
song which was said to be composed by a small country laird's
son, on one of his father's maids, with whom he was in love; and

I saw no reason why I might not rhyme as well as he, for excepting smearing sheep and casting peats, his father living in the moors, he had no more Scholarcraft than I had.—

Thus with me began Love and Poesy; which at times have been my only, and till within this last twelve-month have been my highest enjoyment.

Love and Poesy, the Poesy married to a favourite reel, and brought into play in emulation of a small country laird's son! In this song, 'O once I lov'd a bonie lass', Robert's first known attempt at rhyming, the elements which combined to make him the supreme master of Scottish song were already there. Nelly Kilpatrick must have been pleased to hear it sung of herself—

> She dresses ay sae clean and neat,
> Both decent and genteel;
> And then there's something in her gait
> Gars ony dress look weel

—even if she may have been a little surprised at the anglicized formality of a later stanza—

> 'Tis this in Nelly pleases me,
> 'Tis this enchants my soul;
> For absolutely in my breast
> She reigns without control

—which might well have come from the pen of half a dozen minor English eighteenth-century poets.

To the mature Burns, love meant first and foremost, one thing only: physical passion. His affair with Nelly, however, was innocent enough, and soon over, as are most of those affairs which awaken boys to the sexual significance of adolescence. Although Nelly's 'reign' was passing, thereafter the 'hairst' was for Robert a time of potential danger; a time of spontaneous fertility, both physical and poetic.

But for the moment, his mind was soon distracted by the difficulties which were gathering fast about his father. On 7th November, 1769, according to his tombstone, Provost Fergusson had died. The

seventy stony acres were still proving intractable with only the failing
William and his two adolescent sons to work them, and with nine
mouths to be fed from their yield. Robert wrote of their difficulties:

> My father was advanced in life when he married; I was the
> eldest of seven children; and he, worn out by early hardship, was
> unfit for labor.—My father's spirit was soon irritated, but not
> easily broken.—There was a freedom in his lease in two years
> more, and to weather these we retrenched expenses.—We lived
> very poorly; I was a dexterous Ploughman for my years; and the
> next eldest to me was a Brother, who could drive the plough very
> well, and help me to thrash. . . . My indignation yet boils at the
> recollection of the scoundrel tyrant's insolent, threatening
> epistles, which used to set us all in tears.

The 'scoundrel tyrant' was the factor whose duty it was to draw in as
regularly as possible arrears of rent due to the deceased man's estate.
The failing state of William Burnes's health, made the more bitter by
his consciousness of his own hard-working though constantly ill-
rewarded rectitude, must have turned the insistent demands of the
factor into a sore affront to his pride.[1] Factors, however, have rarely
been noted for their generosity or human understanding, and William
Burnes soon had difficulty in keeping up with his payments.

But the old man—prematurely aged by his years of struggle—had
no intention whatever of giving in. Harassed though he was by the
factor's dunning and the hard obstinacy of his soil, William Burnes
still thought of his children's education. That summer, Robert's
seventeenth, he spent in Kirkoswald at 'a noted school, on a smuggl-
ing coast', learning 'mensuration, surveying and dialling', studies in
which he felt he had made 'pretty good progress'. The school was
kept by Hugh Rodger, a sharp-tongued pedagogue, and was only
about a mile away from the farm of Samuel Broun, a maternal uncle
of Robert's with whom he boarded. The 'pretty good progress' came
to an abrupt end, however, for although he 'went on with a high
hand' in his geometry 'till the sun entered Virgo', a month which
was 'always a carnival' in his bosom—

[1] Yet it would appear that Burnes put up with the factor's 'snash' for almost
eight years subsequent to the death of Fergusson.

a charming Filette who lived next door to the school overset my Trigonometry, and set me off in a Tangent from the sphere of my studies.—I struggled on with my Sines and Co-sines, for a few days more; but stepping out to the garden one charming noon, to take the sun's altitude, I met my Angel,

—'Like Proserpine gathering flowers,
Herself a fair flower'—[1]

It was in vain to think of doing any more good at school.—The remaining week I staid, I did nothing but craze the faculties of my soul about her, or steal out to meet with her.

The 'charming Filette' was called Peggy Thomson. Although once again the affair was innocent, Robert later presented her with a sentimentally-inscribed copy of the Kilmarnock poems; and when he was making his farewells, intending—or pretending—to go to the West Indies, he called upon his 'once fondly lov'd and still remembered dear', whose husband escorted him three miles along the road, where both parted in tears.

The Kirkoswald stay also widened Robert's knowledge of mankind. Its small population was a mixture of farmers, sailors and smugglers, who no doubt did indulge in 'scenes of swaggering riot and roaring dissipation' after the manner of their kind. Even so, if at Kirkoswald Robert really learned, as he claimed, 'to look unconcernedly on a large tavern-bill', it must have been the bills of his companions he glimpsed, for the straitened circumstances at Mount Oliphant could hardly have enabled Robert to have had much pocket-money to spend on drink.

In Whitsun 1777, when Robert was eighteen, the family at last got themselves free of Mount Oliphant and moved into the farm of Lochlie ten miles to the north-east in the parish of Tarbolton. Thus ended the first major phase in Robert's life. Up till then he had been an adolescent, with opportunities to improve his knowledge greater than were at that time open to most country boys of his station. By modern standards, of course, his sporadic schooling was poor indeed. But Robert made more than ordinary use of such

[1] Milton, *Paradise Lost*, Book IV, l. 269.

guidance as came his way. The functions of Campbell, Murdoch and Rodger were little more than those of signposts, pointing the intellectual roads for him to follow. Campbell's instruction could hardly have amounted to much, though it is to him that the credit goes for making a beginning: Murdoch opened for Robert the stately portals of English literature, and put him in the way of reading Shakespeare, Milton, Dryden, Thomson, Gray, Akenside, Shenstone, Pope, Addison, Richardson and many lesser writers of the day: to Murdoch also was due Robert's knowledge of French and, indirectly, his smattering of Latin: Rodger gave him a grounding in mathematics which was to stand him in good stead in his Excise days. From his father he had gained some knowledge of history, geography, philosophy and theology: from his mother and old Betty Davidson, the foundation upon which he later built up his study of Scottish folk-song.

He was thus in no sense an 'unlettered ploughman'—although in later years, when it suited him to adopt such a pose for the gratification of the Edinburgh patricians, he did so without hesitation—any more than his tall, gaunt, severe-looking father was an unlettered gardener, although in William's case spelling was a weak point and the range of his attainments much narrower. But the awkward and rustic youth who left Mount Oliphant behind him with few regrets, in spite of his reading was still painfully unsure of himself. Already the severe physical strain which the recent family difficulties had forced him to bear, had made its first inroad upon his health. Already he was subject to turns of melancholia, and to moods of that prideful touchiness which was to manufacture so many difficulties for him in later life. Already, too, he must have been inwardly chafing at the rigidity of his father's rule. 'Love and Poesy', indeed, were his only sure means of escape from what must have seemed to him then a far from inviting prospect. Though he had not yet made much progress in the art of 'Love', he had at least made some progress with 'Poesy'.

2

Lochlie
1777–84

I

THE farm of Lochlie[1] lies in a saucer of land at the northerly end of a track which strikes off the main road between Tarbolton (pronounced locally 'Tarbowton') and Mauchline, about half-way between the two places. It took its name after a lochan in the hollow, and even today, for all the advances in methods of draining and cultivation, there are still rushes at the bottom of the hollow. Though Robert arrived at Lochlie in the middle of the growing pains of adolescence and of maturing genius—growing pains which made him by turns moodily indrawn upon himself, yet desperately anxious to match his wits against those of other lively young fellows —William Burnes must surely have had some hope for the future of the new project he was undertaking. Once again, however, he had made a hopeless bargain; this time, unfortunately, not even in writing; for David McLure, an Ayr merchant, apparently had such complete confidence in his new tenant that no written agreement was deemed necessary.

The farm consisted of a hundred and thirty sour and swampy acres, for which William was to pay the exorbitant rent of a pound an acre. McLure may also have loaned some money to his new tenant to enable him settle himself in, and build up upon the inadequate farm stock he had managed to save from the Mount Oliphant débâcle. At any rate, Robert later said that: 'The nature of the bargain was such as to throw a little ready money in his [William's] hand at the commencement; otherwise the affair would have been impracticable.'

'The affair' did, of course prove to be 'impracticable' in the end.

[1] Or Lochlea, to give it its modern spelling.

But for the first four years, the hard work which William exacted from his family and himself at least enabled them to maintain their position. These years were probably the happiest the Burns family were ever to know. When the children were not at work in the fields or about the farm, William saw to it that their minds were suitably occupied in an improving way. While the tradition that neighbours would come upon the family gathered round the dinner-table each with a spoon in one hand and a book in the other is, to say the least of it, picturesquely improbable, learning was clearly valued for its own sake; and William became more than ever the head of a patriarchal circle, always watching for the opportunity to mix 'all with admonition due'. Whilst some of the admonition would no doubt certainly be due, much of it probably was not so. As Robert became more keenly aware of the cramping atmosphere of his home life, he sought refuge more often in books and with new friends.

His reading expanded to take in a 'Collection of English Songs', his vade-mecum—'I pored over them, driving my cart or walking to labor, song by song, verse by verse; carefully noting the true tender or sublime from affectation and fustian.' He also became acquainted with Pope's *Homer*; with *Ossian*, in the elaborate and partly fabricated version with which James Macpherson had won the hearts of European sentimentalists; with more of the work of what Robert himself called 'the sentimental poets'; with contemporary prose, including Sterne's *Sentimental Journey* and Henry Mackenzie's tearful but immensely popular novel, *The Man of Feeling*; and with Greek and Roman mythology through Andrew Tooke's *Pantheon*. In addition, he got to know the issues of periodicals like Addison's and Steel's *Spectator*, and Walter and Thomas Ruddiman's *Weekly Magazine or Edinburgh Amusement*, which had been founded in 1768, and which from 1771 to 1773 had published the exciting new Scots poems of the gifted but unfortunate young Edinburgh poet, Robert Fergusson (1750–74).

Such a welter of different styles and outlooks—and there were others—undoubtedly confused his critical perception. The minor poets of the Augustan era he obviously admired to the end of his days; but his imitations of them were invariably unsuccessful. The sentimental novelists like Sterne and Mackenzie no doubt impressed

him partly because of their following amongst the gentry, and partly because of the elevated pose which they adopted and sustained: a humanistic pose which helped the upper classes of the late eighteenth century to avoid having to consider the crudely brutal world of those in lower stations. Sterne, to be sure, relieved his sentimental posing with bursts of realistic bawdry—which would also make a perfectly natural appeal to Robert—but Henry Mackenzie had recourse to no such redeeming feature. Indeed, he was hailed by the patricians of Edinburgh as a Sterne purged of his grossness, just as Sydney Dobell was hailed a century later as a Shelley purged of his sensuousness. Mackenzie, though a diverting enough character, as an author was purely a purveyor of material to match the manners of his moment.

Of the others, Pope may have sharpened Robert's taste for satire. Milton's Satan seems to have impressed Robert far more than Milton's style, while Shakespeare does not seem to have influenced him in any way at all. Sustained by the philosophical writings of Francis Hutcheson, David Hume and others, Robert's ultimate reaction to the dogged Calvinism of his father's textbooks was to adopt the humanistic deism of his day, a doctrine common enough amongst the Edinburgh patricians but regarded as more or less heretical by the worthies of the rural communities in which he was to move and find his social life for some years to come.

Of the two near-by townships, Tarbolton was the larger. There, Robert quickly made lively new friends. David Sillar, a poetaster and a farmer's son, was a year younger than Robert. He came from Spittleside, a mile out of the village, played the fiddle—he is even reputed to have tried to teach Robert the instrument—and was generally an intelligent fellow. But he was a poor poet, as is shown by his *Poems Chiefly in the Scottish Dialect* brought out in 1789 by the printer that had issued Robert's Kilmarnock poems. Still, it was to Sillar that Robert wrote his two racy 'Epistles to Davie'. John Rankine of Adamhill, another new farmer-neighbour, was a coarser character, of whom Robert was nevertheless very fond. John Wilson, who later became the butt of 'Death and Dr Hornbook', was an impoverished schoolmaster who eked out the thinness of his living by acting as clerk to the Kirk Session, grocer, and even

amateur apothecary. Then there was Alexander (Saunders) Tait, a
retired bachelor tailor of splenetic temperament, who was also a bad
versifier, and who later savagely turned his talents against Sillar and
both Robert and his father, for what reason, unless it may have been
literary jealousy, is hard to discover now. There was also kindly
James Findlay, the local exciseman, who later became Robert's
instructor in the profession.

The records of the early Lochlie days are fairly scanty, but it is not
difficult to imagine Robert, as his social instincts developed, rapidly
coming to regard the hours spent with his friends and his books as
the only savour in his otherwise drab existence.

In the winter of 1779, he apparently felt that his peasant manners
were in need of more polish: perhaps he also felt the need of other
than male companionship. At any rate, as he tells us,

> to give my manners a brush, I went to a country dancing school.
> —My father had an unaccountable antipathy against these
> meetings; and my going was, what to this hour I repent, in
> absolute defiance of his commands.—My father, as I said before,
> was the sport of strong passions; from that instance of rebellion
> he took a kind of dislike to me, which, I believe was one cause of
> that dissipation which marked my future years.—I only say,
> Dissipation, comparative with the strictness and sobriety of
> Presbyterean country life. . . .

William Burnes shortly afterwards managed to suppress his anti-
pathy enough to allow the rest of the family also to take dancing
lessons. Indeed, it may not have been so much the dancing that
William feared as the mettlesome flash of his eldest son's eyes, and
the ever-ready sharpness of his wit.

The following winter Robert's wit found plenty of scope when
the Tarbolton Bachelors' Club was founded. If the Club was not
actually Robert's idea, he was certainly the leading figure and first
president of it. David Sillar and Gilbert Burns were also amongst the
five other original members. The first meeting was held on 11th
November 1780. Robert was in the chair, and the theme of the
debate was: 'Suppose a young man, bred a farmer, but without any
future, has it in his power to marry either of two women, the one a

girl of large fortune, but neither handsome in person nor agreeable in conversation, but who can manage the household affairs of a farm well enough; the other of them a girl every way agreeable in person, conversation and behaviour, but without any fortune: which of them shall he choose?' Robert, needless to say, was all for the fortuneless lass 'agreeable in person'. Other subjects of debate included: 'Whether do we derive more happiness from Love or Friendship?'; 'Whether is the savage man or the peasant of a civilized country in the most happy situation?'; and 'Whether is a young man of the lower ranks of life likeliest to be happy, who has got a good education and his mind well-informed, or he who has just the education and information of those around him?'—subjects, all of them, which today, phrased in modern terms, still engage the attentions of earnest and self-important debaters in University Unions and Young Men's Clubs. The actual wording of the subjects debated in the Tarbolton Bachelors' Club suggests that Robert had a hand in formulating them. For him, the Club not only provided an audience, the approving flame of whose applause warmed his mind to that brilliant vitality which found expression in the easy eloquence of his speech in adult life, but also afforded him an opportunity of discussing with his fellows behind a pose of impersonality, subjects which were genuinely very near his heart. Robert must have been aware already that he possessed more education than those around him, yet he certainly was not happy; aware, too, that his immediate prospects of marrying a girl with or without a fortune, on the usual labourer's wages of seven pounds a year which his father allowed those members of the family who worked on the farm, were not exactly bright.

Dr Currie, who first printed the notes of the Club's meetings, also printed the Rules and Regulations, which he called a 'curious document evidently the work of our poet'. The Club was to meet at Tarbolton every fourth Monday night, hear the question, draw lots as to which speaker was to speak first, elect a president for the next meeting, then 'after a general toast to the mistresses of the club', dismiss. There was to be no 'swearing and profane language' and no 'obscene and indecent conversation'. Members, who were never to exceed sixteen bachelors in number, were not to communicate the

affairs of the Club to 'any person but a brother member'. A member who married might retain his position 'if the majority of the club think proper'. The tenth and most significant rule reads:

> Every man proper for a member of this Society, must have a frank honest, open heart; above any thing dirty or mean; and must be a professed lover of one or more of the female sex. No haughty, self-conceited person, who looks upon himself as superior to the rest of the Club, and especially no mean-spirited, worldly mortal, whose only will is to heap up money, shall upon any pretence whatever be admitted. In short, the proper person for this Society is, a cheerful, honest-hearted lad; who, if he has a friend that is true, and a mistress that is kind, and as much wealth as genteely to make both ends meet—is just as happy as this world can make him.

The English influence behind the document is obvious. As Dr Daiches says: 'These young men were trying to domicile the English genteel tradition in rural Scotland.' The hyper-sensitive fear of ridicule, the scorning of wealth, and the extraordinary insistence on a plurality of loves (a proposition which Robert found, when he tried it in practice later on, certainly did not render him as happy as this world could make him) all suggest Robert's influence.

At first, however, he was to be content with a single love, a servant-girl called Alison (or Ellison) Begbie from a neighbouring farm. Very little is known about her for certain, beyond the fact that she was a Galston farmer's daughter, and that she was probably the recipient of an unsuccessful epistolary courtship, the development of which is traced in five letters interesting as examples of Robert's early neo-classical prose style. The originals of the letters have never been found—probably they were lost or destroyed by Dr Currie's descendants, who accounted for the disappearance of a good many Burns manuscripts—and what are probably the rough drafts which Robert himself retained, are undated. Most recent biographers, however, place the incident, and therefore the letters, in the early months of 1781, following the lead of Professor De Lancey Ferguson. When the affair first assumed importance in Robert's mind, Alison had no

real reason to think that the flashing-eyed eloquent son of 'Auld
Lochlie', who wore a plaid the colour of dead leaf when everyone
else wore shepherd's grey, and who was the only youth in the village
to tie his hair, was really in love with her.

What you may think of this letter when you see the name that
subscribes it I cannot know; and perhaps I ought to make a long
Preface of apologies for the freedom I am going to take, but as
my heart means no offence but on the contrary is rather too
warmly interested in your favor, for that reason I hope you will
forgive me when I tell you that I most sincerely and affectionately
love you.—I am a stranger in these matters A——, as I assure
you, that you are the first woman to whom I ever made such a
declaration so I declare I am at a loss how to proceed.

Such a well-phrased straightforward letter no doubt gave her feel-
ings of natural pleasure. Country lovers were not always so formal
and so polite, and this one was worth the slow difficulty which
reading caused her. But whatever was a simple lassie to make of the
next letter, which rises to its climax in an obviously contrived
literary pose?—

The sordid earth-worm may profess love to a woman's per-
son, whilst in reality his affection is centred in her pocket: and the
slavish drudge may go a-wooing as he goes to the horse-market
to chuse one who is stout and firm, and as we may say of an old
horse, one who will be a good drudge and draw kindly. I disdain
their dirty, puny ideas.

The crux of the matter comes in the fourth letter, when he proposes
marriage:

There is one thing, my dear, which I earnestly request of you,
and it is this: that you would soon either put an end to my hopes
by a peremptory refusal, or cure me of my fears by a generous
consent.

The answer was a 'peremptory refusal', so Robert rounded off the
correspondence with a dignified letter in which he stated: 'I must
now think no more of you as a mistress, still I presume to ask to be
admitted as a friend.'

Alison came out of the experience scatheless. Out of her refusal, Robert learned one thing: that 'the way of a man with a maid' is certainly not to woo her with stately love-letters.

Three songs of this period possibly refer to Alison Begbie— 'Bonie Peggy Alison', a lightly-tapping reel measure which sets out Burns's belief that human love is the richest pleasure any man may know:

> When in my arms, wi' a' thy charms,
> I clasp my countless treasure, O!
> I seek nae mair o' Heav'n to share
> Than sic a moment's pleasure, O!—

'The Lass of Cessnock Bank', in which the beloved is likened to the countryside and its moods and plants—one warms especially to her 'two sparkling rogueish een'—and the exquisite 'Mary Morison', the middle verse of which sets off with a simplicity that has seldom been equalled that lack of favour which all women other than the beloved find in the lover's eyes:

> Yestreen, when to the trembling string
> The dance gaed thro' the lighted ha',
> To thee my fancy took its wing,
> I sat, but neither heard nor saw;
> Tho' this was fair, and that was braw,
> And yon the toast of a' the town,
> I sigh'd, and said amang them a',
> 'Ye are na Mary Morison.'

True, 'Bonie Peggy Alison', in so far as any Burns song was ever based directly on an actual model drawn from life, may possibly have been a still more shadowy figure than Alison Begbie—the 'Montgomerie's Peggy' of a slightly earlier song, who was apparently housekeeper at Coilsfield House, and with whom, according to his sister, Isabella, Robert 'contracted an intimacy'[1] while they sat in the same church. This is the view taken by Mrs Carswell. Because of its perfection, many critics have also doubted the

[1] The expression is Isabella's, not mine. 'Intimacy' has changed its meaning somewhat over the last century and a half.

correctness of attributing 'Mary Morison' to this period in Robert's life, although the weight of evidence appears to be overwhelmingly in favour of such a placing.

A succession of minor 'affairs' is part of the normal development of any young man of twenty years, so it is highly probable that at this stage Robert did, in fact, flirt with at least some of the other local lasses with whom tradition associates his name. But the failure of the Alison Begbie affair depressed him deeply, and probably played the main part in making him decide on a change of occupation. If the future of a farmer's son made so little of an appeal to a woman, might not the career of a tradesman offer better matrimonial prospects?

Shortly before he left Lochlie, Robert became a Freemason, being admitted on 4th July 1781. Freemasonry flourished in rural Lowland Scotland—and indeed throughout much of Europe—during the latter part of the eighteenth century. The sentimental deism and humanistic benevolence which made up the philosophical temper of the age provided encouraging soil for the growth of Freemasonry among the labouring classes. Tarbolton was a particularly strong centre, and there were actually two lodges in the village, one of which had seceded from the other. (Even universal brotherhood was not proof against the Scots love of secession.) They came together again under St David Lodge, of which Robert became a member, though eventually he went with the seceders who, a few months later, set up another rival lodge, St James Kilwinning. The hearty drinking comradeship of 'the sons of light' and their succouring of the poor and needy, gave Robert deep satisfaction. He quickly gained ascending honours in their ranks. The ideas of the brotherhood on the dignity of Man, and on the glories of Freedom, coincided more or less with his own. Through his Masonic connexions, too, he made many influential friends who were later to be of the greatest practical assistance to him; notably, Gavin Hamilton, the Mauchline lawyer; Dr John Mackenzie, the family medico; and James Dalrymple of Orangefield, a local laird to whom Robert eventually owed the patronage of the Earl of Glencairn. But we must now follow the poet to Irvine.

II

The Irvine interlude began about midsummer 1781. Flax-growing had been practised since the Burns's first moved to Lochlie. Robert and Gilbert had both rented from their father portions of land on which to cultivate their flax, not without success. (The *Glasgow Mercury* for the third week of January 1783 contained the announcement of a prize of three pounds, awarded to Robert by a society interested in agricultural experiment, for the quality of his lintseed.) Clearly, there might be money in flax, particularly if the grower was also able to prepare the crop for the spinners, and so get for himself the profits of the 'middlemen' flax-dressers. There might also be an improvement in social status, at any rate in the eyes of a potential bride.

Details of Robert's Irvine days are unfortunately scanty; still more unfortunately, they have been laced with colourful and improbable legends. There was a man named Peacock living in a shop in the Glasgow Vennel, who may have been a relative of Robert's mother. Possibly, it was with Peacock that Robert lived. But he seems to have entered into some kind of partnership with another flax-dresser whose 'heckling-shop' was probably in the High Street.

The new adventure did not prosper. Flax-dressing was hard, confining work, sore on the hands and tedious in the extreme. Robert, already unhappy because of Alison Begbie's refusal of him, became ill and deeply melancholy. His father, perhaps uneasy about the state of his son's health, came down to Irvine on a visit at Martinmas. Dr Snyder suggests that William Burnes may have come on to Irvine after a necessary business trip to Alloway in connexion with the sale of the 'clay biggin' and the remaining part of the land there to the Shoemakers' Guild of Ayr. Be that as it may, hard upon William's returning heels, there came to Lochlie a letter dated 27th December which would have alarmed any normal father. After declaring that his health was mending, 'but by very slow degrees', Robert gave way to the languor of adolescent despair.

The weakness of my nerves has so debilitated my mind that I dare not either review past events, or look forward into futurity;

for the least anxiety, or perturbation in my breast, produces most unhappy effects on my whole frame.—Sometimes, indeed, when for an hour or two, as is sometimes the case, my spirits are a little lightened, I glimmer a little into futurity; but my principal, and indeed my only pleasurable employment is looking backwards and forwards in a moral and religious way—I am quite transported at the thought that ere long, perhaps very soon, I shall bid an eternal adieu to all the pains, and uneasiness and disquietudes of this weary life; for I assure you I am heartily tired of it, and, if I do not very much deceive myself I would contentedly and gladly resign it . . .

Then follows a quotation from Pope's *Essay on Man*; an unacknowledged echo from the dying speech of the weepy and ineffectual Harley, hero—if such a term may be applied to anyone so entirely unheroic—of Mackenzie's *Man of Feeling*: 'I am not formed for the bustle of the busy nor the flutter of the Gay I shall never again be capable of it'; a regret that the writer has not made the most of his father's example of virtuous piety; and a curiously down-to-earth postscript announcing that his meal has run out, but that he is going to borrow until he gets more.

William, already harassed by the importunings of David McLure, who in turn had been financially crippled by the failure of the Douglas, Heron and Company's Bank at Ayr in 1773, may have regarded his son's letter as more of a sign of grace than anything else. But to other readers, in spite of its emotional immaturity, it bears the marks of Robert's later epistolary manner. The memorable phrases, like 'I glimmer a little into futurity', the pat Augustan quotation put in for balanced effect, and the tendency to dramatize a situation to the uttermost, at the expense of accuracy; all these were to become permanent characteristics of his prose style.

Nevertheless, even if he really did not wish for death—except, perhaps, in the self-pitying way that all young men at one time or another claim to do so, clinging furiously to life if death looks like taking them at their word!—Robert was genuinely unhappy, and the memory of his unhappiness still persisted vividly when he was writing to Dr Moore.

My twenty-third year was to me an important era. Partly thro'
whim, and partly that I wished to set about doing something in
life, I joined with a flax-dresser in a neighbouring town, to learn
his trade and carry on the business of manufacturing and
retailing flax.—This turned out a sadly unlucky affair.—My
Partner was a scoundrel of the first water who made money by
the mystery of thieving; and to finish the whole, while we were
giving a welcome carousal to the New year, our shop, by the
drunken carelessness of my Partner's wife, took fire and was burnt
to ashes . . . and to crown all, a belle-fille whom I adored and who
had pledged her soul to meet me in the field of matrimony, jilted
me with peculiar circumstances of mortification.

If this, as is generally assumed,[1] refers to Alison Begbie, then of
course Robert was indulging in falsification to protect his wounded
vanity, for she certainly had not 'pledged her soul' to meet him in
matrimony, and therefore did not jilt him.

He goes on:

The finishing evil that brought up the rear of this infernal file
was my hypochondriac complaint being irritated to such a de-
gree, that for three months I was in a diseased state of body and
mind. . . .

His complaint, however, was not hypochondria as he supposed, but
the beginnings of endocarditis, a disease brought on by the cruel
man-strain of the farm labour which his boyish frame had had to
endure.

In spite of the pervading gloom of the Irvine days, Robert made
one firm friend—a friend to whom he devoted more space in his
autobiographical letter than to any other male. Robert, as he
developed became more and more strongly attached to the business
of living. He usually faced up to life with immense gusto and
courage. It is easy to understand how he chose for the object of his

[1] Matthew P. MacDiarmid (*The Poems of Robert Fergusson*: S.T.S. 1954)
suggests that the reference is to Jean's 'abandonment' of the poet in 1786.
Writing in 1787 to Dr Moore, however, it is hard to see how Burns could
ante-date that affair by four years, and deliberately place it in the context of the
Irvine troubles.

hero-worship the unlucky, warm-blooded, picaresque sailor Richard Brown, who thought little of seducing a girl if he wanted her, and who had a taste—if perhaps a doubtful one—for poetry.

He was the son of a plain mechanic; but a great Man in the neighbourhood taking him under his patronage gave him a genteel education with a view to bettering his situation in life. The Patron dying, just as he was ready to launch forth into the world, the poor fellow in despair went to sea; where after a variety of good and bad fortune, a little before I was acquainted with him, he had been set ashore by an American Privateer on the wild coast of Connaught, stript of everything. . . .

This gentleman's mind was fraught with courage, independence and Magnanimity, and every noble, manly virtue.—I loved him, I admired him, to a degree of enthusiasm; and I strove to imitate him.—In some measure I succeeded: I had the pride before, but he taught it to flow in proper channels.—His knowledge of the world was vastly superiour to mine, and I was all attention to learn.—He was the only man I ever saw who was a greater fool than myself, when WOMAN was the presiding star; but he spoke of a certain fashionable failing with levity, which hitherto I had regarded with horror. Here his friendship did me a mischief. . . .

Later on, when Brown had become 'Captain of a large Westindiaman belonging to the Thames' and a respectably married family man, he strongly denied ever having initiated Burns into 'a certain fashionable failing', and Robert's statement was probably the cause of the friendship ending. But whether or not Brown did teach Robert the art of seduction, he certainly first suggested that a poet ought to publish his work.

. . . do you recollect (Robert wrote to the Captain in December 1787) a Sunday we spent in Eglinton woods? you told me, on my repeating some verses to you, that you wondered I could resist the temptation of sending verses of such merit to a magazine: 'twas actually this that gave me an idea of my own pieces which encouraged me to endeavour at the character of a Poet.

It is probable that the 'verses of such merit' were the two stanzas of the poem 'On the great recruiting during the American War', which Dr Daiches calls 'a song of sexual swagger'.

> I murder hate by field or flood,
> Tho' glory's name may screen us.
> In wars at hame I'll spend my blood—
> Life-giving wars of Venus:
> The deities that I adore
> Are Social Peace and Plenty;
> I'm better pleased to make one more
> Than be the death of twenty . . .

Nevertheless, such a sense of the power of his sexuality is natural in any young man of Burns's age.

At least this poem has a healthy ring about it when tried against the lugubrious 'A Prayer in the Prospect of Death', or the even more melancholy 'Stanzas on the Same Occasion', couched in the simple stanza form of the Scottish psalms, and which were the chief poetic fruits of the Irvine stay.

Why, after the disastrous New Year fire, Robert hung on at Irvine until the spring of 1782, is not at all clear. Mrs Carswell credits him with a concentrated bout of literary study—mostly with books read in a bookshop because he was too poor to buy them!—during these months, and suggests that it was then he made his first serious acquaintance with the poems of Robert Fergusson. It may be so.[1] She at least has several will-o'-the-wisp traditions to support her. I think it more probable that Robert was simply unwilling to go back to the tight-reined drudgery of Lochlie, a moment before he had to. For there was much at Irvine to satisfy a young poet's interest in life.

Although already in decline, Irvine was still a more important seaport than Ayr; a bustle of sailors, smugglers, tradesmen, ropeworkers, coal-hewers, carters, bleachers, brewers and distillers.

[1] But the evidence contained in Burns's own work seems to rebut her. The direct influence of Fergusson did not make itself apparent in his poems until 1784. Burns's copy of Fergusson was probably that of the 1782 edition, published two months or so *after* Burns had left Irvine.

Smuggling at the end of the eighteenth century had become almost a major British industry. There was a tax of twenty shillings a gallon on imported wine—a staggering amount in relation to the values of the time—and lesser taxes on tea, French silk, laces, spirits and a wide range of other goods. Every inducement was thus offered to the smuggler to run the risk of being caught by the overworked officers of the understaffed Excise. The Ayrshire ports were as near to Glasgow as the smugglers dared venture, and even Irvine was considered to be rather too near the danger line.

Because of the industrial development which was taking place in the hinterland, Irvine also attracted a good deal of licit trade. It still had a fine harbour, even although it was no longer the third seaport in Scotland as it had been at the time of the Union of 1707 (having lost its supremacy to Greenock); and proud ships sailed from that harbour to the Indies and the Americas. One, indeed, was commanded by Captain John Galt, whose son, the future novelist, was a delicate child of four during Robert's sojourn in the town.

A year later, when writing to his old schoolmaster Murdoch, Robert was to declare:

> I seem to be one sent into the world, to see, and observe; and I very easily compound with the knave who tricks me of my money, if there be any thing original about him which shews me human nature in a different light from anything I have seen before. In short, the joy of my heart is to 'study men, their manners, and their ways'[1]: and for this darling subject, I chearfully sacrifice every other consideration. I am quite indolent about those great concerns that set the bustling, busy Sons of Care agog; and if I have to answer the present hour, I am very easy with regard to any thing further.

In other words, Robert, having failed as a flax-dresser, and being desperately conscious that he lacked an aim in life, was quite willing to let the activities of the Sons of Care provide him with a colourful spectacle. It is essential for every poet to be able to stand and stare at life; to take in sights, sounds and savours as they are offered, and to

[1] Pope: *January and May.*

absorb the touch and texture of various ways of living. Because of his relatively confined upbringing, Robert's need for this sort of absorbing experience must have been greater than the need of many a poet who matured earlier in years. Late maturing is, however, a national Scots characteristic: we have produced very few prodigies.

By March the state of affairs at Lochlie was such that he could no longer put off facing up to his family responsibilities. (Robert's strong sense of family responsibility—one of his most attractive characteristics—saved him from many follies throughout his career.) The outbreak of the American Revolution in 1775 had brought distress to many British workers, especially to the weavers; and to make matters worse, no sooner had it ended than the winter of 1782–3 came with such severity that crops were blighted, and starvation threatened many families in the West. William Burnes no doubt suffered with the rest.

On top of this latest calamity, which brought a wave of sickness in its wake, the news reached Robert that his father had become involved in legal action. Robert returned home full of foreboding.

The trouble between William Burnes and McLure sprang from their lack of a written agreement. The dispute arose over the question of how much each man was to pay towards the high cost of liming the poor soil, fencing, and putting up new farm buildings. In September 1782, since neither could agree, they submitted the matter to the arbitration of James Grieve of Boghead, representing McLure, and Charles Norval of Coilsfield, representing Burnes. Meanwhile, pending a decision, William withheld payment of his rent.

Unfortunately, the arbitrators could not agree either, so the whole matter was laid before John Hamilton of Sudrum, who was to act as referee or 'Oversman'. Hamilton, however, found that the tangled accounts took some sorting out, and it was not until August 1783 that he announced his decision. He ruled that of the £775 which McLure alleged William Burnes owed him, £543 was in effect written off on account of improvements made by the tenant, and earlier payments of rent.

Meanwhile, McLure, by now so deeply in debt himself that no one knew whether the disputed rent belonged to him or his creditors,

had become impatient, and had taken out a writ of sequestration on the stock and crops of Lochlie in an attempt to force full payment. William Burnes thereupon took the case to the Court of Session in Edinburgh. When his first petition was thrown out on a technicality, he promptly sent in another: and there for a time the matter lay.

Robert, who must have followed his failing father's legal battle with some alarm, began his *First Commonplace Book* in April:

> Observations, Hints, Songs, Scraps of Poetry &c. by Robt Burness; a man who had little art in making money, and still less in keeping it; but was, however, a man of some sense, a great deal of honesty, and unbounded good-will to every creature rational and irrational.—As he was but little indebted to scholastic education, and bred at a plough-tail, his performances must be strongly tinctured with his unpolished, rustic way of life; but as I believe, they are really his own, it may be some entertainment to a curious observer of human-nature to see how a plough-man thinks, and feels, under the pressure of Love, Ambition, Anxiety, Grief, with the like cares and passions, which, however diversified by the Modes and Manners of life, operate pretty much alike, I believe, in all the Species. . . .

Then followed two quotations from Shenstone; an observation on the relationship between love, music and poetry; the song to Nelly Kilpatrick, together with a criticism of it to show the world—for Robert was obviously now writing with the idea of an approving audience in his mind's eye—that he was aware of its shortcomings; a note on remorse, agreeing with Adam Smith's definition of it as 'the most painful sentiment that can embitter the human bosom'; and some indifferent but deeply-troubled lines of blank verse, 'Thought, in the Hour of Remorse, Intended for a Tragedy'.

Meanwhile, the tragedy of one unsubmitting heart was rapidly playing itself towards the final curtain, William's consumption made his cheeks so haggard and his body so thin that Robert and Gilbert could no longer avoid acknowledging the fact that in a matter of months they would have to fend for themselves and the family, an opinion borne out by their doctor, John Mackenzie of Mauchline. So Robert sat down and wrote an account of the

happenings in Ayrshire to his first cousin, James Burness, a Montrose lawyer, finishing by sending William's warmest wishes, 'probably for the last time in this world'.

It was in the late autumn of 1783 that Gavin Hamilton, liberal opponent to Auld Licht Calvinism, Freemason and Mauchline lawyer, got to hear of the family plight, perhaps from his clerk John Richmond. Hamilton is said by tradition to have disliked McLure personally, and tradition is certainly backed up by subsequent developments. Hamilton had recently leased from the Earl of Loudon, to whom he was factor, one hundred and eighteen acres of Mossgiel farm, about a mile from Mauchline village. Probably it had originally been the genial lawyer's intention to farm the place himself; but for some reason he grew tired of the idea. He therefore suggested to Robert and Gilbert that they should lease Mossgiel from him at the very moderate rent of £90 a year. They could begin in a quiet enough way, but at least they should not be destitute and 'driven forth . . . forlorn' when the final blow struck their father. To frustrate McLure further, Gavin Hamilton suggested that the girls in the household should become, retrospectively, labourers in William's employ, as the boys had already been for several years. The crops at Lochlie, the moment they were sown, could be sold in the field to buyers in Tarbolton; and however much McLure might rage about sharp practice, there would be precious little else left for him to do.

Meanwhile, at Lochlie, the dying man waited and watched. A local girl called Elizabeth Paton had been taken on to help Agnes with the work. She was a coarse girl with masculine features, but she had a shapely figure: and William noticed that the eyes of his eldest son roved after her whenever 'Lizzie' moved about the room. Burns recorded his early interest in the girl in a bawdy song, 'My Girl She's Airy', which he later copied into his Commonplace Book and is now in The Merry Muses (1965). It reflects the attitude of a young man who still regards sex as a kind of country sport.

> My Girl she's airy, she's buxom and gay,
> Her breath is as sweet as the blossoms in May;
> A touch of her lips it ravishes quite;

She's always good natur'd, good humor'd and free;
She dances, she glances, she smiles with a glee;
 Her eyes are the lightenings of joy and delight;
Her slender neck, her handsome waist
Her hair well buckl'd, her stays well lac'd,
Her taper-white leg, with an et, and a, c,
 For her a, b, e, d, and her c, u, n, t,
 And Oh, for the joys of a long winter night!!!

On 27th January 1784, the news reached Lochlie that William had won his case in Edinburgh. He had every penny of the balance-money saved up and set aside to deposit with the Court. William Burnes, the stern, unbending Calvinist, had won to the end of his days in rugged independence. But the final battle in defence of his honour exhausted his small savings, and sapped the last of his strength.

As January gave place to February, one worry still nagged at the old man's heart. In dying, at least he would not leave the family in debt. But he would have to leave them to the care of Robert; and of Robert he was unsure.

On the morning of 13th February, it was the turn of Isabella and Robert to keep watch by the sick-bed. Suddenly their father drew himself up from his pillow, and in a thin reflection of his former voice, solemnly exhorted his daughter always to follow the path of virtue and to shun vice. Isabella tells us that he paused for a moment before adding that there was but one member of the family about whose future behaviour he was troubled. Robert came across to the bedside and asked: 'Father, is it me you mean?' His father told him that it was. Robert turned back to the window, tears streaming down his cheeks, his whole frame trembling under the restraint he had to impose upon his emotions. A few hours later William Burnes resigned his care-worn spirit to the grim God of his forebears. His wasted body was laid to rest in the old kirkyard at Alloway, near the cottage, where, twenty-six years before, he and Agnes Broun had begun the drama that was to bring them reflected immortality.

So ended the second major division of Robert's life. He started it

as a gawky country boy of more than ordinary intelligence. He
ended it as a great poet in the making who had already shown his
mettle, a rebel against the business of having to earn a prosaic living,
and a man upon whom an incurable heart-disease had fastened
its grip.

Varied as was to be Robert's song achievement in the years ahead,
he never wrote anything more delicately perceptive than 'Mary
Morison', one of the first fruits of his study of Scots folk-music.
Even the technical foundation of his later satires and verse-letters
was laid at Lochlie, in 'The Death and Dying Words of Poor
Mailie, The Author's Only Pet Ewe', and the pendent poem 'Poor
Mailie's Elegy'. According to Gilbert, these pieces arose out of an
actual incident. Robert had bought a ewe and two lambs from a
neighbour and had tethered them near the Lochlie farmhouse.
While out ploughing, a startled-looking herd-laddie, Hugh Wilson
by name, suddenly rushed up to the brothers with the news that the
sheep had strangled herself and was lying in a ditch. The sheep,
however, proved merely to have become entangled and was easily
rescued from her plight. But the whole incident, in particular the
grotesque appearance of the frightened herd-boy, amused Robert.
As he and Gilbert were trudging home from their ploughing that
evening, Robert is said to have produced the poem more or less in
its present form.

In the poem, the dying ewe addresses to the frightened herd-boy
her last wishes and warnings; hopes that her son will always behave
in a seemly fashion; that her daughter will be fortunate in the rams
with whom she consorts; and that her kind master will burn the
cursed rope.

The tradition on which 'Poor Mailie' is based goes back, so far as
Scotland is concerned, to the *Moral Fables* of Robert Henryson
(1425?–1506?), the earliest Scots poet to put human sentiments into
the mouths of animals.

The earliest specimen of such verse in which a dying animal gives
forth a poetic 'will', seems to be Hamilton of Gilbertfields' 'The
Last Dying Words of Bonny Heck, a famous Greyhound in the
Shire of Fife'. 'Habbie Simpson the Piper of Kilbarchan', written by
Robert Sempill of Beltrees (c1594–c1668) provided Hamilton,

Ramsay, Fergusson and Burns, and many minor eighteenth-century Scots poets, with what was to become the characteristic stanza of the eighteenth-century Literary Revival—so much so, in fact, that Ramsay dubbed it 'Standard Habbie'. Sempill's elegy begins

> Kilbarchan now may say alas!
> For she hath lost her Game and Grace
> Both Trixie and the Maiden Trace:
> But what remeid?
> For no man can supply his place,
> Hab Simson's deid.
>
> Now who shall play 'The day it daws'?
> Or 'Hunt up when the cock he craws'?
> Or who can for our Kirk-town-cause,
> Stand us in stead?
> On Bagpipes now nobody blaws
> Sen Habbie's dead.

'Standard Habbie' is an easy stanza to write, particularly when the burden of the verse is quick-moving, colloquial social comment, with perhaps a satirical edge. Robert in time came to vary the form a little by sometimes substituting half-rhymes for full ones, especially at the end of the four long lines, which in any case conclude less forcefully than the two short ones.

Useful as 'Standard Habbie' was to him—and he became its most powerful exponent—even in the Lochlie days he was already experimenting with a wide range of rhythms and rhyming patterns. To take but a few instances, consider the ballad-like rhythms of 'John Barleycorn' and 'The Ronalds of the Bennals'; or the determined dexterity of 'The Lass o' Cessnock Banks', in which Robert rhymes 'een' no less than fourteen times, betraying no sense of strain.

By the end of the Lochlie period, then, Robert had finished not only his long apprenticeship to living, but also his apprenticeship to literature. The promise and the power excited his imagination. Within a few months he was to pree them both to the full.

3

Mossgiel
1784-5

I

In March 1784 the family moved into Mossgiel, two miles to the south-east, which Robert and Gilbert had rented from Gavin Hamilton 'as an asylum for the family in case of the worst', as Gilbert put it. 'The worst', thanks to Gavin Hamilton's shrewdness, had not turned out to be as terrible as it might have been, for the ruse of claiming back-wages out of William Burnes's estate on behalf of the older girls as well as for the boys, gave the family a little ready money to come and go upon.

Mossgiel was from the beginning a family concern, stocked, Gilbert tells us,

> by the property and individual savings of the whole family. . . .
> Every member of the family was allowed ordinary wages for the
> labour he performed on the farm. My brother's allowance and
> mine was seven pounds per annum each. And during the whole
> time this family concern lasted, which was four years, as well as
> during the period at Lochlea, his expenses never in any one year
> exceeded his slender income. As I was intrusted with the keeping
> of the family accounts, it is not possible that there can be any
> fallacy in this statement, in my brother's favour. His temperance
> and frugality were everything that could be wished.

As head of the family, the others naturally looked to Robert as their leader. He arrived at Mossgiel full of high intentions, and determined to overcome his urges towards what he called 'social and amorous madness'.

> I entered upon this farm with a full resolution, 'Come, go to, I
> will be wise'!—I read farming books; I calculated crops; I
> attended markets; and in short, in spite of 'The devil, the world

and the flesh', I believe I would have been a wise man; but the first year from unfortunately buying in bad seed, the second from a late harvest, we lost half of both our crops: this overset all my wisdom, and I returned 'Like the dog to his vomit, and the sow that was washed to her wallowing in the mire'.[1]

Buying in bad seed does not suggest that the farming books had imparted as much knowledge as they should have done. Throughout his life, however, Robert was unsure of his farming judgement. Whenever a major decision had to be taken on a farming issue, he leaned heavily upon the advice of some friend, only to receive advice which was usually as unsound as his own unaided judgement. Even before the family left Lochlie, when the stocking of Mossgiel was being discussed, Robert wrote to Gavin Hamilton:

> As you were pleased to give us the offer of a private bargain of your cows you intend for sale, my brother and I this day took a look of them and a friend with us on whose judgment we could something depend, to enable us to form an estimate—If you are still intending to let us have them in that way, please appoint a day that we may wait on you and either agree amongst ourselves or else fix men to whom we may refer it, tho' I hope we will not need any reference.—
>
> P.S. Whatever of your dairy utensils you intend to dispose of we will probably purchase.

Mossgiel today is a pleasant enough place, looking over the rolling fertile fields of southern Ayrshire to the distant Firth of Clyde and the heroic ruggedness of the Arran hills: as Wordsworth saw it:

> Far and wide
> A plain below stretched seaward, while, descried
> Above sea-clouds, the peaks of Arran rose;
> And, by that simple notice, the repose
> Of earth, sky, sea, and air was vivified.

In Robert's day, according to Gilbert, the farm lay 'mostly on a cold wet bottom'. But even making due allowance for the bad seed, the frosty years, the late springs and the undrained condition of the

[1] St Peter ii. 22.

soil, Nature clearly cannot be given the main share of blame for the fact that the Mossgiel venture proved almost as disastrous as those of Mount Oliphant and Lochlie. The ultimate cause of this failure was simply that the head of the household, for all his good intentions, soon found that his heart lay not in farming, but in the wider world of letters.

During the latter part of their first spring in the new farm and throughout the summer, Robert had to suffer another onslaught of his Irvine trouble. It brought him very low, and caused him to enter in his *Commonplace Book* in August 1784: 'A prayer, when fainting fits, and other alarming symptoms of a pleurisy or some other dangerous disorder, which indeed still threaten me, first put Nature on the alarm.'

Possibly the poem was actually composed under similar circumstance in Irvine the year before, and only transcribed into the *Commonplace Book* under the fearful stress of the depression which accompanied this, his second serious attack of advancing endocarditis. Sir James Crichton-Browne, whose examination of Robert's medical history first disposed of the prevailing nineteenth-century notion that the poet died of drunkenness, explained that:

> His sensations, which only those who have thus suffered can fully realize, were terrible, kept him in fear of sudden death, and led to acute compunction for errors real or imaginary.

During these depressing months of indisposition, Robert was under the care of Dr Mackenzie of Mauchline, who had attended William Burnes in his last illness. Mackenzie had been trained at Edinburgh University and had settled in Mauchline at the invitation of Sir John Whitefoord, the local laird. He married Helen Miller, one of the 'Mauchline Belles', and became a close friend of Robert's. He has been much criticized for prescribing not only the wrong treatment for Robert's ailment, but one which, in all probability, accelerated the progress of the disease. He instructed his patient to plunge into cold baths and to get rid of this melancholy by still harder farm work, when clearly Robert should have been ordered complete rest. But as Dr Fleming Gow recently pointed out, Dr Mackenzie could not possibly have diagnosed the true nature of Robert's disease

without the aid of the stethoscope, which was not invented by Laënnec until 1819.

By autumn, however, the natural vigour of Robert's constitution had brought him through this second attack; and, though each new attack enabled the disease to gain a firmer hold, by late August, his spirits had so recovered that the usual autumnal carnival raged in his bosom.

The house at Mossgiel, with its two rooms downstairs given over to his mother, his sisters and the younger members of the family, and its two attic rooms reached by means of a ladder, in one of which stood Robert's writing-desk, was hardly big enough to afford anybody a great deal of privacy. So, when he was not writing at his little table, Robert spent much of his leisure away from home; at Largieside, the home of Elizabeth Paton, who had not moved with them to Mossgiel. Restored to full health and spirits, with his father no longer alive to restrain him, and under the influence of the full harvest moon, Robert at last surrendered to his strong sexual urge. Elizabeth Paton, in spite of her plain face, had an enticing figure. Most important of all, and without any question of marriage arising between them, she was willing to give herself to the eager Robert at the end of August, that fatal moment when 'corn riggs are bonie'.

Robert, however, still needed male companionship as much as in the Tarbolton days. He kept up his Masonic connexion with the Tarbolton lodge, and served as Depute-Master from July 1784 till November 1786.

But Mossgiel lies in the parish of Mauchline; so it was to Mauchline rather than to Tarbolton that he turned for his new friendships. The heart of Mauchline (or Machlin, as it used to be called) has not greatly altered since Robert's time, though the church in which he listened to the uncompromising sermons of the Reverend Dr William ('Daddy') Auld, made way in 1827 for the present building, which was put up in 1829. Many characters from the Burns story rest within the iron-railed cemetery, among them 'Daddy' Auld himself, and his lieutenant 'Holy Willie' Fisher; Gavin Hamilton and his one-time clerk John Richmond; the innkeeper Agnes Gibson, better known as 'Poosie Nansie', and her equally disreputable daughter 'Racer Jess', so called because of her ability and willingness

to run errands at great speed when suitably tipped; Nanse Tinnock, another village ale-wife; Jean Armour's parents, and the four daughters of Jean and Robert who died in infancy. Around the church, too, still stand many of the buildings in which these characters lived out their lives. These include the tower called the 'Castle'; the houses of Gavin Hamilton, 'Daddy' Auld, and Dr John Mackenzie; Poosie Nansie's inn—still a public house—where the 'Jolly Beggars' came together; Johnnie Dow's 'Whitefoord Arms', in Robert's day the most genteel drinking-house in the village but now a general store; James Armour's house; and the house which was once Nanse Tinnock's inn. Although they no longer have roofs of thatch, the red sandstone exteriors of the buildings have altered little in more than a century and a half.

Robert's friendship with social superiors like his landlord Gavin Hamilton, and with Dr Mackenzie probably contributed something towards the unsettled state of his mind at this time, inspiring him with vague aspirations which he could hardly define let alone satisfy, and which ill-accorded with the steady routine of a farmer. He found a freer kind of happiness in the company of a doctrinally unorthodox wine-merchant, forthright John Goldie; or kind, frail Robert Muir, another wine-merchant, who died of tuberculosis four years later. Both these men lived in Kilmarnock. Then there was Robert Aiken, 'orator Bob', a talkative, successful lawyer who lived in Ayr, and who, although twenty years older than the poet, became one of his staunchest friends and most useful patrons.

During his first winter in Mossgiel, Robert was probably happiest of all in the irresponsible company of John Richmond, his most intimate Mauchline friend, and James Smith, a linen draper in the village. Both Richmond and Smith were nineteen when Robert entered the Mauchline circle. Neither of them had much in the way of personality or talent; but what they both had, and what they shared with Robert, was an adolescent desire to flout social convention. Together, they formed the 'Court of Equity',[1] the principal object of which was to punish under the parish pump, fornicators who would not acknowledge the girls they had seduced. All three were themselves 'successful' fornicators. Richmond and Smith soon

[1] An extract is given on pages 310–12.

made Mauchline too hot to hold them. Richmond's amour with Jenny Surgeoner (whom he married six years later) led to his doing public penance before he left for Edinburgh. Smith went from Mauchline to Linlithgow, where he became a partner in a calico-printing business, after the failure of which he sailed for St Lucia and thereafter disappeared from ken.

The guardian of Mauchline's morals, 'Daddy' Auld, was seventy-five years of age when Robert brought him a certificate of good conduct from Dr Peter Woodrow, the parish minister at Tarbolton.[1] Auld was a stout upholder of the Calvinist faith, untainted by the smallest touch of liberalism. He held his charge for just over fifty years, and when, shortly before he died in 1791, he sat down to write for Sir John Sinclair's *Statistical Account* an outline of the changes that had taken place in the village since he first became its pastor, he found much to sadden him.

> The manner of living and dress, is much altered from what it was about 50 years ago. At that period, and for some time after, there were only two or three families in this parish who made use of tea daily; now it is done by at least one half of the parish, and almost the whole use it occasionally. At that period, good two-penny strong ale, and home spirits were in vogue; but now even people in the middling and lower stations of life, deal much in foreign spirits, rum-punch, and wine. In former times, the gentle-men of the country entered into a resolution to encourage the consumption of their grain, and, for that purpose, to drink no foreign spirits. But, in consequence of the prevalence of smuggl-ing, and the heavy taxes laid on home-made liquors, this patriotic resolution was either forgotten or abandoned.—As to dress, about 50 years ago there were few females who wore scarlet or silks. But now nothing is more common than silk caps and silk cloaks, and women in a middling station are as fine as ladies of quality were formerly. The like change may be observed in the dress of the male sex, though perhaps not in the same degree.

'Daddy' Auld, however, was not the sort of man to fash himself

[1] Dated 4th August, 1784, it testified the good character of Agnes Brown (Burns's mother) and her children.

unduly about anything so fickle as changed ideas on dress. What worried him most was the fact that from the cities came not only new fashions in clothes, but new rational notions, which sought to temper the strictness of the simple, inflexible doctrine he had preached throughout his long life. As it was primarily over a matter of doctrine that 'Daddy' Auld and his most gifted parishioner clashed; and since the great satires which flashed from Robert's pen during the winter of 1785 and the spring of 1786 cannot properly be appreciated without some knowledge of the position of the Scottish Church in the late eighteenth century, I now propose briefly to digress in order to sketch in the religious background against which the next phase of Robert's life was to be played.

II

By the middle of the sixteenth century, the old right wing Catholic Church in Scotland had become so riddled with corruption that it had not the strength to defend itself against the attacks of the left wing Reformers, who, under John Knox, had established Presbyterianism as the system of church government in Scotland with the support of the majority of the Scottish people, by about 1560. The Reformers' original aim was also to win England and Ireland over to their way of thinking, and by 1643, when the first Solemn League and Covenant was signed, it seemed as if England would, in fact, turn Presbyterian. By 1661, however, the climate of opinion had veered, and England instead adopted Episcopalianism, a compromise to which Lowland Scots were bitterly hostile. From London, the later Stuart Kings sought to establish Episcopalianism in both Kingdoms. Then followed the struggles of the Covenanters, led by preachers who had been driven from their manses to make way for Episcopalian parsons, and who held their conventicles in remote glens and fields under armed guard always on the look-out for the troops of the 'bloody persecutor', Claverhouse. Their troubles came to an end in 1688, with the signing of the Revolution Settlement which re-established the Presbyterian Church in Scotland.

The creed of the re-established Presbyterian Church, like that of its predecessor, was based on the doctrine of predestination, first

formalized in John Calvin's *Institutes*, published in Geneva in 1536. This doctrine set forth God's twofold irrevocable decree, whereby a small part of the human race was predestined to enjoy eternal happiness while the remainder were fore-doomed to eternal damnation. God's grace alone saved the fortunate few, and His grace could not be earned or won.

This absurd theory, together with certain of Calvin's more reasonable principles rejecting the Catholic notion of the transubstantiation of the communion elements and dealing with such matters as ministerial status and permissible lay influence in the Kirk, found native expression in Knox's *Scottish Confession of Faith*, upon which Presbyterianism had been set up in Scotland in 1560. Needless to say, the doctrine of predestination inevitably destroyed itself. Under cover of God's grace, the Elect could do no wrong; could lie, thieve, or even murder, and still be held to have been justified. James Hogg's novel, *The Private Memoirs and Confessions of a Justified Sinner*, a remarkable psychological study, illustrates with relentless logic the demoralizing effect that the assured knowledge of God's grace had upon one member of the Elect. This, then, was the doctrine which was still preached in the country districts of Scotland towards the close of the eighteenth century.

In the towns, however, it had been largely defeated and discredited by the moral gospel of humanistic deism put forward by several early eighteenth-century philosophers, and made popular by Francis Hutcheson (1694-1746), Professor of Moral Philosophy in the University of Glasgow for the last seventeen years of his life. But to 'Daddy' Auld and his country kind, Hutcheson's conception of a beneficent and reasonable God bordered on heresy.

Alongside this doctrinal difference, there ran another parallel cause of contention. The Presbyterians were entirely against any system of patronage whereby a minister was appointed to his living not by the call of the congregation, but by the choice of a lay patron who was usually the local landlord. The rights of congregations to choose their own ministers were thought to have been adequately safeguarded by the Treaty which united the Scots and English Parliaments in 1707. Unluckily, however, a High Tory Government, devoted to the interests of the Anglican Church, soon came to

power in London. In the hope of mortifying Presbyterianism in Scotland and protecting parish ministers who were really Episco-palian at heart—many of whom in their turn, had been purged in the so-called Presbyterian Inquisition of 1690—the Government passed an Act abolishing the congregational rights of election, and giving back the appointment of ministers to lay patrons.

Most of the troubles and divisions of the Scottish Church sprang from this breach of the Treaty of Union, though no doubt a stub-born spirit of individualism, very characteristic of Lowland Scot-land, helped to foment them. The leaders of the first important movement of protest were the brothers Ebenezer and Ralph Erskine. Ebenezer, who had been minister of Portmoak in Kinrosshire, was one of a group of ministers who, on 2nd November 1733, signed an Act of Secession at Gairneybridge, in protest against lay patronage. The new body, the Associate Synod, was itself struck by secession after secession, dividing into Burghers and Anti-Burghers (on a purely theoretical scruple about its members' relations with the State); and into New Lights and Old Lights (Auld Lichts) over various theological points. The Established Church was affected by a secession over the question of patronage in 1752.

The general movement of the Church was, inevitably, towards liberalization and the triumph of common sense. The diehards clung on to their antique power for a while; but by the time Burns's satires struck at them, that power was already waning, though it was still very considerable.

Since the Reformation, the ordinary Scotsman had come to look upon the Church as the main source of authority in his daily life. The Union of 1707, by removing political authority from the hands of Scotsmen, left the Church with still more effective power over the many plain, simple people, who went on supporting it, despite the tyranny it exercised over their daily lives, because they hated Episcopacy; and because Presbyterianism, for which their fathers and grandfathers fought and died, had rescued their great-grand-fathers from the corrupt and reputedly even more intolerable yoke of Rome.

In Burns's day, the Kirk Session of the Church of Scotland—the lowest of the ecclesiastical courts—still had a Gestapo-like power

to peer into the private circumstances of family life. It gave certificates of good conduct, where it saw fit; in cases of unsanctified union between the two sexes, it had powers to rebuke publicly and to fine the offending parties; and it could compel regular attendance at Church, though of what ultimate avail this might be to those not of the Elect is hard to see.

Immediately above the Kirk Sessions there were the Presbyteries, made up of representatives from several grouped parishes. Above the Presbyteries came the Synods, composed of from two to eight adjacent Presbyteries. On top of them all was the rule of the General Assembly. The decision of a lower court could be confirmed or revoked by appeal to a higher. Ultimately, therefore, over all the pettifogging actions of the Kirk Session hung the General Assembly's threat of excommunication, the severest form of which made a man legally, though latterly not in practice, a State outlaw.

Inevitably, such a system of local spying made for hypocrisy, prurient, vengeful curiosity, and petty tyranny. By the end of the eighteenth century, much of this apparatus of rigid ecclesiastical control had been swept away—having been reduced to absurdity in the eyes of most church-goers—and the framework itself relaxed. The satires of Robert Burns played no small part in helping to bring about the liberalization of religious thought in Scotland.

Such, then, was the religious climate in which the poet was brought up, and with whose elaborate organization he collided almost as soon as he reached manhood.

III

By the early winter of 1784, Elizabeth Paton's condition was becoming generally obvious. Robert's mother wished him to marry the girl, but Gilbert and his sisters—who were probably more realistic—opposed any such idea. Others outside the family circle saw humour in the situation. Rough, 'rude, ready-witted' John Rankine, whose farm lay about half-way between Largieside and Mossgiel, could not let pass such an opportunity to make fun of Robert's embarrassment. Robert replied first with two insignificant stanzas, and then with the clever and daring 'Epistle to John

Rankine', in which the poet describes his seduction in terms of the field. The 'poacher-court' got to hear of the 'paitrich hen' he had brought down with his gun, so he had to 'thole the blethers' and pay the fee. However, he tells Rankine, as soon as her 'clockin'-time is by', and the child is born, he means to have further 'sportin' by an' by' to get value for his guinea: which, as Crawford remarks, is very much 'the humour of the lads of the village: rough, full of energy and pride in physical prowess, but not to be taken too seriously.'

When the child was born on 22nd May 1785, Robert, to his credit, responded to his first experience of paternity not with any further display of sexual boastfulness, but in 'A Poet's Welcome to his Love-Begotten Daughter' (or, as Robert more pithily put it, to 'his Bastart Wean'), with warmly-glowing tenderness.

> Welcome! my bonie, sweet, wee dochter,
> Tho' ye come here a wee unsought for,
> And tho' your comin' I hae fought for,
> Baith kirk and quier;
> Yet, by my faith, ye're no unwrought for—
> That I shall swear! . . .

> Lord grant that thou may ay inherit
> Thy mither's person, grace, an' merit,
> An' thy poor, worthless daddie's spirit,
> Without his failins,
> 'Twill please me mair to see thee heir it,
> Than stocket mailens . . . [*farms*

Two days after she was born the baby was baptized, receiving her mother's name; and Robert acknowledged that he was her father. 'Dear-bought Bess,' as he was later to call her, came to live at Mossgiel, where she stayed under her grandmother's patient care until her father's death. She then returned to her own mother, who was by this time happily married to a ploughman. Elizabeth Paton's only other appearance in Robert's life was in 1786, when she made a claim on him, but accepted a settlement of twenty pounds which he paid her out of the profits of the Kilmarnock edition.

'Dear-bought Bess' in due course married John Bishop, overseer

at Polkemmet, and was buried at Whitburn when she died in 1817.

The Elizabeth Paton incident, and the two main poems it brought forth, throw light on another aspect of Robert's nature. He could swagger and defy public opinion, and even put on a show of glorifying his rakishness.

> Tho' now they ca' me fornicator,
> An' tease my name in kintra clatter,
> The mair they talk, I'm kennt the better,
> E'en let them clash;
> An auld wife's tongue's a feckless matter
> To gie ane fash.

But in the end, when the sweet fruits 'o' mony a merry dint' were born, Robert invariably revealed himself as an upholder of the 'happy fireside clime, Wi weans and wife'; in the kindly garb of a family man, rather than in the assumed cloak of the irresistible seducer.

With the possible exception of Highland Mary whose death, possibly in child-birth, induced in him acute feelings of remorse, the women who satisfied his passions seem always to have come to mean less to him than the children they bore him.

Of what went on in the family circle at Mossgiel between the birth of Robert's first child in May, and the death of his youngest brother John (who was buried in a second-quality mort-cloth, all that could be afforded) at the age of fifteen during the last days of October, we know very little. Robert, at the height of his powers, was neglecting his farm and composing his satires, with Mauchline politics and personalities for inspiration. A lesser poet would have responded to such stimulants with a crop of purely local verse. Robert responded by making these parish-pump happenings reflect upon and reveal basic human falsehoods and truths. He reached the universal through the local.

One of the earliest and best of the satires, 'Death and Doctor Hornbook', arose, according to Gilbert, out of a minor quarrel at a Masonic meeting between the poet and the poorly paid John Wilson, the parish schoolmaster at Tarbolton who ran many side-lines to eke out his scanty salary, and who on this occasion had been

boasting of his medical skill. In the poem, Robert describes how, going home from the clachan:

> The clachan yill had made me canty, [*village ale—merry*
> I was na fou, but just had plenty;
> I stacher'd whyles, but yet took tent ay
> To free the ditches;
> An' hillocks, stanes, an' bushes kenn'd ay
> Frae ghaists an' witches.

In this happy and harmless state of partial inebriation, nowhere else so pithily described, the poet:

> ... there wi *Something* did forgather,
> That put me in an eerie swither;
> An awfu' scythe, out-owre ae shouther,
> Clear-dangling, hang;
> A three-tae'd leister on the ither [*fish-spear*
> Lay, large an' lang.

This 'queerest shape' that e'er he saw turned out to be Death. The two gave each other a jovial greeting, and sat down on a stone; whereupon Death began to lay forth woefully about the skill of his opponent John Hornbook, who, using such 'cures' as the 'farina of beans and pease', 'sal-alkali o' midge-tail-clippings' and 'urinus spiritis of capons', put a dozen into 'Johnnie Ged's Hole' (Johnnie Ged being the grave-digger) for every one that Death could account for. Just as he was about to outline a plan for stopping Doctor Hornbook doing such harm and depriving Death of his rightful victims:

> ... The auld kirk-hammer strak the bell
> Some wee short hour ayont the *twal*,
> Which rais'd us baith:
> I took the way that pleas'd mysel,
> And sae did *Death*.

Robert's skill in handling the 'Standard Habbie' stanza throughout the narrative is of itself remarkable. The poem, at times ironic in its mockery, at times merely comic in a kindly way, gathers effect because the poet uses the common Scots device of reducing

universal facts like human self-deception and Death to the level of everyday familiars. By this apparent diminishment, our sense of their omni-presence, even in local surroundings, is tellingly increased. Indeed, the speed of the narration, the delicate handling of satire that borders on fantasy, and the vivid precision of the detail in which the story is set, seem to anticipate 'Tam o' Shanter'.

'Death and Doctor Hornbook' did not unduly annoy its victim. Indeed, he interpreted it as rather a compliment, and went on quietly dispensing his 'd——d dirt' as before. Eight years later, he even applied to Robert for advice upon the bettering of his scholastic position. Robert gave him the advice he sought, and Wilson followed it, abandoning an Edinburgh project and moving instead to Glasgow where he taught first in the High Street, and later in his own 'commercial academy' in the Gorbals. The poem circulated in manuscript—it was not published until 1796—and caused great amusement. Because of the personal nature of its subject—who was, after all, no more than a harmless hard-up quack—it lacks the sheer power of the great satires which were to follow. They also circulated first in manuscript, but amusement was by no means the only reaction they provoked.

In his autobiographical letter, Robert says:

> I now began to be known in the neighbourhood as a maker of rhymes.—The first of my poetic offspring that saw the light[1] was a burlesque lamentation on a quarrel between two rev^d Calvinists, both of them dramatis person [*sic*] in my Holy Fair.—I had an idea myself that the piece had some merit; but to prevent the worst, I gave a copy of it to a friend who was very fond of these things, and told him I could not guess who was the Author of it, but that I thought it pretty clever.—With a certain side of both clergy and laity it met with a roar of applause.—Holy Willie's prayer next made its appearance, and alarmed the kirk-Session so much that they held three several meetings to look over their holy artillery, if any of it was pointed against profane Rhymers.

[1] Presumably in manuscript. In spite of Mr Crawford's reference to it as 'Burns's first published work', it does not appear to have been printed before 1796.

Robert's own testimony cannot always be relied upon where matters affecting the chronological order of his poems are concerned. 'The Twa Herds, or The Holy Tulyie' may or may not have been written before 'Death and Doctor Hornbook'. However, it is a satire based upon 'a bitter and shameless quarrel between two Rev-gentlemen Moodie of Riccarton and Russell of Kilmarnock' over a matter of parish boundaries. The contestants in the 'tulyie' (brawl) are presented as herds in a pastoral setting, which at once reduces their dignity. Judging by the poem, the verbal heat which the two 'Auld Licht' ministers generated must have been considerable. Even although the piece is clearly an occasional one, abounding in references to divisions of local doctrinal opinion which make it difficult reading today, something can still be savoured of Robert's enjoyment in seizing the opportunity the quarrel afforded him to deflate the pretensions of the ministers and mock at the reactionary faction of the right:

> The twa best herds in a' the wast,
> That e'er ga'e gospel horn a blast
> These five and twenty simmers past—
> Oh, dool to tell!
> Hae had a bitter black out-cast
> Atween themsel . . .

> Sic twa—O! do I live to see't,
> Sic famous twa should disagree't,
> And names like 'villain', 'hypocrite',
> Ilk ither gi'en,
> While 'new-light' herds, wi' laughin' spite,
> Say neither's lien! [*lying*

The next volley from Robert's armoury proved to be still more deadly. The friend to whom Robert had given a copy of 'The Twa Herds', and who had so approved of it, was Gavin Hamilton. When in the late summer of 1784, Gavin Hamilton became involved in a dispute with the Kirk Session, a dispute which dragged on until July the following year, it was natural that Robert should follow the course of his friend's case with interest.

On the urgings of one of their number, austere, narrow-minded William Fisher, the Mauchline Kirk Session decided that the moment was opportune for them to call to order those parishioners who were considered doctrinally unsound. Their first choice fell upon Hamilton, because in addition to being a known moderate, and having descended from a family with Episcopalian connexions, he had recently transgressed against some of the Church's minor rules. Hamilton was not the man to submit to prying persecution, and he remonstrated with the Kirk Session by letter. The upshot was that he was eventually presented with a list of charges under four headings: (1) Unnecessary absence from Church on two Sabbaths in December and three Sabbaths in January. (2) Setting out on a journey to Carrick on the third Sabbath in January. (3) Habitual, if not total, neglect of family worship. (4) Abusive letter to the Kirk Session, dated 13th November 1784. For these offences Hamilton was in due course to be censured. But he refused to accept the Kirk Session's censure and immediately appealed to the Presbytery of Ayr, who found in his favour. The Session in its turn counter-appealed to the next higher court, the Synod of Ayr and Glasgow, who again found in favour of the defendant.

Robert celebrated the triumph of his friend—and incidentally, of the liberal viewpoint—with 'Holy Willie's Prayer', one of the finest satires in any European tongue.

'Holy Willie was a rather oldish, bachelor elder, in the parish of Mauchline,' Robert tells us in a note with which he prefixed the poem in the Glenriddell manuscript.

and much and justly famed for that polemical chattering which ends in tippling orthodoxy, and for that spiritualised bawdry which refines to liquorish devotion. In a sessional process with a gentleman in Mauchline—a Mr Gavin Hamilton—*Holy Willie* and his priest, Father Auld, after full hearing in the Presbytery of Ayr, came off but second best, owing partly to the oratorical powers of Mr Robert Aiken, Mr Hamilton's counsel; but chiefly to Mr Hamilton's being one of the most irreproachable and truly respectable characters in the country. On losing his process, the muse overheard him at his devotions as follows:

O Thou that in the heavens does dwell!,
Wha, as it pleases best Thysel,
Sends ane to heaven and ten to hell,
 A' for Thy glory!
And no for ony gude or ill
 They've done before Thee.

I bless and praise Thy matchless might,
When thousands Thou has left in night,
That I am here before Thy sight,
 For gifts and grace,
A burning and a shining light
 To a' this place.

Right from the start, Holy Willie establishes the purity of his orthodoxy and the fact that he is one of the Elect. His performance has even an authentic prayer-like atmosphere. But as he goes on, he reveals, first, his nauseating self-righteousness:

What was I, or my generation,
That I should get such exaltation?
I, wha deserv'd most just damnation,
 For broken laws,
Sax thousand years are my creation,
 Thro' Adam's cause.

—and then his bare-faced hypocrisy:

But yet, O Lord, confess I must,
At times I'm fash'd wi' fleshly lust;
And sometimes too in warldly trust
 Vile Self gets in;
But Thou remembers we are dust,
 Defil'd wi' sin.

O Lord—yestreen—Thou kens—wi' Meg—
Thy pardon I sincerely beg:
O' may't ne'er be a livin plague,
 To my dishonor!
And I'll ne'er lift a lawless leg
 Again upon her.

After further confessions of sin, all of which he found com-
fortably excusable, Holy Willie then proves to his own satisfaction
that these fleshly lusts are sent by the Lord to keep him humble, and
so 'maun e'en be borne'. Then comes the climax of the poem: a
spiteful cursing of Gavin Hamilton, Robert Aiken (who defended
Hamilton) and the Presbytery of Ayr, for having so discomfited the
petitioner. In psalm-like tones, the poem breathes on to its mock-
solemn conclusion:

> Lord, in Thy day o' vengeance try him!
> Lord, visit them that did employ him!
> And pass not in Thy mercy by them;
> Nor hear their prayer;
> But for Thy people's sake destroy them,
> And dinna spare!

> But Lord remember me and mine
> Wi' mercies temporal and divine;
> That I for grace and gear may shine,
> Excell'd by nane!
> And a' the glory shall be Thine!
> Amen! Amen!

The veracity of the picture is completed and the sheer impudence
of the creature in crediting the Almighty with his own meannesses
of spirit, is driven home by these last six telling lines.

The actual occasion which called forth the satire has receded into
the background of forgotten local history, and we are left with an
ageless indictment of cringing, unctuous hypocrisy. As a poem,
'Holy Willie's Prayer' is, in Mr Crawford's words, 'a perfect work
of art', and as such, quite beyond criticism. Every stroke tells and is
the stroke of a master. But the poem also makes totter, with great
angry hammer-strokes—for here the satire really is angry, though
the bitterness is kept under strict control—the absurd creed of
predestination.

'Holy Willie' Fisher, to whom we owe the inspiration of the poem,
probably merited all that Robert gave him. The hypocritical elder had
to be officially rebuked by 'Daddy' Auld in 1790 for drunkenness.

Later, he came under suspicion in connexion with the disappear-
ance of money from a poor-box entrusted to his keeping. He came
to a miserable end, freezing to death by the roadside one stormy
night in February 1809.

'The Holy Fair', the next of Robert's assaults upon the preten-
sions of the 'Auld Lichts', written in the autumn of 1785 after Gavin
Hamilton's case had ceased to be 'news', is equally telling; not the
least so because the satirist retains his good-humour throughout, and
his laughter is more devastating than his anger. The poem, it is said,
played the main part in bringing about the removal of the excesses it
satirized.

Holy Fairs, held periodically in the fields near the church, were
popular Communion festivals which may have owed their origin to
the Conventicles of the Covenanters. However that may be, folk
from the neighbouring parishes flocked in to hear a concentrated
orgy of preaching. In 1759 there was published a pamphlet called
'Letter from a Blacksmith to the Ministers and Elders of the Church
of Scotland, in which the Manner of Publick Worship in that
Church is considered, its Inconveniences and Defects pointed out,
and Methods of removing them honestly proposed.' Dr Snyder
suggests that it was the source of Robert's poem, although there is
no evidence that he was actually aware of the blacksmith's produc-
tion. In any case Robert had only to look with his own eyes at one
or other of the Fairs held in Ayrshire in the 1780's. The blacksmith,
after rhetorically asking to be allowed to describe the scene, goes on:

'At first, you find a great number of men and women lying
together upon the grass; here they are sleeping and snoring,
some with their faces towards heaven, others with their faces
turned downwards, or covered with their bonnets; there you
find a knot of young fellows and girls making assignations to go
home together in the evening, or to meet in some ale-house; in
another place you see a pious circle sitting around an ale-
barrel, many of which stand ready upon carts, for the refresh-
ment of the saints. . . . When you get a little nearer the speaker,
so as to be within reach of the sound, though not of the sense
of the words . . . you will find some weeping and others laughing,

some pressing to get nearer the tent or tub in which the parson is sweating, bawling, jumping, and beating the desk; others fainting with the stifling heat, or wrestling to extricate themselves from the crowd: one seems very devout and serious, and the next moment is scolding or cursing his neighbours for squeezing or treading on him; in an instant after, his countenance is composed to the religious gloom and he is groaning, sighing, and weeping for his sins: in a word, there is such an absurd mixture of the serious and comic, that were we convened for any other purpose than that of worshipping the God and Governor of Nature, the scene would exceed all *power of farce.*

Robert particularizes, and so vivid is his characterization, fixes for us at the end of every subtle thrust a perfect specimen illustrating each type of absurdity. He begins with a description of how the poet, out walking on a fine 'simmer Sunday morn', fell in with Fun, Superstition and Hypocrisy, who told him they were:

> . . . 'gaun to Mauchline "Holy fair",
> To spend an hour in daffin;
> Gin ye'll go there, yon runkl'd pair,
> We will get famous laughin
> At them this day.'

The poet agrees, and, after the Scots custom, goes home to put on his best clothes. Then follows a racy description of the bustling, variegated scene outside the Fairground, drawn with swift, sure strokes, and in an absolute warmth of sheer enjoyment:

Here farmers gash, in ridin graith,	[*attire*
Gaed hoddin by their cotters;	[*jogging beside*
There swankies young, in braw braid-claith,	[*broadcloth*
Are springin owre the gutter.	
The lasses, skelpin barefit, thrang,	
In silks an' scarlets glitter;	
Wi' sweet-milk cheese, in monie a whang,	[*big piece*
An' farls bak'd wi' butter,	[*oatcakes*
Fu' crump that day.	[*crisply brittle*

Once past the collection-plate at the field's entrance, the poet

surveys the folk who are gathering; some sitting on chairs and stools, some talking business, and some just 'busy bletherin, Right loud, that day'.

> Here stands a shed to fend the show'rs, [*ward off*
> An' screen our countra gentry;
> There 'Racer Jess', an twa-three whores,
> Are blinkin at the entry.
> Here sits a raw o' tittlin jads, [*giggling girls*
> Wi' heavin breasts an' bare neck;
> An' there a batch o' wabster lads,
> Blackguarding frae Kilmarnock, [*come bent on mischief*
> For fun this day.
>
> Here some are thinkin on their sins
> An' some up o' their claes; [*clothes*
> Ane curses feet that fyl'd his shins,
> Anither sighs an' prays:
> On this hand sits a chosen swatch, [*group of the Elect*
> Wi' screw'd up, grace-proud faces;
> On that a set o' chaps, at watch,
> Thrang winkin on the lasses [*busy*
> To chairs that day . . .

One may note, in passing, the effect gained by the swift juxta-position of those concerned with sins and claes.

Then comes a description of the happy man settling himself down beside his lass, his arm round the back of her chair, his hand stealing unnoticed down to her bosom. This is the stanza which brings about the transition from a description of the listeners to a vigorous picture of the doctrinal and rhetorical absurdities of the reverend performers. Some, like Alexander Moodie, stamp and fume; others, like George Smith, talk learnedly above their listeners' heads; while one at least, Alexander Miller, preaches though he is only half-hearted in his Orthodoxy, because, as Burns puts it, 'the birkie wants a manse'.

While the preaching is in progress, the lads and lasses start 'form-ing assignations', while the older folk doze or drink. Then suddenly 'Black Russell' gets up and begins to speak of the Calvinist's physical

Hell; whereupon the poet takes his hardest stroke of all at the beliefs
of the Orthodox:

> A vast, unbottom'd, boundless pit,
> Fill'd fou o' lowin brunstane, [*flaming brimstone*
> Whase ragin flame, an' scorchin heat,
> Wad melt the hardest whun-stane! [*whinstone*
> The half-asleep start up wi' fear,
> An' think they hear it roarin,
> When presently it does appear,
> 'Twas but some neebor snorin
> Asleep that day.

Again, there is the swift and witty juxtaposition of the massive
and the tiny, the pretentious and the absurd.

The ludicrous awakening of the slumberers effects another transi-
tion, this time from the proceedings themselves to the 'skailing', the
comic absurdity of the Holy Fair being deftly pointed in the final
stanza.

> How money hearts this day converts
> O' Sinners and o' Lassies!
> Their hearts o' stane, gin night, are gane [*before*
> As saft as ony flesh is.
> There's some are fou o' love divine;
> There's some are fou o' brandy;
> An' monie jobs that day begin,
> May end in Houghmagandie [*fornication*
> Some ither day.

David Daiches draws attention to the way in which the use of theo-
logical terms here reverses the older practice of using secular love
terms to denote divine love. Thomas Crawford comments that for
Burns here, Houghmagandie and the Life Force are in the end
stronger and better than either the White Christ of the morality-men
or the Jehovah and Muckle Black Deil of the extreme Calvinists.

I have treated this poem at some length, because it illustrates
several important technical aspects of Robert's achievement. In his
autobiographical letter, he tells us, referring both to the Irvine days

and to the last months at Lochlie: 'Rhyme . . . I had given up; but meeting with Fergusson's Scotch poems, I strung anew my wildly-sounding rustic lyre with emulating vigour.'

Just as it had been the production of a squire's son which caused him to 'emulate' into song, so it was the work of Fergusson that gave Robert's muse the 'heeze', or uplift, which enabled him to produce the great satires.

Much has been made of Burns's borrowings from Fergusson.[1] The 'model' for 'The Holy Fair' was Fergusson's 'Leith Races', as a comparison of their opening stanzas shows. But here, as in all other cases where such borrowings occur (with the exception of 'The Cotter's Saturday Night', discussed later), they form but the *points de depart* for altogether higher flights of invention than the lender himself could attain. Burns's borrowings are of no more importance than, in another sphere, Handel's or Mozart's.

The stanza form used in 'The Holy Fair' is based on the old popular form to be found in 'Christis Kirk on the Green' and 'Peblis to the Play'. Both these poems treat of vigorous peasant festivals, which gives Burns's choice of it on this occasion added significance.

Burns's technical superiority over other eighteenth-century Scots poets—indeed, over all earlier poets, except perhaps William Dunbar who, on purely metrical grounds, was certainly Burns's equal—rests to a considerable extent on his ability to handle the movement of a poem; using a musical metaphor, to 'modulate' freely and rapidly through any keys he chooses, however remote they may seem from his 'home tonic'. The flexibility with which he handles his narrative in 'The Holy Fair' is astonishing; just how astonishing may be judged by forcing oneself to notice how little the restrictions of the difficult old form obtrude upon one's attention. Nor is there any division of influence. 'The Holy Fair' remained throughout a poem in the Scots vernacular tradition.

Of the other anti-'Auld Licht' poems written in late 1785 or the early months of 1786, the 'Address to the Deil', by reducing Satan to homely Scots proportions, strikes another indirect blow against Calvinism. What would devout church-goers, accustomed to hell-

[1] By Ritter, who attacks the matter with Teutonic over-thoroughness, and others more moderate.

fire sermons in which the Devil's dire powers were graphically
pointed, think of such admonition as this?

> Hear me, auld 'Hangie', for a wee,
> An' let poor, damnèd bodies be;
> I'm sure sma' pleasure it can gie,
> Ev'n to a deil,
> To skelp an' scaud poor dogs like me, [*slap — unmanageable*
> An' hear us squeel!

Auld Hangie, or Satan or Cloutie—Robert was not particular as
to what title the Deil chose for himself—is stripped of his powers,
and made to seem ridiculous. His discomfiture must have reflected
back upon the stalwart champions of his physical existence and
punitive powers, the 'Auld Licht' ministers themselves.

Indeed, the satires already mentioned, together with 'The Ordi-
nation', which attacks the induction of a patron's choice minister in
Kilmarnock but because of its references to differences in local
church politics has now lost something of its bite, and the later
poem 'The Kirk's Alarm', together make up what W. E. Henley
called 'certainly the most brilliant series of assaults ever delivered
against the practical bigotry of the Kirk'.

An important point about the satires, however, is that Robert was
attacking neither the Kirk itself, nor religion, 'maid divine'; although
his attitude to it seems to have been not untinged with scepticism,
and least in some of his moods. In September 1785, when the Rever-
end John M'Math, the liberal-minded assistant to Wodrow in
Robert's old parish of Tarbolton, wrote to the poet for a copy of
'Holy Willie's Prayer', he not only got what he asked for, but also
one of the poet's earliest verse-epistles. In this, Robert makes it
clear that the direction of his attack is against those who use religion
to cloak their own hypocritical pretensions and shortcomings:

> But I gae mad at their grimaces,
> Their sighin, cantin, grace-prood faces,
> Their three-mile prayers, an' hauf-mile graces,
> Their raxin conscience, [*accommodating*
> Whase greed, revenge, an' pride disgraces
> Waur nor their nonsense. . . .

They take religion in their mouth;
They talk o' mercy, grace an' truth,
For what? to gie their malice skouth [*scope*
 On some puir wight,
An' hunt him down, o'er right an' ruth,
 To ruin streight.

All hail, religion! maid divine!
Pardon a muse sae mean as mine,
Wha in her rough imperfect line
 Thus daurs to name thee;
To stigmatise false friends of thine
 Can ne'er defame thee.

During those hectic months of the winter of 1785–6, Robert and
his muse were not, however, by any means wholly taken up with
their attacks upon misused religion. In one stanza of 'The Holy
Fair' (that beginning 'Leeze me on drink!'), Robert had already
opined that 'whisky-gill or penny-wheep' never failed 'to kittle up
our notion' (enliven our wits) at any hour of the day or night. He
now wrote two pcems—possibly, Hans Hecht suggests, in Nanse
Tinnock's pub—in forthright praise of the national liquor, 'Scotch
Drink' and 'The Author's Earnest Cry and Prayer, to the Right
Honourable and Honourable, the Scottish Representatives in the
House of Commons'. The first, 'Scotch Drink' is clearly modelled
as regards form and progression on Fergusson's 'Caller Water'.
Burns begins with a mildly Bacchanalian statement of purpose:

Let other poets raise a fracas
'Bout vines, an' wines, an' drucken Bacchus,
An' crabbet names an' stories wrack us,
 An' grate our lug: [*ear*
I sing the juice Scotch bere can mak us [*barley*
 In glass or jug.

This works up to an ecstatic climax:

Leeze me on thee, John Barleycorn,
 Thou king o' grain!

The poet then goes on to outline the use of the brew in various aspects of Scotland's social life, with particular reference to the happiness 'John Barleycorn' brings to the poor. He finishes with a stanza which has a characteristic ring of proud and simple contentment:

> Fortune! if thou'll but gie me still
> Hale breeks, a scone, an' whisky gill,
> An' rowth o' rhyme to rave at will, [*abundance*
> Tak a' the rest,
> An' deal't about as thy blind skill
> Directs thee best.

'The Author's Earnest Cry and Prayer', a slighter piece, is cast in the form of an appeal to the Scottish Members of Parliament to repeal the heavy taxation on whisky at a time when the Excise officers were acting against the producers of whisky with increased severity. The most striking part of it is the close of the Postscript which, after pointing out (with rather forced patriotism) how much better Scots soldiers fight and die for 'royal George' with a 'Highland gill' in their stomachs, suddenly warms into as honest and ardent a toast as ever passed the lips of any Scotsman:

> Scotland, my auld, respected mither!
> Tho' whiles ye moistify your leather, [*moisten*
> Till whare ye sit, on craps o' heather, [*crops*
> Ye tine your dam; [*lose*
> Freedom and Whisky gang thegither,
> Tak aff your dram!

From this same winter, too, dates the cantata 'The Jolly Beggars'. When Robert Chambers was collecting material for his biography of the poet, John Richmond, then an old man, gave a verbal account to him of how 'The Jolly Beggars' came to be written. Chambers thus related it:

The poem is understood to have been founded on the poet's observations of an actual scene which one night met his eye, when, in company with his friends John Richmond and James

Smith, he dropped accidentally at a late hour into the humble hostelry of Mrs Gibson, more familiarly named Poosie Nansie, already referred to. After witnessing much jollity amongst a company who by day appeared as miserable beggars, the three young men came away, Burns professing to have been greatly amused with the scene, but particularly with the gleesome behaviour of an old maimed soldier. In the course of a few days, he recited a part of the poem to Richmond, who informed me that, to the best of his recollections, it contained, in its original complete form, songs by a sweep and a soldier, which did not afterwards appear.

The atmosphere in which the poetic beggars assemble is also that of the disreputable Poosie Nansie's pub. She herself had been censured by the Kirk for resetting stolen property, and for repeated drunkenness. To this last charge, she had replied, with admirable if misdirected spirit, that she had every intention of 'continuing in the sin of drunkenness'.

The opening 'recitative'—which, like the other similar links between the songs, is not written to any air—sets the scene: a frosty, blustery night 'when hailstones drive wi' bitter skyte'. The 'randie, gangrel bodies' stream in to the warmth of the tavern, and before long, they are 'quaffing and laughing', and ranting and singing till 'the vera girdle rang'.

The soldier 'in auld red rags', sitting by the fire with his whisky in one hand, his other round his 'doxy' who is wrapped in a ragged blanket, sings the first song; a swaggering affair with a 'Lal de daudle' chorus, in which he tells of the wounds he has received in the course of his profession, and how, having now a wooden arm and leg, he must beg; though:

> Yet let my country need me, with Elliot[1] to head me,
> I'd clatter on my stumps at the sound of a drum.

One can almost hear the irregular, drunken voices of the full company roaring out the 'Lal de daudle' at the end of each verse!

[1] George Augustus Eliot, later Lord Heathfield, the defender of Gibraltar against the Spaniards in 1782.

He ended; and the kebars sheuk [*rafters*
 Aboon the chorus roar;
While frightened rattons backward leuk, [*rats*
 An' seek the benmost bore. . . . [*innermost hole*

Next, the soldier's 'doxy' staggers to her feet, and proceeds to list the successes she has met with in *her* profession, beginning with a 'sodger laddie' and moving on to a 'godly old chaplain'. Thereafter:

Full soon I grew sick of my sanctified sot,
 The regiment at large for a husband I got. . . .

By the time she has seized her glass and joined 'in a cup and a song', the warmth, the generally accepted amorality, and the irrepressible humour and courage of this gathering of social misfits and outcasts have been fully established, and with unexcelled vigour and humanity.

Next comes the sad song of a disillusioned professional fool: it has bite in it, however, despite the slightly awkward scansion of the actual thrust.

Poor Andrew that tumbles for sport,
 Let nae body name wi' a jeer;
There's even, I'm tauld, i' the Court
 A tumbler ca'd the Premier.

Then comes the lament of a 'raucle carlin' for her 'braw John Highlandman', who, it seems, has been hanged, 'A Highland lad my love was born'. The widow comforts herself, not entirely unsuccessfully, with a can.

And now a widow I must mourn,
 The pleasures that will ne'er return;
No comfort but a hearty can,
 When I think on John Highlandman.

The words of this song, set to a reel tune 'O, An Ye were Dead, Gudeman', seem to stir earlier Jacobite folk-song overtones.

Next, a professional fiddler, 'a pygmy Scraper' 'wha us'd at trysts an' fairs to driddle', took the floor to serenade the widow:

> Wi' hand on hainch, and upward e'e, [*haunch*
> He croon'd his gamut, one, two, three,
> Then in an arioso key,
> The wee Apollo
> Set off wi' allegretto glee
> His giga solo.

His philosophy, taken from an old song in David Herd's *Ancient and Modern Scottish Songs* (1st edition, 1769; new enlarged edition, 1776), is, 'Whistle Owre the Lave O't'.

> I am a fiddler to my trade,
> An' a' the tunes that e'er I played,
> The sweetest still to wife or maid,
> Was 'Whistle owre the lave o't'.

The fiddler, a more refined creature than the others, as the use of the Italian musical terms cunningly suggests, brings a note of lighter tenderness into the company as he woos the widow. But a 'sturdy caird' has also designs on her, and drawing his 'roosty rapier', he warns the fiddler off. The fiddler begs for mercy, though he 'feign'd to snirtle in his sleeve' when the loud-mouthed tinker started his boastful song.

> My bonie lass, I work in brass,
> A tinkler is my station;
> I've travell'd round all Christian ground
> In this my occupation;
> I've ta'en the gold, an' been enrolled
> In many a noble squadron;
> But vain they search'd when off I march'd
> To go an' clout the caudron.

The tune 'Clout the Cauldron' appears in Ramsay's *The Tea-Table Miscellany* where Ramsay's beggar also declares that he is a tinkler to his trade.

In this present case, however, the later tinkler won his suit.[1]

[1] As will be seen from the unexpurgated version of the text published in Dick's *The Songs of Robert Burns*, the fiddler achieved success behind a hencoop while the tinker was singing.

The caird prevail'd—th' unblushing fair
 In his embraces sunk;
Partly wi' love o'ercome sae sair,
 An' partly she was drunk. . . .

This, the first suggestion of objective satirical comment, preludes the appearance of the poet himself 'a care-defying blade', on the centre of the floor. His utterance has a dignity and an objectivity which those of the others do not possess. Whereas their sentiments were all very much in character, the bard's sentiments have an unmistakable personal note. He professes his love 'to all the fair'.

 Their tricks an' craft hae put me daft,
 They've ta'en me in, an' a' that;
 But clear your decks, an' here's the Sex!
 I like the jads for a' that.

For a' that, and a' that,
 An' twice as muckle's a' that,
My dearest bluid, to do them guid,
 They're welcome till't for a' that.

The bard's song met with a thunder of applause—so much so that 'the jovial throng' requested him to let them have another song, 'a ballad o' the best'. This last song, originally set to the older of two English tunes called 'Jolly Mortals fill your Glasses',[1] not only gathers up and synthesizes the spirit of the whole cantata, but is a complete poetic expression of pure anarchism. In the sweaty, smelling atmosphere round Poosie Nansie's fire, these people whom Society has rejected, hail what is to them an ideal life in which social, religious and moral conventions simply do not exist.

[1] In what is so far the best setting of 'The Jolly Beggars', that made by Cedric Thorpe Davie for the Saltire Singers to perform at *Scottish Festival Braemar* 1953, the two English tunes—both poor—are replaced by two Scots tunes. Four reel tunes are employed in the Finale, a *quodlibet*. Realistically staged, Burns's cantata oddly anticipates Brecht.

Life is all a variorum,
 We regard not how it goes;
Let them cant about decorum,
 Who have character to lose.

A fig for those by law protected!
 Liberty's a glorious feast!
Courts for cowards were erected,
 Churches built to please the priest.

Anarchy, adopted on a general scale, would eventually lead to the abnegation and destruction of any form of civilization. In one sense, its glorification by Burns in 'The Jolly Beggars' is but another of his exercises in romantic escapism: for just as, in a moment of crisis, he could cry out:

O why the deuce should I repine,
 And be an ill foreboder?
I'm twenty-three and five feet nine,
 I'll go and be a sodger.

so, in another mood, he could comfort himself with the thought that:

The last o't, the warst o't,
 Is only but to beg.

The soldier is not, after all, a free agent defying the forces of Society, but one of Society's servants from whom it demands unquestioning obedience, and from whom, in the end, it requires something utterly distasteful to any sensitive man: the killing of other men. The beggar, for all his vaunted 'freedom' is in reality not in the least independent. He can only exist by virtue of the industry which enables his benefactors to have enough and to spare; and, as Hilton Brown amusingly observes, he has always to keep one eye open for the police.

What soldier and beggar may have in common, when it comes to the bit, is a certain sturdy heroism in the face of unpleasantness and hardship. What 'The Jolly Beggars' catches for us, as it has never been caught before, is a living glimpse of that heroism, mixed, as it is

in reality, with lust, drunkenness, poverty and ragged squalor. No matter how much physical misery human beings may bring upon themselves, or have thrust upon them, the human spirit can still burst into a warm, glancing flame on the slightest pretext: can still show a kind of heroic idealism none the less heroic for being inverted.

Burns's beggars are real beggars, neither symbols nor mere figures of literature; and their cantata is the expression of that revolt against 'the scheme of things' which finds a sympathetic echo at some time or another in even the most decorous heart. 'Humanity caught in the act', was Henley's and Henderson's epigrammatic verdict on 'The Jolly Beggars'.

Burns's model for his cantata may have been an inoffensively convivial poem from *The Tea-Table Miscellany*, 'Merry Beggars', wherein a poet, an 'attorney-at-law'; a soldier, a courtier, a 'gut-scraper' and a preacher, all make brief appearances, profess happiness in their beggars' calling, and announce in chorus:

> Who'er would be merry and free,
> Let him list, and from us he may learn;
> In palaces who shall you see
> Half so happy as we in a barn?

In the same collection 'The Happy Beggars' presents a gathering of female vagrants, one of whom sings:

> A fig for gaudy fashions,
> No want of clothes oppress us;
> We live at ease with rags and fleas,
> We value not our dresses.

The influence of the 'Gaberlunzie Man' and 'The Jolly Beggar', both attributed to King James V, is also clearly discernible. The tradition of beggars' poetry was certainly firmly established in Scots literature. Christina Keith points out that its sources go back to Old French and the medieval Latin lyrics. Burns wrought out of that tradition as it reached him, a more powerful and authentic poem than anything his predecessors had achieved.

One of the most striking aspects of 'The Jolly Beggars' is the

poet's understanding of the potentialities of the tunes he employs.
(He used two of the tunes again for separate, though not entirely
unrelated, songs—'Whistle Owre the Lave O't' and 'For a' that an'
a' that'—both of which appeared in Johnson's *Scots Musical
Museum*. 'I once was a maid, tho' I cannot tell when', the 'doxy's'
song, and 'Let me ryke up' also appeared on their own in *The Merry
Muses of Caledonia*, of which more anon.) The man who matched
'Let me ryke up to dight that tear', to the lightsome, yet wistful,
strain of 'Whistle Owre the Lave O't', and 'My bonie lass, I work in
brass' to 'Clout the Caudron', with its clanking anvil-like rhythmic
stroke-effect, was obviously a man with a sensitive musical ear, and
one on intimate terms with Scots folk-song as well as the numerous
earlier eighteenth-century collections of 'music in the vernacular'.

The popular notion that Burns only turned his attention to song
after he had joined partnership with Johnson is, of course, errone-
ous. In September 1785, by which time he had already written
several songs, Robert entered this analysis of Scots song-charac-
teristics in his *Commonplace Book*.

There is a certain irregularity in the old Scotch Songs, a redun-
dancy of syllables with respect to that exactness of accent &
measure that the English Poetry requires, but which glides in,
most melodiously with the respective tunes to which they are set.
For instance, the fine old Song of 'The Mill Mill O', to give it a
plain prosaic reading it halts prodigiously out of measure; on the
other hand, the Song set to the same tune in Bremner's collection
of Scotch Songs which begins 'To Fanny fair could I impart, & c'
it is most exact measure, and yet, let them be both sung before a
real Critic, one above the biasses of prejudice, but a thorough
Judge of Nature,—how flat and spiritless will the last appear,
how trite, and tamely methodical, compared with the wild-
warbling cadence, the heart-moving melody of the first.—This
particularly is the case with all those airs which end with a hyper-
metrical syllable.—There is a degree of wild irregularity in
many of the compositions & Fragments which are daily sung to
them by my compeers, the common people—a certain happy
arrangement of old Scotch syllables, & yet, very frequently,

nothing, not even *like* rhyme, or sameness of jingle at the ends of the lines.—This has made me sometimes imagine that perhaps, it might be possible for a Scotch Poet, with a nice, judicious ear, to set compositions to many of our most favorite airs, particularly that class of them mentioned above, independent of rhyme altogether.—

This entry shows how deeply Robert, himself to be that 'Scotch Poet, with a nice, judicious ear', was already considering the technical subtleties of Scots song. Another entry runs thus:

> By the way, these old Scottish airs are so nobly sentimental that when one would compose for them; to south the tune, as our Scotch phrase is, over and over, is the readiest way to catch the inspiration and raise the Bard into that glorious enthusiasm so strongly characteristic of our old Scotch Poetry.

A poet who, before setting a tune to words, hummed it over and over again until he had mastered its personality, must have had uncommon natural musical sensibility, however much he might disown musical knowledge in the academic sense.

As well as these theoretical entries in the *Commonplace Book*, there are several songs and fragments of songs. One of the incompleted songs which fairly trots along, as if the poet envisaged himself on horseback, begins:

> When first I came to Stewart Kyle
> My mind it was na steady,
> Where'er I gaed, where'er I rade,
> A mistress still I had ay:
>
> But when I came roun' by Mauchline town,
> Not dreadin anybody,
> My heart was caught, before I thought,
> And by a Mauchline lady.

That gay fragment portended the major crisis in Robert's life. The 'Mauchline Lady' was Jean Armour.

4

Mossgiel

1786

I

JEAN ARMOUR was one of the eleven children of James Armour, master stone-mason and contractor in Mauchline, a respected pillar of the Kirk and a Freemason. She was born on 24th February 1765, and brought up almost entirely in her native village. When Robert first came to Mossgiel, she was not quite nineteen years of age.

Tradition has it that they first met at a dance held in a tavern at the end of race week in April 1784. Robert's collie is said to have followed him to the dance, where the poet was not much in demand as a partner (doubtless on account of his 'dangerous' reputation); as he turned out his too-faithful follower, the poet is supposed to have expressed a wish that he could find a lass who would love him as well as his dog. Jean Armour—a dark, square-faced shapely girl—is supposed to have overheard the remark, and a week or so later on a chance—or maybe not so chance—encounter on the village green, to have asked the poet if he had found his faithful lass yet.

The important point about the story is that if it is true—Jean's story many years later was very different, which is perhaps not altogether surprising—it suggests that she sought out Robert. Such a provocative encounter as that on the village green could only seem an invitation to be accepted. The acquaintance developed, though not too quickly at first, because Robert's mind was partly occupied by the thought of that child of his which Lizzie Paton was carrying. Once 'dear-bought Bess' had been safely born, however, Robert forgot about getting the value from her mother which he had promised himself for his golden guinea, and turned seriously to Jean, whom he had by now listed as one of the Belles of Mauchline.

In the end, as she must have been well aware, there could only be one result. By the close of 1785, Jean Armour was pregnant.

Plainly, Robert's original idea was to marry her. In September 1784, he had set forth his arguments in favour of matrimony to his friend John Tennant of Glenconner.

> ... And then to have a woman to lye with when one pleases, without running any risk of the cursed expense of bastards and all the other concomitants of that species of Smuggling—These are solid views of matrimony.

'Solid views' they certainly were, if not very elevated. But that Robert had tenderer feelings towards Jean than this letter suggests, is shown by his reference to her in the 'Epistle to Davie, a Brother Poet', sent to David Sillar in January 1785.

> ... This life has joys for you and I;
> An' joys that riches ne'er could buy;
> An' joys the very best.
> There's a' the pleasures o' the heart,
> The lover an' the frien';
> Ye hae your Meg, your dearest part,
> And I my darling Jean!

> It warms me, it charms me,
> To mention but her name:
> It heats me, it beets me, [*makes me glow*
> An' sets me a' on flame. *rapturously*

The thought of Jean's child released in him the full force of parental tenderness. Tenderness, pride in his physical prowess as a lover, which must have been considerable, defiance of the forces of authority that had humiliated him once and would do so again, male protectiveness and female loving trust—these emotions are all gathered into a superb song he wrote at this time, and which he put into Jean's mouth.[1]

[1] Its technical starting-point may have been a rather feeble song in *The Tea-Table Miscellany*, 'The Cordial'.

O wha my babie-clouts will buy?
Wha will tent me when I cry? [*care for*
Wha will kiss me where I lie?
 The rantin dog the daddie o't.

Wha will own he did the faut? [*fault*
What will but the groanin-maut? [*ale to sustain the*
What will tell me how to ca't? *midwife*
 The rantin dog the daddie o't.

When I mount the creepie-chair [*stool of repentance*
Wha will sit beside me there?
Gie me Rob, I seek nae mair,
 The rantin dog the daddie o't.

Wha will crack to me my lane? [*talk alone*
Wha will mak me fidgin fain? [*eager for more*
Wha will kiss me o'er again?
 The rantin dog the daddie o't.

With ultimate matrimony still in view, he and Jean signed some sort of paper, possibly in the presence of Smith, pledging themselves to each other. In Scots law, a marriage by declaration would have been legally binding, either following upon or immediately preceding intercourse.[1] Of course if no witnesses were present at the declaration and either party later chose to deny the existence of the verbal bond, then it could not be proved. Hence, no doubt, Robert's anxiety to allay any possible doubts in Jean's mind as to his own honourable intentions by providing her with a written document.

In late February or early March 1786, Jean, armed with her paper, broke the news to her parents that she was married to Robert, and expecting his child. Her father was shocked and horrified—he had to be revived with a cordial—not so much at the fact that his daughter was pregnant—happenings of that sort were not, after all, particularly out of the ordinary in eighteenth-century Scotland—but that the man who had 'ruined' her was the rakish, blasphemous,

[1] Marriage by declaration remained valid in Scotland until 1939.

unsuccessful rhyming-farmer of Mossgiel. In old Armour's mind, concern for his daughter's reputation at once took second place to concern for his own wounded pride. *He* would show young Mossgiel what a decent, God-fearing citizen thought of such worthless paper promises! The unlucky document was taken from Jean and laid before the lawyer Robert Aiken of Ayr, who was finally prevailed upon to mutilate it by cutting out the two names; an act which did not alter the legal position at all, though old Armour firmly believed that it ensured the status of his daughter as a single woman.

Just why Aiken agreed to mutilate the marriage-contract—for such, in effect, it was—has puzzled many writers on Burns. Old Armour, however, can hardly have been in a very reasonable mood to deal with on this particular occasion, and lawyers before and since have been known to do pointless things which were not actually harmful in order to appease an irascible client. Aiken may very possibly have supposed that Robert would realize the binding nature of the verbal contract, whatever happened to the paper.

While all this was going on Mrs Armour, a lady of severe and undoubted virtue, dispatched her erring daughter to Paisley, where she was put under the care of relations. In Paisley, there was at least the remote chance that a certain Robert Wilson, who had hitherto shown more than a passing interest in the girl, might still be prepared to take her, unborn child and all.

These two happenings struck a severe blow at Robert's pride and self-esteem. Aiken, Robert declared, cut his 'very veins' with the news of the mutilation, while Jean's departure seemed to him plain desertion. Writing to Gavin Hamilton on 15th April, his emotions were troubled and confused.

> Perdition seize her falsehood and perjurious perfidy! but God bless her and forgive my poor, once-dear, misguided girl.—She is ill-advised.

To John Arnot of Dalquhatswood, in Ayrshire—who was a subscriber to the Kilmarnock edition and whose father, James, had been factor to the Earl of Loudon—Robert poured out his heart. The letter is a curious production, culminating in a hysterical climax, yet relaxed enough in parts to allow the inclusion of a dragged-in quotation

from Milton, and an elaborately worked out metaphorical account of the manner of Jean's seduction, which is decidedly flippant, not to say bawdy. Yet it is a good letter, showing Burns's prose style at its best and most varied. Evidently it was thought so too by the author, for he included a copy of it in the Glenriddell Manuscript.

I have been all my life, Sir, one of the rueful-looking, long-visaged sons of Disappointment.—A damned star has always kept my zenith, & shed its baleful influence, in that emphatic curse of the Prophet—'And behold whatsoever he doth, it shall not prosper!'—I rarely hit where I aim: & if I want anything, I am almost sure never to find it where I seek it.—For instance, if my pen-knife is needed, I pull out twenty things—a plough-wedge, a horse-nail, an old letter or a tattered rhyme, in short, everything but my pen-knife; & that at last, after a painful, fruitless search, will be found in the unsuspected corner of an unsuspected pocket, as if on purpose thrust out of the way.—Still, Sir, I had long had a wishing eye to that inestimable blessing, a wife.—My mouth watered deliciously, to see a young fellow, after a few idle, commonplace stories from a gentleman in black, strip & go to bed with a young girl, & no one durst say, black was his eye; while I, for just doing the same thing, only wanting that cere-mony, am made a Sunday's laughing-stock, and abused like a pick-pocket.—I was well aware though, that if my ill-starred fortune got the least hint of my connubial wish, my schemes would go to nothing.—To prevent this, I determined to take my measures with such thought and forethought, such a caution & precaution, that all the malignant planets in the Hemisphere should be unable to blight my designs.—Not content with, to use the words of the celebrated Westminster Divines, 'The outward & ordinary means', I left no *stone* unturned; sounded every unfathomed *depth*; stopped up every *hole* & bore of an objection: but, how shall I tell it! notwithstanding all this turning of stones, stopping of bores &c—whilst I, with secret pleasure, marked my project *swelling* to the proper crisis, & was singing te Deum in my own fancy; or, to change the metaphor, whilst I was vigorously pressing on the siege; had carried the counter-scarp, & made a

practicable breach behind the curtain in the gorge of the very principal bastion; nay, having mastered the covered way, I had found means to slip a choice detachment into the very citadel; while I had nothing less in view than displaying my victorious banners on the top of the walls—Heaven and Earth must I 'remember'! my damned Star wheeled about to the zenith, by whose baleful rays Fortune took the alarm, & pouring in her forces on all quarters, front, flank, & rear, I was utterly routed, my baggage lost, my military chest in the hands of the enemy; & your poor devil of a humble servant, commander in chief for-sooth, was obliged to scamper away, without either arms or honours of war, except his bare bayonet and cartridge-pouch; nor in all probability had he escaped even with them, had he not made a shift to hide them under the lap of his military cloak.—

Whilst he was writing all this, the enjoyment of his own skill in elaborating his military metaphor seems to have so occupied his mind that the urgent reality of his feelings was for the time being forgotten. But it burst out in a grand crescendo a few lines farther on:

How I bore this, can only be conceived.—All powers of recital labor far, far behind.—There is a pretty large portion of bedlam in the composition of a Poet at any time; but on this occasion I was nine parts & nine tenths, out of ten, stark staring mad.—At first, I was fixed in stuporific insensibility, silent, sullen, staring like Lot's wife besaltified in the plains of Gomorha.—But my second paroxysm chiefly beggars description.—The rifted northern ocean when returning suns dissolve the chains of winter, and loosening precipices of long accumulated ice tempest with hideous crash the foaming Deep—images like these may give some faint shadow of what was the situation of my bosom.— My chained faculties broke loose; my maddening passions, roused to tenfold fury, bore over their banks with impetuous, resistless force, carrying every check and principle before them. . . . I reprobated the first movement of my existence; execrated Adam's folly-infatuated wish for that goodly-looking, but poison-breathing gift, which had ruined him, and undone me;

and called on the womb of uncreated night to close over me and all my sorrows.

Finally, he tells Arnot that 'Holy Willie' Fisher and his men have once more been alerted.

> Already the holy beagles, the houghmagandie pack, begin to snuff the scent, & I expect every moment to see them cast off, and hear them after me in full cry: but as I am an old fox, I shall give them dodging and doubling for it; & by & bye, I intend to earth among the mountains of Jamaica.

The idea of fleeing to Jamaica to escape the inconvenience of one's indiscretions was not uncommon in eighteenth-century Scotland. The sugar plantations were owned and run by Europeans, many of them Scots, though the actual labour was done by Negro slaves. The mortality rate amongst white settlers was high in these days before anything was known of tropical medicine; and the prospect of emigration only presented itself to those who were in desperate straits, or who had some capital and were willing to run considerable risk in the hope of making a quick fortune.

Robert belonged to the former category. He can hardly ever have seriously considered how ill-suited he was temperamentally to be a slave-driver. But the gesture of defiance to the 'holy beagles', to the sneering, angry Armours, and to their apparently faithless daughter, appealed to his romantic instincts.

Even making due allowance for the view that Robert's Jamaican proposal was a romantic gesture, I find it impossible to accept the popular notion that in all probability he never had any real intention of sailing. In the light of the elaborate preparations he actually made, such a view implies an amount of carefully co-ordinated play-acting which a man suffering Robert's mental stress would be most unlikely to be able to devise and keep going consistently.

At home, caught on the rebound, he had got himself into difficulties with yet another girl, as we shall shortly see. His position was not dissimilar to that of a bigamist, in spite of the single man certificate which, by remaining silent about the verbal promise that accompanied the luckless Armour paper, he had deceived the incor-

ruptible Auld into giving him. A man of Burns's temperament would only resolve on flight to Jamaica when his present situation seemed to be absolutely desperate. Confronted with the circumstances which faced Burns in the summer of 1786, which of us would not then have been tempted to resort to flight?

He had apparently accepted a job on an estate near Port Antonia with Charles Douglas, an Ayrshire planter. The poet was to be Douglas's book-keeper at a salary of £30 a year. Robert would hardly have fixed up this job and gone to the bother of making passage arrangements—there were no travel agencies in those days —if from the start he never had any real intention of leaving Scotland at all. Nor does the tone of the references to Jamaica in his letters seem to me to suggest that he was acting a part. What may legitimately be inferred from them is that from the very beginning the Jamaican plan was utterly repugnant to him, though no doubt he enjoyed dramatizing his sufferings, as we all do; and that as the pressure of home events upon him unexpectedly slackened, his resolution not unnaturally wavered. Finally, when, in October, something happened which put him outside the possible reach of the law as a bigamist, he immediately and gladly abandoned the whole idea of emigration. It had been an emergency measure, and the emergency was over: which is not to say that neither emergency nor the measures to cope with it had never existed.

Meanwhile in Mauchline the 'holy beagles' were not put off their scent by Mrs Armour's assurance that her daughter was on a perfectly normal visit to her Paisley relations, and would return soon. Jean did, in fact, return early in June. On 12th June, Robert wrote of this to David Brice, a Mauchline friend who had become a shoemaker in Glasgow. By now, Robert had apparently persuaded himself that Jean bore the major responsibility for the whole situation!

> Poor, ill-advised, ungrateful Armour came home on Friday last.— ... What she thinks of her conduct now, I don't know; one thing I know, she has made me compleately miserable.— Never man lov'd, or rather ador'd, a woman more than I did her: and, to confess a truth between you and me, I do still love her to

distraction after all, tho' I won't tell her so, tho' I see her, which I don't want to do.— . . . I have tryed often to forget her: I have run into all kinds of dissipation and riot, Mason-meetings, drinking matches, and other mischief, to drive her out of my head, but all in vain: and now for a grand cure: the Ship is on her way home that is to take me out to Jamaica; and then, farewell dear old Scotland, and farewell dear, ungrateful Jean, for never, never will I see you more!

A few days later, arising out of a summons to appear before the Kirk Session on 18th June, Jean sent a brief confession to the minister.

I am heartily sorry that I have given and must give your Session trouble on my account. I acknowledge that I am with child, and Robert Burns in Mossgiel is the father. I am, with great respect, your humble servant. . . .

The next stage was for the guilty parties to submit three times to the public rebuke of the Kirk. Robert wrote to Richmond on 9th July about this impending ordeal.

I have waited on Armour since her return home, not by—from any the least view of reconciliation, but merely to ask for her health; and—to you I will confess it, from a foolish hankering fondness—very ill-plac'd indeed.—The Mother forbade me the house; nor did Jean show that penitence that might have been expected.—However the Priest, I am inform'd, will give me a certificate as a single man, if I comply with the rules of the Church, which for that very reason I intend to do.—

'Daddy' Auld allowed Robert to stand in his own pew, instead of in the place of repentance. Jean and her friends, who probably felt that Robert was getting off much too lightly and shirking his not inconsiderable share of the blame, wanted him to stand by her side; but Auld would not agree to this, 'which bred a great trouble'. Although the Kirk Session was getting something of its own back on Robert for the satires he had levelled at them the previous winter, Auld probably still had a certain respect for the 'profane rhymer'. Certainly, Robert never referred to him in tones more disparaging than

those of reluctant awe, although Auld inflicted more humiliation on the poet than any other minister.

By keeping silent about his verbal vows, Robert eventually got his certificate as a single man. In the middle of his compliance 'with the rules of the Church', he wrote a letter to Smith accompanying the copy of a poem, possibly 'The Court of Equity'. Hostility towards any idea of regularizing his position with Jean, the thought uppermost in his mind, bursts out of it:

> Against two things however, I am fix'd as Fate: staying at home, and owning her conjugally.—The first, by Heaven I will not do! the last, by Hell I will never do!

Even under the pressure of such angry determination, he relaxes a little when he thinks of her,

> If you see Jean tell her, I will meet her. So help me Heaven in my hour of need!

Quite apart from her supposed desertion (which could surely have been explained away by Jean as soon as she returned to Mauchline?), there was perhaps a much more pressing reason why Robert should now have turned so vehemently against the idea of marriage to her, and why he was so desperately anxious to be relieved of all practical responsibility towards her. On 6th August, the Sunday of his last penitential appearance with Jean, another anxious girl was living with her parents in Campbeltown, possibly some months gone with his child, and in possession of his promise to marry her. Her name was Mary Campbell.

II

Mary Campbell, Robert's Highland Mary (though never so called by him), became the heroine of the nineteenth century's Burns legend. In it, her role was that of a Beatrice, 'the virgin bride of fancy' whose memory rose ever before him, as Neil Munro put it. There were obvious reasons why nineteenth-century Burnsites should be anxious to cherish such a view, and why some people still

do. But most probably Mary Campbell played no such silly senti-
mental role. She was a woman, therefore could be woo'd: she was a
woman, therefore could be, and very possibly was, won.

The facts of her appearance in the Burns story have been exam-
ined in considerable detail by two biographers, Dr Snyder and
Hilton Brown. Dr Snyder reached the conclusion that Mary
Campbell more than likely produced Robert's child, and died in
doing so; and though Hilton Brown, armed with some later
information, challenges it, he still, in spite of his caution, seems to
agree. Some recapitulation of the facts is necessary here.

Mary Campbell, the elder daughter of Archibald Campbell of
Daling and Agnes Campbell of Auchamore, was born in the year
1763. Of this marriage there were also two sons and another
daughter. The younger daughter married a stone-mason called
Anderson. The Campbells lived first at Auchamore, near Dunoon,
then at Campbeltown, and finally at Greenock, where Mrs Campbell
had relations.

For some reason not now discoverable Mary Campbell, once she
reached employable age, made her way to Ayrshire, where, accord-
ing to Gavin Hamilton's married daughter Mrs Todd, the girl was
employed as nursemaid to young Alexander Hamilton, born on 15th
July 1785. Thereafter she may—or she may not; no one can defin-
itely say—have been briefly employed as dairymaid at Coilsfield.

At this point, let us in passing attempt to lay a recently-raised
ghost, whose presence further, and in my view needlessly, disturbs
an already confused situation. Hilton Brown discusses the possible
identification of 'Highland Mary' with a Mary Campbell of Dun-
donald, who apparently let herself be seduced by a fornicator called
Hay. It is, of course, a mildly curious coincidence that two Mary
Campbells, both easily accessible to ardent young men, were in the
district more or less at the same time. But Robert was not in the
habit of sharing his loves, nor of consorting with whores or women
who could not give him their undivided attention. Because of this,
and since no mention of the fornicator Hay has ever appeared in any
Burns connexion whatever, Mary Campbell of Dundonald and her
own particular indiscretions may safely be left in peace.

We do not know, however, just precisely where or when Robert

set eyes on his Highland Mary. (She is entitled to her soubriquet even although she only came from the Cowal coast; for Robert Reid, who wrote under the pseudonym Senex, found that Gaelic was spoken by all the inhabitants of Dunoon in 1779 when he spent the summer there.) According to Robert's sister Isabella, he took up with Mary at the time of Jean's supposed desertion: and Jean was sent to Paisley in March 1786.

'The Highland Lassie O', an indifferent song probably written about this time, tells us that the poet means to go to the Indies, and that he has apparently engaged to marry his Highland Lassie (which Robert's mother later stated to have been her son's intention once he was free of Jean).

> She has my heart, she has my hand,
> By secret troth and honor's band!
> Till the mortal stroke shall lay me low,
> I'm thine, my Highland Lassie, O.

The note which Burns later wrote on this indifferent production is, however, of immense importance.

> This was a composition of mine in very early life before I was known at all in the world.—

He probably exaggerates his youth looking back retrospectively. In March 1786, he was still not 'known at all in the world', since the Kilmarnock Poems did not appear until July of that year.

> My Highland Lassie was a warm-hearted, charming young creature as ever blessed a man with generous love. After a pretty long tract of the most ardent reciprocal attachment, we met by appointment, on the second Sunday of May, in a sequestered spot by the Banks of Ayr, where we spent the day in taking farewell, before she should embark for the West Highlands to arrange matters among her friends for our projected change of life. At the close of Autumn following she crossed the sea to meet me at Greenock, where she had scarce landed when she was seized with a malignant fever, which hurried my dear girl to the grave in a few days before I could even hear of her illness.

True, this note was first published by R. H. Cromek in his *Reliques of Robert Burns* (1808), where he erroneously stated that the original appeared in the interleaved copy of the *Scots Musical Museum*[1] which the poet prepared for Robert Riddell of Glenriddell in 1794. Still, Davidson Cook (*Burns Chronicle*, 1922) and Professor De Lancey Ferguson are both of the opinion that the note is genuine, and that Cromek's only error was in the citation of its source, since he failed to reveal that he made use of at least one other Burns manuscript.

Where Burns was concerned, 'a warm-hearted, charming young creature as ever blessed a man with generous love', can hardly be squared with a 'virgin bride of fancy'. Nor is it likely that the man who later advised his youngest brother to 'try at once for intimacy' was likely to fail to make the fullest use of that 'pretty long tract of the most ardent reciprocal attachment'.

At any rate, on the second Sunday of May (if Cromek's note is accepted) Robert and Mary met on the banks of the Ayr and, according to tradition, exchanged Bibles. Robert's Bible, if he ever received one, has never been traced. Mary's Bible, a copy of a two-volume edition published in Edinburgh in 1782, found its way to the Ardrossan house of her younger sister's husband, the stone-mason

[1] It is presumably one of several notes torn out of the original. When James C. Dick published his *Notes on Scottish Songs by Robert Burns* in 1908, he distinguished Burns's own notes from notes in the book by Riddell himself, and he accused Cromek of inventing the remaining notes. Acting on a hint in a newspaper article by David Cuthbertson in 1921, however, Davidson Cook discovered a separate Burns manuscript, written on Excise paper. This manuscript, now one of the Laing Manuscripts in the possession of the University of Edinburgh Library, revealed that most of the notes alleged by Dick to be spurious were, in fact, genuine, though not part of the original interleaved Museum.

Cromek's reputation for integrity was thus restored. It is possible that the torn out leaves may yet be found, as well as the few notes not covered by the 1922 manuscript. In the meantime, however, the 'Highland Lassie' note is clearly more credible than it was prior to Davidson Cook's discovery.

The Songs of Robert Burns and *Notes on Scottish Songs by Robert Burns* by James C. Dick, together with Davidson Cook's *Annotation of Scottish Songs by Burns*, was reissued, with a preface by Henry George Farmer, by Folk Lore Associates, Hatboro, Pennsylvania U.S.A., in 1962.

Anderson. He presumably passed it to his son, who took it and himself to Canada, where it came to light at Caledon, near Toronto, in 1840. It is now in the Burns Monument at Ayr.

The fly-leaves of both volumes are inscribed. Mary's name appears in the first volume, Robert's in the second. But both names have been deliberately smudged, mutilated by Mary's parents no doubt at the time they destroyed Robert's letters to her. An 'M' and part of an 'a' are all that survive of Mary's name, a 'Robert' and the 's' of the surname, together with what looks like the old spelling of Mossgiel, Mossgaville, all that can still be deciphered of Robert's. But underneath his name there is his mason's mark, and also in his handwriting two texts from Leviticus and Matthew, 'deprecating vehemently false swearing and the non-performance of oaths' as Hilton Brown puts it.

A poorish song 'Will ye go to the Indies, my Mary?', apparently referring to this Bible-giving swearing ceremony, also stresses the earnestness of Robert's promises to be true.

> I hae sworn by the Heavens to my Mary,
> I hae sworn by the Heavens to be true;
> And sae may the Heavens forget me,
> When I forget my vow! . . .

> We hae plighted our troth, my Mary,
> In mutual affection to join,
> And curst be the cause that shall part us!
> The hour, and the moment o' time!

The swearing over, Mary then went off to her parents at Campbeltown, with whom she apparently spent the summer and early autumn, during which period she remained unemployed. In October, she came to Greenock, where her mother had relations, ostensibly (according to the descendants of the relations) on her way to take up a situation in Glasgow at Martinmas—the November Quarter day in Scotland. Robert, however, says she came to meet him. If in fact she left Ayrshire pregnant, then her journey to Greenock seems to suggest three possibilities: (1) That she died in child-birth of typhus fever, then raging in the town, having come to

Greenock to bear her child out of reach of the prattling tongues of Campbeltown folk. (2) That she refrained from taking employment throughout the summer because of her condition, though she hoped to be able to work again by Martinmas after the child had been born. (3) That she was turned out of her parents' home (or insisted on leaving), intending to bear the child and meet Robert at Greenock, and thereafter hoping to get from him a definite settlement about the nature of their future together.

There is no real evidence to suggest that he actually intended taking her to Jamaica with him. He may, of course, have made this bargain with her in March as part of his efforts to impress her with his fidelity, when he entertained the Jamaican project with more resolution than he could sustain as the months wore on, and the dangers which threatened him seemed less menacing. The one interpretation that seems to me incredible is that advanced by Mrs Carswell, who suggests that Mary came to Greenock with her parents from whom she had concealed the fact that she was five, perhaps seven months gone.

All this, of course, is pure speculation. Improbable as it may seem, Mary might not have been gone with Robert's child at all. The posthumous history of the case, however, seems to add weight to the belief that she was.

When Mary died in Greenock in October 1786, whether from a fever contracted in child-bearing or from nursing her brother Robert, she was buried in the 'lairs' of the old West Highland churchyard owned by her host and relation, Peter Macpherson. Fifteen years later, Greenock formed the first of the Burns Clubs (which now number over seven hundred). On 23rd February 1803, the Committee minuted that they had unanimously decided to ask Mr Macpherson 'to allow the Club to add a tablet to the memory of Mary Campbell to his lairs'. The monument was not actually erected for another forty years. When it did go up—a tasteless, pretentious thing—it made plain that Mary Campbell and Highland Mary were one and the same person so far as the Greenock Burns Club was concerned.

Thus, seven years after Robert's death, when many who must have been Mary Campbell's contemporaries were still living, the

facts of her flesh-and-blood existence, death and burial were generally accepted by Greenockians. Furthermore, writing to Robert in November 1792, George Thomson, the editor of *Select Scottish Airs*, added as a postscript to his letter:

> Your verses upon 'Highland Mary' are just come to hand; they breathe the genuine spirit of poetry and, like the music, will last for ever. Such verses, united to such an air, with the delicate harmony of Pleyel superadded, might form a treat worthy of being presented to Apollo himself. I have heard the sad story of your Mary: you always seem inspired when you write of her.

Apart from the fact that these few lines show up the basic absurdity of Thomson's artistic notions (of which more will be said later), they reveal that some common friend had carried the tragic news of Mary from poet to editor, since so far as is known the two never met. The nature of Mary's end seems thus to have been fairly common knowledge. So much, then, for those who would have us believe that she never existed at all, except as a spiritual notion which lifted Burns out of his carnal self!

The remains of Mary Campbell lay undisturbed in Peter Macpherson's lair by the shores of the Clyde for a hundred and twenty four years. During this time, Greenock expanded industrially, and the venerable part of the town about the Old West Kirkyard fell into a ruinous state. In 1920, more room was needed for the further expansion of a shipbuilder's yard, and Greenock Corporation, after much argument, decided to transport the contents of the old graveyard to the newer Greenock West cemetery. Thus it came about that on 5th November 1920, Mary Campbell's grave was opened, in the presence of various officials representing the Corporation (of whom for our purposes, the most important was a certain ex-Bailie Carmichael), and the Burns Federation.

'At the bottom of the North lair, in the north-west corner' as the ex-Bailie described the exact position, was found the bottom board of an infant's coffin, sodden with water but retaining its shape. To Snyder, writing in 1932, this seemed a pretty convincing piece of evidence on behalf of the theory that Mary died in or just after childbirth; to Mrs Carswell, in 1930, it was complete proof.

Lairs are not single graves, however, and, as an article in the *Greenock Telegraph* on 4th January 1921 makes plain, the remains of more than one mortal were brought to light at the exhumation— three skulls, a thigh-bone, part of a jaw-bone with 'four teeth in a good state of preservation', some smaller bones, and some human flesh gone 'black and quite hard'. There was also a great quantity of wood. Unfortunately, no forensic expert examined the remains— that might have seemed sacrilege to the sentimentalists—and no wood expert examined the baby's coffin-board, before the casket containing these bits and pieces was reinterred in its new resting place topped once again by the statue.

In 1932, with these prolific remains to back his argument, Dr Lauchlan Maclean Watt, a confirmed Mariolater, came forward in a letter to the *Times Literary Supplement* with a case which sought to annul the value of the infant's coffin-board as relevant evidence. A leading undertaker had assured him that a mother who died in child-birth, and whose infant died with her, would be buried in one coffin, the child being laid across her breast. But of course Mary's child could easily have survived her by a day or two—or a week or two— and so would have required an infant's coffin. Dr Maclean Watt's case was hardly a strong one.

But what should be a very curious result of Dr Maclean Watt's letter? Why, a certain Mr Hendry of Greenock, who throughout the very considerable hubbub caused up and down the country by Mrs Carswell's book two years before had held his peace, suddenly came forward with the story of an ancestor of his, a Captain Duncan Hendry, whose wife, like Mary Campbell before her, made the journey from Campbeltown to Greenock in 1826, in this case with the object of bearing a legitimate child. Where should the Captain take his wife but to a house near that of Peter Macpherson? And when the child, a girl born on 4th January 1827, died on the 27th of the following month, where should she be buried but in the obliging Peter Macpherson's lair?

Mr Hendry was a friend of ex-Bailie Carmichael. At some stage not specified, the ex-Bailie told Mr Hendry about the discovery of the infant coffin-board, and was in return told by Mr Hendry that it probably belonged to Captain Duncan Hendry's child who had died

in 1827. A tradition in the Hendry family persisted that they had a relative buried in Highland Mary's grave.

Had Mr Hendry, a Greenockian, come forward with his statement in January 1921, when his own local paper, the *Greenock Telegraph*, first printed its own article on the exhumation and discovery of the coffin-board, his story would have been easier to accept. It might still have been possible to accept it in 1930, when Mrs Carswell was under heavy fire for having demolished the Beatrice-Mary notion. But Mr Hendry was apparently only brought forward by some person or persons unknown in 1932, in immediate response to the *Times Literary Supplement* controversy (which he himself, incidentally, did not appear to have read), as additional ammunition for Dr Maclean Watt's defensive artillery. I have no doubt that Dr Maclean Watt believed Mr Hendry to be genuine. But I take a much less open-minded view of the affair than does Hilton Brown, the only Burns biographer to examine it so far. To me, the Hendry story seems to bear all the marks of the spurious legend, and to be about as convincing as are those vague and absurd claims of quite ordinary families to distant blue blood. As to the manner of its presentation, I cannot get rid of my suspicion that the story might never have been produced at all but for the enthusiasm of some local Mariolater, who had heard of the Hendry legend, who knew of the need of the Mariolaters for new evidence, and who thus set out first to convince Dr Maclean Watt, then to deceive the world at large, in the interests of Mary's posthumous reputation.

Some readers may think this far-fetched. Fortunately, we have as witness a Mr Alan Bayne, writing in the Burns Chronicle of 1906:

> Highland Mary for ever remains as the inspirer of Burns at his best, and so is linked to him eternally; and whoever seeks to defile this ideal maiden deserves the reprobation of all pure-minded men and women.

The first part of his statement is, of course, nonsense. The two songs Burns wrote to the living Highland Mary are both mediocre. ('Sweet Afton', in spite of Gilbert's assertion to the contrary, is not thought by most authorities to refer to Mary Campbell at all.) There

remains only the hysterical poem called by others 'To Mary in Heaven', of which more in due course.

What finally impels me, after due consideration of the Hendry case and of Hilton Brown's judicial cautioning, to accept with Snyder the theory that Mary Campbell probably died bearing Burns's child, is the fact that no other interpretation really appears to make sense when the episode is refitted into the story of the poet's life.

III

During the last months of 1785, Robert decided to publish a selection of his poems. His *Commonplace Book*, which had been begun with some idea of it eventually being overseen, came to an abrupt end in October. Throughout the winter, in spite of his being a 'professed lover of one or more of the female sex', his muse was active and fertile. Indeed the quantity and quality of the poems produced in this *annus mirabilis*, as Dr Daiches calls it, is almost incredible. By the end of spring 1786, he had therefore a good deal of work from which to make a selection. At the beginning of April, about the same time as he first mentions his intention of going to Jamaica, the proposals inviting subscriptions for his book went to the press.

Robert did not lightly reach the decision to publish his poems. As he says in his autobiographical letter:

> I weighed my productions as impartially as in my power; I thought they had merit; and 'twas a delicious idea that I would be called a clever fellow, even though it should never reach my ears a poor Negro-driver, or perhaps a victim to that inhospitable clime gone to the world of Spirits. . . . To know myself had been all along my constant study.—I weighed myself alone; I balanced myself with others; I watched every means of information how much ground I occupied both as a Man and as a Poet: I studied assiduously Nature's DESIGN where she seem'd to have intended the various LIGHTS and SHADES in my character.—I was pretty sure my Poems would meet with some applause; but at the worst, the roar of the Atlantic would deafen the voice of Censure, and the novelty of West-Indian scenes make me forget Neglect.

One reason which may have weighed with Robert in reaching his decision to put out a book was his need for money; to pay amongst other things, for his passage to the West-Indian scenes. True, in his Proposal-form he had stated:

> As the author has not the most distant mercenary view in publishing, as soon as so many subscribers appears as will defray the necessary expense, the work will be sent to press.

But the next step in the Armour story revealed that a decidedly mercenary view was open to Robert's mind. Having heard that the poet was planning to slip away to the West Indies, and knowing that he was about to publish a book, old Armour forced Jean to sign a complaint against the father of her unborn child. Although the Church was being satisfied by the public penance of the two young people, the Law had still to be reckoned with. As a result of Jean's complaint, her father got a writ *in meditatione fugae* taken out against Robert.

Robert, however, heard about the impending writ before it materialized, and proceeded to take sharp-witted evasive action. On 22nd July, he executed a deed of trust in favour of his brother Gilbert, conveying to him all his property and 'the profits that may arise from the Publication of my Poems presently in the Press'. Gilbert was also made trustee for Robert's daughter Elizabeth Paton, and given 'the Copyright of said Poems' to help clothe and educate the girl as if she was his own—a trust which, incidentally, Gilbert faithfully honoured so far as was in his power.

Robert then had to go into hiding to prevent the threatened warrant for his arrest being served upon him. On 30th July 1786, deeply perturbed, he sat down at the Allan's farm of Old Rome Foord, near Irvine, and wrote to his friend John Richmond, now 'Clerk to Mr Wilson, Writer to the Signet, Edinburgh':

> My hour is now come.—You and I will never meet in Britain more.—I have orders within three weeks at farthest to repair aboard the Nancy, Capn Smith, from Clyde, to Jamaica, and to call at Antigua.—This, except to our friend Smith, whom God

long preserve, is a secret about Mauchlin.—Would you believe it?
Armour has got a warrant to throw me in jail till I find security
for an enormous sum.—This they keep an entire secret, but I
got it by a channel they little dream of:

Jean herself perhaps? Or Aiken the lawyer?—

and I am wandering from one friend's house to another, and like a
true son of the Gospel 'have no where to lay my head'.—I know
you will pour an execration on her head, but spare the poor, ill-
advised girl for my sake; tho', may all the Furies that rend the
injured, enraged Lover's bosom, await the old harridan, her
Mother, until her latest hour! May Hell string the arm of Death to
throw the fatal dart, and all the winds of warring elements rouse
infernal flames to welcome her approach! For Heaven's sake burn
this letter, and never show it to a living creature.—I write it in a
moment of rage, reflecting on my miserable situation—exiled,
abandoned, forlorn—I can write no more—let me hear from you
by the return of Connel—I will write you ere I go.

The following day, *Poems, Chiefly in the Scottish Dialect,* was pub-
lished. This book, which is discussed at length in the 'Interlude'
chapter, succeeded beyond the author's wildest expectations. The
volume was eagerly passed about among his local friends; farm-
hands were scraping together the necessary three shillings to buy
copies; and even 'the first Gentlemen in the County' and their
ladies became what we would nowadays call his fans. By the end of
August, only thirteen copies out of an edition of six hundred and
twelve copies remained unsold. It carried Robert's fame far beyond
the confines of his parish; and it brought him money. Because of the
money, Old Armour relaxed his attitude and the poet was able to
come out of hiding fortified by the knowledge that some of the 'first
Gentlemen in the County' would befriend him should the warrant
be executed. According to Robert at any rate, even Jean would then
gladly have embraced 'that offer she once rejected, but it shall never
more be in her power'.

He now seriously set about his preparations for joining the
Nancy at Greenock. He paid what was meant to be a last visit to

Tarbolton Lodge, where his brother masons gave him a triumphant welcome. He rode about the countryside calling on various friends to collect subscriptions and to say farewell. On one of these visits, to the house of Dr Douglas in Ayr, he met a couple of newly-returned Jamaican travellers, a Mr and Mrs White. They were horrified at his intention of taking a ship which would land him at a port from which he would have to make an extra two hundred miles journey across disease-ridden country, expose him to a grave risk of catching fever, and cost his master a further fifty pounds. They advised instead that he should sail by Captain Cathcart's ship, the *Bell*, due to leave Greenock for Kingston later in September. Cathcart, it so happened, was a friend of Gavin Hamilton's. Back at Mossgiel, Robert wrote to Smith admitting that this report of the Jamaican Whites had somewhat 'deranged his plans'.

However, derangement or no, he apparently set off for Greenock, calling on the way at the house of the Reverend George Lawrie, the 'New Licht' minister of Loudon, Newmilns. At Loudon he was warmly welcomed. Lawrie felt that Scotland's newly-revealed poet should somehow be prevented from leaving 'old Scotia's shores'. Possibly Lawrie indicated that he would see what could be done in Edinburgh. At any rate, instead of riding towards the coast and Greenock, Robert turned back home, making the excuse in a letter to Richmond that the master of the *Nancy* had not given him notice enough to allow him time to wind up his affairs. (If Mary Campbell was to meet him at Greenock on this occasion, had she been put off by letter? We do not know, as his letters to her were destroyed by her father, who came to execrate the very name of Burns.) A more potent reason for his delaying tactics was Jean's condition. He had called on her on his way home and found her 'threatened with the pangs of approaching travail'. He could not help being 'very anxious for her situation'. Although the ship's passage was held up for a day or two, he let the *Nancy* sail without him.

On Sunday evening, 3rd September, Jean's brother came up to Mossgiel to tell the poet that his sister had borne twins. Robert sat down to write Richmond again, bawdily exulting in this further proof of his sexual power.

Green grow the rashes O
Green grow the rashes O
The lasses they hae wimble bores
The widows they hae gashes O . . .

In sober house I am a priest;
 A hero when I'm tipsy O;
But I'm a king and every thing,
 When wi' a wanton Gipsey O . . .[1]

The letter, which came to light only after Professor De Lancey
Ferguson's *Letters of Robert Burns* was published, and has so far
only been quoted in part by Dr Daiches, is incomplete, finishing
with what looks like a postscript:

Wish me luck dear Richmond! Armour has just brought me a
a fine boy and girl at one throw. God bless the little dears!

Two days later, as the *Nancy* was dipping her way down the Firth
of Clyde, 'Daddy' Auld baptized the babies, naming them Robert
and Jean.

At Mossgiel, there was now the harvest to attend to. Lawrie had
perhaps told Robert of his intention to write to his friend the blind
but influential poetaster Dr Thomas Blacklock about the Kil-
marnock poems. Robert may have been hopefully curious to see
how a leader of the Edinburgh literati judged the productions of the
ploughman poet, so artfully played up by Robert in his preface. At
any rate, later in September, the *Bell* also cast her ropes without the
poet on board.

Then there was also the question of a second edition of his book,
the first having completely sold out. The printer John Wilson of
Kilmarnock, was unwilling to risk a new edition unless the poet paid
about £27 for the paper necessary for an edition of a thousand, the
most he would even consider. No doubt the canny man feared that
local demand had been fully met; that the gentry would soon tire of
the novelty of Scots poems; and that it would be wiser to leave
things in the fairly satisfactory way they stood.

[1] *The Merry Muses.*

Wilson's attitude was the more annoying, because in the third week of September, Robert, at third hand through Lawrie and Gavin Hamilton, heard the opinion of Dr Blacklock. The Doctor's letter to Lawrie was dated 4th September, so must have been delayed in transmission by one or other of those through whose hands it had passed.

> Many instances have I seen of nature's force and beneficence, exerted under numerous and formidable disadvantages (wrote the Doctor), but none equal to that, with which you have been kind enough to present me. There is a pathos and delicacy in his serious poems; a vein of wit and humour in those of a more festive turn, which cannot be too much admired, nor too warmly approved; and I think I shall never open the book without feeling my astonishment renewed and increased. It was my wish to have expressed my approbation in verse; but whether from declining life or a temporary depression of spirits, it is at present out of my power to accomplish that agreeable intention.
>
> Mr Stewart, professor of morals in this university, had formerly read me three of the poems and I had desired to get my name inserted among the subscribers; but whether this was done or not I never could learn. I have little intercourse with Dr Blair, but will take care to have the poems communicated to him by the intervention of some mutual friend. It has been told me by a gentleman, to whom I showed the performances, and who sought a copy with diligence and ardour, that the whole impression is already exhausted. It were therefore much to be wished, for the sake of the young man, that a second edition, more numerous than the former, could immediately be printed; as it appears certain that its intrinsic merit, and the exertion of the author's friends, might give it a more universal circulation than any thing of the kind which has been published within my memory.

Despite the cold, patronizing formality of the style, as chilly as an Edinburgh east wind, Dr Blacklock was obviously coming as near as he could to expressing considerable enthusiasm for Burns's work. To one round whose 'folly-devoted head' the storm of mischief was thickening, and who had not yet heard a single opinion on any

of his poems from a professional litterateur acquainted with the latest literary fashions, even such a qualified and patronizing praise as Dr Blacklock's must have brought gratification and joy. But not even Dr Blacklock's opinion could make Wilson the printer change his mind. Clearly there was nothing further to be hoped for from Kilmarnock. What, then, about Edinburgh itself? Might there not be a chance of publication there?

During the next few weeks, Robert rode about the countryside enjoying his literary triumph. At Catrine Bank, the home of Dugald Stewart, Professor of Moral Philosophy in the University of Edinburgh—a kindly man whose influence greatly exceeded his talents, if Lord Cockburn is to be believed—Robert dined with Lord Daer the brilliant younger brother of the Earl of Selkirk, and celebrated the 'ne'er-to-be-forgotten day' with a panegyrical poem which showed that, like most acutely class-conscious people, he could change his tune quickly enough when the exalted person was likely to be a useful friend.[1]

But in spite of his sudden success, in spite of the growing prospects of Edinburgh fame, he was suffering acute mental anguish. He began a letter to Aiken, in which he discusses the difficulties of a second edition, and tells the lawyer that he has 'been feeling all the various rotations and movements within, respecting the Excise'. This leads Robert to wonder what possible effect the consequence of his 'follies' might have on his prospects of adopting a career in the Excise. But the mere mention of his 'follies' seem to be enough to set him off. Suddenly he bursts out:

> . . . I have for some time been pining under secret wretchedness, from causes which you pretty well know—the pang of disappointment, the sting of pride, with some wandering stabs of remorse, which never fail to settle on my vitals like vultures, when attention is not called away by the calls of society, or the vagaries of the Muse. Even in the hour of social mirth, my gaiety is the madness of an intoxicated criminal under the hands of the executioner.

[1] Lord Daer, however, was a radical Whig whose political viewpoint was not dissimilar from that held by Burns during the last years of his life.

What could there still be which caused Robert's gaiety to be 'the madness of an intoxicated criminal under the hands of the executioner'? And why those 'wandering stabs of remorse?' Success and fame were his. Mossgiel, although not exactly flourishing, was at least not threatened with the disaster that had befallen his father's farms. The Armour affair had resolved itself, and Jean herself was apparently compliant again.

There may still have been the case of Mary Campbell on his conscience. If she was shortly to bear his child, his bigamy—for such, by the Scots law of the day, it almost certainly was—would become common knowledge. Mary's parents might pursue an even stronger and more determined course of action against him than had Jean's.

But this problem, if it was in fact what was causing him such acute and haunting distress, was solved for him by Fate in the most cruel way possible; by Mary's mysterious death in Greenock. One afternoon in late October, a letter was delivered to Robert, addressed by an unknown hand. His youngest sister later related to Dr Chambers that Robert took it over to the window to get more light; that as he read it, his face turned pale; and that thereafter, without a word to anyone in the room, he turned on his heels and strode out of the farm. No one now knows by whom this strangely disturbing letter was written, nor the precise nature of its contents. But if it was from Mary's father, or from one of her brothers, it would no doubt be couched in harsh terms. The male Campbells are supposed to have forbidden the mention of the name of Burns after her death; to have refused even to discuss the poet's relationship with Mary; and to have burned all his letters to her. Would they have adopted such an extreme attitude if a child of Robert's had not been at least a contributory cause of Mary's early death? It is hard to think so.

As Snyder puts it: 'For the only time in his career, so far as we know, Burns's lawless love of a woman cost her her life, and the life of her child.' If such was so, any man with even normally sensitive feelings would do his best to bottle up his remorse, and would avoid talking about an episode which he could not recall without shame and regret.

For three years after her death, that is exactly what happened. Robert made no mention of Mary, so far as can be discovered.

Then suddenly, the cork flew up from the bottle and his remorse poured over: in his answer (dated 7th July 1789) to a reprimanding letter from Mrs Dunlop, wherein he tells her that her letter has given him 'more pain than any letter, one excepted, that I ever received': in the poem we call (though Burns did not so call it) 'To Mary in Heaven', which he sent to Mrs Dunlop on 8th November 1789; and in an hysterical comment on this poem made in another letter to Mrs Dunlop dated 13th December, the same year.

Robert had been married to Jean for eighteen months when he wrote:

> My Mary, dear, departed Shade!
> Where is thy place of heavenly rest?
> See'st thou thy Lover lowly laid?
> Hear'st thou the groans that rend his breast?

In the December letter to Mrs Dunlop, he wishes that he could believe more ardently than he can in a 'World to come': for there, he would meet:

> . . . an aged Parent, now at rest from the many buffetings of an evil world against which he so long and bravely struggled. . . . There should I, with speechless agony of rapture, again recognize my lost, my ever dear MARY! whose bosom was fraught with Truth, Honor, Constancy and Love—

After quoting the first stanza of 'To Mary in Heaven' he adds:

> . . . Your goodness will excuse this distracted scrawl which the writer dare scarcely read, and which he would throw into the fire, were he able to write any thing better, or indeed any thing at all.

If such hysteria was not induced by overflowing remorse which at all costs the poet had to get out of his system (and to whom better than this elderly mother-confessor?), what other emotion could possibly have been its cause?

At the end of October 1786, however, the news of Mary's death had also a brutal, practical significance. It broke the menace of bigamy: and it made emigration to Jamaica unnecessary.

On the 15th November, he told Mrs Dunlop:

> I am thinking to go to Edinburgh in a week or two at farthest, to throw off a second impression of my book. . . .

Robert Aiken of Ayr, it seems, had been making postal soundings in the capital on the poet's behalf; but an affair of such magnitude could not possibly be settled by correspondence alone. On 27th November 1786, Robert therefore set out for Edinburgh on a 'pownie', begged on his behalf by John Samson from George Reid, farmer of Barquharie, near Ochiltree. And, if all else failed, a ship called the *Roselle* was due to sail from Leith for Savannah on 17th December.

The Kilmarnock Poems

I

ONCE and once only did Burns have the opportunity of presenting to the public a completely new book of verse the contents of which he had fully revised and polished. Towards the close of his life, it had been his intention to bring out a collection of those of his songs which best pleased him; but that was not to be. *Poems, Chiefly in the Scottish Dialect* has thus an added importance for us, quite apart from its astonishing riches, as being our only evidence of the Bard's work as he wished it to be finally considered.[1]

This evidence shows us that he himself wished to be remembered in two roles: as a Scots poet exulting in the vigour of the native traditions; and as an English poet skilled in the uses of that genteel sentimentality so necessary to win the ear and the applause of the Edinburgh patricians. In other words, the dichotomy that was first set up in the poet's mind as a result of the differing pulls exerted by the 'official' and the 'unofficial' mentors of his boyhood days, at last came right out into the open.

It makes itself evident even in the Preface to the Kilmarnock volume:

> The following trifles are not the productions of the Poet, who with all the advantages of learned art, and perhaps amid the elegancies and idlenesses of upper life, looks down for a rural theme, with an eye of Theocrites or Virgil. To the author of this, these and other celebrated names their countrymen are, in their original languages, 'A fountain shut up, and a book sealed'. Unacquainted with the necessary requisites for commencing Poet by rule, he sings the sentiments and manners, he felt and saw in himself and his rustic compeers around him, in his and their native language. . . . To amuse himself with the little crea-

[1] The additions included in the two Edinburgh editions of the book are considered later.

tions of his own fancy, amid the toil and fatigues of a laborious life; to transcribe the various feelings, the loves, the grief, the hopes, the fears, in his own breast; to find some kind of counterpoise to the struggles of a world, always an alien scene, a talk uncouth to the poetical mind; these were his motives for courting the Muses, and in these he found Poetry to be it's own reward.

Having thus introduced himself as a modified version of Rousseau's noble savage, he proceeds to quote Shenstone; 'Humility has depressed many a genius to a hermit, but never raised one to fame'— noble no doubt, but hardly an observation within the ken of a savage, however modified! Then he goes on to make it plain that while he 'certainly looks upon himself as possest of some poetic abilities', he would never dream of comparing his talents to 'the genius of a Ramsay or the glorious dawnings of the poor unfortunate Fergusson'. Finally, he thanks his patrons, asks them to make every allowance for 'Education and Circumstances in Life', and invites them, should he be convicted of dullness and nonsense, to be 'condemned, without mercy, to contempt and oblivion'.

The dichotomy between the traditions of Scots literature and the influence of the contemporary English poetry of 'sensibility', is also apparent in the curious mixture of Scots and English work which makes up the contents of the book. It even breaks out in the middle of potentially excellent Scots poems like 'The Cotter's Saturday Night', and the 'Epistle to Davie', marring their artistic unity. It was an inevitable division in the sensibility of even the most patriotic writer brought up in the mental climate of a country that had thrown in its lot with its neighbour, England, and affected both Fergusson, and, more disastrously, the less gifted Ramsay. Fortunately, however, it was never able to tear Burns's genius asunder—indeed, as he grew older, he gained the ability to integrate the two to some extent—and the Kilmarnock volume remains one of the most impressive first collections ever to appear.

The book went to John Wilson's press on 13th July 1786, when Robert's personal affairs were moving towards their distracting climax. It seems possible that at the last moment he changed his mind as to the final form of the book, perhaps acting upon advice from

Wilson, adding all those poems which come after the 'Dedication to Gavin Hamilton'. In any case, Burns had abundant material to choose from, for throughout the autumn and winter of 1785 and the spring of 1786, his Muse had been at its most productive.

The Kilmarnock volume contains in all forty-four poems and a fairly full glossary. Of these, nine were epigrams or epitaphs (including an epitaph on his father), and four were songs. Burns did, on occasion, hit off a deft epigram, like his outburst on being refused admittance to the Carron Iron Works; or an amusing impromptu stanza like his answer to a dinner invitation ('Sir, Yours this moment I unseal'). But none of the epigrams or epitaphs in the Kilmarnock volume come up to the standard of either of these. With one exception, the songs are also trivial, the exception being 'It was upon a Lammas night'. This autumnal song, which goes to the tune 'Corn Rigs', celebrates the spontaneous raptures of physical love with a generous fullness which neither Burns nor anyone else has ever surpassed. It is, indeed, the implied sexuality of so many of Burns's love songs, that gives them their superiority over the conventional versified sighings and compliment-payings of the period. The very rhythm of 'Corn Rigs' has a sort of satisfied ardency which underlines the delight which the poet found with Annie.

> I lock'd her in my fond embrace;
> Her heart was beating rarely:
> My blessings on that happy place,
> Amang the rigs o' barley!
> But by the moon and stars so bright,
> That shone that hour so clearly!
> She ay shall bless that happy night
> Amang the rigs o' barley.

Besides these thirteen more or less minor poems, Burns included six of the melancholy English pieces which were written during his bouts of physical and mental depression. These are also of little literary consequence. There were two political poems: 'The Author's Earnest Cry and Prayer', already discussed, and 'A Dream', wherein the poet imagines himself to have been present at King George's birthday levee of 1796. 'The Dream' spanks along at a

brisk pace in the same stanza-form as 'The Holy Fair', and contains one of the best of those quotations so proverbial in their terse aptness that they now lie under almost every Scots tongue—'But facts are chiels that winna ding. An' daurna be disputed.'

'The Dream' was designed to be a satirical take-off of the official Birthday Ode XVI by the Laureate, Thomas Warton. Warton evokes classical times to fill out his paeans of empty praise.

> The bards of Greece might best adorn
> With seemly song, the Monarch's natal morn;
> Who, thron'd in the magnificence of peace,
> Rivals their richest real theme:
> Who rules a people like their own,
> In arms, in polish'd arts supreme;
> Who bids his Britain vie with Greece.

Burns takes an altogether different approach to the Monarch's natal morn.

> I see ye've complimented thrang,
> By monie a lord an' lady:
> *God Save the King*'s a cuckoo sang
> That's unco easy said ay:
> The poets, too, a venal gang,
> Wi' rhymes weel-turn'd an' ready,
> Wad gar you trow, ye ne'er do wrang,
> But ay unerring steady,
> On sic a day.

Despising courtly diplomacy of this sort, Burns reminds his sovereign that far from ruling a people like his own, the loss of the American colonies has greatly depleted the number of the king's subjects:

> Your royal nest, beneath your wing,
> Is e'en right reft and clouted,
> And now the third part o' the string,
> An' less, will gang about it
> Than did ae day.

Unfortunately the concluding stanzas, which deal with the 'young

Potentate o' Wales' and the Duke of York and Albany, 'young, royal Tarry-breeks', the future George IV and William IV, over-step that boundary of wit which separates satire from abuse, and however justified the poet's strictures may or may not have been, result artistically in a weak conclusion to his poem.

Of the anti-Calvinistic poems, 'The Holy Fair' was included, as was also the 'Address to the Deil'. But most of the others were left out. 'The Twa Herds' and 'The Ordination' were almost certainly omitted because Burns had no wish to burden his first published volume with the risks which a direct and open challenge to Orthodoxy might have incurred; 'Holy Willie's Prayer' could all too easily have been mistaken for an attack upon religion itself; while the Epistles to John Goldie and John M'Math, both ministers stout in defence of theological liberalism, were probably left out for fear of involving the persons concerned in trouble with the Kirk authorities.

Other notable omissions were 'Death and Dr Hornbook', left out probably because Burns at first regarded its publication as carrying his attack on the harmless eccentricities of a friend too far—though he later waived his scruples and put it in the 1787 Edinburgh edition; the 'Address to Beelzebub', an onslaught upon two Highland lairds, Mackenzie of Applecross and Macdonald of Glengarry, who were supposed to be preventing Highlanders from emigrating to Canada, in order to preserve the supply of cheap labour for their estates—had Burns lived a normal span and encountered the first of the Clear-ances, he might have found himself changing this particular tune—; and, for obvious reasons, that quasi-anarchic exultation 'The Jolly Beggars'.

However, in spite of these omissions—which, together with the songs and smaller pieces also left out, would alone have made up a second volume as distinguished as the first—the range and variety of the book is astonishing. Three themes recur in many of the poems, two of them touched upon in the Preface: the pleasure the poet derived from writing his verses; his determination to win fame not only for himself but for his particular part of Scotland; and his conviction, usually tempered with mild acceptance, that this world's gear is far from fairly distributed.

Let us now consider the other poems which make up the bulk of the Kilmarnock volume, in the order in which they are to be found.

First comes 'The Twa Dogs, a Tale'. It was completed in February 1786. Here, Burns was working in a literary tradition which sprang out of the medieval animal fable, developed through Robert Henryson (whose birds and animals are really human beings, so far as their feelings and emotions are concerned, in spite of the accuracy of the natural detail in which they are set), and flourished in Burns's youth through the mock-elegies and dying pronouncements of innumerable animals 'gifted' with human prescience.

Henryson's delightful fable wherein a town mouse and a country mouse exchange views on their respective ways of life, may have given Burns the germ idea for 'The Twa Dogs', in which a poor man's dog and a rich man's dog hold a similar conversation of comparison. The technical model, however, was Fergusson's 'Mutual Complaint of Planestanes and Causey', a dialogue in octosyllabic couplets between the crown of the road—the only paved part in the eighteenth century—and the slope towards the gutter.

Burns carries his conversation into wider reaches of thought and feeling than either Henryson's or Fergusson's protagonists touch upon.

Caesar, a Newfoundland dog, was 'keepet for his Honor's pleasure'.

> His lockèd, letter'd, braw brass-collar
> Shew'd him the gentleman an' scholar.

Luath—modelled on a favourite dog of the poet's who had recently been killed—was, on the other hand, a working collie:

> . . . a gash an' faithfu' tyke,
> As ever lap a sheugh or dyke. [*ditch or wall*
> His honest, sonsie, baws'nt face, [*handsome white-striped*
> Ay gat him friends in ilka place;
> His breast was white, his tousie back [*shaggy*
> Weel clad wi' coat o' glossy black;
> His gawsie tail, wi' upward curl,
> Hung owre his hurdies wi' a swirl. [*hips*

Luath was, in fact, a canine Robert Burns; a hard-working, genial fellow, who carried his pride high.

Having introduced each other, these dogs 'who were na thrang at hame', do their bit of nosing and snuffing—a good piece of doggy psychology this—and then 'set down upon their arse' to begin a discussion on 'the lords o' creation'. In other words, they compare rich men and poor men. Caesar pities the lot of poor folk at the hands of the gentry. Luath, in reply, gives a pleasing picture of the brighter side of rural life, and of the joys to be met with at the communal festivals of the people. Then he makes a chance reference to the politicians who travel to Parliament in London. Suddenly, on the note of travel, there occurs one of those remarkable modulations in which Burns specialized; the lines crispen and lose their geniality, and before the reader quite realizes what has happened, Caesar, the rich man's dog, has embarked upon a contemptuous condemnation of the idle dissipations of some of the folk who belong to his master's social class.

> There, at Vienna or Versailles,
> He rives his father's auld entails;
> Or by Madrid he takes the rout,
> To thrum guitars an' fecht wi' nowt; [*fight bullocks*
> Or down Italian vista startles
> Whore-hunting amang groves o' myrtles:
> Then bowses drumlie German-water, [*drinks*
> To mak himsel look fair an' fatter,
> An' clear the consequential sorrows,
> Love-gifts of Carnival signoras.

Nor are the upper-class ladies any better, though they may all profess to be sisters:

> But hear their absent thoughts o' ither,
> They're a' run deils an' jads thegither. [*outright*

By the time Caesàr has had his say, gloaming has come down upon the dogs, so:

> . . . up they gat, and shook their lugs,
> Rejoic'd they were na men, but dogs;

An' each took aff his several way,
Resolv'd to meet some ither day.

'The Twa Dogs' was in every way a 'safe' opening-piece to the book, for it displays unity of style and purpose, immense ease in the handling of the conversational couplets, and it offers nothing which could give serious offence to anyone. Incidentally, it also contains another of Burns's proverb-like 'quotes':

But human bodies are sic fools
For a' their colleges an' schools,
That when nae real ills perplex them,
They mak enow themsels to vex them. [enough

After 'The Twa Dogs' comes 'Scotch Drink', 'The Author's Earnest Cry and Prayer', 'The Holy Fair', 'Address to the Deil', the two pieces on Poor Mailie discussed earlier, and the first, though not the earliest, of the verse-epistles, that addressed to James Smith.

Here again, Burns was working upon a form that lay ready to his hand. The earliest examples of verse-epistles in Scots are the set of six exchanged between Allan Ramsay and William Hamilton of Gilbertfield. These two correspondents begin by complimenting each other before proceeding to some rather platitudinous philosophizing on the desirability of savouring the joys of the present while youth remains. They then finish with a flourish of mutual joviality. Fergusson also engaged in this sort of correspondence, first of all with one J.S., and then with 'Andrew Gray' of Whistle-ha'. By the middle of the eighteenth century, indeed, so many minor poetasters had taken it up that the form had become a convention.[1]

[1] 'Whistle-ha'' is Scots for 'Parnassus'. Andrew Gray may have been the Rev. Andrew Gray, D.D., minister of Abernethy. He kept up the convention of all pre-Burnsian verse-epistle writers, whereby they wrote themselves down to the 'vulgar' level as a kind of patriotic game. Thus Gray addresses Fergusson:

Dear R, I e'en maun dip my pen,
But how to write I dinna ken;
For learning, I gat fient a grain,
 To tell me how
To write to ony gentleman
 Sic like as you.

Burns used the verse-epistle as often as not to write about himself. His verse-letters are thus more interesting, as well as technically more accomplished, than most examples by other hands.

In the 'Epistle to James Smith', he begins with an extravagant compliment, such as any young man might make to the close friend of his formative years. It occupies three stanzas; then the poet announces the business on hand, which is a consideration of the reasons that prompt poets to write, and the author's views on his own particular prospects of achieving fame.

> Some rhyme a neibor's name to lash;
> Some rhyme (vain thought!) for needfu' cash;
> Some rhyme to court the countra clash, [*get talked about*
> An' raise a din';
> For me, an aim I never fash;
> I rhyme for fun.

But 'Something cries, "Hoolie!"' when he, the author of the letter, thinks of printing his poems, reminding him that poets of far greater learning have thought themselves sure of cash and fame, yet their pages have in the end become food for the moths. So he bridles his ambition.

> Then farewell hopes of laurel-boughs,
> To garland my poetic brows!
> Henceforth I'll rove where busy ploughs
> Are whistlin' thrang. [*busily*
> An' teach the lanely heights an' howes [*lonely hills*
> My rustic sang. *and dales*

At this point, the subject-matter of the poem has been worked to a logical conclusion. But the thought of his own fancied obscurity induces Burns to expand upon the conventional theme of Scots

Had the reverend doctor's learning been seriously questioned in English, he would no doubt have taken a different view!

Curiously enough, the only poem of any lasting merit by James Beattie, the author of a once-famous piece, 'The Minstrel', is a Scots verse-letter in 'Standard Habbie' addressed to Alexander Ross (author of the pastoral poem 'Helenora, or the Fortunate Shepherdess').

verse-epistles; so off he goes on a platitudinous excursion over the well-worn theme of the wisdom of celebrating the Present Moment's joys, till we come to what is virtually a restatement of Ramsay's Scots rendering of Horace. Ramsay puts it thus:

> Let neist day come as it thinks fit,
> The present minute's only ours;
> On pleasure let's employ our wit,
> An' laugh at fortune's feckless pow'rs.
>
> Be sure ye dinna quat the grip [*quit*
> O ilka joy when ye are young,
> Before auld age your vitals rip,
> An' lay ye twafald o'er a rung.
>
> Sweet youth's a blythe an' hertsome time;
> Then, lads and lasses, while it's May,
> Gae pu' the gowan in its prime,
> Before it wither an' decay.

Burns writes:

> The magic-wand then let us wield;
> For, ance that five-an'-forty's speel'd, [*reached*
> See, crazy, weary, joyless eild, [*old-age*
> Wi' wrinkl'd face,
> Comes hostin, hirplin owre the field, [*weighing and*
> Wi' creepin' pace. *limping*
>
> When ance life's day draws near the gloamin, [*twilight*
> Then fareweel vacant, careless roamin;
> An' fareweel cheerfu' tankards foamin,
> An social noise;
> An' fareweel dear, deluding woman,
> The joy of joys!

We may note in passing that 'five-an'-forty' was the age at which Ramsay decided a poet could no longer expect to receive inspiration, and the age after which he himself virtually retired from verse-making.

'Social noise', an Augustan description of the friendly stour in a

pub, warns us that the poem is in danger of coming apart, and modulating into an unrelated key; the characterless key customarily used by minor eighteenth-century poets for moralizing. This is exactly what happens. 'O Life, how pleasant, in thy morning,' Burns declares; and through the next four English stanzas the poem meanders through a meditation on the vagaries with which Fortune distributes her benisons. It revives at once when it moves back into Scots as the poet implores Fortune to grant him the gift he most desires— 'Ay rowth (an ample supply) o' rhymes.' Give such honours as are conventionally bestowed, he says, upon soldiers, maids of honour, the Prime Minister, business men; but give him plain food and the Muses' inspiration. Compared with these, what indeed are the rewards of the rich? This leads him to what is at once both the climax of the poem and its coda: a scathing attack on the 'unco guid' and the respectable for the narrowness of their sympathies.

> O ye douce folk that live by rule,
> Grave, tideless-blooded, calm an' cool,
> Compar'd wi you—O fool! fool! fool!
> How much unlike!
> Your hearts are just a standing pool,
> Your lives, a dyke! . . .
>
> Ye are sae grave, nae doubt ye're wise;
> Nae ferly tho' ye do despise [*wonder*
> The hairum-scairum, ram-stam boys,
> The rattling squad:
> I see ye upward cast your eyes—
> Ye ken the road!

As so often with the composer Schubert, Burns seems about to let a new impulse which stirs in his coda carry him completely away. But on this occasion, he resists the temptation, and with a few brisk chords in the home tonic, he brings the poem to a deft finish within the convention:

> Whilst I—but I shall haud me there—
> Wi' you I'll scarce gang ony where—
> Then, Jamie, I shall say nae mair,

But quat my sang, [*finish*
Content wi' you to make a pair,
Whare'er I gang.

Next in the volume comes 'A Dream', followed by 'The Vision',
an earlier poem which Burns tinkered with from time to time. It
begins, as do so many of his poems, in the Fergusson manner,
painting a picture of a particular scene. In this case the picture is of a
winter evening, sharp and telling in its detail.

The sun had clos'd the winter day,
The curlers quat their roaring play,
And hunger'd maukin taen her way, [*hare*
 To kail-yards green,
While faithless snaws ilk step betray
 Whare she has been.

The poet gladly goes inside his cottage:

There, lanely, by the ingle-cheek,
I sat and ey'd the spewing reek,
That fill'd, wi' hoast-provoking smeek,
 The auld clay biggin;
An' heard the restless rattons squeak
 About the riggin.

We are reminded of Robert Henryson setting himself down beside
his ingle in fifteenth-century Dunfermline.

I mend the fyre and beikit me about,
Than tuik ane drink my spreitis to comfort,
And armit me weill fra the cauld thairout:
To cut the winter nicht and mak it schort,
I tuke ane Quair, and left all other sport, [*book*
Writtin be worthie Chaucer glorious, [*by*
Of fair Creisseid, and worthie Troylus.

Such warm interiors are, of course, fairly common in Scots
poetry between Henryson and Burns, and the opening of 'The
Vision' merely illustrated yet another thread which bound Burns so
firmly to the Scots literary tradition. I draw this passing compari-
son, however, because it seems to me that there are many bands of

kinship between Henryson and Burns; both excel in imagining and describing the feelings of small animals; both have ready sympathy for human foibles; both had stored in their hearts a pressing flood of compassion for the poor and the weak, often most effectively released when they were comparing the ways of mice and men.

On this occasion, however, Burns begins to muse, not on 'worthie Troylus', but upon how he had spent his

> . . . youthfu' prime,
>> An' done naething,
> But stringing blethers up in rhyme
>> For fools to sing.

Suddenly the door flies open, and in the light of his blazing fire he sees:

> A tight, outlandish hizzie, braw,
>> Come full in sight.

The lady, who turns out to be Coila, his Scottish Muse, then steps into the room. The poet sees that she is comely, and, as might have been expected of Burns's Muse, that she has a good leg, which he likened to that of his Bess, though before the break with the Armours it was Jean's limb which had the honour of forming this strange comparison.[1] Coila then displays a mantle 'of greenish hue', a picture of the rivers, hills and towns of Ayrshire, which she claims to represent.

The poem is divided into Duans which, as Burns explained in a footnote, is a 'a term of Ossian's for the division of a digressive poem'. In the second Duan, Coila addresses her protégé in Augustan English. She tells him that she has followed his career with interest, and taught him his 'manners-painting-strains'. Yet for all that, he can neither learn, nor can she teach him:

> . . . To paint with Thomson's landscape glow;
> Or wake the bosom-melting throe,
>> With Shenstone's art;
> Or pour, with Gray, the moving flow,
>> Warm on the heart.

[1] Jean's leg was eventually restored to the place of honour!

However, the lot of a rustic Bard is not to be despised.

> To give my counsels all in one,
> Thy tuneful flame still careful fan;
> Preserve the dignity of Man,
> With soul erect;
> And trust the Universal Plan
> Will all protect.

With this piece of advice typical of the sentimental deism of Burns's day, she places a wreath of holly round the poet's head and departs.

'The Vision' is concerned with the main themes which animated so much of his early poetry—the conflict between the poetic temperament and that of more conventional folk; the inequality surrounding the world's distribution of wealth and honours; the distrust of money-grubbing for its own sake. Its merits seem to me to outweigh the passing unease which its rhetorical demerits give the reader. It is a poem on which the doctors have always disagreed. Mr Crawford thinks '"The Vision" one of Burns's highest achievements', and its movement 'from a vernacular prelude to a rhetorical centre and conclusion . . . highly successful.' Dr Daiches finds the tone of the latter part of the poem so far removed from that of the opening that the poem goes wrong. Dr Daiches attributes this to Burns trying to strike an attitude for the benefit of a genteel audience. When 'The Vision' was first written, however, he had no such audience immediately in view. It may equally well be that he merely failed, lacking a clear purpose, to versify sentiments which he had already expressed so much better in prose towards the end of his *Commonplace Book*.

> However I am pleased with the works of our Scotch Poets, particularly the excellent Ramsay, and the still more excellent Ferguson [*sic*], yet I am hurt to see other places of Scotland, their towns, rivers, woods, haughs, and etc immortalized in such celebrated performances, whilst my dear native country, the ancient Baileries of Carrick, Kyle, and Cunningham, famous both in ancient and modern times for a gallant, and warlike race of in-

habitants; a country where civil and particularly religious Liberty have ever found their first support, and their last asylum; a country, the birthplace of many famous Philosophers, Soldiers, and Statesmen, and the scene of many important events recorded in Scottish History, particularly a great many of the actions of the GLORIOUS WALLACE, the SAVIOUR of his Country; Yet, we have never had one Scotch Poet of any eminence, to make the fertile banks of Irvine, the romantic woodlands and sequestered scenes on Aire (Ayr), and the healthy, mountainous source, and winding sweep of Doon, emulate Tay, Forth, Ettrick, Tweed and etc. This complaint I would gladly remedy, but alas! I am far unequal to the task, both in native genius and education . . .

This was, of course, exactly the task to which Burns's genius *was* equal. But he usually failed whenever he forgot to think in terms of 'the ancient Baileries of Carrick, Kyle and Cunningham', and strove instead to reproduce Shenstone's 'bosom-melting throes'.

It was no doubt Burns's desire to perpetuate the old Scots country customs associated with the 31st October which led him to write the next poem in the book, 'Halloween'. It is couched in the folk-festival tradition of 'Christ's Kirk on the Green', 'Of Peblis to the Play' and of many less notable poems celebrating rustic bridals; and it is written in the same stanza-form as 'The Holy Fair'. Yet on the whole, 'Halloween' is one of Burns's least successful poems. The old traditional Scotland which Burns unconsciously saved through the vigour and vitality of his best work, was still to him a contemporary reality. 'Halloween' was perhaps a too-conscious attempt to preserve customs, and their expression, already almost moribund in Burns's day. The Scots employed[1] contains more local words that have since become archaic and forgotten, than are to be found anywhere else in his work; and most of the superstitions and futurity-peering customs which he records have so completely

[1] Christina Keith draws attention to it containing, along with the 'The Auld Farmer's New-Year Morning Salutation', 'the finest Lallans Burns ever wrote'. Yet this feeling that the words are in themselves often more important than what is being said, as in 'Halloween', was the criticism constantly, and often with justification, levelled against the twentieth-century Lallans Makars, seeking to revive the old tongue.

died out that not even the poet's footnotes can make them of interest except to the specialist in folk-lore.

The custom whereby lads and lasses place together their chestnuts on the ribs of a fire, saying to themselves whom the nuts represent, and waiting to see whether they burn together, or whether one or other of the nuts jump out of the fire, is still occasionally to be met with at Halloween parties in country districts. Two of Burns's stanzas describing this one surviving custom give some idea of the vigorous movement of this best section of the poem.[1]

> The auld Guidwife's weel-hoordet nits [*nuts*
> Are round an' round divided,
> An' monie lads an' lasses' fates
> Are there that night decided:
> Some kindle, couthie, side by side,
> An' burn thegither trimly;
> Some start awa, wi' saucy pride,
> An' jump out owre the chimlie [*fireplace*
> Fu' high that night.

> Jean slips in twa, wi' tentie e'e;
> Wha 'twas, she wadna tell;
> But this is *Jock*, an' this *me*,
> She says in to hersel:
> He bleez'd owre her, an' she owre him,
> As they wad never màir part
> Till fuff! he started up the lum,
> An' Jean had e'en a sàir heart
> To see't that night.

The next poem in the book is 'The Auld Farmer's New-Year Morning Salutation to his Auld Mare, Maggie, On Giving her the Accustomed Ripp of Corn to Hansel in the New Year'. By general consent, it is the most successful of all Burns's animal poems.

In Scotland (and probably in many other agrarian countries as well) there exists a warm fellow-feeling between the shepherd and

[1] Burns's 'Halloween' owes something both to Fergusson's 'Hallow-Fair,' and to the lively 'Hallow-E'en' of John Mayne.

his dogs, the farmer and his horses. It has nothing to do with that sentimental Kiplingesque feeling for animals which attempts to give dogs 'souls'. The relationship Burns portrays so successfully is that between working partners who respect each other's qualities, and who have shared many of life's buffetings and triumphs together. It is a realistic relationship, not unmixed with that kindness which the superior partner bestows on the inferior. Burns starts off by saluting his mare as she now is.

> A Guid New-year I wish thee, Maggie!
> Hae, there's a ripp to thy auld baggie:
> Tho' thou's howe-backet now, an' knaggie, [*hollow-*
> I've seen the day, *backed and*
> Thou could hae gaen like ony staggie *bony*
> Out-owre the lay.

> Tho' now thou's dowie, stiff an' crazy,
> An' thy auld hide as white's a daisie,
> I've seen thee dappl't, sleek an' glaizie,
> A bonie gray:
> He should been tight that daur't tae raize thee,
> Ance in a day.

The poet then remembers how he came by his mare, twenty-five years before; how she had carried him to woo; to Fairs; in his cart; and at the plough. He then vows that for such good service, she will never be allowed to starve, and that she shall end her days in peace. The prevailing emotion of the concluding stanza, as has often been observed, is not so very far removed from that of 'John Anderson, My Jo'.

> We've worn to crazy years thegither;
> We'll toyte about wi' ane anither;
> Wi' tentie care I'll flit thy tether,
> To some hain'd rig, [*reserved ridge*
> Whaur ye may nobly rax your leather, [*stretch*
> Wi' sma fatigue.

'The Auld Farmer's New-Year Morning Salutation' is a splendid

example of the way in which Burns could make what, on the face of it, is material for local poetry, carry the significance of universality.

II

In considering the next poem, which occupies a central position in the book, it is necessary to bear in mind the influence of a number of non-literary factors in order to appreciate why one of Burns's most uneven major productions should have become one of his most popular.

Until Burns's own poetry swept through Scotland, ousting all other bards in the affections of the Scottish peasantry, Sir David Lyndsay of the Mount had some claim to be regarded as the national bard. In every cottage where books of any sort were to be found at all, alongside the Bible in English would be 'the warks o' "Davie" Lyndsay'. Between 1555, the probable date of Lyndsay's death, and the publication date of the Kilmarnock Poems, over forty editions of Lyndsay's 'warks' appeared, as well as numerous reprints of individual poems and selections in collections and anthologies.

There were two reasons why Lyndsay, though by no means the greatest of the Auld Makars, should have become the most popular. He was the only major Makar to come down on the side of the Reformation (indeed, his drama 'Ane Satire of the Thrie Estatis in Commendatioun of Virtue and Vituperation of Vice' played no little part in helping the Reformation forward): and his verse was interlarded with pithy, proverb-like sayings, couched in good hamely Scots which simple people could easily get by heart and remember. So long as the Presbyterian Church remained effectively militant—and so long as no more quotable serious poet came forward—Lyndsay's place as the national bard, the literary defender of his country's religious freedom, was assured.

Neither Ramsay nor Fergusson were greater poets than Lyndsay; nor were they so much making their appeal to the peasant strata of society (wherein poetry and piety have been closely associated since the Reformation, no doubt due to the Scots custom of singing the psalms in metrical versions), as to the more liberal-minded strata typified by the middle and upper classes of Edinburgh society,

the lawyers, the professors, the wealthy tradesmen, and the nobility, all of whom had come to be more or less aware of their age's sentimental humanism. It was to this latter audience than many of Burns's earlier poems were, in fact, though not always in theory, addressed. With 'The Cotter's Saturday Night', however, Burns reached the wider peasant public; Lyndsay's public, who did not care overmuch if the poetry was at times rather poor so long as it reflected their manners, their way of life, and, above all, their narrow but undeviating concept of religion. With 'The Cotter's Saturday Night', Burns ousted Lyndsay as the national bard. Between 1786 and the date of writing, there have been only four complete editions of Lyndsay's works, though, of course, his assured place in Scots literature has resulted in the appearance of periodic selections. Over the same period, there have been more editions of Burns's works than I would care to try to count.

The irony of the situation is that when Burns was actually writing 'The Cotter's Saturday Night' late in 1785 or early in 1786, he was not really aiming at the target he hit. He was aiming—or at least he appears to have been aiming—at showing off the simple virtues of the Scottish peasants' way of life to the Edinburgh patricians, and at the same time making it plain to them that while he himself was of peasant stock and could paint rustic manners realistically, he could also stand back and indulge in fashionable 'bosom-melting throes'. In other words, the linguistic dichotomy with which Burns had to contend throughout his literary life, actually seemed to him a force in his favour, in much the same way as Ramsay, a fellow-sufferer, thought that by making use of both the English and the Scots word for an object, he was employing a richer vocabulary than an author who had only one or other at his disposal.

Before 'the gentles', Burns was usually ill at ease, and he therefore fell back upon what he conceived to be an acceptable pose. (It frequently was far from acceptable, many of his intended compliments to people on a higher social level than himself being, in fact, examples of arrogant tactlessness.) No poet can write at his best while sustaining a conscious pose, and Burns was no exception.

The model for 'The Cotter's Saturday Night' was an excellent poem by Robert Fergusson, 'The Farmer's Ingle', in which the

scenes in a farmhouse kitchen from gloaming till bedtime are sympathetically portrayed. Fergusson's poem begins with an invocation to his muse to 'chant' of these things 'in hamely strains', an invocation which she answers most successfully. 'The Farmer's Ingle' finishes with a benediction, calling down peace and plenty on the farming folk, in simple, sonorous tones.

> Peace to the husbandman an a' his tribe,
> 　Whase care fells a' our wants frae year to year;
> plough] Lang may his sock and couter turn the gleyb, [earth
> 　And bauks o' corn bend down wi' laded ear.
> May SCOTIA's simmers ay look gay and green,
> 　Her yellow har'sts frae scowry blasts decreed; [showery
> May a' her tenants sit fu' snug and bien,
> 　Frae the hard grip of ails and poortith freed,
> And a lang lasting train o' peacefu'l hours succeed.

Burns's ground plan is similar to Fergusson's: but Burns felt obliged to fill out his framework with pseudo-philosophical reflection, whereas Fergusson was content simply to record what he saw.

Burns begins his poem with one of the most absurd stanzas he ever wrote, and one in which his tactlessness is embarrassingly evident.

> My lov'd, my honour'd, much respected friend!
> 　No mercenary bard his homage pays;
> With honest pride, I scorn each selfish end,
> 　My dearest meed, a friend's esteem and praise:
> 　To you I sing, in simple Scottish lays,
> The lowly train in life's sequester'd scene;
> 　The native feelings strong, the guileless ways;
> What Aiken in a cottage would have been;
> Ah! tho' his worth unknown, far happier there, I ween!

'Pride' was, of course, a key-word in Burns's make-up and vocabulary, frequently used with unfortunate and strident effect when he was addressing 'the gentles'. The real absurdity is what Dr Daiches calls the 'preposterous sentimentalism which would actually suggest that the plump and prosperous little lawyer would have been happier in a cottage than in his comfortable house in Ayr!'

After this false beginning—which may possibly have been a later addition—the poem sets out on what should have been its proper course, starting, as so often with Burns, from a magnificently-drawn, well-observed picture of a peaceful local scene in the true Spenserian stanza, containing a distant echo of Gray.[1]

> November chill blaws loud wi' angry sugh; [*whistling sound*
> The short'ning winter‑day is near a close;
> The miry beasts retreating frae the pleugh
> The black'ning trains o' craws to their repose: [*crows*
> The toil-worn Cotter frae his labor goes,—
> This night his weekly moil is at an end,
> Collects his spades, his mattocks, and his hoes,
> Hoping the morn in ease and rest to spend,
> And weary, o'er the moor, his course does hameward bend.

Thereafter, the poet describes the Cotter's children running out 'to meet their dad'; the arrival of the elder bairns, who have been helping in the field, and the appearance of Jenny, 'woman grown', who deposits 'her sair-won penny-fee, To help her parents dear'. Then comes the disintegration. Enjoying these social hours, the children exchange news, while:

> The parents partial eye their hopeful years;
> Anticipation forward points the view;
> The mother, wi' her needle and her shears,
> Gars auld claes look amaist as weel's the new; [*makes clothes*
> The father mixes a' wi' admonition due.

There is almost no need to comment on the curious mixture of English and Scots, or the stilted nature of the first two lines although Mr Crawford puts forward the novel view that they have 'an intentionally humorous undertone'. In comes a 'neibor lad' to woo Jenny, whose mother becomes hysterically concerned lest he be some 'wild, worthless rake'. This leads the poet to his climax of

[1] I once heard a somewhat alcoholic chairman close a Burns Supper with what was ostensibly a quotation from 'The Cotter's Saturday Night'—'The Pleughman hameward plods his weary way, And leas the warld tae derkness an' tae me.' No one apparently saw anything strange about this 'quotation'!

artificial absurdity. He strikes an operatic pose, and dons eighteenth-century grease-paint rhetoric.

> Is there, in human form, that bears a heart,
>> A wretch! a villain! lost to love and truth!
> That can, with studied, sly, ensnaring art,
>> Betray sweet Jenny's unsuspecting youth?
> Curse on his perjur'd arts! dissembling, smooth!
> Are honour, virtue, conscience, all exil'd?
>> Is there no pity, no relenting ruth,
> Points to the parents fondling o'er their child?
> Then paints the ruin'd maid, and their distraction wild.

As verse, that is probably one of the silliest stanzas ever written by a great poet. What makes the sensitive reader uncomfortable, however, is not so much the manner of its expression, as the reflection that at the time he was writing, the poet had himself employed 'his perjur'd arts! dissembling, smooth!' to seduce at least two young women, and had proved himself singularly unsympathetic towards the 'distractions wild' of the parents of one of them!

The poem improves again as it moves into a description of the supper the Cotter and his family enjoy. Descriptions of Scots fare were a speciality of late seventeenth- and early eighteenth-century Scots poets, and even quite minor songsters achieved success in them.

After the meal comes family prayers.

> The cheerfu' supper done, wi' serious face,
>> They, round the ingle, form a circle wide;
> The sire turns o'er wi' patriarchal grace,
>> The big ha'-bible, ance his father's pride: [*large Bible*
>> His bonnet rev'rently is laid aside, *that lay in the hall*
> His lyart haffets wearing thin and bare; [*gray side-locks*
>> Those strains that once did sweet in Zion glide,
> He wales a portion with judicious care; [*selects*
> And 'Let us worship God!' he says with solemn air.

The poem then moves back to English to describe their praises, this time with justification, English being the language associated

with the worship of God since John Knox first replaced the Latin Bible with an English translation, being too impatient to wait for the Scots version which was being prepared. (Incidentally, he thus dealt the death blow to Scots as an integrated tongue, since he blocked the main arteries of its heart.) Finally, Burns ends with two rather forced benedictory stanzas similar in strain to Fergusson's, but in English and rather less effective.

Gilbert has related how once Robert commented upon the solemn impression the words 'Let us worship God' made on him. It is the sympathy and accuracy of Burns's treatment of country worship which, in spite of the poem's grave flaws, secured its popularity. Throughout the nineteenth century what W. E. Henley called the 'Common Burnsite' (a fervent apostle of the poet, but having no interest in literature), if asked what he considered to be Burns's greatest poem, would almost certainly answer: 'The Cotter's Saturday Night.' Yet Burns also moved the sophisticated Henry Mackenzie with this poem. Mackenzie, indeed, saw in it a description of

> one of the happiest and most affecting scenes to be found in a country life . . . a domestic picture of rustic simplicity, natural tenderness, and innocent passion that must please the reader whose feelings are not perverted.

In the light of which, and in spite of its unsatisfactory blemishes, who could have the temerity to maintain that 'The Cotter's Saturday Night' had not achieved a very remarkable success?

Next in the Kilmarnock volume comes 'To a Mouse', which bears the sub-title, 'On Turning her up in her Nest, with the Plough, November 1785'. It is one of Burns's most frequently translated and most admired poems, perhaps because it gives memorable expression to the sense of foreboding which we all feel at some time or another when we suddenly discover ourselves to be face to face with an inscrutable future. It is not really an animal poem in the sense that 'The Auld Farmer's New-Year Morning Salutation' is an animal poem. In 'To a Mouse', the poet, with tender compassion, pities the tiny creature to whom he has unwittingly brought terror; remarks upon the close relationship between the world of animals and the world of men; and without the slightest touch of self-pity, clinches

the personal compassion in the last two stanzas, and points the lesson of the poem.

> But Mousie, thou art no thy lane,
> In proving foresight may be vain:
> The best laid schemes o' Mice an' Men,
> Gang aft agley. [*go often wrong*
> An' lea'e us nought but grief and pain, [*leave*
> For promis'd joy.
>
> Still thou art blest, compar'd wi' me!
> The present only toucheth thee:
> But Och! I backward cast my e'e,
> On prospects drear!
> An' forward, tho' I canna see,
> I guess an' fear!

This poem is rooted firmly in the Scots tradition, both linguistically, and in the intimate, realistic attitude to Nature which it reveals. True, there is a momentary reversion to neo-classical English in the second stanza, where the poet is . . .

> . . . truly sorry Man's dominion
> Has broken Nature's social union . . .

But it has an obvious element of truth in its sentiment, and is so closely integrated into the Scots texture and so fleeting that it is hardly a blemish.

'Epistle to Davie, a Brother Poet', the earliest poem in the book, was probably written in January 1785, Davie being David Sillar, a poetaster rather than a poet, as his published works show. However, great poets often manifest a tendency to elevate the status of contemporary minor poets, even mere versifiers, either out of their heart's kindness, or to consolidate themselves. It is, for instance, impossible to believe that all the unknown poets listed by William Dunbar in his 'Lament for the Makars' could have been as gifted as he suggests, while in our own day, C. M. Grieve ('Hugh MacDiarmid') has done his best to promote many a minor talent.

In this particular 'Epistle', Burns chose one of the hardest stanzas

he ever tried to handle. It is the old Scots 'bob-wheel' stanza hitherto used most memorably by the sixteenth-century poet, Alexander Montgomerie in his allegory 'The Cherry and the Slae'. Apart from the fact that it probably suggested the stanza-form to Burns,[1] the 'Epistle' has nothing in common with the older poem.

True to its tradition, the 'Epistle to Davie' is about the respective situations of the writer and the recipient, though mainly about that of the writer. Once again, Burns opens with a picture of a particular scene, another Winter interior, passing swiftly to the real business of the poem.

> While winds frae off Ben-Lomond blaw,
> An' bar the doors wi' drivin' snaw,
> An' hing us owre the ingle,
> I set me down to pass the time,
> An' spin a verse or twa o' rhyme,
> In hamely, westlin jingle.
> Whilst frosty winds blaw in the drift,
> Ben to the chimla lug,
> I grudge a wee the great-folk's gift.
> That live sae bien a' snug:
> I tent less, and want less
> Their roomy fire-side;
> But hanker, and canker,
> To see their cursed pride.

He then goes on to develop the theme of these last six lines, stating pithily the whole case against the elegant unbalanced social structure of the eighteenth century, and laying bare the seed it contained of its own destruction.

> It's hardly in a body's pow'r,
> To keep, at times, frae being sour,
> To see how things are shar'd;

[1] Probably either through Watson's *Choice Collection of Comic and Serious Scots Poems*, which appeared between 1706 and 1711, and was the opening flourish of the whole eighteenth-century Revival; or through Allan Ramsay's touched-up anthology of the Makars, *The Ever Green: A Collection of Scots Poems Wrote by the Ingenious before 1600*, which came out in 1724.

How best o' chiels are whyles in want,
While coofs on countless thousands rant [*behave recklessly*
And ken na how to ware't . . . [*spend*

What so strongly differentiates Burns from all other poetical re-
formers is that he rarely allows his natural bitterness against
injustice to sour the warmth of his heart. Instead of pressing home
his trenchant criticism, as he might easily have done, he reflects upon
the blessings which he and Sillar can count:

> . . . But Davie, lad, n'er fash your head,
> Tho' we hae little gear
> We're fit to win our daily bread;
> As lang's we're hale and fier:
> 'Mair spier na, nor fear na',[1]
> Auld age ne'er mind a feg;
> The last o't, the warst o't,
> Is only but to beg.

The fear of poverty, always at the back of Burns's mind, could at
worst be resolved by beggary. De Lancey Ferguson reminds us that
'the tradition of the blue-gowns, or licensed beggars still persisted
in rural Scotland', though, of course, the Edie Ochiltree type of
'privileged mendicant' had ceased to exist before Burns's day.
In rich and consistent Scots, however, he proceeds to elaborate his
own romantic view of the ease of mind with which he associated the
beggar's profession. This leads him to set forth his basic philosophy
of life through a further four stanzas—a philosophy which, while
detesting the hypocrisy of false pride often associated with the
possession of great riches, accepts the lot of cheerful poverty, since
happiness has its true seat in the individual heart.

> Nae treasures nor pleasures
> Could make us happy lang;
> The heart ay's the part ay
> That makes us right or wrang.

With the eighth stanza, which extols the virtues of Meg and Jean,

[1] A quotation from Ramsay.

the two men's respective lasses, the poem ought properly to have ended. Instead, Burns suddenly switches into English in order to attach a pompous and stilted prayer to the Almighty asking Him, rather unreasonably, to make Jean His 'most peculiar care', since love is the chief brightener of 'the tenebrific scene'. Fortunately, the thought of Jean's love brings Burns back again into Scots, and sets his 'Pegasus' running 'an unco fit'. Burns then manoeuvres the poem to a quick if somewhat overdue conclusion.

> But least then the beast then,
> Should rue this hasty ride,
> I'll light now, and dight now
> His sweaty, wizen'd hide.

Until the point when the poem wanders into Anglified abstractions, it is brilliantly successful, showing Burns to be a more spontaneous master of this exacting verse-form than even Montgomerie himself. It is not technical difficulty which causes the poem thereafter to deteriorate, but, once again, the inherent dichotomy which racked the poet's muse.

The five sombre English poems produced during bouts of illhealth and depression follow next. In order, they are: 'The Lament, occasioned by the unfortunate issue of a friend's amour' (a piece of conventional grieving in the most artificial of eighteenth-century poetic styles): 'Despondency, an Ode': 'Man was made to Mourn, a Dirge' (which reflects the more or less unremitting toil which was, and in many countries still is, the peasant's lot, the essential defeatism of the poor, and contains the proverb-like phrase 'Man's inhumanity to Man, Makes countless thousands mourn!' foreshadowing Wordsworth's 'Alas, the gratitude of men, Hath oftener left me mourning'): 'Winter, a Dirge': and 'A Prayer in the Prospect of Death'.

No space need be wasted on these pieces written in a foreign mode of which Burns was not really a master. Nor need much time be spent on 'To a Mountain Daisy, On turning one down, with the Plough, in April 1786', which was an attempt to repeat the success of 'To a Mouse'. In spite of the few Scots words with which the earlier stanzas are sprinkled, it is couched entirely in English. What

is one to make of Farmer Burns who, having uprooted one amongst
the thousands of weeds he must have destroyed in his day because
they threatened good husbandry, bursts forth in this strain?—

> Wee, modest, crimson-tippèd flow'r, [*small*
> Thou's met me in an evil hour;
> For I maun crush amang the stoure [*dust*
> Thy slender stem:
> To spare thee now is past my pow'r
> Thou bonie gem.

To use successfully the literary device known as the *pathetic
fallacy*, which for poetic purposes assumes a flower to have human
qualities, is difficult indeed. Burns certainly could not use it properly.
He either wrote from the heart, or else he wrote badly: and his heart
did not dictate to him such conventional banalities as the 'purpling
East' for the dawn, or 'thy scanty mantle clad' for a daisy's petals,
nor 'prudent Lore' for common sense.

As in 'The Cotter's Saturday Night', the poem becomes totally
ridiculous when Burns strikes a virtuous pose and likens the
crushed daisy to:

> . . . the fate of artless Maid,
> Sweet flow'ret of the rural shade!
> By Love's simplicity betray'd,
> And guileless trust,
> Till she, like thee, all soil'd, is laid
> Low i' the dust.

The maid and daisy image is clearly a false one, comparing
a greater object to a lesser and the sentiment is too obviously
worked-up for purely literary purposes. Once again, however, the
poem hit its target. 'Man of Feeling' Mackenzie praised it for 'the
precision of intimacy' with which the Poet handled nature, and for
his 'delicate colouring of beauty and taste', qualities to a modern
reader conspicuous by their absence. Mackenzie quoted it in full
when he reviewed the Kilmarnock Poems in the December 1786
issue of *The Lounger*.

Passing over another of the melancholy English poems, 'To Ruin'

we come to one of the best of all Burns's verse letters, 'Epistle to a
Young Friend', dated May 1786. The young friend was Andrew
Aiken, son of 'Orator Bob' Aiken in Ayr. The advice the young
man received was set forth in a conventional enough stanza-form.
Yet the lines are alert with easy vitality, and the poet's thoughts
flow into their mould, crystallizing into a greater number of examples
of Burns's quotable proverbial wisdom than is to be found in any
other of his poems. This 'Epistle' is also the clearest and simplest
statement which Burns left us of his own creed.

> I'll no say men are villains a';
> The real, harden'd wicked,
> Wha hae nae check but human law,
> Are to a few restricked: [*restricted*
> But Och! mankind are unco weak,
> An' little to be trusted;
> If *Self* the wavering balance shake,
> It's rarely right adjusted!

Wickedness of the worst sort is rare among men: but self-interest
is the ruling weakness and vice—now, as in Burns's day! The
fatherly advice which follows has been compared with the advice
which Polonius gives to Laertes in Shakespeare's *Hamlet*, and by
no means entirely to Burns's disadvantage.

> Ay free, aff han', your story tell,
> When wi' a bosom crony;
> But still keep something to yoursel
> Ye scarcely tell to ony
> Conceal yoursel as weel's ye can
> Frae critical dissection;
> But keek thro' every other man,
> Wi' sharpen'd, sly inspection.
> The sacred lowe o' weel plac'd love,
> Luxuriantly indulge it;
> But never tempt th' illicit rove,
> Tho' naething should divulge it:
> I wave the quantum of the sin;

> The hazard of concealing;
> But och! it hardens a' within,
> And petrifies the feeling!

Burns had cause for knowing this, for he was writing it in the middle of his own crisis with Jean Armour and Mary Campbell.

One of Burns's changing attitudes to religion is made clear in stanzas IX and X—the eighteenth-century deist's view of a benevolent and reasonable God.

> The great Creator to revere,
> Must sure become the Creature;
> But still the preaching cant forbear,
> And ev'n the rigid feature:
> Yet ne'er with Wits profane to range,
> Be complaisance extended;
> An Atheist-laugh's a poor exchange
> For Deity offended!

Such a setting forth of sound bourgeois advice, however, is apt to provoke a hostile reaction, especially when the adviser is famed for not acting up to what he preaches. Burns, anticipating this difficulty, gets over it by twisting the poem to an uncommonly deft finish.

> ... In ploughman phrase, 'God send you speed'
> Still daily to grow wiser;
> And may ye better reck the rede, [*heed the advice*
> Than ever did th' Adviser!

Andrew Aiken prospered, becoming a merchant at Liverpool, and finally British Consul at Riga.

'On a Scotch Bard Gone to the West Indies', is sometimes produced as evidence in support of their case by those who maintain that Burns never really intended to go to Jamaica. It is in the form of a mock-elegy for a fictitious departed poet, and belongs to the convention which earlier produced such mock-elegies as Ramsay's 'On John Cowper, the Kirk-Treasurer's Man' (who was not, of course, dead at all at the time of writing). Burns, however, is not celebrating his own death, but his flight to Jamaica. I cannot see that the brisk,

half-bantering, slightly satirical tone he adopts against himself neces-
sarily suggests lack of sincerity of purpose. He was rarely one to
whine in self-pity.

> He saw Misfortune's cauld *Nor-west*
> Lang mustering up a bitter blast;
> A Jillet brak his heart at last, [*jilt*
> Ill may she be!
> So, took a berth afore the mast,
> An' owre the Sea.

It seems possible that Burns originally intended his volume to end
with 'On a Scotch Bard' and 'A Dedication to Gavin Hamilton,
Esq', which follows it, the remaining pieces being added as an after-
thought, perhaps to fill out the sheets. Otherwise, the placing of the
'Dedication' as the twenty-sixth poem in the book is hard to
understand.

In any case, the 'Dedication' really deserves to be linked with the
Kirk satires. It begins with a warning that the poet is not going to
flatter his patron. As that patron was associated in Burns's mind with
the ecclesiastical 'tulyie' (struggle) which culminated in Hamilton's
triumph over the Kirk Session, and produced 'Holy Willie's Prayer',
it was not unnatural that the poet should at least refer to these events.
In point of fact, however, he jogs himself into fine satirical strain, as
in 'Holy Willie's Prayer' pretending to uphold the viewpoint of the
victim he is in reality lashing. Thus, though Gavin Hamilton is a
good 'Master, Landlord, Husband, Father'. . . .

> That he's the poor man's friend in need,
> The Gentleman in word and deed,
> It's no through terror of D——tion;
> It's just a carnal inclination,
> And Och! that's nae regeneration![1]

Burns goes on to explain how his patron could become a man of
sound doctrine:

[1] The last line was left out of editions after the first. It is sometimes given in
popular editions, sometimes not; another indication of the desirability of a
collected 'final' text of the poems.

> Learn three-mile pray'rs, an' half-mile graces,
> Wi' weel-spread looves, an' lang, wry faces; [*palms*
> Grunt up a solemn, lengthen'd groan,
> And d—— a' parties but your own;
> I'll warrant then, ye're nae Deceiver,
> A steady, sturdy, staunch Believer.

After wishing Hamilton a fruitful progeny, Burns finishes with another of those awkward compliments of his which he made so clumsily to his social superiors. Should Hamilton ever become as poor as the poet, then a new relationship between them might be possible.

> ... If friendless, low, we meet together,
> Then, sir, your hand—my friend and brother.

No doubt the comfortably-off Hamilton was generous enough to overlook the implications of this doubtful compliment!

'To a Louse' is a companion piece to 'To a Mouse' and 'To a Mountain Daisy', but its affinities are with the hamely realism of the former rather than with the inflated posturing of the latter.

'To a Louse, On Seeing one on a Lady's Bonnet at Church', to give the piece its full title, provided Burns with a theme after his own heart, letting him contrast the loathsome associations of the creature with the fine lady's social pretensions. He makes rich fun of the louse's progress up to the top of the lady's bonnet, with a suggestion of sexual symbolism in the fourth stanza.

> Now haud you there, ye'er out o' sight,
> Below the fatt'rils, snug an' tight; [*ribbon-ends*
> Na faith ye yet! ye'll no be right [*confound you*
> Till ye've got on it,
> The vera tapmost, tow'ring height
> O' Miss's bonnet.

As a final thrust against her airs and graces, Burns suddenly addresses her by her colloquial Christian name, as if, after all, she was just a simple country lass. This poetic levelling prepares the way for the greatest of all Burns's proverb-like declarations.

O Jenny, dinna toss your head,
An' set your beauties a' abread! [*abroad*
Ye little ken what cursèd speed
 The blastie's makin!
Thae winks and finger-ends, I dread, [*These*
 Are notice takin!

O wad some Pow'r the giftie gie us
To see oursels as others see us!
It wad frae monie a blunder free us
 An' foolish notion:
What airs in dress an' gait wad lea'e us,
 And ev'n Devotion!

The final group of poems in the book, save for the songs and the epitaphs, is made up of a number of verse-epistles, many of them showing Burns in his best Scots vein. Two are addressed to John Lapraik, an elderly farmer-bard who lived about fourteen miles away from Mossgiel, and who later also had his poems put out by Wilson of Kilmarnock. Lapraik was neither a very good poet nor a particularly bad one: he also alternated between Scots and polite English, as the last stanza of his best-known piece, 'When I Upon Thy Bosom Lean', shows:

I'll lay me there and tak' my rest;
And if that aught disturb my dear,
I'll bid her laugh her cares away,
 And beg her not to drap a tear.
Ha'e I a joy? it's a' her ain.
 United still her heart and mine;
They're like the woodbine round the tree,
 That's twined till death shall them disjoin.

Burns, feeling that Lapraik, like Sillar and the rest, was a necessary part of his literary environment, chose to regard him as a good poet.

The first epistle, dated 1st April 1785, follows the general pattern of the eighteenth-century verse-epistle form, as developed by Burns. His *point de départ*, is, as usual, an actual scene, this time a brief

description of some of the characteristic outdoor happenings of early
Spring:

> While briers an' woodbines budding green,
> An' paitricks scraichin loud at e'en, [*patridges screeching*
> An' morning poussie whiddin seen, [*hare moving*
> Inspire my muse, *quickly*
> This freedom, in an unknown frien',
> I pray excuse.

Then follows the customary personal compliments, leading to the
main business of the poem, which is to set forth his own poetic
creed.

> I am nae poet, in a sense,
> But just a rhymer like by chance;
> An' hae to learning nae pretence;
> Yet, what the matter?
> Whene'er my muse does on me glance,
> I jingle at her.

Critics, he declares, may sneer at a rustic poet like himself. But
what of the critics themselves, and the 'jargon' of their 'Schools'?

> A set o' dull, conceited hashes,
> Confuse their brains in college-classes!
> They gang in stirks, and come out asses,
> Plain truth to speak;
> An' syne they think to climb Parnassus
> By dint o' Greek.

Burns then sets forth the core of his own poetic creed; the basic
essential, indeed, of any true poet's equipment.

> Gie me ae spark o' nature's fire,
> That's a' the learning I desire;
> Then tho' I drudge thro dub an' mire
> At pleugh or cart,
> My muse, tho' hamely in attire,
> May touch the heart.

The poem winds up with suitable sentiments on the pleasures of

conviviality, and comes to another of Burns's cleverly manipulated
conclusions.

> But, to conclude my lang epistle,
> As my auld pen's worn to the gristle;
> Twa lines frae you wad gar me fissle, [*tingle*
> Who am most fervent,
> While I can either sing or whistle,
> Your friend and Servant.

Lapraik duly replied to this racy epistle in kind; so, three weeks
later, on 21st April 1785, Burns sat down to write again. This time,
the opening spring picture is one of activity, the season being later,
and the personal burden of the poem is autobiographical. In his
twenty-sixth summer, though the poet is not rich, and has had more
than the usual run of bad luck, his warm, unenvious native common-
sense still enables him to enjoy contentment.

> Do ye envy the city gent,
> Behind a kist to lie an' sklent, [*chest deceive*
> Or purse-proud, big wi' cent. per cent.
> An' muckle wame.
> In some bit brugh to represent [*burgh*
> A bailie's name?

> Or is't the paughty, feudal thane,
> Wi' ruffl'd sark an' glancing cane,
> Wha thinks himsel nae sheep-shank bane, [*no unimport-*
> But lordly stalks; *ant person*
> While caps and bonnets aff are taen,
> As by he walks?

The poet's ambitions, however, are much more democratic, and
he makes them memorable:

> Were this the charter of our state,
> 'On pain o' hell be rich an' great',
> Damnation then would be our fate,
> Beyond remead;
> But, thanks to heaven, that's no the gate [*way*
> We learn our creed.

> For thus the royal mandate ran,
> When first the human race began,
> 'The social, friendly, honest man,
> Whate'er he be—
> 'Tis *he* fulfils great Nature's plan,
> And none but he'.

William Simson, schoolmaster in his native Ochiltree, also wrote to Burns in the spring of 1785, and the verse-epistle which Burns dispatched in answer to Simson's communication is dated the month of May. Simson's letter—now lost to us—presumably praised Burns's talents as a poet; and Burns, in his reply, comes straight to the point. Naturally, he is pleased at the compliments he has received, but he will not allow himself to be flattered.

> My senses wad be in a creel, [*my head would be*
> Should I but dare a hope to speel *turned*
> Wi' Allan, or wi' Gilbertfield [*climb*
> The braes o' fame;
> Or Fergusson, the writer-chiel,
> A deathless name.

Mr Crawford feels this stanza suggests that Burns was 'dreaming of publication nearly a year before he circulated his proposals for the Kilmarnock Edition'. I do not agree.[1] In any case, by placing himself below Allan Ramsay, William Hamilton of Gilbertfield and Robert Fergusson on the Parnassian slopes, Burns is, of course, hopelessly underassessing his own gifts, though one suspects that he was perfectly well aware of this. He was always conscious of the debt he owed his Scots literary predecessors. He was also acutely aware of the very real merit of Fergusson's work—more aware, indeed, than the people of Scotland have been since.

> O Fergusson! thy glorious parts
> Ill suited law's dry, musty arts!
> My curse upon your whunstane hearts,
> Ye Enbrugh Gentry!
> The tythe o' what ye waste at cartes [*cards*
> Wad stow'd his pantry! [*have filled*

[1] Burns's letter to Richard Brown of 30th December, 1787, contradicts the idea

Had Fergusson lived—Burns was a boy of fifteen when the older poet died in his twenty-fourth year—the two might well have 'run together in magnificent double harness', for in many respects their gifts were complementary. Fergusson, for all his love of the country, was essentially a town poet, a recorder of urban sights and manners.[1] Burns, on the other hand, had no intimate experience of town life. But Fergusson had scarcely time to do more than merely establish his talent before 'the sweet bells jangled out of tune' and he died insane. His work, like that of Ramsay and many other Scottish poets, has only a national significance. It means little or nothing to the English or the American reader. In this respect Fergusson does not differ from the national poets of most other small countries. Unfortunately, however, the loudly-proclaimed superiority of Anglo-American literature—a literature written in 'standard' English—as taught in Scottish schools, is accepted unquestioningly by most Scots. Fergusson has no real place in this literature: therefore Fergusson's work is more or less unknown, even to the majority of Scots folk.

In an intellectually healthy Scotland, Fergusson would have been honoured in the manner, if not perhaps quite to the degree, that Burns honoured him. Room would certainly have been found in the Capital city—which houses memorials to many a forgotten nonentity—for a statue of her native bard. But in a Scotland solemnly bent on eradicating her national characteristics, that she may merge her self-conscious impotence as soon as possible in the way of life of her English conquerors, no Scots poet at all except Burns is honoured,[2] let alone read. And even Burns is read and honoured mostly for the wrong reasons!

[1] In his stimulating essay 'A Study of the Poetry of Robert Fergusson' contained in the introductory volume to his Scottish Text Society edition of *The Poems of Robert Fergusson*, Matthew P. MacDiarmid very properly draws attention to the accuracy of Fergusson's nature observation. The fact remains, however, that excellent in their directness as are such country-poems as the 'Ode to the Gowkspink' and 'The Farmer's Ingle', it is the town poems which form the more personal and significant part of Fergusson's contribution to Scots literature.

[2] Though MacDiarmid, for so long neglected, now holds an honorary doctorate from a Scottish university. *A Drunk Man Looks at the Thistle* has become an accepted Scottish classic, and he himself is now the centrepiece of what amounts almost to an academic cult.

Burns's driving ambition, when he kittled up his rustic muse to give himself ease, was to sing of Scotland, and in particular of his own airt—

> Ramsay an' famous Fergusson
> Gied Forth an' Tay a lift aboon;
> Yarrow an' Tweed, to monie a tune,
> Owre Scotland rings,
> While Irwin, Lugar, Ayr an' Doon,
> Naebody sings.

This state of affairs Willie Simson and himself are to put to rights. The picture of his native land thus conjured up is elaborated in the following stanzas into a salute in honour of those who fought with 'glorious Wallace'. This leads the poet to pay tribute to the charms of 'Coila's haughs an' woods', and then to Nature herself.

Burns's appreciation of Nature was of the simplest, most practical sort. He was rarely moved deeply by sights of natural grandeur, and never stirred into verse by scenes 'Whose strange effects may well be felt, but cannot be exprest', as Sir William Alexander of Menstrie put it; or, as Dr Daiches points out, never apparently troubled by a later poet, Byron's, awareness of what it is

> To mingle with the Universe and feel
> What I can ne'er express, yet cannot all conceal.

Storms, to be sure, did awe Burns, as they have awed and inspired most Scots poets; but storms affect a man going about his farm, or riding his horse, in an immediately practical way. No other form of scenic romance or sublimity seems to have made any impact on his muse. Burns's view of Nature was, in fact, essentially that of the practical man: he looked downwards, at a mouse, at a daisy, at wimpling burns and prattling rivers, and at his faithful farm beasts. But he had no eyes for Nature's heroic beauty, therefore no poetic interest in the rugged outlines of Arran's mountain peaks[1]

[1] Almost the first fact I registered about Burns as a very young child. We holidayed for some years on the Ayrshire coast, and my father frequently commented on the oddity of there being not a single reference to Arran in any of Burns's poems or letters. While perhaps it was Scott who quickened English response to the heroic attitude to scenery, Thomson, whom Burns admired and sometimes emulated, had already continued the never-dormant Scottish tradition of response to Nature's grandeur in *The Seasons*.

lying across the Firth of Clyde, almost within sight of his birthplace. Thus, it is not to the expansive glories of sea or sky that his own muse turns for inspiration; but to a much more gentle manifestation of Nature.

> The Muse, nae Poet ever fand her,
> Till by himsel he learn'd to wander,
> Adown some trotting burn's meander.
> An' no think lang; [*not find time tedious*
> O sweet, to stray an' pensive ponder
> A heart-felt sang!

If he can but be allowed to go on enjoying this aspect of Nature's face, the busy world can 'drudge an' drive' after its treasure so far as he is concerned! Thus he states his case to Simson; then, with another clever flourish, he signs himself off.

> While Highlandmen hate toils an' taxes;
> While moorlan herds like guid, fat braxies;
> While Terra Firma, on her axis,
> Diurnal turns,
> Count on a friend, in faith an' practice,
> In Robert Burns.

Though there is less of his proverb-like wisdom in this letter than in the two to Lapraik, it is a masterpiece of pointed and unstrained colloquial writing, abounding in autobiographical revelations. The postscript—really a separate poem—gives a witty account of yet another local Auld versus New-licht quarrel, the relating of which the poet suddenly remembers was to have been the main purpose of his letter.

The Kilmarnock volume ends with the Epistle to John Rankine, already discussed; the songs 'It was upon a Lammas night'; 'Now westlin winds', 'For thee, Eliza, I must go'; 'The Farewell to the Brethren of St James's Lodge, Tarbolton' (a stilted neo-classical piece); the Epitaphs and Epigrams; and 'A Bard's Epitaph', the burden of the advice in which is similar to that given to young Andrew Aiken, though on this occasion expressed in rather colourless, pompous English.

III

Placed individually under the lense of criticism, it is easy to detect minor flaws and blemishes in some of the poems in the Kilmarnock volume. It is equally easy to see clearly the astonishing technical accomplishment of the best poems, though much less easy to analyse and describe that accomplishment in exact critical terms. In the end, however, the poems in the Kilmarnock volume cannot only be regarded as individual pieces—superb though many of them are in their own right—but as a *corpus*; the great centre-piece of Burns's whole remarkable output. For they also make a collective impact, and have a collective significance. It is largely for this reason that not all the relentless prying of 'the destructive element' over more than a century and a half has achieved much against any but the poorest of Burns's pieces—and those mostly minor English poems which cannot benefit from the protection of the immortal armour with which the warmth and sincerity of the poet's personality has girded the Scots poems.

Taken all in all, the Kilmarnock poems preserve, with extraordinary vigour and clarity of detail, the life and manners of rural Scotland just before the ever-pressing influences of Industrialism and Englishry disrupted the ancient traditional pattern. Lord Cockburn considered the eighteenth century to be the last truly *Scottish* century. Burns caught and fixed that Scottishness before its cracking fragments disintegrated. Because he was a peasant in a primarily agrarian community, and because he was not a literary innovator but a poet peculiarly aware of the individual mood of every major Scots poet during the preceding four centuries, the picture Burns fixed carried the overtones of Lowland Scotland from the time of her emergence from a half-legendary Celtic mist, until her disappearance into the gathering acquisitive gloom of the imperial British fog.

I do not mean to suggest for a moment that Burns's achievement justifies the comparative neglect to which his compatriots have treated almost every other Scottish poet; only to try to make it clear why Burns's work has hitherto exerted such an enormous influence over the Scots; an influence which for long prevented them from seeing and judging the poems as literature rather than as an

essential part of Scotland, and which has produced the phenomenon of the semi-literate, letterless fanatic dubbed by W. E. Henley the 'Common Burnsite' (now, happily, more literate, although perhaps less common).

The world at large, of course, cannot be expected to apply other than the customary canons of criticism to Burns's Kilmarnock Poems. By any standards, the volume was a remarkable one: even more remarkable, in many ways, than the *Lyrical Ballads*, which was not, after all, the work of a single poet.

Scotland never had an Augustan age, and never really lost touch with nature. From the days of Gavin Douglas, Scots verse had been distinguished for accuracy of observation. When the old Scots poets went indoors, it was usually to rest from the labours of the field. Out-of-doors, their observation was that of the farmer, rather than of the romantic.

To many eighteenth-century English and Anglo-Scottish readers, *Poems Chiefly in the Scottish Dialect* was interesting because of its warmth and humanity. They were attracted by qualities temporarily overlaid in contemporary English poetry, but soon to reappear in the romantic movement. But they fell into the trap which Burns had so artfully set for them in his Preface when he suggested that he was an unread rustic; for they delighted in the romantic situation which the unpredictable combination of rusticity and genius suggested to them. They welcomed the English-style sensibility of his poorer poems; and they enjoyed, with reservations about his undisguised dash of libertinism, his country humour.

The October 1786 edition of the *Edinburgh Magazine*, edited by James Sibbald, though it considered Burns had not 'the doric simplicity of Ramsay, or the brilliant imagination of Fergusson', commented to:

> those who admire the creations of untutored fancy, and are blind to many faults for the sake of numberless beauties, his poems will yield singular gratification. His observations on human characters are acute and sagacious, and his descriptions are lively and just. Of rustic pleasantry he has a rich fund, and some of his softer scenes are touched with inimitable delicacy....

The character Horace gives to Ofellus is particularly applicable to him: Rusticus abnormis sapiens, crassaque Minerva. (Countryman, one of Nature's philosophers, and rough mother-wit.)

A few weeks later, the December issue of Henry Mackenzie's periodical *The Lounger* appeared, carrying a review from the pen of the Man-of-Feeling himself. Like the anonymous review in Sibbald's[1] paper, Mackenzie's was in the main highly flattering and encouraging, though it also showed the influence of contemporary Anglo-Scottish polite taste:

> I know not if I shall be accused of . . . enthusiasm and partiality when I introduce to the notice of my readers a poet of our own country, with whose writings I have lately become acquainted; but, if I am not greatly deceived, I think I may safely pronounce him a genius of no ordinary rank. The person to whom I allude is Robert Burns, an Ayrshire ploughman. . . .
>
> In mentioning the circumstances of his humble station, I mean not to rest his pretensions solely on that title or to urge the merits of his poetry when considered in relation to the lowness of his birth, and the little opportunity which his education could afford. These particulars, indeed, might excite our wonder at his productions; but his poetry, considered abstractedly, and without the apologies arising from his situation, seems to me fully entitled to command our feelings and to obtain our applause.
>
> One bar, indeed, his birth and education have opposed to his fame—the language in which most of his poems are written. Even in Scotland the provincial dialect which Ramsay and he have used is now read with a difficulty which greatly damps the pleasure of the reader; in England it cannot be read at all, without such a constant reference to a glossary as nearly to destroy the pleasure. . . .
>
> Though I am far from meaning to compare our rustic bard to Shakespeare, yet whoever will read his lighter and more humorous poems . . . will perceive with what uncommon penetration and sagacity this Heaven-taught ploughman, from his humble and unlettered station, has looked upon men and manners.

[1] Probably by Dr Robert Anderson (1750–1830).

Sibbald, with his 'Rusticus, abnormis sapiens', and Mackenzie with his 'Heaven-taught ploughman', between them confirmed in Burns's mind what was in danger of becoming with him a stylized pose; a pose Burns himself had presumably intended to be no more than a harmless minor falsification of fact to benefit the immediate reception of his book. Yet not only did it come to affect his own attitude to his art, but after his death it developed into a major legend encrusting the truth to such an extent that even now, attempts to crack it off are liable to produce cries of indignant protest from at least the Common Burnsites. Between them, these two reviewers were thus also largely responsible for the dreadful crop of postmen poets, plumber-boy poets, baker poets and so on, whose puerile hiccuping imitations filled out the sixteen volumes of Edward's *Modern Scots Poets*, published between 1880 and 1897, wherein the local bardsters were even classified by occupation!

On the whole, the Kilmarnock volume circulated mainly around Ayrshire, though the Scottish reviews certainly carried word of the new poet's fame to literary folk all over Scotland. There were even a few London reviews. In December 1786, *The Monthly Review*'s notice of the poems likened the collection to 'a heap of wheat carelessly winnowed', and suggested that the modern ear would be 'disgusted with the measure of many of these pieces, which is faithfully copied from that which was most in fashion among the ancient Scottish bards, but hath been we think with good reason, laid aside by the later poets'. It also echoed Mackenzie by regretting that 'these poems are written in some measure in an unknown tongue'. And in February 1787, *The English Review* published a notice, favourable in its general trend, but suggesting that the fact of his fame had been 'procured by novelty' rather than merit, and that the poet had 'too great a faculty of composition' and was 'too easily satisfied with his own productions'. The profferer of this advice may have been Dr John Moore, the author of the novel *Zelucco*, and the recipient of Burns's famous autobiographical letter.

Making due allowance for the fact that poetry reviewers, then as now, are often failed poets who find it hard to praise without reawakening their own sense of frustration, Burns had little reason to be dissatisfied with the reception given to his book in cultured

circles. He had even less reason to be dissatisfied with the delight it created on a more humble social level. His first biographer, the erratic, cankered journalist, Robert Heron, recorded:

> It is hardly possible to express with what eager admiration and delight the poems were everywhere received. They eminently possess all those qualities which can contribute to render any literary work quickly and permanently popular. They were written in phraseology, of which all the powers were universally felt; and which being at once antique, familiar and now rarely written, was hence fitted to serve all the dignified and picturesque uses of poetry, without making it unintelligible. The imagery, the sentiments, were at once faithful, natural and irresistibly impressive and interesting. These topics of satire and scandal in which the rustic delights; that humorous delineation of character, and that witty association of ideas, familiar and striking, yet naturally allied to one another, which has force to shake his sides with laughter; those fancies of superstition, at which he still wonders and trembles, those affecting sentiments and images of true religion which are at once dear and awful to his heart, were represented by Burns with all a poet's magic power. Old and young, high and low, grave and gay, learned or ignorant, all were delighted, agitated, transported. I was at that time resident in Galloway, contiguous to Ayrshire, and I can well remember, how that even plough-boys and maid-servants would have gladly parted with the wages they earned the most hardly, and which they wanted to purchase necessary clothing, if they might but procure the works of Burns. . . .

Probably no other poet's works could have induced eighteenth-century plough-boys and maid-servants to part with their scanty wages. They did so not only because to them Burns must have seemed the champion of their feudal-like oppression; not only because they may have known, personally or by repute, many of the characters he satirized; but also because in the Kilmarnock poems they saw reflected, not the cold, hard, over-privileged Anglified Scotland of their masters and mistresses, but the warm immediate Scotland of themselves and their rustic forbears.

Having won the applause of the Ayrshire peasantry and the sturdy middle classes, and having at least aroused the interest of the London intellectuals and the scarcely less Anglified intellectuals of Edinburgh, Burns resolved to exploit this promising literary situation to the full.

Part II

5
Edinburgh: The First Winter
1786–7

I

ROBERT set out for Edinburgh astride his borrowed 'pownie', on Monday 27th November 1786. The journey took him two days. The poet spent the intervening night with a Mr Prentice and a circle of admirers at Covington Mains, near Biggar in Lanarkshire, where he was wined and dined in a style so lavish that the rider was as jaded as his steed when they jogged into Edinburgh's Grassmarket the following evening.[1] There, Robert was met by his old Mauchline crony John Richmond, now a clerk in a law office, and by John Sampson, brother to a Kilmarnock friend, Sampson the seed merchant. Richmond had come to meet Burns out of friendship and because Robert was to stay with him. Sampson had come because he wanted the weary pony to take him back to Ayrshire next day, an arrangement different from that which Robert had reached with the owner of the beast, and one which the poet only agreed to on hearing that it had the sanction of James Dalrymple of Orangefield, near Monkton, an influential friend who had given him a letter of introduction to the Earl of Glencairn.

The room to which Robert was conducted by Richmond, whose bed he was to share for an additional payment of three shillings a week to Mrs Carfrae the landlady, was situated on the first floor of a house in Baxter's Close. This was one of the narrow wynds or lanes which threaded its odoriferous way north and south between the towering lands of the Lawnmarket. The house in which the poet stayed was demolished more than a century ago, to be replaced by an incongruous red-sandstone building containing a Robert Burns

[1] He had breakfasted along with Mr Prentice, at Hillhead Farm, half a mile away, as the guests of Mr and Mrs James Stodart, who had been present at the party on the 27th, and lunched with Mr John Stodart, banker at Carnwath.

Bar. The back windows of the old house looked out over the residence of Lady Stair (d. 1731), wife of Viscount Stair, the father of modern Scots law. Shockingly maltreated in Victorian times and then unsympathetically and unskilfully restored, Lady Stair's house became a museum-piece when it was presented to the town by Lord Rosebery in 1907, and now contains relics of Burns, Scott and Stevenson.

In 1786, however, it was still in aristocratic hands. The peculiar intermingling of the various levels of Edinburgh society—one result of the Old Town's increasingly cramped living conditions throughout most of the eighteenth century—must have been brought home to Robert by the surprising fact that within a stone's throw of his bedroom window was the home of a nobleman, while immediately above him was the 'working-room' of a group of prostitutes. The noise made by these ladies of easy virtue at first disturbed the poet's sleep, but in time he came to derive no little amusement from the effect their ongoings had on the sensibilities of the pious Mrs Carfrae.

The Edinburgh into which Burns thus temporarily settled was a bewildering panorama of ancient vernacular colour and smelly squalor. A few pigs still roamed the streets, nosing amongst the litter in the gutters. At ten o'clock every night, the windows of the lands were still wont to open for servants to pour the day's household slops[1] and rubbish into the streets, to be collected by half-hearted and inefficient scavengers with wheel-barrows at seven o'clock the next morning. The French cry 'Gardez l'eau', Scotified by the servants of the rich into 'Gardy loo', was shouted with a similar disregard of probable consequences resulting from any neglect of their warning, as many a modern golfer's vain cry of 'Fore' after the ball has been struck! True, by 1769, seventeen years before Burns arrived in the capital, the English journalist Thomas Pennant had noted that while

> in the closes or alleys the inhabitants are very apt to fling out their filth, etc., without regarding who passes . . . the sufferer may call every inhabitant of the house it came from to account, and make

[1] Including the contents of the chamber-stools.

them prove the delinquent, who is always punished with a heavy fine.

Yet when Boswell brought Dr Samuel Johnson to Edinburgh in 1773, he records that he could not prevent his distinguished visitor from

> being assailed by the evening effluvia of Edinburgh. I heard a late baronet, of some distinction in the political world in the beginning of the present reign, observe that 'walking in the streets of Edinburgh at night was pretty perilous, and a good deal odoriferous'. The peril is much abated, by the care which the magistrates have taken to enforce the city laws against throwing foul water from the windows; but, from the structure of the houses in the old Town, which consist of many stories, in each of which a different family lives, and there being no covered sewers, the odour still continues. A zealous Scotsman would have wished Mr Johnson to be without one of his five senses upon this occasion. As we marched slowly along, he grumbled in my ear, 'I can smell you in the dark'! But he acknowledged that the breadth of the street, and the loftiness of the buildings on each side, made a noble appearance.

The loftiness of the buildings—some of the lands had as many as fourteen storeys—made necessary by the cramping of the eighteenth-century City into more or less its medieval bounds, resulted in a shortage of water. Along the High Street would be seen the tribe of Water Caddies, bent under the weight of the casks on their backs as they carried water from the public wells which, Lord Cockburn tells us, 'were then pretty thickly planted in the principal street'. Up the narrow turnpike stairs to the six-roomed apartments of people of quality, or the two- or three-roomed flats of the lower gentility, these Caddies bore their kegs.

Because of 'the evening effluvia'—referred to locally as 'the flowers of Edinburgh'—the 'best people' chose to live in the middle flats of the lands. Poorly-paid clerical workers, runners and scavengers occupied the lower flats: aristocrats, professional men and ladies of independent means had their houses in the middle floors:

above them might be the shopkeepers, the merchants, and the dancing and music masters: on top of them all, in the garrets and attics, were to be found the artisans and labourers. Inevitably, all social classes met from time to time—if nowhere else on the winding stairs, which could not carry two-way traffic, and were always a sore trial to a behooped Countess—and although social distinctions were rigidly enough observed on public occasions, there developed a feeling of communal friendliness, almost a family feeling, amongst the occupants of this squeezed-up town. Everyone, in fact, knew what everyone else was doing, so robberies were less frequent than they became in the 1780's, when the richer people had started to depart, and the social tone of the Old Town had taken its first downward turn.

Edinburgh's later reputation for the cold aloofness of its middle and upper classes was a product of the social revolution which occurred when the Old Town at last spilled its banks, and the wealthier folk began to abandon their cosy, clarty ancestral lands for the spacious graces and formalities of the New Town. The first move in this direction had been made as early as 1765, when speculative builders constructed George Square and Brown Square. These squares were at first considered to be hopelessly out of the way, and the real overspill did not begin until 1772, when the first bridge leapt its arch over the gulf between the humph-backit ridge of the Old Town and the gentler ridge of the New, between which lay a swampy marsh called the Nor' Loch. In Burns's day, Princes Street, George Street and Queen Street were already developing westwards. Sedan chairs, carried by Highland characters noted for the volubility of their Gaelic execrations whenever their swift passage was hindered, began to give place to still swifter hackney carriages. The Town Guard, that band of aged and infirm ex-soldiers who did duty as policemen when almost the only crime to be dealt with in quantity was drunkenness, and whom Robert Fergusson ridiculed so mercilessly, were becoming unable to cope with their enlarging responsibilities. The seven-year-long criminal career of the notorious Deacon Brodie—highly respected merchant by day, key-forger and thief by night—was drawing towards its climax, which resulted in his flight to Holland, his arrest and trial, and his execution on the drop

gallows, himself the first victim of the new manner of death-dealing which he had invented as being more humane than the old method of turning off a criminal from a ladder. There was much talk, too, about an attempted balloon ascent: and a so-called Learned Pig was being exhibited in the Grassmarket.

One of Robert's first actions on recovering from the fatigues of his journey to the Capital was to write to Sir John Whitefoord, who had taken an interest in him at Mauchline and who was then in Edinburgh, assuring the knight that he was not 'the needy, sharping author, fastening on those in upper life, who honour him with a little notice of him or his works'. He was still a little unsure of himself in his new surroundings.

But a week later, Robert had tasted fairly fully the delights of 'Edina, Scotia's darling seat' (as he later rather absurdly addressed the Capital, providing a twentieth-century firm of sanitary engineers with an apt name for another kind of seat); for to Gavin Hamilton he wrote:

> For my own affairs, I am in a fair way of becoming as eminent as Thomas à Kempis, or John Bunyan; and you may expect henceforth to see my birthday inserted among the wonderful events, in the Poor Robin's and Aberdeen Almanacks, along with the black Monday, and the battle of Bothwel Bridge.—My Lord Glencairn & the Dean of the Faculty, Mr H. Erskine, have taken me under their wing; and by all probability I shall soon be the tenth Worthy, and the Eighth Wise Man, of the world. Through my Lord's influence it is inserted in the records of the Caledonian Hunt, that they universally, one and all, subscribe for the 2d Edition.—My subscription bills come out tomorrow. . . .

Clearly, Robert had wasted little time. He had gained for himself the interest of powerful patrons; settled the business of his second edition; and had gone a fair way towards captivating Edinburgh's most exclusive set by winning the subscriptions of the Caledonian Hunt.

The most important of Robert's patrons was without doubt the 14th Earl of Glencairn (1749–91), an amiable, good-looking man

who, unluckily, enjoyed but indifferent health. Burns first en-
countered Glencairn in 1785, when the Earl, as lay patron, presented
an Auld Licht candidate for the vacant pulpit of Kilmarnock Parish,
against his own noble wishes but out of deference to what he
deemed to be popular feeling. Burns lampooned this candidate, the
Reverend William Mackinley, in 'The Ordination', and won Glen-
cairn's private admiration.

When the poet presented himself in Edinburgh, armed with
Dalrymple of Orangefield's letter, the Earl at once warmly
welcomed him. Glencairn and his mother, the Dowager Duchess,
themselves took up twenty-four copies of the second edition;
and it was thanks to Glencairn that the Caledonian Hunt took
up a further hundred copies, thus earning the dedication of the
book.

Henry Erskine, Dean of the Faculty of Advocates, whom Robert
also met during his first ten days in the city, was the second son of
the Earl of Buchan, and distantly related to Glencairn by marriage.
He had won himself a brilliant reputation as the most eloquent and
most able of the Scottish barristers of his generation, and a witty
reputation amongst the literati for his performance on the occasion
of Dr Johnson's Edinburgh visit, when he pulled Boswell aside,
pressed a shilling into his hand, and murmured, 'For the sight of
your bear!' Erskine admired Burns's poetry, and like so many other
men and women in all walks of life, was captivated by the poet's
personal charm. By allowing it to be known that he considered
Burns his friend, Erskine paved the way for Robert's acceptance by
Edinburgh Society.

Very soon, the poet knew all in the Capital who were reputed to
be worth knowing. His success was assured when he won the
approval of the 4th Duke of Gordon and, even more important, that
of his vivacious Duchess who had all Edinburgh at her feet. The
Duchess, Jane Maxwell (d. 1812), was celebrated not only as a
beauty—the eighteenth-century equivalent of a pin-up girl—but
also as a woman who paid scant regard to the conventions. Her
character was sketched with somewhat reluctant admiration by an
anonymous barrister (quoted in the Chambers-Wallace edition of
Burns's works) in February 1786.

The good town is uncommonly crowded and splendid at present. The example of dissipation set by Her Grace the Duchess of Gordon is far from showing vice (in) her own image. It is really astonishing to think what effect a single person will have on public manners, when supported by high rank and great address. She is never absent from a public place, and the later the hour, so much the better. It is often four o'clock in the morning before she goes to bed, and she never requires more than five hours' sleep. Dancing, cards and company occupy her whole time.

Her manners in London were the same as her manners in Edinburgh, and her admirers included not only Pitt and his Scottish protégé Dundas, but the King himself.

Burns soon got to know Lord Monboddo, the eccentric judge who believed that human beings were born with fragments of tails which were subsequently docked by conspiring midwives, and who was thus accidentally a primitive precursor of Darwin. Monboddo had a lovely daughter, Elizabeth,[1] whom Robert praised in his 'Address to Edinburgh', and whose untimely death in 1790 stirred him to write an elegy apparently more deeply-felt than most similar productions from his pen.

Criticism and advice of a silly kind were not long in being bestowed upon Burns. They came from the rather pompous tongue of David Stuart, the 11th Earl of Buchan, who, although he was one of the founders of the Scottish Society of Antiquaries and was desperately anxious to be known as an enlightened patron of the arts, was not equipped by nature for the role. Robert wisely ignored literary advice which he considered unsound, from however exalted a quarter it was directed.

Less exalted in rank if not in intellect than his friends of the 'noblesse' (as Burns called them), were those amongst the

[1] Gossip-loving Mrs Alison Cockburn, in a letter to a friend dated 30th December 1786, declared: 'The town is at present agog with the ploughman poet who receives adulation with native dignity, and is the very figure of his profession—strong and coarse—but has a most enthusiastic heart of LOVE. He has seen dutchess Gordon and all the gay world. His favrite for looks and manners is Bess. Burnet—no bad judge indeed.'

Edinburgh literati who became friendly with him, or were charmed by his personality. Their leader was Henry Mackenzie (1745–1831), by profession a successful conveyancer, who certainly approved of Burns's work in a general way, though he never seems to have become very intimate with the poet.

Although Mackenzie, who was forty-six during Burns's first Edinburgh winter, had written nothing of any consequence for more than twelve years, the popular sentimentalism of his novels *The Man of Feeling* and *The Man of the World* had given him a position of authority in Scottish Letters. He was then editing his short-lived periodical *The Lounger*, the December 1786 edition of which carried his review of the Kilmarnock poems. It appeared only eleven days after Robert's arrival in the Capital, and must have seemed a happy augury for the second edition. Understandably, gratitude added to his earlier veneration for '*The Man of Feeling*— a book I prize next to the Bible', may have led Burns to overestimate the literary status of the older man: but whatever Mackenzie's own literary shortcomings may have been, and in spite of his total (though perhaps understandable) earlier failure to see any merit in the work of poor Robert Fergusson (who had had the temerity to dash off an amusing piece called 'The Sow of Feeling'!),[1] Mackenzie deserves credit for having provided the poet with knowing approbation at a time when he much needed it. The applause of the little-read, be it earls' or underlings', is a pleasant enough sound in a poet's ears: but the discerning praise of a fellow-craftsman, however dissimilar his own artistic aims, is worth far more.

Dr Hugh Blair (1718–1800), preacher, professor and man-of-letters, was also considered a great man in his day. Generous David Hume called him a vain, fussy, kind-hearted little man that everybody liked. Yet he seems to have possessed most of those unpleasantly unctuous qualities which one commonly associates with religionists who became successful in the late eighteenth and nineteenth centuries. He abhorred the Scots tongue, considering it barbaric and ungenteel, and he had enough of a guid conceit of himself to regard his own aesthetic judgements as absolute and

[1] Burns's 'great admiration of Fergus[s]on,' Mackenzie later stated, 'shewed his propensity to coarse dissipation'.

beyond question. Two years short of seventy, he was at this time not only minister of the High Kirk of Edinburgh, but also the occupant of a University chair specially created for him, that of Rhetoric and Belles Lettres. His literary tastes, not unnaturally, were modelled on the manners of the English poets of his youth: cold, correct and classical, usually to the point of stiffness. The blind Dr Blacklock had doubted if Blair, in view of his 'highly polished' taste and the regularity of his emotions, would appreciate a genius such as Burns's, which displayed 'sallies of a more impetuous order'. There Dr Blacklock was wrong. Blair naturally disliked 'The Jolly Beggars'; but he praised 'Death and Dr Hornbook' as well as 'John Barleycorn', which suggests that he cannot have been altogether as stiff-necked as his reputation and his sermons suggest. (Gosse called them 'Blair's bucket of warm water', while another Victorian critic, Sir Leslie Stephen, wrote scathingly of Blair 'mouthing his sham rhetoric'.)

On 9th April 1787, Burns began his *Second Common-place Book* which, unlike the first, was clearly never intended for publication. Its *point de départ* was Gray's observation that 'half a word fixed upon or near the spot, is worth a cart-load of recollection', and in it, Burns drew frank pen-portraits of some of his Edinburgh associates. Burns's recorded verdict upon the stately Blair is vivid and penetrating. It follows a somewhat chilling paragraph on Glencairn, written while the poet was temporarily piqued with his noble patron for having paid too much attention to a blue-blooded blockhead, and not enough to the poet.

> With Dr Blair I am more at ease. I never respect him with humble veneration; but when he kindly interests himself in my welfare, or, still more, when he descends from his pinnacle and meets me on equal ground, my heart overflows with what is called *liking*: when he neglects me for the carcase of greatness, or when his eye measures the difference of our points of elevation, I say to myself with scarcely an emotion, what do I care for him or his pomp either?
>
> It is not easy to form an exact judgment of anyone, but in my opinion Dr Blair is merely an astonishing proof of what industry

and application can do. Natural parts like his are frequently to be met with; his vanity is proverbially known among his acquaintances.

Blair was probably on no more intimate terms with Burns than was Mackenzie. Nor did Burns ever become intimate with Blacklock, whom, indeed, he came near to wounding by his failure to let the kind old man know he was in Edinburgh.

Though Professor Dugald Stewart (1753–1828) also belonged to the intellectual strata of the rich and fashionable set, Burns probably came to know him best of all. He certainly paid high regard to Stewart's opinions. They had dined together before the poet set out for Edinburgh, at the Philosophy Professor's country house, Catrine Bank, near Mauchline.

Dugald Stewart, who only came to Ayrshire during his vacations, had carried back with him to Edinburgh his copy of the Kilmarnock poems, which he had lent to Henry Mackenzie, the outcome of the loan being *The Lounger* review.

In his *Second Common-place Book*, Burns wrote of Stewart:

> An exalted judge of the human heart, and of composition. One of the very first public speakers; and equally capable of generosity as humanity. His principal discriminating feature is: from a mixture of benevolence, strength of mind, and manly dignity, he not only at heart values, but in his deportment and address bears himself to all the Actors, high and low, in the drama of Life, simply as they might merit in playing their parts. Wealth, honors, and all that is extraneous of the man, have no more influence with him than they will have at the Last Day.

In a letter to *The Lounger*, printed by Currie in his *Life of Burns*, Stewart wrote of Burns:

> His manners were then, as they continued ever afterwards, simple, manly, and independent; strongly expressive of conscious genius and worth; but without anything that indicated forwardness, arrogance, or vanity. He took his share in conversation, but not more than belonged to him. . . . Nothing, perhaps, was more remarkable among his various attainments, than

the fluency, and precision, and originality of his language, when
he spoke in company . . .

It is easy to understand why Burns should have valued his friendship
with a man of such intelligence as Stewart more highly than with
many of the aristocrats who so eagerly sought his company to make
their frippery parties 'complete'.

Another man with whom Burns's friendship arose out of intellec-
tual sympathy, was the Reverend William Greenfield (d. 1827). He
was Professor of Rhetoric and minister of St Andrew's Church
when Burns arrived in Edinburgh, though three months later he had
become the elderly Blair's associate-preacher. The climax of his
career came in 1796, when, as Moderator of the General Assembly,
Edinburgh University conferred on him an honorary Doctorate of
Divinity. Two years later, he toppled from his high eminence. What
his crime was, there is now no means of telling. But he fled to
England with his family (where he lived the remainder of his life
under the assumed name of Rutherford),[1] was deprived of his
charge and of his University degree, and placed under sentence of
excommunication. The 'flagrant reports concerning his conduct'
which the Presbytery of Edinburgh considered before passing their
terrible punishment must have been serious indeed! Yet history has
drawn a merciful veil over his case which no investigator has so far
succeeded in prying aside. To Burns, however, in 1787, Greenfield
was:

> a steady, most disinterested friend, without the least affectation of
> seeming so; and as a companion, his good sense, his joyous
> hilarity, his sweetness of manners and modesty, are most engag-
> ingly charming.

It was to Greenfield that Robert revealed a nagging uneasiness
which troubled him, even before he had been two months in the
Capital.

[1] And published, in 1809, *Essays on the Sources of the Pleasures received from
Literary Composition*, on the strength of which Sir Walter Scott introduced
him to John Murray, to whose *Quarterly Review* Greenfield contributed under
the name of Richardson.

Never did Saul's armour sit so heavy on David when going to encounter Goliah, as does the encumbering robe of public notice with which the friendship and patronage of some 'names dear to fame' have invested me.—I do not say this in the ridiculous idea of seeming self-abasement, and affected modesty.—I have long studied myself, and I think I know pretty exactly what ground I occupy, both as a Man & a Poet; and however the world, or a friend, may sometimes differ from me in that particular, I stand for it, in silent resolve, with all the tenaciousness of Property.—I am willing to believe that my abilities deserved a better fate than the veriest shades of life; but to be dragged forth, with all my imperfections on my head, to the full glare of learned and polite observation, is what, I am afraid, I shall have bitter reason to repent.—

I mention this to you, once for all, merely, in the Confessor style, to disburthen my conscience, and that—'When proud Fortune's ebbing tide recedes'[1]—you may bear me witness, when my bubble of fame was at the highest, I stood, unintoxicated, with the inebriating cup in my hand, looking forward, with rueful resolve, to the hastening time when the stroke of envious Calumny, with all the eagerness of vengeful triumph, should dash it to the ground.

In spite of Robert's obvious enjoyment of his principal image—an enjoyment which betrayed him into re-using it, slightly modified, to other correspondents—in spite, too, of the element of self-dramatization inherent in his character, which the heightened emotional tone of his forebodings reveals, this letter does suggest that he was already aware of the basic falsity of his position. Though there was as yet no hint of any action against him on the part of 'envious Calumny'—the faction of Pitt's stately lackey Henry Dundas, the so-called uncrowned king of Scotland, simply ignored Burns—clearly he felt insecure in the company of the 'great'. They were not his kind, even although, as Dugald Stewart tells us, he spoke English in their company with fluency and precision, 'and avoided more successfully than most Scotchmen the peculiarities of Scottish

[1] Shenstone: Elegy VII.

phraseology'. They treated him at first as the latest rage, an amusing and fashionable 'must' for a successful party. They fell under the spell of his astonishing personality, and might have come to regard him in the light of an equal by virtue of his intellectual attainments, if only he had given them the chance. But he did not want such a position: at any rate, he was constitutionally unable to seize and develop the opportunities it might have offered. Some possible reasons for the comparative failure of his Edinburgh visit are discussed later on. Meanwhile, the *raison d'être* of the visit, the second edition of his poems, must now be considered.

II

When Burns arrived in Edinburgh, he selected the forty-two year old publisher and Secretary of the Edinburgh Chamber of Commerce, William Creech, to be his literary agent. Although Creech later did become Burns's publisher, and issued an edition of the works during the poet's lifetime, he was not in any accurate sense the publisher of the second and simultaneous third editions of the poems, since the financial risk was borne entirely by Burns, who paid both the printer and the binder.

Creech, an alert dapper little man, as his *Fugitive Pieces* testify, with 'half a squint at his own interest', and who always 'affected black silk breeches and generously powdered hair', had in his youth been tutor and travelling companion to the Earl of Glencairn when that nobleman had borne the title of Lord Kilmaurs. Glencairn may thus have commended Creech to Burns. But it seems too much to suggest, as some writers have done, that because Burns's literary agent was also in a sense a member of the Glencairn-Erskine set, that the poet was really only made welcome in Edinburgh by a closely-knit clique. Creech was, in fact, the leading Edinburgh publisher of his day, having a connexion with the London house of Cadell, and a list of authors which included Henry Mackenzie, Thomas Campbell and James Beattie. His shop, which stood at the foot of the Luckenbooths—a quaint old building which, until 1848, spliced the High Street by St Giles into a couple of narrow lanes—was situated below Allan Ramsay's former premises, and was the

natural resort of the literati of the day. The publisher held a levee, attended by writers and printers, in his house in Craig's Close every morning until noon. Then he devoted a couple of hours to work in his shop, resuming his levee in the afternoon, and carrying on with it until four o'clock. He had a reputation for being mean over the provision of refreshment for his guests—perhaps hardly surprising, since if all his levees were well-attended, he must have entertained them in droves!—for never having been known to have prosecuted a man for debt; and for being equally genial and leisurely in the discharge of his own debts to others, as Burns was later to discover.

Creech, in turn, introduced the poet to his printer, William Smellie (1740–95), a friendly eccentric, nineteen years the poet's senior, and decidedly lacking in the social graces. As well as being Burns's second printer, his main claim to fame was that in 1771 he became the first editor of the *Enclyclopaedia Britannica*, though he also won some repute as a scholar and translator. The son of a prosperous Edinburgh mason, Smellie played a leading part in Edinburgh's club life.

Because of the cramped-up living conditions of the Old Town, few men spent their evenings at home. Instead, they crowded into one or other of Edinburgh's multi-smelling taverns, and ate, drank, and made merry in club company. Some of the Clubs had fanciful styles. For instance, there was the Boar Club, which met in Daniel Hogg's tavern in Shakespeare Square. It was founded in 1787 while Burns was in Edinburgh by, amongst others, the 'cellist Johann G. C. Schetky, a native of Darmstadt who had settled in Edinburgh. Its members were all 'boars', their meeting-place the 'sty', their decisions 'grunting'. The Facers Club, which met earlier in the century in Lucky Wood's Canongate ale-house, got its name from the rule whereby its members had to throw in their own faces any drink which they left at the bottom of their glasses. The Cape Club, which met in James Mann's tavern, in Craig's Close, the 'Isle of Man Arms', took its name from the physical difficulty which one of its outlying members habitually encountered in getting his bearings once he passed through the Nether bow, difficulties his brother-members dubbed 'rounding the Cape'. This club had many distinguished members, including Deacon Brodie (whose club name

was 'Sir Lluyd'); David Herd, the collector of Scottish folk-poetry; the artists Alexander Runciman and Henry Raeburn; and the poet Robert Fergusson ('Sir Precentor').

The Cape Club, though meeting then in different taverns, still flourished in Burns's day. But the club at which he found the most congenial relaxation from the formalities of patrician society, was the Crochallan Fencibles. They met in Dawney Douglas's tavern in Anchor Place, farther up which William Smellie had his business premises. It took its name from the landlord's fondness for singing the Gaelic song 'Crodh Chailein' (Colin's Cattle), and in facetious imitation of the volunteer corps then being raised in the city.

For a mere sixpence, suppers of tripe, rizzared haddocks, mince collops, and hash could be enjoyed by its members, all of whom bore quasi-military titles, and included Adam Smith (who left for London seeking a cure for his shattered health the day before Burns got round to calling on him about a Government sinecure which the economist had thought of trying to procure for the poet, on the instigation of Mrs Dunlop); Hugh Blair, James Beattie, Adam Ferguson the moral philosopher, Henry Mackenzie, Henry Erskine, the law lords Hailes and Monboddo, Newton and Gillies, as well as humbler legal men like Alexander Cunningham and William Dunbar ('Rattlin', roarin' Willie') and non-legal members like the critic and historian Gilbert Stuart, Matthew Henderson, and the jovial, broad-minded Robert Cleghorn, farmer of Saughton Mills. Drink flowed freely at these suppers, and much of the talk must have been bawdy. From Burns, two of the Fencibles, Smellie and Cleghorn, received poems and letters which presumably reflected the tone of the Club. Those to Smellie were burnt by Smellie's unctuously pious biographer Robert Kerr, as being 'totally unfit for publication'. Those to Cleghorn also disappeared, though not before they shocked the eyes of—of all people!—Lord Byron. It was for the Crochallans however, that Burns wrote his magnificent collection of bawdy lyrics, later surreptitiously published (with puerile additions not his own) as *The Merry Muses of Caledonia*. A humorous sense of the bawdy is a normal attribute of any comparatively uninhibited healthy man. Burns brought to it superb literary accomplishment. His genius for lyric bawdry is discussed in a later chapter.

By the beginning of December, Burns and Creech had reached a business understanding, the precise details of which have never actually been known. Two weeks later, the subscription bills were out, and Creech advertised the book as being 'in the press, to be published for the sole benefit of the author'.

The progress of the book was plotted by Burns in his letters to his friends. On 14th January 1787, he reported to John Ballantine that he had corrected the hundred and fifty-second page. But it was not until 22nd March that the poet was able to announce that the task of proof-correcting had been completed.

He did so to Mrs Dunlop. Frances Anna Wallace Dunlop of Dunlop (1730–1815) was the daughter of Sir Thomas Wallace of Craigie, who claimed descent from a cousin of Sir William Wallace, the great Scottish patriot, a fact which more than a little added to the admirable Scots pride of his daughter. At the age of eighteen, she made a runaway match with John Dunlop of Dunlop, and bore him seven sons and six daughters. Just before Burns's fame attracted the notice of county folk, Mrs Dunlop suffered a severe double blow, throwing her into a state of mind 'which, had it long continued, my only refuge would have been a madhouse or a grave'. Her eldest surviving son, Sir Thomas Wallace, having married a sister of the vivacious and eccentric Duchess of Gordon, got himself so deeply into debt that in 1783 he had to sell the ancestral estate of Cragie. A few months later, Mrs Dunlop's husband died.

Under the weight of her double grief, life seemed to hold no further interest for her. Then someone gave her a copy of the Kilmarnock poems, and the force of Burns's genius roused her from her lethargy. She immediately ordered six copies of the book. Robert's note of apology for only being able to supply five, began a correspondence and a friendship which, but for a painful estrangement in the eighteen months before his death, lasted to the end of his days. She was garrulous (he wrote more letters to her than to any other single correspondent), the possessor of a bad pen-hand, tiresome at times in her demands upon his patience, but a warm and sincere admirer. He made of her a sort of mother-confessor, although he did not always consider it advisable to tell her the absolute truth.

Concerned with his prospects of earning a livelihood, she had

suggested to him before he set out for Edinburgh that he might apply for the chair of Agriculture at Edinburgh University, or perhaps even consider buying a commission in the Army. Robert was too well aware of his deficiencies for the former position; but the other proposal caused a stirring of his old romantic conception of the military life. So on 22nd March 1787, he wrote to Mrs Dunlop:

> I have today corrected the last proof sheet of my poems, and have now only the Glossary and subscribers names to print.— Printing this last is much against my will, but some of my friends whom I do not chuse to thwart will have it so.—I have both a second and a third Edition going on as the second was begun with too small a number of copies.—The whole I have printed is three thousand.—Would the profits of that afford it, with rapture I would take your hint of a military life, as the most congenial to my feelings and situation of any other, but 'What is wanting cannot be numbered'.

The Earl of Glencairn, the Marquis of Graham, the Duke of Montague, the Duke of Portland, and all the others whose interest Glencairn had stimulated on behalf of the 'Scotch Bard's Subscription', did so well by Burns that the second edition was, indeed, exhausted before it was issued. Unfortunately, the type had been distributed, so it was hastily re-set, with the result that a good many errors not in the second edition crept into the third. In both cases the price of the volume was five shillings to subscribers and six shillings to the general public.

By this time, the sharp-witted Creech had begun to see in what manner the literary wind was blowing. Scenting a possible bestseller in Burns, he not only took up his five hundred subscription copies for re-sale at a profit of a shilling, but he also entered into an agreement with the poet whereby he, Creech, purchased—or thought he purchased, for Burns had already made over his rights in the Kilmarnock poems to Gilbert as trustee for 'dear-bought Bess'—the copyright of the poems, and so had the right to issue new editions as and when he chose. Henry Mackenzie was asked to suggest a suitable sum which Burns was to receive as outright copyright

payment. He suggested a hundred guineas, for the smallness of which sum he has been censured by later biographers, who have perhaps tended to overlook the fact that Scots poetry had had no sale as a commodity for fifty years before the appearance of Burns's book; that the 'heaven-taught ploughman' considered himself very well rewarded by this amount; and that in any case, Burns's work must still have seemed more of a novelty than an assured asset. A Memorandum of Agreement between Creech and Burns was drawn up on 17th April 1787, whereby Creech was to see if Mr Cadell of London would 'take a share in the Book'. Cadell dithered and swithered. Eventually, Creech took upon himself the whole share. But it was not until 23rd October that he added to the Agreement 'On demand I promise to pay Mr Robert Burns, or Order One Hundred Guineas, value received', and not until 30th May 1788, after much unpleasantness (reflected in the poet's harsh lines 'On William Creech') that Burns at last was able to add 'Received the Contents'. Creech's dilatoriness over the payment for the 500 copies which he had bought wholesale at the subscriber's price for re-sale to the public, was of an even more serious nature, causing the poet the greatest alarm, especially as a false rumour got around that Creech's finances were unsound, and that he might possibly be on the verge of bankruptcy.

The book appeared on 21st April 1787. On 28th September 1787, Burns wrote to Patrick Miller: 'I am determined not to leave Edinr till I wind up my matters with Mr Creech, which I am afraid will be a tedious business.' It proved to be even more tedious than he anticipated; for on 22nd January 1788, he was complaining to Margaret Chalmers that he had sent Creech:

> ... a frosty, keen letter. He replied in forms of chastisement, and promised me upon his honor that I should have the account on Monday; but this is Tuesday, and yet I have not heard a word from him. God have mercy on me! a poor d-mned, incautious, duped, unfortunate fool!

By 19th March, when writing to Mrs Agnes Maclehose, he was still no further forward, and had, indeed, worked himself into a proper paper frenzy:

. . . that arch-rascal Creech has not done my business yester-night, which has put off my leaving town till Monday morning. . . . I have just now written Creech such a letter, that the very goose-feather in my hand shrunk back from the line, and seemed to say, 'I exceedingly fear and quake!' I am forming ideal schemes of vengeance. O for a little of my will on him!

In the event, however, Burns must have realized that such an urbane creature as Creech was not to be persuaded by harsh words, for the letter the publisher actually received was couched in mild and polite terms which do not suggest such urgency:

As I am seriously set in for my farming operations, I shall need that sum your kindness procured me for my copy-right . . . any time between (now) and the first of May as it may suit your convenience to pay it, will do for me.

Final payment was not made until February 1789. Creech later told Burns's first biographer, Heron, that 'the whole sum paid to the poet for the copyright, and for the subscription copies of the book amounted to nearly £1,100'. Off this had to come Smellie's bill for printing the book, and Scott's bill for binding it, as well as whatever Creech may have got back as his own commission for handling the subscriptions, and for his services as literary agent. Dr Snyder considers that the gross total is probably too high, and that the amount Burns himself eventually received might have been somewhere in the region of £853.[1] We have now no means of knowing, for all papers relating to the transaction have long since disappeared. Burns gave his own final verdict on the whole business in a letter to Dr Moore dated 23rd March 1789:

I was at Edin[r] lately, and finally settled with M[r] Creech; and I must retract some illnatured surmises in my last letter, and own that at last, he has been amicable and fair with me.

The text of the new volume ran to very nearly a hundred extra pages. It also carried a fuller glossary than the Kilmarnock Edition

[1] Hans Hecht reckons the poet's profit to have been about £450, which included the stipulated 100 guineas.

had contained. Much against the author's wishes, since he had to bear the cost, a list of subscribers occupied a further thirty-seven pages. In place of the original preface stood the elaborate dedication to the members of the Caledonian Hunt.

Burns took this opportunity to make some changes of spelling in the original poems, some of the old Scots gerundives *-an* and *-in* (themselves corruptions of the Middle-Scots *–and*) being replaced by the English *-ing*. He also added eight new stanzas to 'The Vision'.

Most of the twenty-two poems which now made their appearance in print for the first time were not actually new. 'Death and Dr Hornbook', 'The Ordination' and the 'Address to the Unco Guid', were merely brought out of Burns's drawer, having been found unsuitable for the Kilmarnock Edition. Nothing need be said of the five gloomily religious pieces in English, 'Stanzas on the Prospect of Death', 'O Thou Dread Power', 'Paraphrase of the First Psalm', 'Prayer under the Pressure of Violent Anguish', and 'Ninetieth Psalm Versified', beyond noting that the first and the fourth provide further literary-cum-clinical evidence of the heart disease which had had already laid its grip on Burns, one of the symptoms of which, according to Dr S. Watson-Smith, would be periods of 'anxiety and dreadful suspense'. Of the seven extra songs, by far the finest is 'Green grow the Rashes O' dating from 1783. The others were the rousing ballad in praise of whisky, 'John Barleycorn' (1783); 'My Nannie O' (1783); the decidedly feeble 'Composed in Spring' (1783); and the undated but early drinking-song 'No Churchman am I'.

Of the rest of the additional poems—'The Brigs of Ayr', 'The Calf', (another anti-Orthodox piece), 'Tam Samson's Elegy', (a jovial exercise in mock-elegy, Mr Samson being then still very much alive), 'To Miss Logan' (written in the fly-leaf of a presentation copy of 'Minstrel' Beattie's poems), 'Address to a Haggis', and 'Address to Edinburgh'—the two most interesting are 'The Brigs of Ayr' and the address 'To a Haggis', the latter perhaps more because of its popularity than for its intrinsic merits. Every year, all over the world, men and women stand up at Burns Suppers and declaim to that steaming comestible:

Fair fa' your honest, sonsie face,
Great Chieftain o' the Puddin-race!
Aboon them a' ye tak your place,
 Painch, tripe, or thairm:
Weel are ye wordy o' a grace
 As lang's my arm.

There is a characteristic touch of post-Reformation race-psychology about the fifth stanza, Scotland's former allies becoming symbols of the flashy and trashy to the Calvinists.

Is there that owre his French *ragout*,
Or *olio* that wad staw a sow, [*would surfeit*
Or *fricassee* wad mak her spew
 Wi' perfect sconner,
Looks down wi' sneering, scornfu' view
 On sic a dinner?

Throughout the eighteenth, nineteenth and early twentieth centuries, the French, because of their continued adherence to Catholicism, and in spite of the former Auld Alliance which once bound France and Scotland, were often regarded by the Scottish peasantry as the very epitome of fleshy sinfulness; an attitude which finds more recent expression in 'Hugh MacDiarmid's' 'Crowdieknowe', where a Scotsman, considering the business of the physical resurrection supposed to occur at the sound of the last trumpet, cannot resist a crack against 'thae trashy bleezin Frenchlike folk'.

The fame which Burns's poem has brought to the haggis has resulted in its becoming a seasonal Scottish export. It has also resulted in the perpetuation of particularly feeble music-hall jokes about catching a haggis, and about haggis and bagpipes, variations of which one comedian after another seems to find successfully laughter-provoking. Two other points should perhaps be made, though not laboured. Several writers have seen the annual haggis ceremony at Burns Suppers as a subconscious nod towards a fertility symbol. Mr Crawford thinks that the stanza which goes:

But mark the Rustic, haggis-fed
The trembling earth resounds his tread,

> Clap in his wallie nieve a blade,
> He'll make it whistle;
> An' legs an' airms, an' heads will sned
> Like taps o' thristle.

conceivably 'looks forward to a peasant war in Britain'.

'The Brigs of Ayr' is similar in design to 'The Two Dogs', written during the summer months of 1786, it takes the form of a dialogue between the Auld Brig of Ayr and the New. The Auld Brig doubts the power of the New to stand the test of time.

> Conceited gowk! puff'd up wi' windy pride!
> This mony a year I've stood the flood an' tide;
> And tho' wi' crazy eild I'm sair forfairn. [*age*
> I'll be a Brig when ye're a shapeless cairn!

a prophecy which came true when in 1877 the New Brig collapsed, the arch at the south end having been damaged by floods. The New Brig boasts of its modern architecture, in contrast to the 'Gothic hulk' of the Old, provoking a further flyting from the Auld-Brig, as well as a fine description of the River Ayr in spate.[1]

Unfortunately, the poem begins and ends with two swatches of neo-classical English which mar the splendid virility of the interposing Scots dialogue, leaving 'The Twa Brigs' a less completely satisfying poem than its earlier counterpart.

There were only three newly-composed poems in the Edinburgh volume; 'The Address to Edinburgh'; the lines 'To Miss Logan', and the address 'To a Haggis'. None of these really represented any development in Burns's style. Edinburgh had not so far stimulated his essentially hamely Muse.

Although the book provoked a murmur of undertone criticism because of the alleged 'licentiousness' of some of the poet's work, it

[1] Fergusson's 'Mutual complaint of Plainstones and Causey' and 'The Ghaists' provided Burns with his models. Although 'The Ghaists' is better integrated than Burns's piece, 'The Ghaists' illustrates admirably Fergusson's inability to drive home his ideas with the greater intellectual force which was at Burns's command. Both poems disprove Beattie's assertion in his *Essays* (1776), that to write in the Scots tongue, 'and yet write seriously, is now an impossibility'.

was generally well received. Some of the reviewers contented them-
selves with briefly recalling the excellent reception given to the
Kilmarnock volume, adding a further word or two of renewed
recommendation. The *Scots Magazine* for September 1787 quoted
the dedication to the Caledonian Hunt—an extraordinary mixture
of pomposity, perception, and touchy pride, rising, however, to a
noble dignity at its climax.

> The poetic genius of my country, found me as the prophetic bard
> Elijah did Elisha—at the plough, and threw her inspiring mantle
> over me. . . . She whispered me to come to this ancient metropolis
> of Caledonia, and try my say, under your kind protection. . . . I
> was bred to the plough and am independent. . . . I come to claim
> the common Scottish name with my illustrious countrymen.

In London, the *Monthly Review* for December 1787 rejoiced to see
that Burns 'may now have it in his power to tune his oaten reed at
his ease'—which, of course, he had not—praised 'John Barleycorn',
and then went on to review polite volumes of Augustan twaddle by
the Reverend William Greenwood, John Macgilvray, Miss Eliza
Thompson, and several other certainly inglorious but by no
means mute Miltons.

The *Universal Magazine* for May praised Burns warmly, but
added a patronizing rider:

> It must be allowed that there are exceptionable parts of the
> volume he has given to the public, which custom would have sup-
> pressed or correction struck out; but Poets are seldom critics, and
> our Poet had, alas! no friends or companions from whom
> correction could be obtained. When we reflect on his rank in life,
> and the habits to which he must have been subject, and the
> society in which he must have mixed, we regret perhaps more
> than wonder, that delicacy could be so offended in perusing a
> volume in which there is so much to interest and please us.

All of which shows how successfully Burns convinced at least
some readers that he really was, in fact, just a ploughman!

With his praises sounding abroad—pirated editions appeared

within a few months in Ireland and in America—Burns had now achieved the main purpose of his visit to Edinburgh. He therefore decided to gratify his ardent wish to visit as many as possible of the places whose names were celebrated in Scottish history and song.

Early on the morning of Saturday, 5th May, he set out from Edinburgh towards the Borders on the first of the four short tours he undertook during the spring, summer and autumn of 1787. His travelling companion for the first half of the tour was Robert Ainslie, a genial, hard-drinking womanizing law student whom Burns had met a few months earlier.[1] As the two of them rode towards Berrywell, near Duns, Ainslie's home, which they used as their headquarters—Burns astride his own mare Jenny Geddes—the poet must surely have felt reasonably satisfied with the results of his Edinburgh sojourn. He had been welcomed and fêted as few other suddenly-discovered young poets have ever been honoured; he had been hailed as 'Caledonia's Bard, Brother Burns' by Francis Charteris, the Grand Master of the Canongate Kilwinning Masonic Lodge (to which he was elected a member on the 1st of February) at the January meeting of the Grand Lodge of Scotland; after receiving due permission from the authorities, he had commissioned a stonemason called Robert Burn to erect a headstone over the grave of his idol Robert Fergusson, thus satisfying an urgent sense of literary gratitude; he had wined and dined with many of the greatest of the land,[2] and he had sown the seeds of his own later

[1] Like Richmond, Ainslie became excessively pious in his later years, and spoke cloudily of his early adventures with Burns.

[2] At one party which Dugald Stewart's professorial predecessor Adam Ferguson held at his home in the Sciennes, Burns met young Walter Scott. Sir Walter recorded his impression of the meeting in a letter of 1827 to Lockhart:
'I saw him one day at the late venerable Professor Ferguson's. . . . Of course we youngsters sat silent, looked and listened. The only thing I remember which was remarkable in Burns' manner, was the effect produced upon him by a print of Bunbury's, representing a soldier lying dead in the snow, his dog sitting in misery on the one side, on the other his widow, with a child in her arms.' Underneath the picture were some lines of verse. 'Burns seemed much affected by the print, or rather the ideas which it suggested to his mind. He actually shed tears. He asked whose the lines were, and it chanced that nobody but myself remembered that they occur in a half-forgotten poem of Lang-

partial rejection from Edinburgh Society by bursts of outspoken-
ness which amounted to plain rudeness, and by beginning to make
friends with convivial topers amongst the humbler orders, to say
nothing of the Crochallan Fencibles; characteristics which later led
to his being found 'impossible' by Edinburgh's patrician hostesses.
He had not, however, settled the question of how he was to earn his
living.

But for the time being all seemed fair, apart from this problem of
his future livelihood. The local horizon of his Ayrshire boyhood
and its sudden somewhat artificial Edinburgh extension, were about
to be widened to take in not only other parts of Scotland, but the
whole continent of Scottish song. The day before he left Edinburgh,
he dashed off a note and a song to the Edinburgh engraver James
Johnson (1753–1811), whom he had met a few weeks earlier, and
who was then engaged in getting together the first volume of his
ambitious collection of Scottish Song, *The Scots Musical Museum*.
Thus, in haste and amid the excitement of departure, was forged the
bond which was to bring the humble, ill-educated engraver immor-
tality, and to draw from Burns the songs that were to spread his
fame the wide world over.

horne's called by the unpromising title of "The Justice of the Peace". I
whispered my information to a young friend present, who mentioned it to
Burns, who rewarded me with a look and a word, which though of mere
civility, I then received, and still recollect, with very great pleasure.

'His person was strong and robust, his manners rustic, not clownish; a sort
of dignified plainness and simplicity, which received part of its effect perhaps
from one's knowledge of his extraordinary talents. His features are represented
in Mr Nasmyth's picture, but to me it conveys the idea that they are diminished
as if seen in perspective. I think his countenance was more massive than it
looks in any of the portraits. I would have taken the poet, had I not known
what he was, for a very sagacious country farmer of the old Scotch school—
i.e. none of your modern agriculturists, who keep labourers for their drudgery,
but the *douce gudeman* who held his own plough. There was a strong expres-
sion of sense and shrewdness in all his lineaments; the eye alone, I think, indi-
cated the poetical character and temperament. It was large, and of a dark cast,
and glowed (I say literally *glowed*) when he spoke with feeling or interest. I
never saw such another eye in a human head . . .'

6

Traveller's Tales

JUNE–OCTOBER 1787

I

Two main motives urged Burns to make his Border tour. One he expressed in a letter of 22nd March to Mrs Dunlop, when he declared that he knew

> no dearer aim than . . . unplagu'd with the routine of business . . . to make leisurely pilgrimages through Caledonia; to sit on the fields of her battles; to wander on the romantic banks of her rivers; and to muse by the stately towers or venerable ruins, once the honoured abodes of her heroes.

The other arose out of an offer made to him by Patrick Miller, who had recently purchased the estate of Dalswinton, on the River Nith, near Dumfries. Miller, a man of some means, was a director of the Bank of Scotland, chairman of the Carron Company, and an inventor whose scientific interests led him to experiment unsuccessfully with a pioneer steam-boat. He may also have been the inventor of a weapon called the Carronade, though Dr Roebuck of Sheffield is also a claimant. In any case, Miller admired Burns's work, and sent the poet an anonymous gift of ten guineas not long after Burns reached Edinburgh. Once Miller's identity was disclosed, he offered the poet the lease of a farm on his estate at what he considered to be an advantageous rent. Miller, however, had little practical knowledge of farming—though, true to the manner of his time, he was a keen agricultural improver—and Robert feared from the start that what was offered to him as an advantageous bargain might, in the long run, prove his ruin.

Burns kept an account of his jaunting, which we know as *The Journal of the Border Tour*. The printed version of both this *Journal* and of the *Journal of the Highland Tour* were first put out edited by

Allan Cunningham. Published in 1834, it is marred by suppressions and additions designed to turn the practical poet-farmer of genius into a sentimental journeyer more in accordance with the nineteenth-century romanticized picture of the poet. (Because of his lack of literary scruple, Allan Cunningham was sarcastically dubbed 'Honest Allan', even in his own lifetime.) A facsimile of the *Journal* appeared in 1927, edited by J. C. Ewing, who, however, shirked the unpleasant conclusion that Allan Cunningham had added the portions not to be seen in Burns's manuscript, leaving the accusation to be levelled by Dr Snyder in 1932. In 1943, Professor De Lancey Ferguson re-edited the text, and it is now to be found in *Robert Burns, His Associates and Contemporaries*, a collection of useful source-papers brought out under the general editorship of Professor Robert T. Fitzhugh.

At Berrywell, Burns noted down favourable comments on his host and hostess, Robert Ainslie's parents, and on their family servants. On Sunday, he went to church at Duns. Next day, he crossed the Tweed at Coldstream, and for the first time set foot on English soil. Ainslie, years after the event, claimed that Burns gave an impromptu theatrical display to celebrate the occasion, praying and blessing Scotland, 'pronouncing aloud, in tones of the deepest devotion, the two concluding stanzas of "The Cotter's Saturday Night".' The picture is as absurd as it is improbable; a mere piece of sentimental Victorian tusherie. The poet's recorded observations are terse and to the point, noting the fact that the 'Tweed was clear and majestic—fine bridge', and that his reception from his host and hostess at Coldstream, a Mr and Mrs Brydon, was 'extremely flattering'.

The two travellers crossed back into Scotland the following day, Tuesday the 8th, breakfasting at Kelso, and visiting Roxburgh Palace and the ruins of Roxburgh Castle, Burns noting 'a holly bush growing where James II of Scotland was accidentally killed by the bursting of a cannon'. Next day they were at Jedburgh, whose situation the poet thought 'charming and romantic ... with gardens, orchards, &c. intermingled among the houses—fine old ruins, a once magnificent Cathedral—All the towns here have the appearance of old rude grandeur'. At Jedburgh, he flirted with a Miss Isabella Lindsay, 'a good-humor'd amiable girl; rather short et embonpoint,

but handsome and extremely graceful'. She occupied his attentions for the next few days, her willingness to be dallied with—much to the annoyance of another rather old spinster whom Burns wished 'curst with eternal desire and damn'd with endless disappointment', to say nothing of being crushed in 'the lowest regions of the bottomless Pit' beneath 'the burden of antiquated Virginity!'—encouraging him to whip himself into the belief that he was in love with her.

On 10th May, he visited Wauchope House, whose good wife, Mrs Elizabeth Scot, had sent him a clever rhyming Scots epistle the previous February. In her verse-letter, she had doubted his rustic origin because of the accomplishment of his work, regretted that she could not enjoy an hour or two with him listening to him reciting his poems, and promised to send him a plaid to keep him warm. Amidst the giddy artificialities of 'Edina', Mrs Scot's homely vernacular and honest sentiment stirred Robert's muse to its country depths. He sent her back a magnificent poetic confession, relating how Nellie Kilpatrick had first awakened his powers in the fields, praising the female sex, and accepting the proffered gift of the 'marled plaid'. 'To the Gude-wife of Wauchope House' also contains a declaration of the poet's dearest wish, formed in, and sustained since, his early adolescence:

> Ev'n then a wish (I mind its pow'r)—
> A wish that to my latest hour
> Shall strongly heave my breast:
> That I for poor auld Scotland's sake
> Some useful plan or book could make
> Or sing a sang at least. . . .

Mrs Scot turned out to have 'exactly the figure and face commonly given to Sancho Panza', but also to possess 'all the sense, taste, intrepidity of force, and bold critical decision which usually distinguishes female Authors'.

From Jedburgh, the travellers moved about the Tweed valley, calling first at Kelso again, where Burns met a Mr Robert Kerr, who agreed to accompany him once Ainslie had returned to Edinburgh. They then visited Dryburgh—'a fine old ruined Abbey'—Melrose,

with its 'far-fam'd, glorious ruins', and Selkirk. Next, they moved up the Ettrick valley—'the whole country hereabout, both on Tweed and Ettrick, remarkably stony'—visited Traquair, and Elibanks and Elibraes.

At Selkirk, Burns wrote to Creech, telling the publisher of his itinerary, and enclosing the lively lament for Creech's absence on business in London, 'Willie's Awa'. ('On William Creech', already referred to, was, of course, written later on, when Creech's unwillingness to come to final terms was causing Robert intense anxiety.) The travellers then came back to Berrywell.

The next lap of the tour took in Berwick—'an idle town but rudely picturesque'—where Burns was pleased to be recognized by Lord Erroll, whom he met by chance 'walking round the walls'. At Eyemouth, Robert recorded that he 'took a sail after dinner', this being, so far as is known, the first time he ever trusted himself to the ocean. There, too, the poet was made an honorary member of the Masonic Lodge of St Abbs, though Ainslie had to pay a guinea for his admittance. Next day, at the 'neat little town' of Dunbar, they were entertained by Provost Fall and his wife. Back at Berrywell, Robert tried another flirtation, this time with his travelling companion's sister, Rachel Ainslie. Even 'the amiable, the sensible, the good-humoured, the sweet Miss Ainslie all alone at Berrywell', could not, however, console him for the loneliness he felt at the departure of her brother.

On the last lap of the Border tour, which took him to Newcastle on 29th May and to Carlisle on the 31st, Mr Kerr and a certain elderly Mr Hood proved to be rather sober company, for, as the poet confessed in a letter to Ainslie written at Newcastle: 'I dare not talk nonsense lest I lose all the little dignity I have among the sober sons of wisdom and discretion.'

From Carlisle, Burns intended to journey alone to Dumfries there to look at the Dalswinton farm. Before leaving the English city, however, he sat down in high spirits to write to his friend William Nicol, classical master in the High School of Edinburgh, and a brother Mason. It is an important letter, this one which bears the date-mark, '1st June 1787—or I believe the 39th o' May rather,' for it is Burns's only letter written entirely in Lallans; and, except for a

little children's story 'The Robin and the Wren' attributed to him by his sister Isabella, the only example of his vigorous Scots prose to come down to us. After giving 'Kind, honest-hearted Willie' a racy account of 'Jenny Geddes's' merits, he recounts his two affairs of the heart.

I hae dander'd owre a' the kintra frae Dumbar to Selcraig, and hae forgather'd wi' monie a guid fallow, and monie a weel far'd hizzie.—I met wi' twa dink quines in particler, ane o' them a sonsie, fine fodgel lass, baith braw and bonie; the tither was a clean-shankit, straught, tight, weel-far'd winch, as blythe's a lintwhite on a flowerie thorn, and as sweet and modest's a new blawn plumrose in a hazle shaw.—They were baith bred to mainers by the beuk, and onie ane o' them has as muckle smeddum and rumblegumtion as the half o' some Presbytries that you and I baith ken.—They play'd me sik a deevil o' a shavie that I daur say if my harigals were turn'd out, yet ye wad see twa nicks i' the heart o' me like the mark o' a kail-whittle in a castock.

At Dumfries, which he reached on 4th June, he was made an honorary freeman. There, he found awaiting him a communication from an Edinburgh innkeeper, Mrs Hogg, relating to another 'weel-far'd winch' who had certainly not been 'bred to mainers by the beuk'. Her name was May Cameron, an Edinburgh servant girl who had given herself to the poet during the winter, with the result that the usual consequences of establishing such a fertile connexion were now beginning to show themselves. Going by what he called 'the Devil's Day-book', Robert reckoned that he could not yet have 'increased her growth much. I begin, from that, and some other circumstances, to suspect foul play'. Nevertheless, the girl's plight stayed in his mind for the next three weeks, and on 25th June he wrote to Ainslie in Edinburgh, asking him to

Please call at the Jas. Hogg mentioned, and send for the wench and give her ten or twelve shillings, but don't for Heaven's sake meddle with her as a Piece.—I insist on this, on your honour; and advise her out to some country (friends). You may perhaps not like the business, but I must tax your friendship thus far.—Call

immediately, or at least as soon as it is dark, for God's sake, lest the poor soul be starving.[1]

In spite of his solicitude for her, the incommoded Miss Cameron was not to be so easily bought off.

In the meantime, however, Robert rode on to Dalswinton, looked over the farm and was poorly impressed, and on 9th June arrived back at Mossgiel unannounced; out of humour with himself and the world at large.

The world at home disgusted him too. It received back a different Burns from the one it had watched ride off to Edinburgh in quest of fame just over six months before. The Burns who had gone, for all the success of the Kilmarnock book, had been an upstart, a social nuisance. The Burns who came back had been approved by the 'greatest' in the land; had journeyed about the countryside, his 'Bardship' everywhere respectfully honoured; and, moreover, had now money of his own, or at least the promise of it.

So the Armours forgot their hostility, welcomed him servilely, and no longer denied him the right to see Jean. He did more than see her, on what he later described to Mrs Dunlop as his 'eclatant return to Mauchline': for, as a result of being 'made very welcome by my girl, the usual consequences began to betray her'.

Things were not going well at Mossgiel either. From Edinburgh, Robert had had to send some emergency loans to Gilbert out of the first of the subscription monies. His mother probably looked to her famous son to help out the less fortunate members of the family.

On top of these problems, he still could not make up his mind how he was to earn his living. The prospect of Jamaica once again passed in review before his imagination. In a mood of irritable ennui, he complained in a letter to Nicol:

> I never, my friend, thought Mankind capable of anything gen-
> erous; but the stateliness of the Patricians in Edn^r, and the ser-
> vility of my plebeian brethren, who perhaps formerly eyed me

[1] De Lancey Ferguson dates this letter June 1788, but admits that it may belong to June of the earlier year. In view of the 'Devil's Day-book' reference in the letter to Ainslie dated 25th June 1787, and written from Arrochar, it seems to me that the earlier date is the more probable.

askance, since I returned home, have nearly put me out of conceit altogether with my species.

Milton's Satan replaced *The Man of Feeling* as his hero.

> I have bought a pocket Milton, which I carry perpetually about with me, in order to study the sentiments—the dauntless magnanimity; the intrepid unyielding independence; the desperate daring, and noble defiance of hardship, in that great personage, Satan.

At least no one would deny that Satan's characteristics as portrayed by Milton were more impressive than those of young Harley. The shift of hero-worship was, at least in one sense, a change for the better.

But Robert was too undecided, and too restless, to settle at home. Within a fortnight of his return, he was off again on another journey, this time into West Argyll, and alone. His first port of call was Glasgow, from where he sent home some fine silk for his mother and sisters. But on this, his second tour, he did not keep a journal, and the first we know of his travels is the fragment of a letter of 25th June to Ainslie, the 'Devil's Day-book' letter, written at Arrochar. Robert tells Ainslie—

> I write this on my tour through a country where savage streams tumble over savage mountains, thinly overspread with savage flocks, which starvingly support as savage inhabitants. My last stage was Inverary—tomorrow night's stage, Dumbarton.

At Dumbarton, after a saddle-less race with a Highlander on Loch Lomondside, in which 'Jenny Geddes' tumbled herself, much bruising her master, the poet was again made an honorary freeman. By the end of the month he was back in Mossgiel.

Was it merely ennui that made Robert suddenly embark on this unaccountable journey? Was it to collect subscriptions still due to him, as his autobiographical letter to Dr Moore suggests? Had the journey something to do with his conscience and the death of Mary Campbell, as Dr Snyder tentatively conjectures? Did he make a pilgrimage to Greenock and seek out her grave, as Mrs Carswell cate-

gorically, but without a single strand of supporting evidence, declares? In all probability, we shall never now know.

He spent July idling moodily at Mossgiel, and writing a stilted elegy on the death of Sir James Hunter Blair, the Ayrshire-born Lord Provost of Edinburgh, as well as sketching out his famous autobiographical letter to Dr John Moore.

This letter, from which I have already quoted extensively, tells the poet's own version of his life-story up to the beginning of the Edinburgh sojourn. It was shown to Mrs Dunlop, who criticized it sharply; left undispatched while Burns went on his Highland Tour; and not actually sent off until 23rd September. Dr John Moore (1729–1802), though he had been settled in London for nearly a decade, was a Stirling man who had been one of Smollett's teachers, and who was the father of Sir John Moore of Corunna. He got to know Burns's work through his friendship with Mrs Dunlop, and thereafter he was zealous in bombarding the poet with wrong-headed advice, urging Burns to give up Scots in favour of English, and to go in for nature poetry. Moore's advice was, indeed, doubly absurd, since not only had Burns very little ability and less self-critical power where the handling of verse in the English tradition was concerned, but he was also quite impervious to scenery of the heroic order. The journals of his tours record only the most mundane comments on views and vistas, while historical associations, unless of direct patriotic significance, seem to have entirely escaped his attention.

Why this letter, and several later important epistles, should have been directed to Moore, whom Burns had never met, has never satisfactorily been explained. Possibly the inflated and temporary reputation which the well-meaning but pompous medico had acquired by virtue of his novel *Zelucco*, published the previous year, made him seem to the poet a person worthy of veneration. In any case, the autobiographical letter finished with yet another indication of Robert's prevailing uncertainty of purpose.

By 8th August, Burns was back again in Edinburgh, three weeks before he had originally planned to begin his Highland Tour with William Nicol. Probably his purpose was to try once again to extract further funds from Creech, since the months of jaunting and idleness and the forthcoming third tour must have combined to

make severe demands on his pocket. He had also helped Gilbert over his difficulties with a loan of £180, on which no interest was to be charged, and for the repayment of which no date had been fixed.

When Burns reached Richmond's Lawnmarket lodgings again, he found this time that another bed-fellow was shortly expected. He therefore moved on the second day to Nicol's house in Buccleuch Square, then a new and fashionable quarter.

He had no sooner settled in than May Cameron, dissatisfied with her 'ten or twelve shillings', took out a writ against him. He admitted liability, and was thereupon formally freed from the unpleasant menace of arrest which the writ implied.

Whether or not his immediate business with Creech was successful we do not know: but by 25th August, Nicol was at last free to travel, and the two men set out for the Highlands, this time travelling in a chaise. 'Nicol thinks it more comfortable than horseback', Burns wrote to Ainslie, 'to which I say Amen'.

II

Burns's *Journal of His Tour in the Highlands* suffered even more than the *Journal of the Border Tour* from the romantic interpolating of Lockhart and/or Cunningham. Here again, however, a facsimile edition has been published, enabling the general reader to see what Burns actually did write. His comments, as in the earlier *Journal*, are terse, revealing a farmer's interest in the state of the soil, and a poet's interest in the human beings whom he encountered on his travels.

The first day, Burns and Nicol journeyed to Falkirk, via Linlithgow, which inspired an outburst that reveals a positively modern sense of the unfitness of many buildings for their purpose!

> What a poor, pimping business is a Presbyterian place of worship, dirty, narrow and squalid, stuck in a corner of old Popish grandeur such as Linlithgow, and, much more, Melrose! ceremony and show, if judiciously thrown in, absolutely necessary for the bulk of mankind both in religious and civil matters.

At Falkirk, on Sunday 26th, we learn from his letter to Robert Muir, he

knelt at the tomb of Sir John the Graham, the gallant friend of the immortal Wallace; and two hours ago I said a fervent prayer for Old Caledonia over the hole in a blue whinstane, where Robert de Bruce fixed his royal standard on the banks of Bannockburn.

The entry about Bannockburn in the *Journal* reads:

> Came on to Bannockburn—shown the old house where James 3d was murdered—the field of Bannockburn—the hole where glorious Bruce set his standard—Come to Stirling.

The 'fervent prayer for Old Caledonia', described in the letter to Muir was, however, too much for Allan Cunningham, who, like James Barke in our own day, delighted in nothing so much as in putting romantic fiction into the dead, defenceless poet's mouth.

> Here no Scot can pass uninterested (Cunningham fabricated). I fancy to myself that I see my gallant heroic countrymen coming o'er the hill and down upon the plunderers of their country, the murderers of their fathers; noble revenge and just hate glowing in every vein, striding more and more eagerly as they approach the oppressive, insulting, blood-thirsty foe! I see them meet in gloriously triumphant congratulation on the victorious field, exulting in their heroic royal leader and rescued liberty and independence!

Although even an eye inexpert in textual criticism should detect that this outburst does not belong to the style of the rest of the *Journal*, reputable critics have been misguided enough to see the 'seeds of famous later songs . . . especially "Scots, wha hae wi' Wallace bled" . . . in these patriotic outbursts'.[1]

In one sense, of course, 'Scots wha hae' probably did arise out of recollections of the Bannockburn visit, though not out of this apocryphal passage; for the fruit of all four tours was the stimulus they gave to the poet's lyric imagination, thus preparing him for the great work with Johnson and Thomson which lay ahead.

At Stirling, Robert was indiscreet enough to allow his Jacobitism poetic expression. With a diamond ring given him by the Earl of

[1] Notably Hans Hecht.

Glencairn, Robert scratched on a tavern window a verse the significance of which would have been obvious even to the dullest-witted.

> The injured Stewart line is gone,
> A race outlandish fills their throne;
> An idiot race, to honour lost;
> Who know them best despise them most.

It is not often that any poet has publicly allowed himself such frank expression on matters affecting the Royal House.

From Stirling, the travellers moved along the Ochils to Harvieston, where Gavin Hamilton's mother, sister Charlotte, and brother were living. Charlotte's close friend Margaret (Peggy) Chalmers, a Mauchline farmer's daughter, was at that moment in Edinburgh. From Harvieston, the travellers crossed the Ochils to Crieff, next day moving up past Ossian's grave to Taymouth, Aberfeldy, and thereafter travelling via Grandtully and Logierait to Blair Atholl. On 31st September, they supped with the Duke and Duchess of Atholl. At Atholl House, the poet was closely observed by Josiah Walker, tutor to the Duke's son. Walker later wrote a study of the poet which, if not always kind, showed more perception than most of the other early biographical studies.

> His person, though strong and well knit, and much superior to what might be expected in a ploughman, was still rather coarse in its outline. His stature, from want of setting up, appeared to be only of the middle size, but was rather above it. His motions were firm and decided, and though without any pretensions to grace, were at the same time so free from clownish constraint, as to show that he had not always been confined to the society of his profession. His countenance was not of that elegant cast which is most frequent among the upper ranks, but it was manly and intelligent, and marked by a thoughtful gravity which shaded at times into sternness. In his large dark eye the most striking index of his genius resided. It was full of mind, and would have been singularly expressive, under the management of one who could employ it with more art, for the purpose of expression.
>
> He was plainly but proudly dressed, in a style midway between

the holiday costume of a farmer and that of the company with which he now associated. In no part of his manner was there the slightest degree of affection. In conversation he was powerful. His conceptions and expression were of corresponding vigour, and on all subjects were as remote as possible from commonplaces.

On the way to Blair Atholl, Burns called at the home of Neil Gow, the prince of Scottish fiddle-composers, and heard him play.

A short, stout-built, honest highland figure (Burns recorded), with his grayish hair shed on his honest social brow—an interesting face, marking strong sense, kind openheartedness mixed with unmistrusting simplicity.

While supping with the Atholls, Burns met a man who was destined to be of inestimable service to him. The meeting is recorded simply as: 'Sup—Duke—Mr Graham of Fintrav'. Graham had just been appointed one of the Scottish Commissioners for the Excise.

On 2nd September, the chaise moved north again; past snow-clad hills; past the falls of Bruar (which produced the decidedly forced lines 'The Humble Petition of Bruar Water'), Dalwhinnie, Aviemore and Dulsie, to Castle Cawdor, where Macbeth murdered Duncan—'saw the bed in which King Duncan was stabbed'—and thence via Fort George to Inverness.

Across Culloden Moor—'Come over Culloden Muir—reflections on the field of battle' is the only comment the glorious dying-ground of the Stewart cause wrung from the Jacobite poet's bosom!—through Nairn, Elgin and Forres, the route led to Fochabers and Castle Gordon, where the Duke and Duchess of Gordon gave the poet a warm welcome and invited him to stay the night. Unfortunately, the Duke apparently failed to give the gruff Nicol an equally warm welcome; and as the affronted pedagogue refused to be relegated to the local inn, Burns had to accompany him on to Cullen, where they spent the night. Excusing himself later in a note accompanying a song ('Streams that glide in orient plains') which he sent to James Hay, the Duke's librarian, Burns lamented 'that unlucky predicament which hurried me, tore me

away from Castle Gordon', and blames that 'obstinate son of Latin-Prose', Nicol, for the affair.

From Cullen, they passed through Banff, Peterhead and Ellon, to Aberdeen. Here, Burns met Bishop Skinner, son of the still-living though venerable author of 'Tullochgorum', and other Scots songs. He also met the deformed minor poet Andrew Shirrefs—'a little decrepit body with some abilities'—who wrote the decidedly feebly pastoral poem 'Jamie and Bess' in imitation of 'The Gentle Shepherd', as well as a magnificent drinking song, 'A Cogie o' Yill', and who finally disappeared in the sordid broken-men's circles of London, after failing in business as an Edinburgh stationer.

In Aberdeenshire, Burns was now back, for the first time, on the soil which had reared his grandfather. He gratified his strong sense of family feeling by visiting several of his distant relations still resident in the district. At Stonehaven, he recorded that he met:

> Robert Burnes, writer in Stonehaven, one of these who love fun, a gill, a punning joke, and have not a bad heart—his wife a sweet hospitable body, without any affectation of what is called town-breeding.

From a letter written to Gilbert on 17th September, after the tour was over, we learn that the poet also met by appointment:

> James Burnes from Montrose. . . . I spent two days among our relations, and found our aunts, Jean and Isabel still alive and hale old women.

On the 13th, he breakfasted at the little fishing village of Auchmithie, thereafter making his second sea excursion along the 'wild rocky coast' to see 'the caverns, particularly the Geary Pot'.

Disembarking at Arbroath, Burns and Nicol travelled on to Dundee, spending a night there, another at Perth, and the final night at Kinross. The entry for Sunday, 10th September reads: 'Come through a cold barren country to Queensferry—dine—cross the Ferry, and come to Edinburgh.'

So ended the longest of Burns's tours. Nicol may have been a less amiable companion than Ainslie, but the ground covered was more

extensive than that traversed in the Border Tour; and there was also the additional pleasure of the reunion with his north-east relations, an event which must have given much satisfaction to one whose family feelings were as loyal as Robert's were. He had found it all, he later wrote to Patrick Miller, 'perfectly inspiring'; and from it, too, he hoped he had laid in 'a good stock of new poetical ideas'.

His main business with Miller, and indeed with himself at that moment was not, however, 'poetical ideas', but whether or not he should accept the offer of the farm at Dalswinton. On 28th September, he tells Miller that he is determined not to leave Edinburgh until he has settled with Creech—his efforts were, of course, once again unsuccessful. Should Miller have left Dalswinton by the time the business is concluded, then Burns presumes he may deal with Miller's factor. But in the event, it was not Creech who caused the final delay.

Robert had long since become a family man without a father's ties or a husband's protracted responsibilities. As well as 'dear-bought Bess', there were Jean's twins. And Jean was pregnant again. So, of course, was May Cameron. Apart from 'the curs'd expense of bastards', which he had once lamented, the welter of emotional conflict implied by it all could not possibly be conducive to any settling down. And Burns now badly wanted to settle down.

Early in October, with the affair of Dalswinton still in suspense, he rode off on his fourth tour, along the Ochils. For company he had Dr James Adair, the son of an Ayr doctor who was related to Mrs Dunlop. He had met Adair through his friend Lawrie of Loudon, and taken an instant liking to him.

This time, Burns did not keep a journal. The travellers passed through Linlithgow, to Stirling. Here, they fell in with Nicol, and the poet is said to have smashed the tavern window which still bore the evidence of his Jacobitism inscribed during his previous visit. But their destination was Harvieston House. Burns may have first seen Margaret Chalmers in Ayrshire; he himself says he met her in the Ochils, though it seems surprising that he did not meet her during the Edinburgh winter of 1786–7, when she regularly read and sang to blind Dr Blacklock. In any case, though not particularly beautiful, she was, in her limited way, an intellectual.

Burns's letters to her abound in quotations and more or less elementary French tags, no doubt inserted because he felt they would make a good impression on a person of her cultural stature. She, at any rate, made a deep impression on him—so much so that he once confessed to her—'when you whisper, or look kindly to another, it gives me a draught of damnation'. That, surely, is the heart's cry of a man desperately in love.

One is sometimes tempted, remembering Burns's casual emotional attitude to Elizabeth Paton, his absence of any sustained emotional attitude at all to May Cameron and her successors Jenny Clow and Anna Park, and his apparent luke-warmness towards Jean, that he was never really so much in love with any woman as with Woman in general—'the sex', as he liked to call them. So long as a girl was willing to submit to him, then for the time being he was satisfied. After his women had given themselves, he seems to have recked little enough for their emotions, though he never failed to show a genuine love for the innocent fruits of his amours.

The reason for this may well have been that he never succeeded in conquering a woman who came anywhere near to being his own intellectual equal. He who so perfectly understood the passions of the human heart and the desires and exultations of the flesh, was, so far as we know, denied the supreme satisfaction of a union in which bodily and intellectual love mingled.[1]

He might, to some extent, have had such love from Agnes Maclehose (Clarinda); but, like Maria Riddell later on, she was already bound by ties of marriage when Robert got to know her. He would almost certainly have had it from Margaret Chalmers. The eight days he spent in her company during his fourth tour were amongst the happiest of his life. Probably he proposed to her and she refused, preferring the humdrum sureness of an Edinburgh advocate, Lewis Hay. There is something infinitely touching about the keenness of

[1] 'Circumstanced as I am,' he wrote to Mrs Dunlop on 10th August 1788, 'I could never have got a female Partner for life who could have entered into my favourite studies, relished my favourite Authors, &c, without entailing on me, at the same time, expensive living, fantastic caprice, apish affectation, with all the other blessed Boarding-school acquirements . . . which are sometimes to be found among females of the upper ranks, but almost universally pervade the Misses of the would-be-gentry.'

Robert's sense of loss in the last letter[1] he wrote Margaret Chalmers, a year after union with her was no longer possible.

> When I think I have met with you, and have lived more of real life with you in eight days than I can do with almost anybody I meet with in eight years—when I think on the improbability of meeting you in this world again—I could sit down and cry like a child!

It may well have been that Burns's restless and promiscuous sexual activity was but a sign of a deep frustration. The Mariolaters of the nineteenth century attempted to make of Mary Campbell the ideal 'spiritual' love of his life; but, as I have already indicated, the evidence suggests that she was, in fact, merely another peasant-girl beguiled into lifting her skirts by the force of Robert's personality and the urgency of his desire. In any event those very skirts may well have been lifted to others before.[2] If anyone whom he sought could have given Robert love on his own terms, Margaret Chalmers was surely that woman: yet she chose not to.

Adair was more fortunate. He fell in love with Charlotte Hamilton, and married her on 16th November 1789.

To console himself for his disappointment, Burns made numerous visits and pilgrimages—to Sir William Murray of Ochtertyre, in Strathearn; and to that dignified and conscientious recorder of the manners of his times, John Ramsay, of the more famous Ochtertyre in Kincardine.[3]

[1] 16th September 1788, from Ellisland.

[2] The Train Manuscript, edited by Professor Fitzhugh, gives Grierson's report on 'Highland Mary's' character—'Loose in the extreme'—and the alleged details of some of her earlier amours in which factual errors occur, though in recent years Train's reputation has been much vindicated by the discovery amongst the Abbotsford papers of some of the documents from which he claimed to have drawn his information.

[3] Ramsay, in his memoirs *Scotland and Scotsmen*, commented that Burns's principles were 'abundantly motely—he being a Jacobite, an Arminian, and a Socinian'. As their discussion seems to have been mostly about religion, Ramsay perhaps did not observe that the Jacobite who hankered after the return of the absolute monarchy of the Stuarts, hankered even more strongly after the liberation of the lower classes from feudalistic subservience to titled landowners.

The two travellers also called on the venerable Mrs Bruce of Clack-mannan Tower, last of a line sprung from a younger brother of Robert the Bruce's father. She 'knighted' the bard with the Bruce's great sword, remarking that she had a better right to perform the ceremony than some people—an honour she also conferred on the Scottish lexicographer Dr Jamieson a few months later. At Dun-fermline, the travellers visited the ruined Abbey—it was not re-stored until the second decade of the nineteenth century—where Adair mounted the cutty-stool of repentance, in the manner of a penitent fornicator, while Robert delivered a comic parody from the pulpit of the admonition inflicted upon him in Ayrshire by 'Daddy' Auld over the Elizabeth Paton affair.

On Saturday 20th October, they crossed the North Ferry, and arrived back in Edinburgh, Burns suffering from a heavy cold. He accepted the offer of a room at the home of William Cruikshank—like Nicol, a Classical Master in the High School of Edinburgh—at No. 2 St James's Square,[1] firmly resolved to settle with Creech as quickly as possible, and to make his decision, one way or the other, in the matter of the farm at Dalswinton.

[1] Now part of Register House.

7
Edinburgh: The Second Winter
1787–8

I

No sooner was Burns back in Edinburgh than he enthusiastically began the work of collecting and refurbishing Scots songs for James Johnson. On 25th October, he wrote to Richmond:

> I am busy at present assisting with a Collection of Scotch Songs set to Music by an Engraver in this town.—It is to contain all the Scotch Songs, those that have already been set to music and those that have not, that can be found.— . . . By the way, I hear I am a girl out of pocket and by careless, murdering mischance too, which has provoked me and vexed me a good deal.— I beg you will write me by post immediately on receipt of this, and let me know the news of Armour's family, if the world begin to talk of Jean's appearance any way.

The 'girl out of pocket' was Jean, the girl-twin, who had died earlier in the month. Grief at her loss—uneasily concealed behind the nonchalant manner of expressing it—and anxiety about the complications likely to ensue over the pregnant condition of her mother, together with a renewed attack of the old 'hypochondria', combined to make Robert restless and unhappy at the beginning of his second Edinburgh winter. Creech's continued refusal to settle forced the poet to extend his intended fortnight's stay week after week, while a second rapid visit to the farm at Dalswinton merely served to reinforce Robert's doubts as to its potentialities. So he continued to dilly-dally for a few more months, restlessly evading the inevitable issues of how he was to earn his living and cope with his increasing family problems. But at first, the business of Scots song engaged most of his attention, and the major part of his creative energies.

Johnson's powers were far from equal to his high aims. For the first volume of the *Museum*, which appeared in May 1787, too late for Burns to conribute more than a couple of songs, the little engraver had drawn his words generously from Ramsay's *Tea-Table Miscellany*, including English verses of obvious mediocrity, and falling back upon English airs to eke out his supply of tunes. Burns was determined that in future bad or silly words must not be sung to beautiful airs, and that only genuine Scots airs should be used. By the autumn of 1787 he had, in fact, become the unacknowledged literary editor of *The Scots Musical Museum*, co-operating with the musical editor, Stephen Clarke, organist of the Episcopal Church in the Cowgate. In spite of the fact that the *Museum* without Burns's aid would have been a small and insignificant collection, relying on tunes from such older collections as Thomson's *Orpheus Caledonius* (1725) and Oswald's *Caledonian Pocket Companion* (1753), the poet more than once reminded Johnson of his subservience to his wishes. Johnson fortunately appreciated the merits and abilities of his great colleague, and allowed Burns his head. The two men became warm friends—Johnson was also a Crochallan Fencible —and the poet must have passed many happy hours in the engraver's office.

Burns adopted several methods of song-collection. He wrote round his poetaster friends like Margaret Chalmers, Dr Blacklock, the Duke of Gordon (through his librarian) and later Mrs Maclehose, touching up the rather feeble social verses which they sent in reply, and causing them to be matched to tunes. He also enlisted the aid of such genuine minor poets as old Dr John Skinner, 'author of the best Scotch Song ever Scotland saw—Tullochgorum's my delight!'

> The world may think slightingly of the craft of song-making, if they please (Burns told Skinner on 28th October), but, as Job says—'O that mine adversary had written a book!'—let them try. There is a certain something in the old Scotch songs, a wild happiness of thought and expression, which peculiarly marks them, not only from English songs, but also from the modern efforts of song-wrights, in our native manner and language. . . .

Besides that 'certain something', there was often also an element of bawdry, which, much as he appreciated it, Burns realized could not be allowed to remain in such a comprehensive and permanent collection as the *Museum*. For Johnson, therefore, he polished and refined, expurgating indecencies, mending broken fragments, and always stamping the finished product with the warm impress of his own lyric genius. The bawdry he transcribed for *The Merry Muses*, first got together for the entertainment of the Crochallan Fencibles, and later added to for his own amusement.

Besides patching half-forgotten fragments of old songs and stimulating others to write for him, Burns also wrote his own words to many tunes that had either lost their own, or had never had any. He had old song-books to draw upon, such as *The Lark* (1765), *The Scots Nightingale* (1779) and *St Cecilia* (1779). He also had a great number of collections of dance tunes.

During the latter half of the eighteenth century, dancing, so long suppressed as sinful by the Calvinists, came back into fashion, though at first under strict surveillance. As Scotland was still nationally conscious, the dances most favoured by lady and serving-lass alike were the native reels and strathspeys. Under the stimulus of the demand they created, there grew up and flourished a whole host of fiddle-composers, much of whose music in the vernacular, though composed in the virile traditional folk-idiom, and often incorporating (unacknowledged) older tunes, abounded in original melodic invention. For many of the airs of, for instance, James Oswald (1711–69), Daniel Dow (1732–83), William McGibbon (1695–1756), William Marshall (1748–1833)—Burns thought him the 'first composer of strathspeys of the age'—and Neil Gow (1727–1807), no words had ever existed. Burns matched words of his own to some of them, having a keen ear for the potential emotional qualities of a quick tune at a slower tempo, as is admirably shown by his sloweddown adaptation of Marshall's 'Miss Admiral Gordon's Strathspey' to go with his own lovely song 'Of a' the airts the wind can blaw'.

His earlier attempts at fiddle-playing no doubt made him sufficiently acquainted with musical notation to be able to record for subsequent transmission to Clarke the tunes he heard as he rode about

the countryside.[1] He may, of course, have memorized such tunes as 'Ca' the Yowes' which he got from an old drunken woman at Irvine, Tibbie Pagan, and later sung them over to Clarke. But even to memorize folk-tunes heard once or twice in this way would call for no small amount of natural musicianship. In any case, he so thoroughly mastered all the collections available to him, that he was later able to tell George Thomson:

> Will you let me have a list of your airs, with the first line of the verses you intend for them. . . . I say, the first line of the verses, because if they are verses that have appeared in any of our Collections of songs, I know them and can have recourse to them.

Burns's interest in the *Museum* never flagged, as many hurriedly scribbled notes dispatched over the next few years, urging on the business, or asking for more words, testify. Sometimes, as in his letter of 15th November 1788, the poet found it necessary to exhort the engraver to maintain the impetus of his enthusiasm, as the scope of the work kept extending itself.

> I can easily see, my dear Friend, that you will very probably have four Volumes.—Perhaps you may not find your account, *lucratively*, in this business; but you are a Patriot for the Music of your Country; and I am certain, Posterity will look on themselves as highly indebted to your Publick spirit.—Be not in a hurry; let us go on correctly; and your name shall be immortal.

That Burns also found it necessary to exhort Stephen Clarke to greater productiveness is shown by the humorously sarcastic note of 16th July 1792.

> Mr B—is deeply impressed with, & awefully conscious of, the high importance of Mr C—'s time, whether in the winged moments of symphonious exhibition at the keys of Harmony,

[1] One or two examples of Burns's music-manuscript have come down to us. Some writers take the view that they show so laboured a hand that they must have been painstakingly copied. Actually, it is as hard to achieve a good music-hand as it is to develop good penmanship. Burns was unlikely ever to have had enough practice at writing notes down to gain any fluency, and the examples may therefore be his quite normal unpractised attempts.

while listening Seraphs cease from their own less delightful strains; or in the drowsy hours of slumberous repose, in the arms of his dearly beloved elbow-chair, where the frowsy but potent Power of Indolence circumfuses her vaprous round, & sheds her dews on, the head of her DARLING SON—but half a line conveying half a meaning from Mr C—would make Mr B—the very happiest of mortals.—

The plain truth was, of course, that Clarke was by nature indolent. Once, he even went so far as to lose a song-packet, not all of which Burns could replace from memory. It certainly is not at all likely that 'listening Seraphs' would have been much impressed by Clarke's harmonies in the *Museum*, for they are so rudimentary as at times to be positively crude. They certainly conform to the theory of Edinburgh's eighteenth-century musical historian, Hugo Arnot, that

> The proper accompaniment of a Scots song is a plain thin dropping base, on the harpsichord or guitar. . . . The full chords of a thorough bass should be used sparingly and with judgement, not to overpower but to support and raise the voice at proper pauses.

At least Clarke's accompaniments were more practical than the florid versions[1] which Burns's later collaborator George Thomson so mistakenly commissioned from some of the leading foreign composers of the day.

Volume Two of the *Museum*—the first which Burns edited—appeared in 1788. It contained forty of his own songs out of a total of a hundred, and a good deal less mediocre drawing-room gentilities in neo-classical English than the first. Volume Three, published in 1790, while Burns was at Ellisland, had approximately fifty songs of his in it, as had also Volume Four, which came out two years later. Because Burns diverted some of his energies when he also undertook to help Thomson collect his *Select Scottish Airs*, the Fifth Volume of the *Museum* did not appear until 1796, though probably it was almost ready for the press at the time of Burns's death.

[1] Those by Haydn and Beethoven, however, have charm, and are of interest, as chippings from the workshops of two of the greatest of composers. Will anyone claim more of twentieth century accompaniments such as Britten's two centuries hence.

Johnson being once again on his own—Clarke died soon after Burns—it took him eleven more years to bring out the Sixth and last Volume, in spite of the fact that his great collaborator had left him plenty of material.

Very few of Burns's contributions to the *Museum* were actually shown as his. After the mystifying manner of the age, he worked out a kind of letter-code to indicate which songs were his, which were remodelled, and in what degree. But in practice, the letters ('K' and 'X' for his own songs, 'Z' for old songs remodelled) are hopelessly misleading, since many songs known from other sources to be by Burns are not lettered at all. Why he should have thus apparently sought after a deliberate semi-anonymity is far from clear. Perhaps he felt that the business of Scottish Song was so near to his heart that he shrank from allowing his contributions, the products of his willing fancy, to face the disinterested criticism of the polite Edinburgh set. Perhaps he thought, too, that when the time should come for him to bring out his best songs in book form, his claims to his own property would then be clearly enough established. But that time, alas, was not to come, though after his death Johnson made some attempt publicly to restore at least part of the credit to where it belonged.

While song was beginning to occupy all Robert's creative powers, he was suddenly drawn into the vortex of a love affair more strange and, in the end, more futile than any he had hitherto experienced.

II

The only practical alternative to farming which Robert seriously considered as a means of earning his living, was a job with the Excise. He had sounded some of his friends about it as early as the autumn of 1786, amongst others Sir John Whitefoord, the Ayrshire laird, who referred to 'your wish to be made a gauger' in a letter to Burns dated 6th December 1786. Thereafter, the matter apparently lay dormant in Burns's mind for about a year.

By the beginning of December 1787, however, and in spite of the pleasure he was finding in his song-work for Johnson, the question of his future livelihood had become desperately urgent. It was then

clearly still the poet's desire to leave Edinburgh as soon as he could be quit of Creech. The Dalswinton farm had to be accepted or rejected: there was now no new edition of his poems in preparation to occupy his attention, or later, to put a new crest of froth on the surge of his fame: the Edinburgh patricians, as he had foreseen, were much less interested in 'the plowman poet' a second winter, when he was no longer 'the rage'; especially since his reputation for outbursts of frankness at polite parties and rumours of his too-great fondness, even preference, for impolite ones were reaching the ears of his genteel hostesses. And he had given needless offence in some quarters by appearing in Tory drawing-rooms wearing a waistcoat of Foxite buff and blue.

So Robert began to say his farewells. On 6th December, perhaps because of some aspect of his Excise ideas, he attended a tea-party at the house of a revenue-officer, John Nimmo. His hostess, Nimmo's slightly soured spinster sister, introduced him to a Mrs James Maclehose, by previous arrangement with that lady.

Agnes—or Nancy, as she was known to her friends—had had an unfortunate life. She had been born, twenty-nine years before, to the wife of a Glasgow surgeon, Andrew Craig. However, several of her ancestors had been ministers, and there was ingrained in her a good deal of that unctuous self-piety associated with the habits of mind of extreme Calvinists. In her day, girls—even the daughters of Glasgow medicos—were scarcely thought worth educating, except in the development of such allurements as were considered necessary to attract a suitable husband. Nancy's allurements were mostly natural; a bosomy figure (as we may see in the Miers silhouette), large, fluttering bright eyes, and a smattering of culture sufficient to encourage poetic pretensions. The first two of these attractions interested James Maclehose, a dissolute young Glasgow law agent, who, although he was forbidden the house by Nancy's disapproving father, found ways and means of seeing her elsewhere—for instance, by making himself the only other occupant of the Glasgow-Edinburgh coach by which Nancy happened to be travelling. This James accomplished by having purchased all but one of the other seats in the coach. The upshot was that in spite of her father and her uncle, Lord Craig, a dignified Edinburgh Lord of Session, Nancy

succumbed to the law-agent's blandishments, and in 1776, became Mrs Maclehose. Four years later, after she had presented her already shiftless husband with three children (of whom two survived), Nancy went back to her father's roof, taking her children with her.

But her father died in 1782, so Nancy came to Edinburgh in search of more up-to-date culture. She lived in a tiny flat off the Potter Row on a small annuity derived from the investment of her father's estate, and suppplemented from time to time by gifts from her uncle, Lord Craig.

Maclehose, in the meantime, lived upon his family, until at length they refused to pay his debts any longer. In 1784, he therefore borrowed the fare from his mother (whom he never repaid) and set sail for Jamaica, that hopeful haven for eighteenth-century Scots in difficulties.

Nancy's interest in culture generally, was no doubt of the ardent, fluffy-minded, dilettante kind still to be met with today amongst amateur lady-poetasters. Her interest in Robert was probably two-fold. There was Mr Burns's poetry, which was winning him such a reputation amongst the best people in Edinburgh. And, of course, there was Mr Burns's equally celebrated reputation for having a way with women. (And women, as Hilton Brown remarks, 'whatever they may profess to the contrary . . . have always at heart a sneaking admiration for a stallion'.) Whatever the mixture of her reasoning, her determination to meet Burns was suitably rewarded.

They met: Robert at once willing to be interested in a practical way, as he was with all suitable women; Nancy making her meaning as clear as the two warring elements of her personality would allow. These elements were the natural hedonistic instincts of any healthy young person whose physical desires have been awakened, then frustrated; and her inherited conviction—which, however, only operated intermittently—that pleasure in this world should not be purchased at the price of damnation in a Calvinistic future world. However, after Miss Nimmo's tea-party, Nancy went straight home and wrote Robert a note inviting him to drink tea with her the following Thursday. He was unable to come on that day, but he could and would come instead on Saturday.

Thereupon, 'Fate held up her finger in warning', in the words of

one biographer: or 'the Devil, seeing his opportunity, stepped in', according to another! What happened, in plain fact, was that the actions of a drunken coachman caused the poet to fall from a coach, with the result that he was bruised by 'a good, serious agonising, damn'd, hard knock on the knee'. His doctor, 'Lang' Sandy Wood, made him lie up. The Saturday tea-party also had to be postponed.

Burns wrote to explain the nature of his mishap on 'Saturday even', 8th December (if the letter-date may be believed, since many of them were later tampered with, for some inexplicable reason, by Mrs Maclehose). In this note, he boldly took up the challenge of the larger invitation which the bright eyes and the plumply rounded figure of the grass-widow seemed to offer.

> I can say with truth, Madam, that I never met with a person in my life whom I more anxiously wished to meet again than yourself.... I know not how to account for it—I am strangely taken with some people; nor am I often mistaken. You are a stranger to me; but I am an odd being: some yet unnamed feelings; things, not principles, but better than whims, carry me farther than boasted reason ever did a Philosopher.

What a flutter the thought of those 'unnamed feelings' must have caused in the heart that beat below Nancy's discreet *fichu*, as she sat down that very evening to reply!

Those 'nameless feelings', she wrote

> I perfectly comprehend.... Perhaps instinct comes nearer their description than either 'Principles' or 'Whims'. Think ye they have any connection with that 'heavenly light which leads astray'? One thing I know, that they have a powerful affect on me, and are delightful when under the check of reason and religion.... Pardon any little freedoms I take with you.

Rarely can a would-be wooer have received encouragement more baffling. On the one hand, he was clearly bidden to go on; on the other, 'reason'—which knows no place in a lover's vocabulary—and 'religion', were pointed out as ultimate, if perhaps distant, barriers.

When Robert next wrote, on 12th December, he was acknowledging verses sent by Nancy four days before.

'Your lines, I maintain it, are poetry, and good poetry . . .' he told her: and he followed up this compliment with:

'. . . friendship . . . had I been so blest as to have met with you *in time*, might have led me—God of love only knows where.'

This, the first mention of 'love', drew from Nancy a sharp reproof: 'Do you remember that she whom you address is a married woman?'

Blocked in his direct frontal approach by the barrier of 'reason', Robert retreated, soothing over his indiscretion, and at the same time following up the more promising indirect line of literary flattery. Professor Gregory had seen Nancy's verses and pronounced them good. Nancy was delighted. A few days later, she expressed the wish to meet Gregory. At Christmas, there was again an exchange of verses, Nancy sending to Robert—

> Talk not of Love, it gives me pain,
> For Love has been my foe;
> He bound me with an iron chain,
> And plunged me deep in woe.

—a fair enough reaction to such an unhappy marriage as hers. The last verse, however, again reminded the recipient of those ultimate barriers which must not be crossed.

> Your Friendship much can make me blest,
> O, why that bliss destroy!
> Why urge the odious, one request
> You know I must deny!

This 'one request' was, of course, by no means 'odious' to Robert, so he suggested that 'only' might be substituted when he matched the poem to the tune 'The Borders of Spey' for the *Museum*. To call Nancy's verse 'worthy of Sappho' was meantime a further sweeping advance along the line of literary flattery. Willingly Robert fell in with her idea of using the Arcadian names of Clarinda and Sylvander in their correspondence. Meanwhile, on 28th December he risked another frontal advance.

I do love you if possible still better for having so fine a taste and turn for Poesy.—I have again gone wrong in my usual unguarded way, but you may erase the word, and put esteem, respect, or any other tame Dutch expression you please in its place.

But the word could no longer be erased. In something of a panic, Clarinda hastily retreated, this time behind the barrier of religion!

Religion, the only refuge of the unfortunate, has been my balm in every woe. O! could I make her appear to you as she has done to me! . . . I entreat you not to mention our corresponding to anyone on earth. Though I've conscious innocence, my situation is a delicate one.

It was indeed. After only one brief meeting, she was deeply in love with a man whose ardent impetuosity both thrilled and frightened her. Her stern, Calvinistic spiritual adviser, the Reverend John Kemp, minister of the Tolbooth Church, would certainly not have approved of the amorous 'commerce' in which she had got herself engaged. Nor would Lord Craig, upon whose generosity she depended for the little extras which lightened, not only her own life, but those of her children, to whom she was genuinely devoted. Somehow, then, she had to devise a means of continuing to attract Burns, yet at the same time refusing the complete physical surrender which her lover craved. The situation was more than delicate: it was an impossible one, containing both the elements of tragedy and of comedy. Their relationship moved rapidly towards its climax in the first month of the New Year, 1788.

To the friend of his youth, and the early stimulator both of his poetic and his amorous propensities, Captain Richard Brown, whose ship was then in port at Irvine, Robert wrote:

Almighty Love still 'reigns and revels' in my bosom; and I am at this moment ready to hang myself for a young Edinr widow.

On 5th January, Robert, hirpling still and travelling to and from the Potter Row in a sedan chair, was able to visit Nancy. During this, the first of six visits that month, he so upset Nancy's religious sensibilities by revealing his admiration for Milton's Satan that he had hastily to explain that he only admired Satan's 'manly fortitude in

supporting what cannot be remedied—in short, the wild broken fragments of a noble, exalted mind in ruins'. Robert showed Nancy his letter to Dr John Moore, thus sketching in for her his own background; he also told her about Jean's condition. The affair moved relentlessly to its hopeless crux between the 12th and the 23rd of January.

After his visit of the 12th, Burns found that his love-making had come fairly and squarely up against the barrier of 'religion'. Clarinda wrote nervously:

> I will not deny it, Sylvander, last night was one of the most exquisite I ever experienced. Few such fall to the lot of mortals! Few, extremely few, are formed to relish such refined enjoyment. That it should be so, vindicates the wisdom of Heaven. But though our enjoyment did not lead beyond the limits of virtue, yet to-day's reflections have not been altogether unmixed with regret.

Her lover reassured her once again.

> I would not purchase the dearest gratification on earth, if it must be at your expense in worldly censure; far less inward peace.

Between the 12th of January and the 23rd, the temperature of the letters also rose steadily. Together again on the 23rd, Sylvander apparently pushed his love-making to the furthest limits it was possible to go, short of intercourse. Afterwards, Clarinda clearly realized that they had come at last to the edge of an abyss, with only 'reason' and 'religion'—barriers which meant little enough to her lover—to hold them back. Her reaction was one of womanly terror.

> I am neither well nor happy. My heart reproaches me for last night. If you wish Clarinda to regain her peace, determine against anything but what the strictest delicacy warrants.

Robert's reply was an impassioned outpouring of hurt protestations, beginning:

> Clarinda, my life, you have wounded my soul . . .

and pledging

Sylvander's honour . . . that you shall never more complain of his conduct.

There was a further impassioned meeting on 26th January, after which Clarinda protested, more mildly:

Perhaps the line you had marked was a little infringed—it was really; but though I disapprove I have not been unhappy about it.

This might have given Robert renewed hope, but the letter was intermingled with long stretches of religious advice anent the salvation of his soul *pace* the Reverend Kemp. 'I wish our kind feelings were more moderate,' she went on, '. . . try me merely as your friend.'

For Burns, whose passion was by now white-hot, friendship of this sort was of little use. So eventually his thwarted physical desire found expression in the merest animal union with Jenny Clow, a serving-girl about whom nothing is known. In vain now did Clarinda, desperate lest her denials should cause her to lose him, hint on 6th February at getting her freedom.

'Your friend may yet live to surmount the wintry blasts of life and revive to taste a spring time of happiness.' In vain did Burns reassure her (and himself) that he was hers 'for life', and in vain did he protest: 'I esteem you, I love you, as a friend; I admire you, I love you, as a woman beyond any one in all the circle of creation.' His mind was probably already revolving around another course, and on his departure from the city, imminent at last.

There was one final hectic exchange of letters just before Burns rode away. People had begun to couple Nancy's and Robert's names, in that brutal, scandalmongering way people (whose own lives are usually devoid of the exultation and excitement of love) frequently do. Clarinda had been reprimanded in writing, perhaps by Mr Kemp, perhaps by Lord Craig himself. In great distress, she sent Burns this 'haughty dictatorial letter', drawing from him four letters written in close succession, dated the 13th, two the 14th, and one the 15th. They apologize for the 'injury' Sylvander has caused to Clarinda's reputation: they protest eternal and disinterested friendship; but they do not offer much in the way of real hope.

Look forward; in a few weeks I shall be some where or other out of the possibility of seeing you: till then, I shall write you often, but visit you seldom. . . . Be comforted, my Love! the present moment is the worst; the lenient hand of Time is daily and hourly either lightening the burden, or making us insensible to the weight.

On 18th February, Burns set his horse towards the west. The business of settling what was to be his future means of livelihood could no longer be evaded. In his saddle-bags, he carried Clarinda's present of two shirts for little Robert, Jean's surviving twin at Mossgiel.

There can be very little doubt that Clarinda was genuinely and deeply in love with Burns more or less from the start. It seems to me to be an inescapable conclusion that up to about 26th January Burns was also in love with Clarinda. But the situation, as I have said, was always hopeless and bound to end in heartbreak, at least for the woman. Yet when Burns left her to go back, by way of Glasgow, to Mossgiel, she seems to have thought, in some obscure womanly way, that she was sure of him.

In Glasgow, Robert spent a merry evening with his old friend Captain Richard Brown, and another at Paisley with a merchant called Alexander Pattison. From Kilmarnock, where he saw his friend the wine merchant Robert Muir, by this time desperately ill with tuberculosis, he wrote a letter to Clarinda, filled out not with the promised messages of love but with boring details about his 'worthy friend Mr Pattison', whom Clarinda did not even know.

He then moved on to Dunlop House, near Stewarton, where he spent two pleasant days with his 'mother-confessor', whom he was meeting for the first time. On Saturday, 23rd February, he called at 'Willie's Mill', Tarbolton, the home of his friend William Muir, whither Jean Armour had been banished—or gone voluntarily to escape the nagging of her parents, irritated at her second lapse and, this time, her failure to 'land' her man. Later the same day, Robert arrived at Mossgiel and wrote again to Clarinda.

Now for a little news that will please you.—I, this morning as I came home, called for a certain woman.—I am disgusted with her; I cannot endure her! I, while my heart smote me for the

prophanity, tried to compare her with my Clarinda; 'twas setting
the expiring glimmer of a farthing taper beside the cloudless glory
of the meridian sun.—Here was tasteless insipidity, vulgarity of
soul, and mercenary fawning; there, polished good sense, heaven-
born genius, and the most generous, the most delicate, the most
tender Passion.—I have done with her, and she with me. . . . I set
off to-morrow for Dumfriesshire.—'Tis merely out of compli-
ment to Mr Miller, for I know the Excise must be my lot. . . .

Clarinda must have been more than ever reassured. A farthing taper
could surely count for little indeed, set against a meridian sun? The
taper, however, was accessible; the sun was not.

<div align="center">III</div>

Back at Mossgiel, Robert made arrangements to inspect the Dal-
swinton estate farm again, this time, since he did not trust his own
judgement, in company with a friend of his father's generation,
John Tennant of Glenconner. On the whole, the poet's instinct
seems to have warned him against Ellisland from the start. At any
rate, before he left Edinburgh, Robert had written both to Robert
Graham of Fintry, whom he had first met on the Highland Tour at
Atholl House, and to the Earl of Glencairn soliciting their influence
on his behalf with a view to his being given an Excise appointment.
To Glencairn he said:

> I know your Lordship will disapprove of my ideas in a request
> I am going to make to you, but I have weighed seriously my
> situation, my hopes and turn of mind, and am fully fixed to my
> scheme if I can possible effectuate it.—I wish to get into the
> Excise; I am told that your Lordship's interest will easily procure
> me the grant from the Commissioners; and your Lordship's
> Patronage and Goodness which have already rescued me from
> obscurity, wretchedness and exile, embolden me to ask that
> interest.

After a Shakesperian reference highly flattering to the recipient,
Robert thus stated his business to Robert Graham.

You know, I dare say, of an application I lately made to your Board, to be admitted an Officer of Excise.—I have, according to form, been examined by a Supervisor, and today I give in his Certificate with a request for an Order for instructions.—In this affair, if I succeed, I am afraid I shall but too much need a patronising Friend.—Propriety of conduct as a Man, and fidety [*sic*] and attention as an Officer, I dare engage for; but with any thing like business I am totally unacquainted.—. . . I know, Sir, that to need your goodness is to have a claim on it; may I therefore beg your Patronage to forward me in this affair till I be appointed to a Division; where, by the help of rigid Economy, I shall try to support that Independence so dear to my soul, but which has too often been so distant from my situation.—

Robert Graham of Fintry used his influence, and Burns got his wish.

Some mystery surrounds the manner of Burns's entry into the Excise. The usual method of entry was for the candidate first to be enrolled as an expectant. In his letter to Ainslie dated 1st November 1789, Burns clearly states, however, that he was never an expectant. In any case, he was kept in suspense until the end of March. 'Pride and Passion', which he called his two 'great constituent elements', welled up in him when he was questioned by a great person 'like a child about my matters, and blamed and schooled for my inscription on a Stirling window'. This, as he told Clarinda, had almost led him to give up his Excise idea.

He was to be questioned a good deal more before he was finally accepted for instruction. The dignitaries of the Excise were careful, then as now, about the personal reputation of their employees, and it may be that they did not consider Robert's relationship with Jean Armour suitable 'propriety of conduct as a Man'.

Meanwhile, Burns and Glenconner visited Ellisland. Glenconner expressed himself as being 'highly pleased with the bargain', and advised Robert to accept it. On 13th March, Robert signed the lease.

Four days later, back in Edinburgh, he was able to tell Clarinda:

My Excise affair is just concluded, and I have got my order for instruction: so far good. Wednesday night I am engaged to sup among some of the principals of the Excise, so can only make

a call for you that evening; but next day I stay to dine with one of
the Commissioners, so cannot go till Friday morning.

After these two interviews, the 'Excise affair' was concluded (on 31st
March), and Burns was instructed to undergo his three weeks' course
at the hands of James Findlay, the Excise officer at Tarbolton.
Hilton Brown conjectures that in these two interviews with the
Excise Commissioners, something may have happened which
caused Robert to take a step otherwise, on the face of it, inexplicable,
about which he was in much less of a hurry to tell Clarinda.

Though for Clarinda's benefit on 23rd February he had found
Jean a 'farthing taper', he had a very different tale to tell Ainslie
when he wrote to him on 3rd March, describing the situation in
which he found Jean on his return from Edinburgh.

> Jean I found banished like a martyr—forlorn, destitute and
> friendless; all for the good old cause: I have reconciled her to her
> fate: I have reconciled her to her mother; I have taken her a
> room: I have taken her to my arms: I have given her a mahogany
> bed: I have given her a guinea; and I have f- - - d her till she
> rejoiced with joy unspeakable and full of glory. But—as I always
> am on every occasion—I have been prudent and cautious to an
> astounding degree; I swore her, privately and solemnly, never to
> attempt any claim on me as a husband, even though anybody
> should persuade her she had such a claim, which she has not,
> neither during my life, nor after my death. She did all this like a
> good girl, and I took the opportunity of some dry horselitter,
> and gave her such a thundering scalade that electrified the very
> marrow of her bones.

This selfish letter, which has drawn more sighs of regret from
sentimental Burnsites than anything else the poet committed to
paper, can hardly be excused as mere sexual bravado to a friend of the
high-spirited days of earlier manhood. It was written on the very
day Jean produced her second set of twins—girls, both of whom
were doomed to die within a few weeks of their birth. If Robert did,
indeed, deliver the 'thundering scalade' of which he boasts, he may
well have been at least partly responsible for their deaths. That

apart, on 3rd March, clearly nothing was further from Robert's mind than marriage with Jean. On 7th March, he told Captain Brown that he has 'towed' Jean

> into convenient harbour where she may lie snug till she unload; and have taken the command myself—not ostensibly, but for a time in secret. . . .

What precisely is meant by 'have taken the command myself' is anybody's guess. If it means that he has secretly married Jean, four days after he has made her swear never to claim him as a husband, then clearly the views of the Excise Commissioners on his relationship with Jean can have had no effect on his sudden volte-face. More likely the phrase is merely another exercise in sexual imagery, and means little more than that he has 'seen her right' as regards shelter and assistance.

On his return from his brief Edinburgh visit to settle the affair of the Excise, and incidentally to reach at last a settlement with Creech, Robert wrote to Margaret Chalmers on 7th April:

> I am going on a good deal progressive in mon grand bût, the sober science of life. I have lately made some sacrifices for which were I viva voce with you to paint the situation and recount the circumstances, you would applaud me.

This again might refer to a secret marriage with Jean, though it might equally well refer to his decision to give up Clarinda. Certainly, it is the first of the post-Great-Man-interview hints, however, ambiguous, which he threw out. There was no doubt, however, about the significance of the information conveyed on 28th April to James Smith, though here again the phrasing is apparently deliberately ambiguous.

> . . . to let you a little into the secrets of my pericranium, there is, you must know, a certain clean-limbed, handsome, bewitching young hussy of your acquaintance, to whom I have lately and privately given a matrimonial title to my corpse.

What precisely did Burns mean by 'lately and privately'? The exact facts of his legal marriage have lain concealed behind that tantalizing phrase for the best part of two centuries, and are likely so to remain.

Over the next few weeks, he broke the news of his marriage to his mother's brother, Samuel Broun of Kirkoswald, to James Johnson, and to Robert Ainslie, who must have got something of a shock, since less than two months before he had received the 'horselitter' letter telling him that Jean had promised never to make matrimonial claims.

Whether Burns married Jean because the Excise Commissioners insisted on him regularizing his relationship with her, or because, having taken on Ellisland, he needed a wife to run the farm-house (which was not, however, then in existence) we shall probably never now know. At any rate, on 5th August 1788, the Mauchline Kirk Session recorded a Minute recognizing Jean and Robert as man and wife, and Burns made his peace with the Church, giving 'a guinea note for behoof of the poor'.

By the Scots law of the day, a verbal declaration of marriage followed by copulation meant that a couple were, in fact, married. Because of the Highland Mary complications, it had suited Robert's purpose to get himself declared a single man in 1786. In point of fact, however, his actual marriage with Jean would almost certainly have been held in law to have been contracted in the spring of that year, since a marriage by declaration followed by copulation could not be affected by the Armour paper-mutilation. Whatever the truth may be, the matter has now only academic interest.

Burns did not deem it necessary to inform Clarinda of his marriage. She received the information orally, and probably after the lapse of a few weeks, from Robert Ainslie, who, in the poet's absence, had struck up a friendly, not to say mildly flirtatious relationship with the lady. For a year she held her peace, angry, disappointed, cheated once again by life, and—not unnaturally—indignant at the unsatisfactory way in which what was for her a grand passion had suddenly and surprisingly petered out. The letter she finally wrote reproaching her former lover has been lost, but we can guess at its accusing nature from Robert's dignified reply, dated 9th March 1789.

As I am convinced of my own innocence, and though conscious of high imprudence & egregious folly, can lay my hand on my breast and attest the rectitude of my heart; you will pardon

me, Madam, if I do not carry my complaisance so far as humbly to acquiesce in the name of Villain, merely out of compliment to YOUR opinion; much as I esteem your judgement, and warmly as I regard your worth.—I have already told you, and again I aver it, that at the Period of time alluded to, I was not under the smallest moral tie to Mrs B—; nor did I, nor could I then know, all the powerful circumstances that omnipotent Necessity was busy laying in wait for me.—When you call over the scenes that have passed between us, you will survey the conduct of an honest man, struggling successfully with temptations the most powerful that ever beset humanity, and preserving untainted honor in situations where the austerest Virtue would have forgiven a fall— Situations that I will dare to say, not a single individual of all his kind, even with half his sensibility and passion, could have encountered without ruin; and I leave you to guess, Madam, how such a man is likely to digest an accusation of perfidious treachery.

Burns, in fact, reminded Clarinda pretty sharply that the credit for not having taken final advantage of her, was his. As long after as July 1791, Clarinda was still accusing her former lover. In November of that year, just after Burns moved into Dumfries, she found out that the Edinburgh serving-girl Jenny Clow, who had borne Burns a boy, was in distress, so Clarinda used this as a further stick with which to beat the poet. Robert replied that he would have taken 'my boy from her a long time ago, but she would never consent', asked Clarinda to give poor Jenny five shillings in his name— apparently the accepted price of peasant bastardy—and promised to see what could be done for her when next he was in Edinburgh.

A month later, when the mutual flow of correspondence spurted out afresh, Clarinda became 'My dearest Nancy'. But the tone employed by Burns was that of cordial friendship rather than love. Beside which, Nancy had been persuaded to sail out to Jamaica to give her now financially successful husband a further trial. On 6th December, those two lovers—ill-fated from the start and upon whose recorded agony of spirit later generations, calling it 'stagey' and 'silly', have seen fit to pour patronizing scorn—met in Edinburgh for the last time.

In January, Nancy sailed aboard the *Roselle*, the very ship which once was to have taken Robert to the same place. Her husband was not on the quayside to meet her. In the end, when she found that her conjugal place had been taken by a Negro mistress who had borne James Maclehose several coloured children, Nancy protested that the climate was too much for her, and sailed back to Scotland when the *Roselle* turned about.

A few further friendly letters passed between Robert and Nancy after her return. But Robert's passion was dead; and Nancy's, though it probably still smouldered, could no longer be matched.

The letters of lovers often make foolish reading to those for whom they were not meant. Discounting this inevitable silliness, the mannerisms of the Age of Sensibility, and, on Robert's side, the posturing phrases which he felt impelled to fall back upon from time to time to equal Nancy's easier style, how can anyone of reasonable human perception fail to sense the genuine ardency of their love at its climax?

Forty years after she had parted from Robert for the last time, Nancy wrote in her *Journal*, on 6th December 1831:

> This day I can never forget. Parted with Burns, in the year 1791, never more to meet in this world. Oh, may we meet in Heaven.

Burns, for his part, ultimately gave lasting proof of the genuineness of his love for Nancy in 'Ae Fond Kiss', one of three songs which he sent her from Dumfries on 21st December 1791, before she sailed for Jamaica. Clearly, the writing of it involved his deepest feelings.

> Had we never lov'd sae kindly!
> Had we never lov'd sae blindly!
> Never met—or never parted,
> We had ne'er been broken-hearted.

So ended an episode in Burns's life which used up much emotional energy that might otherwise have gone into his poetry. So ended, too, his brief days of jaunting literary leisure.

8

Ellisland

I

THE farm of Ellisland lies on the banks of the Nith, six miles from Dumfries, on the Dumfries–Glasgow road. Of all Burns's farming homes, it is the most accessible, and the most attractive. Today the soil is fertile, the neighbouring landscape an undulating Lowland pastoral scene. In Burns's day, the land was unfenced and in poor heart. Sixteen years after the poet's death, the owner, Patrick Miller, in a published review of the state of Agriculture in Dumfriesshire, said of his whole property:

> When I purchased this estate about five and twenty years ago, I had not seen it. It was in the most miserable state of exhaustion, and all the tenants in poverty. . . . When I went to view my purchase, I was so much disgusted for eight or ten days that I meant never to return to this county.

However, having got over his disgust Miller, as we know, offered Ellisland to Burns on what he considered to be 'favourable terms'.[1] In some respects Ellisland was in an even worse plight than the other farms which defeated Burns and his father before him. It did not even possess a farm-house, for instance. Under his agreement with Miller, Burns was to receive from his landlord £300 for the building of a house and the enclosing of the fields.[2]

Having completed his six weeks Excise instruction at Mauchline in May, and settled affairs with the still struggling Gilbert at Mossgiel, the twenty-nine-year-old poet arrived at Ellisland on 11th June, with his mare Jenny Geddes. Until the new house was ready, he was to live near the old tower of the Isle, in a hut which had done duty

[1] A rent of £70 a year, to be 'restricted' for the first three years to £50.
[2] Dr Snyder prints the agreement as an appendix to his book.

as a farm-house to the previous occupant, David Cullie (or Kelly). Jean and the family were meanwhile to remain at Mossgiel—about forty-five miles away—until suitable quarters were made ready to receive them. But Jean was not wasting her time, for she was taking instruction in dairying from Robert's mother.

In the cold and leaky hut—which could hardly have been good for one in Robert's state of health—the only way to keep warm was to crouch over the smoky fire. Indeed, he drew a humorous picture of this uncomfortable 'spence' in his impromptu lines 'To Hugh Parker':

> Here, ambush'd by the chimla cheek,
> Hid in an atmosphere of reek,
> I hear a wheel thrum i' the neuk,
> I hear it—for in vain I leuk:
> The red peat gleams, a fiery kernel,
> Enhuskèd by a fog infernal.
>
> Here, for my wanted rhyming raptures,
> I sit and count my sins by chapters;
> For life and spunk like ither Christians,
> I'm dwindled doun to mere existence;
> Wi' nae converse but Gallowa' bodies,
> Wi' nae kind face but Jenny Geddes.

Prose accounts describing his discomfort in equally vivid terms went out in letters to Margaret Chalmers, Mrs Dunlop, Ainslie and John Beugo, the engraver.

In July, he sent Alexander Cunningham a note of his building plans, and took the opportunity of telling yet another friend of his marriage.

I have been a Farmer since Whitsunday, & am just now building a house—not a Palace to attract the train-attended steps of pride-swoln Greatness; but a plain, simple Domicile for Humility & Contentment.—I am, too, a married man.—This was a step of which I had no idea, when you and I were together.—On my return to Ayr-shire, I found a much-lov'd Female's positive

happiness, or absolute Misery among my hands; and I could not trifle with such a sacred Deposite.—I am, since, doubly pleased with my conduct. . . . When I tell you that Mrs Burns was once *my Jean*, you will know the rest.

In spite of the wretchedness of his living conditions, and the magnitude of the task ahead of him, Burns was not downcast.

He entered upon the Ellisland enterprise in a mood of high courage, conscious that if, in spite of his endeavours, it should fail, he now had the Excise to fall back upon as a kind of insurance against unemployment—he received his Commission, or certificate of proficiency on 14th July. That he did, in the end, fail at Ellisland was not primarily his own fault. It would have taken a man of far more substance than Burns to sweeten its sour and weary soil.

During his years at Ellisland, in spite of the amount of work he had put in, and a continuing run of ill-health and bad luck, he clearly experienced a good deal of real happiness. His marriage with Jean, even if it did not entirely satisfy him physically, and certainly did not give him full intellectual companionship for all her help with his song-work, at least gratified his strong family instinct. 'The happiness or misery of a much-loved creature were in my hands', he repeated to several other of his friends, 'and who could trifle with such a sacred deposit?'

Progress in the erection of a home for his 'much-loved creature' was distressingly slow. The work had been entrusted to a contractor, but he needed a good deal of prodding. On 22nd January 1789 Robert wrote to a Mauchline carpenter, Peter Morrison, who was making some furniture for him, urging speedy delivery.

Necessity oblidges me to go into my new house even before it be plaistered.—I will inhabit the one end until the other is finished.—About three weeks more, I think, will at farthest be my time beyond which I cannot stay in this present house.

But this estimate evidently proved optimistic, for on 8th February, Robert had to write to Thomas Boyd, his mason:

I am oblidged to set out for Edin^r tomorrow se'ennight so I beg you will set as many hands to work as possible during this

week.—I am distressed with the want of my house in a most provoking manner.—It loses me two hours' work of my servants every day, besides other inconveniences. For G - d's sake let me but within the shell of it!

There were to be further urgent appeals to his tradesmen before it was possible for Robert and Jean to enter what was their first real home together the following May. Jean, leaving little Robert behind, came down to Nithsdale from Mauchline early in December with some of the furniture, to share what Robert called the house 'in which a Mr Newal lived during the summer, who is gone to Dumfries in the winter. It is a large house, but we will only occupy a room or two of it.' Her presence at least did away with the need for the distracting journeys to Mauchline every ten days or so; wearisome, even although it was apparently Jean's practice to come so far down the road to meet her husband. Wanting Jean, sitting in his smoky hut, and 'dwindled down to mere existence', Robert wrote for her one of his tenderest love-songs.[1]

> Of a' the airts the wind can blaw, [*directions*
> I dearly like the west,
> For there the bonie Lassie lives,
> The Lassie I lo'e best:
> There's wild-woods grow, and rivers row, [*roll*
> And mony a hill between;
> But day and night my fancy's flight
> Is ever wi' my Jean.

When at last they were installed in Ellisland, another song reflected his independent pride in his enjoyment of married felicity.

> I hae a wife o' my ain,
> I'll partake wi' naebody;
> I'll tak cuckold frae nane,
> I'll gie cuckold to naebody . . .

[1] In his *Notes on Scottish Song* written in the interleaved *Museum*, Burns comments: 'The air is by Marshall; the song I composed out of compliment to Mrs Burns. N.B. It was during the honeymoon.' In view of the difficulty of being sure what Burns meant by 'honeymoon', I rely on Dick, in *The Songs of Robert Burns*, who says: 'It was written at Ellisland in June.'

> I am naebody's lord,
> I'll be slave to naebody;
> I hae a gude braid sword,
> I'll tak dunts frae naebody.

Alas, Fate had dunts enough in store for him! Apart from the distractions and delays of the housebuilding operations, his first harvest at Ellisland was a bad one. The weather was wet, and Robert caught the prevailing disease, as he told Robert Graham of Fintry on 23rd September 1788:

> Though I am scarce able to hold up my head with this fashionable influenza, which is just now the rage hereabouts, yet with half a spark of life, I would thank you for your most generous favor of the 14th, which, owing to my infrequent calls at the post-office in the hurry of harvest, came only to hand yesternight.

The letter thus tardily collected was of the greatest significance to him. On 10th September, seeing how things were going on the farm, Burns had written to Robert Graham:

> Your Hon^ble Board, sometime ago, gave me my Excise Commission; which I regard as my sheet anchor in life.—My farm, now that I have tried it a little, tho' I think it will in time be a saving bargain, yet does by no means promise to be such a Pennyworth as I was taught to expect.—It is in the last stage of worn-out poverty, and will take some time before it pay the rent. —I might have had the Cash to supply the defficiencies [*sic*] of these hungry years, but I have a younger brother and three sisters on a farm in Ayr-shire; and it took all my surplus, over what I thought necessary for my farming capital, to save not only the comfort but the very existence of that fireside family-circle from impending destruction.

Rather than call back the loan and ruin those at Mossgiel, Robert had thought of a proposition:

> There is one way by which I might be enabled to extricate myself from this embarrassment, a scheme which I hope and am

certain is in your power to effectuate.—I live here, Sir, in the very centre of a country Excise-Division; the present Officer lately lived on a farm which he rented in my nearest neighbourhood; and as the gentleman, owing to some legacies, is quite opulent, a removal could do him no manner of injury; and on a month's warning, to give me a little time to look again over my Instructions, I would not be afraid to enter on business. . . . It would suit me to enter on it, beginning of next summer. . . .

Along with this plea went the stately Augustan couplets which make up the 'First Epistle to Robert Graham, Esq., of Fintry Requesting a Favor', the torso of which was merely brought out from his drawer and furbished up for the occasion. It was Graham's favourable answer to this plea that could not be collected because of the pressure of the harvest.

On the face of it, his request for the removal of Leonard Smith seems a blatant piece of wire-pulling which hardly comes well from the pen of so ardent a democrat as Burns. But this aspect of the affair has been overstressed. A week or two later, Robert tells Graham:

> I could not bear to injure a poor fellow by ousting him to make way for myself; to the wealthy son of good-fortune like Smith, the injury is imaginary where the propriety of your rules admits.

Apart from the worries of the farm, and the financial strain under which they laboured, Robert and Jean had family responsibilities of another sort. Early in 1789, they took in temporarily the children of Robert's uncle, Robert Burnes, who had died on 3rd January.

The poet also took under his personal care his own youngest brother William, a youth of twenty-two who seemed unable to settle to anything. Robert had tried to get Bob Ainslie to find William a job as a saddler's apprentice in Edinburgh. Ainslie apparently failed, and William had to board himself upon Robert in Nithsdale. Some months later, William got some kind of a job in Longtown, and shortly afterwards another at Newcastle. Robert wrote regularly, offering fatherly encouragement, and urging his brother to 'fight

like a Man', always remembering that if things did not go well, he could return to Nithsdale. The only piece of strange, though revealing advice from older brother to younger, was Robert's reply when William announced that he was in love.

> I am, you know, a veteran in these campaigns, so let me advise you always to pay your particular assiduities and try for intimacy as soon as you feel the first symptoms of the passion; this is not only best, as making the most of the little entertainment which the sportabilities of distant addresses always gives, but is the best preservative of one's peace.

From Newcastle, William moved to London, where he found yet another job as a journeyman saddler. Robert arranged for his old teacher John Murdoch to visit the youngster, but within a fortnight, William suddenly fell ill and in July 1790, died. Robert paid the expenses of his luckless brother's illness and funeral.

II

It took Graham of Fintry about a year to manipulate the favour which Burns had asked of him. On July 31st 1789, we find the poet telling his patron that the Collector of the Department—a Mr Mitchell—seems to think that the removal of Smith:

> ... will be productive of at least no disadvantage to the Revenue, and may likewise be done without any detriment to him.— Should the Honorable Board think so, and should they deem it eligible to appoint me to officiate in his present place, I am then at the top of my wishes.

On 10th October 1789, the alphabetical list of the names of Excise officers contains Burns's name with, opposite it, the remark: 'Never tryed—a Poet.' To this a later hand was able to add: 'Turns out well.' On 27th October he was sworn into the service as an officer of Excise at the Dumfries Quarter Sessions of Peace, his district, the 'Dumfries first Itinerancy'.

Towards the end of the eighteenth century, Excise duties were levelled on a wide range of articles. In some ways, the idea behind the

duty was much the same as that behind Purchase Tax in our own day, except that the Excise Duty was, so to speak, collected at the source, and methods of evasion were thus much easier to devise. An Excise expert—R. W. Macfadzean—in an interesting essay on *Burns's Excise Duties and Emoluments*[1] thus explains the range, the difficulties, and the reasons for the unpopularity of the work.

In the end of the last century the following were subject to Excise Duties:—Auctions, bricks and tiles, beer, candles, coaches, cocoa-nuts, coffee, cyder, perry, verjuice, glass, hops, hides and skins, malt, mead or Metheglin, paper, pepper, printed calico, silk goods, soap, British spirits, foreign spirits, starch, salt, stone bottles, sweets, tea, tobacco, snuff, wine and wire. The duty upon these articles was, in nearly every case, charged during the manufacture, and the surveillance of the processes entailed upon the officers frequent visits by day and night, on Sunday and Saturday. . . . Of course, no single Excise officer had all these manufactures in his station; but he generally had a number of them, and he was never allowed to forget his responsibility with regard to them all.

When one learns that there were several rates of duty on different grades of even one article—seventy-eight rates of paper duty, for instance, according to size, kind and quality—and that all the individual laws and instructions had to be mastered without the aid of any sort of compendium, one sees why Robert felt he would require 'a month's warning' to 'look over' his instructions before taking up duty.

That duty required him to ride about two hundred miles a week on a horse of his own provision. He also had to testify every two months that his horse was in good order. At night, he had to keep his books up to date—books which were regularly examined down to the last detail by exacting superiors. For these services he received £50 a year, together with fifty per cent of the fines of his 'prizes'; half the goods seized, plus £50 for every arrested smuggler; but no expenses. In July 1790, he was transferred to the Dumfries Third (or

[1] Burns Chronicle 1898.

Tobacco) Division, which at least reduced the weekly mileage he had to cover.

His first area consisted of ten parishes which he visited in ten circuits, or 'rides' as they were officially called. Such a task might well have taxed the physical strength of a stronger man than Burns. Yet on top of it all he still contrived to farm Ellisland, with the help of three or four servants.

A good deal of sentimental nonsense has been written about the indignity of Scotland's greatest poet being forced to become a gauger—by Coleridge, for instance, with his 'Ghost of Maecenas! Hide thy blushing face! They snatched him from the sickle and the plough—to gauge ale-firkins'. Burns himself perhaps first started this trend of thought with his epigram:

> Searching auld wives' barrels,
> Ochon, the day
> That clarty barm should stain my laurels! [*muddy yeast*
> But what'll ye say?
> These movin' things ca'd wives an' weans
> Wad move the very hearts o' stanes.

The fact remains, however, that nobody 'snatched him from the sickle'. He chose to relinquish it, gladly and of his own free will, in order to enter a profession of his own deliberate choosing; a profession which, though it was naturally not popular with would-be evaders of tax, was a comparatively lucrative one by the standards of the time. Burns, for instance, was much better off as an Excise officer than the average schoolmaster (who drew about £20–25 a year), the average minister (whose stipend was about £35) or even the average farmer (lucky to have much left over at all after he had fed himself and his family and paid, albeit miserably, his fee'd helpers), or the average shoemaker (about £20) or tailor (about £15),[1] the last two 'with food in the family'.

To Coleridge, living in a highly intellectualized circle and writing poetry of dream and fantasy, the mere idea of a poet living on a commoner level must have been difficult to conceive. But although

[1] The last two calculated from the daily rates given in 'General View of the Agriculture of the County of Ayr' 1811.

Burns, in the depressed moments of his 'hypochondria' which became more frequent as the strain of carrying out two jobs told upon his sick heart, could loudly lament his lot—as, indeed, all poets occasionally lament the fate which forces them to earn a hard living while people with lesser gifts and more indifferent purpose are granted a life of comparative leisure—by and large he was happy, and indubitably efficient at his work.

He himself summed up this attitude in a mature and sensible letter to Robert Ainslie, dated 1st November 1789.

> You need not doubt that I find several very unpleasant and disagreeable circumstances in my business; but I am tired with and disgusted at the language of complaint against the evils of life.— Human existence in the most favourable situations does not abound with pleasures, and has its inconveniences and ills; capricious, foolish Man mistakes these inconveniences & ills as if they were the peculiar property of his own particular situation; and hence that eternal fickleness, that love of change which has ruined & daily does ruin, many a fine fellow as well as many a Blockhead; and is almost without exception a constant source of disappointment and misery.—So far from being dissatisfied with my present lot, I earnestly pray the Great Disposer of events that it may never be worse, & I think I may lay my hand on my heart and say, 'I shall be content'.

Burns also stressed what he regarded as the favourable aspects of his Excise work to other correspondents: to Lady Elizabeth Cunningham (23rd December 1789) he commented upon 'the knowledge it gives me of the various shades of Human Character'; and Graham of Fintry heard (9th December) how the poet still met with the Muses 'now and then as I jog through the hills of Nithsdale'.

Plenty of evidence survives to show that Burns was efficient at his work. His reports were careful, his actions against major offenders limited not by any fear or favouritism on his part, but by the fact, as he soon discovered, that a friend in high places could get a rich man out of trouble in spite of the law. Stories about his pleas in court for leniency on behalf of small and humble offenders probably mean little beyond the fact that the main duty of a tax collector is to

counter the serious evaders. Both his immediate seniors, Superior Alexander Findlater and Collector John Mitchell, thought highly of his work, and remained his firm friends, even when he quite shamelessly intrigued over their heads with influential people like Graham of Fintry and (through Mrs Dunlop) with William Corbet, one of the two general supervisors for Scotland, in the interests of his own advancement.

His work was naturally made more difficult by his ill-health. The injury to his knee which had precipitated the Clarinda correspondence still bothered him. In September 1789, he had an attack of 'malignant squinancy and low fever'. And to make matters worse, by Christmas of that year the strain of carrying out his double role left him 'groaning under the miseries of a diseased nervous system'. Yet despite these troubles, which were mercifully less in 1790, and the exacting nature of his duties, Burns still found time to enjoy warm friendships, and to play his part in the life of the community.

One of the first to make him welcome when he arrived in Nithsdale was his neighbour Robert Riddell of Glenriddell,[1] whose home, Friars Carse, lay up the River Nith, and was within easy walking distance of Ellisland.

Robert Riddell (1753–94) was the eldest son of Walter Riddell of Glenriddell, an estate in the Dumfriesshire parish of Glencairn. He had been educated at the Universities of St Andrews and Edinburgh. He then joined the Royal Scots as an Ensign, later enlisting in the Prince of Wales Light Dragoons, in which he rose to the rank of Captain, and from which he retired on half-pay in 1782. Two years later, he married Elizabeth Kennedy, a prim easily-offended Manchester girl, and settled down to a life of leisured learning on the newly-purchased estate of Friars Carse. (The name arose out of the early connexion of older buildings on the site with a monastic retreat associated with the Abbey of Melrose.)

Robert Riddell has suffered unjustly at the hands of, without exception, all Burns's biographers. He has been sketched in as a monied prattle-brain who used his wealth to bolster up his pretensions as an antiquarian and a musician: this in spite of the fact that

[1] He heired his father's estate in 1788, but never moved into Glenriddell, which he sold, preferring to live on at Friars Carse.

Burns clearly saw him in a totally different light. Fortunately, the discovery of certain documents known as the Gough–Paton Correspondence now reveal quite clearly that Riddell was not the loud-mouthed charlatan described by writers as eminent as Snyder and De Lancey Ferguson.

By the time Burns got to know him, Riddell's reputation as an antiquary had reached the ears of a certain Richard Gough, who had been entrusted with the task of preparing an enlarged edition of Camden's *Britannia*, a popular reference work which recorded and illustrated authoritatively the surviving antiquities of these islands. To help him with the Scottish part of this undertaking, Gough had the general assistance of George Paton, an authority on, amongst other things, Scots coinage, who recruited other helpers in districts with which he was not familiar. One of these whose services he enlisted was Robert Riddell. Riddell provided Gough with a description of Nithsdale, and notes on many Galloway antiquities, much of which eventually found its way into the enlarged *Britannia*.

Clearly, both Paton and Gough knew what they were talking about. Paton recorded his verdict on the quality of Riddell's information in a letter to Gough dated 26th December 1791. 'Numerous and valuable', he called it. When Riddell died suddenly on 4th April 1794, both Paton and Gough were much distressed. A month after that event, Gough told Paton:

> I looked upon him (Riddell) as the first Antiquary of his Country.

At no time did Riddell publicly claim to be anything other than an amateur musician. His work *A Collection of Scotch, Galwegian and Border Tunes for the violin and pianoforte*, published in 1794, is neither better nor worse than the average professional collection of Scots airs published in the closing decade of the eighteenth century. Burns matched words to several of Riddell's airs; yet J. C. Dick, in his standard textbook and commentary[1] *The Songs of Robert Burns* speaks scathingly of the Captain's powers as a musician. Dick could, however, on occasion be unnecessarily biting in his musical judgements, and his dismissal of Riddell is one such occasion.

[1] See footnote on page 108.

Riddell then, was not the pretentious, dabbling squire he so often is made out to have been, but a well-educated, kindly gentleman who felt immediately drawn to Burns because of his strong interest in Scottish Song. Within a few weeks of their first acquaintance, Riddell was lending Burns help to enable him to get in his first Ellisland harvest. He also gave the poet a key to his newly-built 'Hermitage' gazebo in the grounds of Friars Carse; and he welcomed the poet into the circle of his family and friends.

One of these friends was Captain Francis Grose[1] (1731–91), a brother officer of Swiss origin, also retired, and also an antiquarian.

Grose, who had studied art, was at one time Richmond Herald in the College of Arms, but resigned his tabard to Henry Pugolas for six hundred guineas. Next, he became Paymaster and Adjutant of the Surrey Militia, a position for which he was equally unsuited, since he kept no books and gave no receipts, with the result that he had to use the private fortune heired from his father to make up deficits.

Between 1773 and 1787, Grose had published his *Antiquities of England and Wales*, which contained five hundred and eighty nine views drawn by himself, and had a considerable success. In 1789 he came to Scotland to collect material for a companion work, *Antiquities of Scotland*, which was eventually published, also in two volumes, between 1789–91. He then moved over to Dublin to produce a corresponding Irish volume, but died of an apoplectic fit. An excellent draughtsman and a facile prose-writer, his volumes retain a good deal of interest even today.

During the late summer of 1789, Burns met Grose at Friars Carse, and took to him at once. Grose lived up to his name in appearance—he was fat and jovial—and had an inexhaustible fund of humour. Burns suggested to Grose that he should include an illustration of Alloway Kirk in his book. Grose agreed, provided the poet would furnish 'a witch story' to be printed along with the drawing. The result was 'Tam o' Shanter', which is discussed later in this chapter.

Riddell was also the means of introducing another pleasant interest into the poet's busy life. This was the Monkland Friendly Society,

[1] Whose father settled in London as a jeweller, and fashioned George II's coronation crown.

the main object of which was to provide its tenant-farmer members
with a reasonable selection of literary classics, as well as the standard
authorities on philosophy, history and theology. Riddell himself
testified that:

> Mr Burns was so good as to take the whole charge of this small
> concern. He was treasurer, librarian and censor to this little
> society, who will long have a grateful sense of his public spirit
> and exertions for their improvement and information.

Indeed they did, for, with only a few periodic adjustments in its con-
stitution, the Society survived well into the present century.

Robert, finding himself in a position to order books for the
Society, put the custom in the direction of Creech's old clerk, Peter
Hill who, in 1788, had set up in business for himself. The order
which Hill received in the spring of 1790, written on 2nd March, is
worth quoting, not only because it gives some indication of the
solid taste of these Nithsdale self-improvers but because of the light
it throws on Burns's abilities as a good committee man.

> At a late meeting of the Monkland Friendly Society it was
> resolved to augment their library by the following books which
> you are to send as soon as possible—The Mirror—The Lounger
> —Man of feeling—Man of the world (these for my own sake I
> wish to have by the first Carrier) Knox's History of the Reforma-
> tion—Rae's History of the Rebellion 1715—Any good history
> of the Rebellion 1745—A Display of the Secession Act and
> Testimony by Mr Gib.—Harvey's Meditations—Beveridge's
> thoughts—and another copy of Watson's body of Divinity—
> This last heavy Performance is so much admired by many of our
> Members, that they will not be content with one Copy, so
> Capt Riddell our President & Patron agreed with me to give you
> private instructions not to send Watson, but to say that you
> could not procure a Copy of the book so cheap as the one you
> sent formerly & therefore you await further Orders.

At the same time he also ordered some books for himself:

> . . . as you pick them up, second-handed or any way cheap
> copies of Otway's dramatic works, Ben Johnson's [*sic*], Dryden's,

Congreve's, Wycherly's, Vanbrugh's, Cibber's, or any other Dramatic works of the more Moderns, Macklin, Garrick, Foote, Colman, or Sheridan's.—A good copy too of Moliere in French I much want.—Any other good Dramatic Authors in their native language 1 want them; I mean Comic Authors chiefly, tho' I should wish Racine, Corneille, and Voltaire too.

About this time, as he told Lady Elizabeth Cunningham in a letter of January 1789, he had:

> . . . a hundred different Poetic plans, pastoral, georgic, dramatic, &c. floating in the regions of fancy, somewhere between Purpose and resolve.

The pastoral and georgic pieces were no doubt based on the urgings of such Anglicized conventionalists as Dr John Moore and John Ramsay of Ochtertyre. The dramatic ideas were his own. Ramsay is, indeed, our authority (via Currie) for the story that Burns had actually settled on the plot and title for a play, *Rob MacQuechan's Elshon*, dealing with the somewhat unpromising and almost certainly apocryphal incident in which MacQuechan, Robert the Bruce's cobbler, accidentally drove his awl into the king's foot while trying to repair the royal shoe damaged in a lost battle.

It may well be that although Burns wanted to write plays—apparently on the well-worn themes of Wallace, Bruce and Mary, Queen of Scots, which have brought, and still do bring, most Scots playwrights down in disaster—he had not the necessary sort of ability for successful dramatic projection. Like Browning, Burns was a master of the dramatic monologue. It is one thing to be able to characterize firmly in a swiftly-told tale, but quite another to invent and handle dialogue covering comparable situations.

In any case, the immediate stimulation was the Dumfries Theatre, where Burns was on the free list. For New Year's Day, 1790, he gave its manager, George S. Sutherland, a Prologue—a quite passable neo-classical excursion within an English convention—and wrote another for the benefit night of Mrs Sutherland on 3rd March.

The part played by the poet in local public life was not confined to

the passive Secretaryship of the Monkland Friendly Society. True, he thought it expedient to suppress any outward show of Jacobite sentiments on 5th November 1788, the occasion of the celebration of the hundredth anniversary of William of Orange's descent upon these islands. But when he heard the parish minister, Joseph Kirkpatrick[1]—something of a conservative bigot, if the harsh strictures passed on him by Burns and Robert Riddell are to be believed—scornfully exult from his pulpit over the former royal house of Scotland, Burns could remain silent no longer. He sent a long letter to the Editor of the *Edinburgh Evening Courant*. This document is indeed a noble and well-reasoned political statement, couched in Burns's most carefully-coloured rhetoric, yet animated by genuine philosophical understanding.

> . . . Bred and educated in revolution principles—(i.e. Protestantism)—the principles of reason and common sense, it could not be any silly political prejudice that made my heart revolt at the harsh abusive manner in which the Reverend Gentleman mentioned the House of Stuart. . . .

The Stuarts, Burns maintained, ruled at a time when the conception of the proper relationship between king and people was different from the present view.

> The Stuarts only contended for prerogatives which they knew their predecessors enjoyed, and which they saw their contemporaries enjoying; but these prerogatives were inimical to the happiness of a nation and the rights of subjects. . . .

Burns then recalls how the British constitutional monarchy came to be set up, and agrees that it is justly to be preferred to the 'by God appointed' rule of the Stuarts. He goes on:

> The Stuarts have been condemned and laughed at for the folly and unpredictability of their attempts in 1715 and 1745. That they

[1] Robert Riddell, amazed to learn that Kirkpatrick had failed to mention the Society in his contribution about the Parish for Sir John Sinclair's *Statistical Account*, presented Sinclair with a supplementary piece by Burns, signed 'A Peasant'.

failed, I bless my God most fervently; but cannot join in the ridicule against them. . . .

A few sentences later Burns gives his considered opinion on the American Revolution of 1775, an opinion which, in the years to come, was to broaden into a measure of sympathy for the ideals of the French Revolution, and was to redound sharply upon his own head.

> Man, Mr Printer, is a strange, weak, inconsistent being.—Who would believe, Sir, that in this our Augustan age of liberality and refinement, while we seem so justly sensible and zealous of our rights and liberties, and animated with such indignation against the very memory of those who would have subverted them, who would suppose that a certain people, under our national protection, should complain, not against a Monarch and a few favourite advisers, but against our whole legislative body, of the very same imposition and oppression, the Romish religion not excepted, and almost in the very same terms as our forefathers did against the family of Stuart! I will not, I cannot, enter into the merits of the cause; but I dare say, the American Congress, in 1776, will be allowed to have been as able and enlightened, and, a whole Empire will say, as honest, as the English Convention in 1688; and that the fourth of July will be as sacred to their posterity as the fifth of November is to us.

Burns's interest in politics of a more active nature is reflected in the Election Ballads he wrote during the hustings of 1790. The successful candidate was the son of the poet's own landlord, Patrick Miller, and Burns might have been expected to champion his cause. But Burns so disliked the Duke of Queensberry, who supported the Whig candidate, that he chose instead to support the Tory, Sir James Johnstone of Westerhill. These political poems, written before and after the event—'The Fête Champêtre', 'The Five Car- lins', 'The Election Ballad for Westerha'' and 'The Second Epistle to Robert Graham' are as Mr Crawford says, 'mildly Pittite in tone, but not bitterly anti-whig', but they are now more or less incom- prehensible to us because of their faded local significance. Another

topical piece was published in the *London Star*, a Liberal newspaper whose editor, Peter Stuart, tried to get Burns to join his staff in 1789, and again a year or so later. This poem, 'A New Psalm for the Chapel of Kilmarnock' (or 'Stanzas of Psalmody' as it is called in some modern editions of Burns's works), was written to satirize the day (23rd April 1789) appointed for public thanksgiving in honour of the king's recovery from one of his increasingly frequent bouts of insanity. Burns who, in one of his political moods disliked kings as such, regarded the whole idea of the celebration as a mockery, and the poem is a clever parody of the crudities of psalm meterology. As in 'Holy Willie's Prayer', the writer, 'Duncan M'Leerie' (a name lifted from a bawdy song in *The Merry Muses*), appears to take the side of those who are being satirized. It also touches on the patronage controversy, in which Burns had again become interested.

> ... And now Thou hast restor'd our State,
> Pity our kirk also,
> For she by tribulations
> Is now brought very low!
>
> Consume that High-Place, Patronage,
> From off thine holy hill;
> And in Thy fury burn the book
> Even of that man M'Gill.
>
> Now hear our Prayer, accept our Song,
> And fight Thy Chosen's battle:
> We seek but little, Lord, from Thee,
> Thou kens we get as little.

'That man M'Gill' was Dr William M'Gill, an Ayr minister whom Burns admired because of his theological liberality. His book *An Essay on the Death of Jesus Christ*, took an unorthodox view of Christ's atonement. As a result, the Presbytery of Ayr appointed a commission in April 1789 to investigate and report upon the soundness or otherwise of Dr M'Gill's doctrinal position. The chance was too good to be missed, and the poet once more went for the bigoted Auld Lichts, in 'The Kirk's Alarm'.

Many of the old characters of the Mauchline satires reappear, each 'bob-wheeled' into stanzas of tremendous gusto—the minister Russell ('The Holy Fair'), Mackinlay ('The Ordination'), Moodie ('The Twa Herds'), and Peebles, as well as 'Daddy' Auld, Holy Willie and Poet Burns himself. But the actual level of the satire does not get much beyond the medieval tradition of flyting, or name-calling.

The first draft of the poem was sent to Mrs Dunlop, with a fiery covering letter dated 17th July.

> You know my sentiments respecting the present two great Parties that divide our Scots Ecclesiastics.—I do not care three farthings for Commentators & authorities.—An honest candid enquirer after truth, I revere; but illiberality & wrangling I equally detest.—You will be well acquainted with the persecutions that my worthy friend, Dr M'Gill, is undergoing among your Divines.—Several of these reverend lads, his opponents, have come thro' my hands before; but I have some thoughts of serving them up again in a different dish.—I have just sketched the following ballad, & as usual I send the first rough-draught to you.—I do not wish to be known in it, tho' I know, if ever it appear, I shall be suspected.—If I finish it, I am thinking to throw off two or three dozen copies at a Press in Dumfries, & send them, as from Edin^r to some Ayr-shire folks on both sides of the question.—If I should fail of rendering some of the Doctor's foes ridiculous, I shall at least gratify my resentment on his behalf.

Although the poet cautioned those of his friends to whom he sent copies 'not to let it get into the Publick', it did appear as a broadsheet in Dumfries, with or without Burns's sanction. As Dr M'Gill failed to stand his ground, agreeing, when his case had come before the General Assembly in April 1790, to withdraw the sentences which had caused the commotion, all Robert succeeded in doing was gratifying his resentment on behalf of the New Lichts at the expense of making fresh enemies for himself.

But when he took up the cause of someone whom he considered oppressed, he recked little enough of the consequences to himself. He entered obscure private quarrels in support of principle as readily

as he embarked in defence of public causes. Thus, when an old friend, James Clarke, was threatened with dismissal from his school at Moffat because he was alleged to have inflicted undue punishment on some of his scholars, Burns investigated the facts and decided that Clarke was, in fact, guiltless, and the whole charge an unsavoury frame-up. Burns thereupon wrote letters to influential persons in Edinburgh, drafted letters for Clarke himself to sign, and gave the unfortunate schoolmaster money out of his own slender income to tide him over the privations of the struggle: a struggle which ended in Clarke's complete vindication and restitution in February 1792. Ironically, when Burns himself was later in need of money, Clarke could only repay him in instalments of a guinea, as he was 'furnishing a large house'!

The picture of Burns at Ellisland which emerges, is one of a mature and passionate man, overworked, struggling with decreasing success against impoverished soil, yet playing a full part in communal life, espousing democratic causes (sometimes indiscreetly), and coming with equal readiness to the help of a friend in trouble. It is a kindly picture, for probably Burns was fairly happy in the Ellisland years. His friendship with Mrs Dunlop supplied him with a mental stimulus which Jean could not give him. He named his son, born on 18th August 1789, Francis Wallace, after Mrs Dunlop's patronymic, and it was she to whom he immediately wrote when, on 27th January 1791, his name was placed on the list of those eligible for promotion as Examiners and Superiors: wrote so exultantly, in fact, that she thought he had actually been promoted. It was, indeed, Mrs Dunlop who usually first heard of his joys and of his sorrows.

His friendship with Anna Park, barmaid and niece to the owners of the Globe Inn in Dumfries, was of a different sort. She took him freely to her bosom, and on 31st March 1791 bore him a daughter, Elizabeth, in Leith. Nine days later, Jean also bore him a child, his son William Nicol Burns, named after the poet's Highland Tour travelling companion.

For Anna, Robert wrote what he himself regarded as his best love-song—and which, incidentally, he copied out into *The Merry Muses*.

> Yestreen I had a pint o' wine,
> A place where body saw na;
> Yestreen lay on this breast o' mine
> The gowden locks of Anna.

The rest of the poem does not live up to this promising beginning, and we can hardly share the poet's opinion, though we may applaud his postscript, with its frank avowal of the joys of sexual love, and every man's right to them.

> The Kirk an' State may join an' tell
> To do sic things I maunna;
> The Kirk an' State may gae to hell,
> And I'll gae to my Anna.

Jean—the warm, the understanding Jean—made no undue complaint about Anna's baby,[1] but adopted it into the family when it was weaned. Whatever may have been her intellectual deficiencies, Jean, with an understanding of the passion that fired her poet's flesh, at least showed a tolerance which would surely have been hard to find in any other wife. Indeed, some have suggested she must either have been a saint or a silly. Most probably her love for Robert was such that she accepted him for what he was, not for what others thought he ought to have been.

III

Burns's first Ellisland harvest of 1788 had been a poor one. Admittedly, in the preceding months he was perhaps hardly able to give his lands the attention they demanded. But the following year, not only was the harvest again a loss, but because of his loan to Gilbert, Robert lacked the capital which would have enabled him to weather out three or four bad years in the hope that his efforts to improve the heart of the soil would in the end yield good result.

As early as September 1788, he had told Graham of Fintry that his farm 'by no means promises to be such a Pennyworth as I was taught

[1] After the surrender of her child, Anna disappears from our ken. There are neither grounds for making her out to have been a whore, as some biographers have done, nor for bringing her to a woeful conclusion.

to expect'. By the summer of the following year, just before he took up his Excise duties, he was debating whether he ought to give up farming altogether in favour of the Excise. A few months later, on 11th January 1790, when carrying out the two jobs together, and coming near to a nervous breakdown, he told Gilbert:

> My nerves are in a damnable State.—I feel that horrid hypochondria pervading every action of both body & soul.—This Farm has undone my enjoyment of myself.—It is a ruinous affair on all hands.—But let it go to hell! I'll fight it out and be off with it.

Then, after a few words about the 'very decent Players here just now', he added:

> If once I were clear of this accursed farm, I shall respire more at ease.

The first record of the decision to give up Ellisland occurs in a letter to Graham of Fintry, dated 4th September 1790, and written in the Globe Inn, Dumfries.

> I am going either to give up, or subset my farm directly.—I have not liberty to subset, but, if my Master will grant it me, I propose giving it just as I have it myself, to an industrious fellow of a near relation of mine.—Farming this place in which I live, would just be a livelyhood to a man who would be the greatest drudge in his own family, so is no object; & living here hinders me from that knowledge in the business of Excise which it is absolutely necessary for me to attain.

Nearly another year was to go by before Burns was able to accomplish his wish. It has been said (admittedly on no good authority) that Burns's 'industrious fellow of a near relation'—brother Gilbert, perhaps?—was not acceptable to Patrick Miller, who wanted to sell the farm rather than rent it again, and that discussion of the matter put a strain on the cordiality of their relations. It so happened, however, that in the summer of 1791, the laird of the neighbouring estate of Laggan, a certain John Morin, decided that it would be a good idea for him to extend his ground, evening out the

bulge caused by the river-loop of the Ellisland fields. Accordingly, he offered Miller £1,900 for the farm, and the offer was accepted.

Just before the farm's future was thus happily settled,[1] Robert got leave from the Excise to make a jaunt into Ayrshire in order to be present at Gilbert's wedding. He left Jean and the family at Mauchline. Back in Nithsdale again, he sold his standing crops by auction on 25th August, and, having wined the bidders generously, got 'a guinea an acre, on an average, above value'. He also did well at the subsequent roup of his farm gear. On 10th September the formal renunciation of the Ellisland lease was signed, and Burns won free at last from the weary burdens of a farmer. He paid a brief visit to Edinburgh to see Clarinda, then, on 15th November, he moved his family into Dumfries, where he had rented a cramped half-house in a street near the river, known as the Stinking Vennel.

Throughout 1791 bad luck and ill health had again been his enemies. Early in the year a fall with his horse injured his arm. In March he broke it. Finally, just after he returned from Gilbert's wedding, he again injured his leg, and had to sit with it 'laid on a stool' before him. Yet despite these vicissitudes, he had known happiness, and literary (to say nothing of paternal) achievement at Ellisland.

The astonishing thing is that during the hectic Ellisland period— from June 1788 to November 1791—Burns found time to write not only some of his best and most revealing letters—many of them to Mrs Dunlop, to whom he now made a more or less annual visit—but also a substantial body of verse.

Much of this was occasional poetry, like the epistle 'To James Tennant of Glenconner' (1789), and the epistle 'To Dr Blacklock' within the same year: the elegies on 'Captain Matthew Henderson' (1790) whom Burns sincerely liked, 'On the late Miss Burnet of Monboddo' (1791), and the 'Lament for James, Earl of Glencairn', who died at Falmouth on 30th January 1791, as the ship which was bringing him back to Scotland from a hopeless quest abroad in search of renewed health, was entering the harbour. The death of his noble patron stirred Burns to one of his best efforts in what was

[1] Though Burns seems to have fallen out with Morin (or Morine) about the time of the actual removal, and wrote an uncomplimentary epigram upon him.

essentially a foreign convention. Nor is the lament for the untimely death of Lord Monboddo's second daughter, the beautiful Elizabeth Burnet,[1] lacking in sincerity, though sincerity is not by itself enough to render the alien medium wholly tractable to the poet.

'The Whistle' celebrates a famous drinking contest that took place at Friars Carse on 16th October 1789. 'The little ebony whistle' itself was supposed to have been brought over to Scotland by 'a matchless champion of Bacchus' who accompanied Anne, James the VI's Danish queen. It was laid on the table before the start of a drinking orgy, and whoever was able to blow it after his companions were below the table, retained it as a trophy. The Dane lost it to Sir Robert Lawrie of Maxwelton, who in turn lost it to a member of the Riddell family. The competitors during the bout at which Burns was present[2] were Sir Robert Lawrie, the M.P. for Dumfriesshire, Robert Riddell the host, and Alexander Fergusson of Craigdarroch, who blew the winning blast.

The ballad in celebration of this event is a jingling, Anglicized affair cast in a stanza-pattern later favoured by Sir Walter Scott and lesser early nineteenth-century Scottish poets. The stanzas which describe the withdrawal of two of the contestants give some idea of the worth of the piece.

> Then worthy Glenriddel, so cautious and sage,
> No longer the warfare ungodly would wage:
> A high Ruling Elder to wallow in wine!
> He left the foul business to folks less divine.

[1] Alexander Young, a prim Tory Writer to the Signet, recording that Miss Burnet was . . . frequently mentioned by Burns with great admiration, and most justly, adding; 'for she was a remarkably handsome and a very amiable young woman. She had one great personal defect however—her teeth were much decayed and discoloured, but fortunately she had a very small mouth, and took care not to open it much in mixed company.'

[2] William Hunter, one of the servants at Friars Carse, later testified that 'When the gentlemen were put to bed, Burns walked home without any assistance, not being the worse of drink'. That Burns, by the standard of the age, was not a heavy drinker, is also borne out by the testimony of the Ellisland servants.

The gallant Sir Robert fought hard to the end;
But who can with Fate and quart bumpers contend?
Though Fate said, a hero shall perish in light;
So uprose bright Phoebus—and down fell the knight.

Next uprose our Bard, like a prophet in drink;—
'Craigdarroch, thou'lt soar when creation shall sink!
But if thou would flourish immortal in rhyme,
Come—one bottle more—and have at the sublime!

Thy line, that have struggled for freedom with Bruce,
Shall heroes and patriots ever produce:
So thine be the laurel and mine be the bay;
The field thou hast won, by yon bright God of Day!'

Many other occasional pieces were written at this time, of which
the most interesting were the 'ode' sacred to the Memory of Mrs
Oswald of Auchencruive (1789) a poem in which Burns's dislike
of that barrier of aloof snobbishness which separated the upper
class from the common folk, led him to speak in the accents of a
rather ugly class-hatred; and that rollicking piece 'On Captain
Grose's Peregrinations Thro' Scotland', written in an effective
friendly mocking vein. With warm protestations of friendship the
poet pokes kindly fun at the Captain's interests:

> Hear, Land o' Cakes, and brither Scots
> Frae Maidenkirk to Johnny Groat's—
> If there's a hole in a' your coats,
> I rede you tent it: [*warn you attend to it*
> A chield's amang you, taking notes, [*fellow*
> And, faith, he'll prent it.

The last two lines are celebrated. But Grose's antiquarian activities
were to stimulate Burns to a far greater achievement, 'Tam o'
Shanter'. In the jovial Captain's search for antiquities, Burns saw a
further chance to spread the fame of his native shire. Accordingly he
provided Grose with a list of the most interesting old buildings in
Ayrshire, including Alloway Kirk, of which Grose promised to
include a picture in his book, provided the poet would supply a

traditional witch story to go with it. Burns agreed. He knew of three such stories, but it is the second of these folk-tales, set forth in an undated letter to Grose, which is the real source of the poem.

On a market day in the town of Ayr, a farmer from Carrick, and consequently whose way lay by the very gate of Aloway kirkyard, in order to cross the river Doon at the old bridge, which is about two or three hundred yards further on than the said gate, had been detained by his business till by the time he reached Aloway it was the wizard hour, between night and morning.

Though he was terrified with a blaze streaming from the kirk, yet as it is a well-known fact, that to turn back on these occasions is running by far the greatest risk of mischief, he prudently advanced on his road. When he had reached the gate of the kirk-yard, he was surprised and entertained, through the ribs and arches of an old gothic-window which still faces the highway, to see a dance of witches merrily footing it round their old sooty blackguard master, who was keeping them all alive with the power of his bagpipe. The farmer stopping his horse to observe them a little, could plainly descry the faces of many old women of his acquaintance and neighbourhood. How the gentleman was dressed, tradition does not say; but the ladies were all in their smocks; and one of them happening unluckily to have a smock which was considerably too short to answer all the pur-pose of that piece of dress, our farmer was so tickled that he involuntarily burst out, with a loud laugh, 'Weil luppen, Maggy wi' the short sark!' and recollecting himself, instantly spurred his horse to the top of his speed. I need not mention the universally known fact, that no diabolical power can pursue you beyond the middle of a running stream. Lucky it was for the poor farmer that the river Doon was so near, for notwithstanding the speed of his horse, which was a good one, against he reached the middle of the arch of the bridge, and consequently the middle of the stream, the pursuing, vengeful hags were so close at his heels, that one of them actually sprung to seize him; but it was too late; nothing was on her side of the stream but the horse's tail, which imme-diately gave way to her infernal grip, as if blasted by a stroke of

lightning; but the farmer was beyond her reach.—However, the
unsightly, tail-less condition of the vigorous steed was to the
last hours of the noble creature's life, an awful warning to the
Carrick farmers, not to stay too late in Ayr markets.

The tale is here told in the folk-manner as Burns must have heard it
told to him by people who could still believe in witches and their
associated superstitions. But Burns was able to make the best of two
worlds. Being educated, he could take the tale as it came from the
soil, yet maintain an ironic detachment: and—if tradition is to be
believed—in the space of one short day stolen from his rounds, not
only give his new version a witty poise, but turn it at the same time
into a vivid poetic narrative.

'Tam o' Shanter' is written in the octosyllabic couplets which
Ramsay had used for his 'Fables and Tales' after those ,of La
Fontaine, and is in the tradition of Cowper's 'John Gilpin' and
Byron's 'Mazeppa'. In Burns's hands, however, the pace is alto-
gether swifter, the handling of the medium incomparably more sure
and deft.

The poem begins with a mock-philosophical prologue, in which
the bustle of the market town is established and we are introduced
to Tam, and subtly persuaded that, lovable though he is, his wife's
estimate of him as 'a skellum, A blethering, blustering, drunken
blellum', is probably correct.

> When chapman billies leave the street, *[packmen fellows*
> And drouthy neebors neebors meet;
> As market days are wearing late,
> An' folk begin to tak the gate;
> While we sit bousing at the nappy *[ale*
> An' gettin' fou and unco happy,
> We think na on the lang Scots miles,[1]
> The mosses, water, slaps, and stiles, *[bogs*
> That lie between us and our hame,
> Whare sits our sulky, sullen dame,
> Gathering her brows like gathering storm,
> Nursing her wrath to keep it warm.

[1] A Scots mile was longer than an English or imperial mile.

This truth fand honest Tam o' Shanter,
As he frae Ayr ae nicht did canter....

After a brief enumeration of some of Kate's complaints against her husband's indiscretions, Burns interpolates a gentle expression of ironic regret that husbands so often disregard the advice of their wives. He then gets down to the business of telling the well-known story.

Warm and glowing is Burns's description of Tam drinking with:

> ... Souter Johnny,
> His ancient, trusty, drouthy crony;
> Tam lo'ed him like a very brither;
> They had been fou for weeks thegither....

Burnsites have tried to trace originals for the two characters. Probably such originals existed, but the popular notion that they ought to have, is no mean tribute to Burns's power of characterization.

Part of the greatness of 'Tam o' Shanter' is its absolute freedom from sententious moralizing. True, the poet frequently interjects his own comments on the situations he is describing, but only to give witty point to them, never to censure. For the most part, in telling the story, as Mr Crawford observes, Burns 'assumes the voice and language of a narrator whose outlook is indistinguishable from that of Jock Tamson, the Scottish John Smith'.

Tam may, indeed, have been a rogue and a drunken fool; but Burns is only concerned with Tam's character at the beginning of his adventure. And Tam is magnificently drunk. Who has better described the sheer exultation of drunkenness than Burns?

> Kings may be blest, but Tam was glorious,
> O'er a' the ills o' life victorious!

Many times in his poems Burns sweeps away the cold arguments of logic with a glorious emotional gesture of this sort: a great cry of the blood against the restrictions with which reason would seek to tame its proud ebullience. Such sensuous heart-cries may displease the moralizers, may smutch the pretty picture of the National Bard which the narrow men down the years have tried to establish; but it

is this very clamouring of the blood that keeps Burns's best work so exciting and so stimulating, when so much else in which the driving force is less elemental has worn thin and wearisome.

The comment which the poet provided on Tam's happy state has given rise to a good deal of critical argument. For Burns suddenly appears to switch over into English, or what looks like English:

> But pleasures are like poppies spread,
> You seize the flow'r, its bloom is shed;
> Or like the snow falls in the river,
> A moment white—then melts for ever;
> Or like the borealis race
> That flit ere you can point their place;
> Or like the rainbow's lovely form
> Evanishing amid the storm—
> Nae man can tether time or tide;
> The hour approaches Tam maun ride;
> That hour, o' night's black arch the key-stane,
> That dreary hour he mounts his beast in;
> And sic a night he taks the road in,
> As ne'er poor sinner was abroad in.

The first eight lines of that quotation were once used by Dr Edwin Muir to illustrate a thesis that since Scots disintegrated as a homogenous language capable of expressing Scottish life at all levels, Scots writers have more and more tended to *feel* in Scots but *think* in English.[1] The illustration is hardly a happy one, for the succession of English images which make up the lines in question are far more obviously expressions of feeling than of thought. In any case, back into Scots again, 'that hour o' night's black arch the key-stane' is at least as thoughtful an image as any of its predecessors.

Dr Daiches, seeking to correct Dr Muir, thinks that the lines are 'written in a deliberately "fancy" English . . . a form of expression which will set the sternness of objective fact against the warm, cosy and self-deluding view of the half-intoxicated Tam. What more

[1] *Scott and Scotland* (1936). He subsequently altered his views in the years before his death, to the extent of becoming a well-wisher of the Lallans revival.

effective device than to employ a deliberate neo-classic English poetic diction in these lines?' All of which is as may be; but is the language really so very neo-classical? These eight English lines, with the possible exception of the one word 'evanishing'[1] seem to me to be singularly unencumbered by poetic diction, and in fact to be remarkably taut and direct. I am much more inclined to accept the view of Dr Douglas Young[2] that in the disputed passage: 'there is a deep-seated Scotticism counter-weighing the superficial Anglicism of stray words and, of course, Anglicized orthography.' Douglas Young suggests that the passage may well have sounded rather like this in Burns's day:

> But pleesyurs are like poppies spraid,
> Ye seize the fleur, its bleum is shaid;
> Or like the snaw faas in the river
> Yae moment white, than melts for ever;
> Or like the borealis race,
> That flit ere you can paint their place;
> Or like the rainbow's luvely foarum
> Evanishin amid the stoarum. . . .

Doubtless Dr Young has a point, even if only to the extent that English on a Scots tongue has a sound of its own.

Dr Kurt Wittig, on the other hand, claims[3] that Burns's use of 'near-English', moving easily back into Scots, is what gives the poem 'a touch of perfection'.

To return to 'Tam o' Shanter': Tam sets out through the storm in a night:

> . . . a child might understand
> The Deil had business on his hand.

This, the first mention of the Deil, with its overtones of witches' orgies and the black arts of many Scottish centuries, arouses in us expectancy for the horrors to come. At first it is natural horrors that mark the path of Tam's Progress:

[1] Which was nevertheless a popular word with the authors of the Scots Ballads.

[2] *Plastic Scots and the Scots Literary Tradition.*

[3] *The Scots Literary Tradition.*

By this time he was 'cross the ford,
Whare in the snaw the chapman smoor'd; [*smothered*
And past the birks and meikle stane, [*birches big stone*
Whare drunken Charlie brak's neck-bane;
And thro' the whins, and by the cairn,
Whare hunters fand the murder'd bairn . . .

and so on; until:

. . . glimmering thro' the groaning trees,
Kirk-Alloway seem'd in a bleeze.

Fortified by 'bold John Barleycorn', Tam presses Maggie forward, to investigate the sounds of mirth and dancing which were coming out of the ruined though illuminated walls. The 'unco sight' he saw made Tam draw in his reins, and Burns draws up the movement of his verse-paragraph before rattling off his terrifying description of the Deil and his lady-followers revelling amidst their traditional Scottish surroundings:

Coffins stood round, like open presses,
That shaw'd the dead in their last dresses;
And, by some devilish cantraip sleight, [*weird trick*
Each in its cauld hand held a light—
By which heroic Tam was able
To note upon the haly table,
A murderer's banes, in gibbet-airns;
Twa span-lang, wee, unchristen'd bairns;
A thief new-cutted frae a rape,
Wi' his last gasp his gab did gape;
Five tomahawks, wi' blude red-rusted;
Five scymitars, wi' murder crusted;
A garter which a babe had strangled,
A knife a father's throat had mangled—
Whom his ain son o' life bereft—
The grey hairs yet stack to the heft; [*stuck to the handle*
Wi' mair of horrible and awefu',
Which ev'n to name wad be unlawfu'.

It is difficult to avoid the suspicion that by placing the murderer's arms on the 'holy table' and introducing the 'unchristen'd bairn', Burns was seizing a passing opportunity to take yet another crack at 'Auld Licht' superstitions. In an essay in *New Judgements*, William Montgomerie infers a subconscious connexion between the Burns of the early anti-Kirk satires, and the Burns of 'Tam o' Shanter'.

'Auld Nick's place in the poem is significantly in the Kirk, though in opposition to it. He is a creature of the historical past, like his warlocks and witches. . . . He is part of the human personality suppressed by Calvinism, Burns the poet and fornicator . . . summing up in himself all the elements in the Scotsman that the Kirk, unable to destroy them . . . has suppressed.'

The effect of this cumulative gathering of country terrors is overwhelming, and it is small wonder that Tam 'glowr'd, amaz'd and curious' as the witches and warlocks danced, in the midst of this Hellish paraphernalia, to the music of Auld Nick's pipes.[1]

At this point in the proceedings, Burns once again detaches himself from the business of story-telling and addresses Tam, making it plain by inference that he, the author, is as amused at Tam's belief in superstitions as is the reader.

> Now Tam, O Tam! had thae been queans,
> A' plump and strapping in their teens!
> Their sarks, instead o' creeshie flannen, [greasy
> Been snaw-white seventeen hunder linnen!—
> Thir breeks o' mine, my only pair,
> That ance were plush, o' gude blue hair,
> I wad hae gi'en them aff my hurdies [buttocks
> For ae blink o' the bonie birdies!
>
> But wither'd beldams, auld and droll,
> Rigwoodie hags wad spean a foal [wizened
> Lowping and flinging on a crummock, [staff
> I wonder didna turn thy stomach.

[1] It is noteworthy that William Dunbar, in 'The Dance of the Seiven Deidly Sins', also allots the Devil the bagpipes as his natural musical instrument!

It is, indeed, these cleverly-placed ironic mock-sympathetic inter-
jections that give the poem much of its superb verve.

Tam, however, becomes particularly interested in one of the
witches, 'wee Nannie', who seems to be a recent recruit to the con-
tingent, and neither to have quite lost her human qualities nor yet to
have had the opportunity of changing the inadequate 'cutty sark'
which she had worn as 'a lassie'. Burns describes her dance to the
point where:

> Tam tint his reason a' thegither [*lost*
> And roars out 'Weel done, Cutty-sark!'
> And in an instant all was dark;
> And scarcely had he Maggie rallied,
> When out the hellish legion sallied.

The pursuit is fast and furious, the tempo of the verse quickening
as Burns views the fantastic chase with mock alarm and expresses
sympathy for Tam's impending fate—'In hell they'll roast thee like a
herrin'!' But evil spirits cannot cross running water, and fortunately
the Doon is near at hand. Maggie clatters up the bridge, but before
she gets over the middle of the arch:

> Nannie, far before the rest,
> Hard upon noble Maggie prest,
> And flew at Tam wi' furious ettle: [*design*
> But little wist she Maggie's mettle—
> Ae spring brought off her master hale,
> But left behind her ain grey tail:
> The carlin claught her by the rump, [*clutched*
> And left poor Maggie scarce a stump.

So the tale proper ends. But Burns has one more ironic comment
to make, this time in the form of a ludicrous moral.

> Now, wha this tale o' truth shall read,
> Ilk man and mother's son, take heed:
> Whene'er to drink you are inclined,
> Or cutty sarks run in your mind,
> Think! ye may buy the joys o'er dear,
> Remember Tam o' Shanter's mare.

One can almost see the smile on the poet's face as he puts across this preposterous simplification, just as one can see Sir David Lyndsay's smile as he naïvely disowned all knowledge of what passed between Squire Meldrum and Margaret Lawson when the Squire returned from recapturing Boturich Castle, though a few lines later he informs us, in matter-of-fact tones, that not long after the lady bore the Squire a son! Understatements and simplifications of this sort do, in fact, form an important ingredient of Scotland's national humour.

'Tam o' Shanter' is unquestionably Burns's greatest long poem. The skill with which he adjusts the tempi of his verse-paragraphs to suit the nuances of their context, the adroitness with which he adjusts the viewpoint to interject ironic comment, the wealth of memorable imagery, and the obvious warm enjoyment which the poet clearly gets in the telling of his own tale, all combine to make it a masterpiece.

It first appeared in the *Edinburgh Magazine* for March 1791, and a little later the same month, in the *Edinburgh Herald*. It also came out in Grose's *Antiquities* the following month. Even before it was published, it had proved its popularity by the demand for manuscript copies. 'Go on,' wrote Alexander Fraser Tytler, the Judge-Advocate of Scotland, after he had read the poem in the *Edinburgh Magazine*, 'write more tales in the same style—you will eclipse Prior and La Fontaine; for with equal wit, equal power of numbers and equal naïvete of expression, you have a bolder and more vigorous imagination.' 'Your approbation, Sir,' replied Burns, 'has given me such additional spirits to persevere in this species of poetic composition, that I am already revolving two or three stories in my fancy. If I can bring these floating ideas to bear any kind of embodied form, it will give me an additional opportunity of assuring you how much I have the honour to be, &c.—'

Alas for Scottish Literature! none of these 'floating ideas' were ever given 'embodied form', and 'Tam o' Shanter' remains the single glory of its kind in Burns's output, and an outstanding memorial to his days at Ellisland.

But there were other shorter memorials no less great in their own ways. There were the songs: 'Auld Lang Syne', which in a curious

way manages to celebrate both the personal relationship between man and woman, and shared masculine comradeship, an achievement which possibly accounts for its success. It has replaced 'Guidnicht and Joy be wi' ye A'' as the Scottish farewell-song, being now sung (usually inaccurately) at Scots partings the world over; 'John Anderson, my Jo', the most touching salute to ageing married love ever written: 'To Mary in Heaven'; the rather artificial but popular English song, 'My Heart's in the Highlands' (artificial, because the poet's heart was rooted firmly in the Lowlands); that most glorious of all drinking songs 'Willie Brew'd a Peck o' Maut', arising out of a happy visit to Moffat where William Nicol was holidaying, in company with another schoolmaster holidaying at Dalswinton, Allan Masterton, who wrote the tune; and 'Beware o' Bonie Ann', which celebrates the maturing charms of Allan Masterton's youthful daughter.

It was probably while he was at Ellisland, too, that Burns began for his friend Robert Riddell his invaluable annotations on Scots song in an interleaved copy of *The Scots Musical Museum*; notes which eventually covered the first four volumes of that work. He also began the book known as the *Glenriddell Manuscript*, into which he copied a selection of what he considered to be his best letters. It was intended for Riddell's library, but was never presented because of an unfortunate rupture in the relations of the two men and the early death of the Laird of Friar's Carse.

9

Dumfries

I

DUMFRIES, to which Burns came to spend the last years of his life, stands on the banks of the Nith about nine miles above the junction of that river with the Solway. It grew up around a much-used ford, became a Royal Burgh in 1186, and provided the scene for the irruption into Scottish history of Robert the Bruce (1305). For it was here in Dumfries that the Bruce slew his rival the Red Comyn—in the chapel of the Minorite Friars, which stood near the corner of what are now Castle Street and Friar's Vennel. But in every way Dumfries was an historic town, as Burns knew. For Prince Charlie had stayed there on his retreat from Derby in 1746. And earlier still—in the thirteenth century—Lady Devorgilla, wife of the Founder of Balliol College, had built a noble stone bridge in place of the ancient ford. This bridge still stands, near the new stone bridge farther up the river which was erected while Burns was a resident of the town.

In Burns's day, Dumfries was a bustling town of some 5,600 inhabitants, living in red brick and sandstone houses, built mostly around the High Street and its continuation, the Kirkgate. So said Sir John Sinclair's *Statistical Account*. Another source-book, written within a decade of Burns's death, adds:

> The situation of the town, rising gradually from the river, is beautiful and advantageous. It is allowed by strangers to be neat and well built. It is well lighted, and neatly paved.[1]

It possessed, furthermore, an early eighteenth-century Town Hall quaintly placed in the middle of the main street; a house of correction; a theatre; an 'elegant suite of assembly rooms'; two churches

[1] *The Beauties of Scotland*, Vol. II, 1805, by Robert Forsyth.

—St Michael's, which was built just after the Reformation, and the New Church of 1727—as well as chapels for Episcopalians, Methodists, Antiburghers, and the sect of Relief; a subscription Infirmary, opened in 1777; a printing house and a newspaper, the *Weekly Journal*; a library dating from 1750; and branches of three Scottish banks.

There were out-of-doors diversions too; the Race Week held by the Dumfriesshire and Galloway Club, and the annual King's birthday shooting tournament, when the members of the Seven Trades marched in procession to a wapinschaw, where they competed for James VI's 'Siller Gun'.[1]

The Incorporation of Traders was strong for the size of the place. Dumfries possessed a 'tan-works', while 'stockings, hats, linen, and coarse woollen cloths' were also manufactured, though mostly for local consumption. Great cattle-markets and horse-fairs were held in the town three times a year—at Candlemas Fair, the first Wednesday after the 13th of February; on the first Wednesday of July; and at the Road Fair, on the first Wednesday after the 25th of September —to attend which drovers came in from adjacent counties and the north of England. The harbour—two miles down the river— handled small coasting vessels—and several other ships registered at the port exported potatoes and coal, and imported tobacco and wine.

Dumfries, then, was no sleepy provincial town, but a miniature south-western centre on its own, animated by a healthy civic life. Smollett, indeed, made young Melford (in *Humphry Clinker*) say of it twenty years before Burns arrived:

> If I was confined to Scotland for life, I would choose Dumfries as the place of my residence.

Such, then, was the town which welcomed Burns at the beginning of the winter of 1791—a pleasant, lively town, the largest he had ever stayed in for any length of time, and admirably suited to cater for his social tastes. Near by, too, stood Sweetheart Abbey, also built by Lady Devorgilla, and where she and John Balliol, her husband, lie buried: the ruined Lincluden Abbey, with its peaceful monastic associations; and, down the river, that ancient seat of the

[1] John Mayne's poem, 'The Siller Gun,' describes one such late eighteenth-century tournament.

Maxwells, Caerlaverock Castle, whose very name conjures up the clangour of Border clashes. The only point against Dumfries, indeed, was its climate, which, because of its low-lying site and proximity to the marshes around the Solway, was inclined to breed mists and a chest-clinging damp.

Captain John Hamilton's house in what is now Bank Street, to which Burns first moved with Jean, young Robert and the two Ellisland babies Francis Wallace and William Nicol, stood near the quayside, almost on the Nith. Probably Anna Park's baby—which went first to Mossgiel—joined the household not long after they had settled in. At any rate, the house soon became too small for them, and on 19th May 1793, they moved to a more commodious self-contained house in Mill Vennel (now Burns Street), also owned by their friend Hamilton. Today, this house is a museum, which, even by modern standards, would be regarded as a tolerably spacious family home.

In Dumfries, Robert quickly acquired new male friends. He was the sort of man who made men friends easily, not only among the humbler folk he met and drank with in the Globe Inn, but also among professional people who were better able to appreciate the brilliance of his intellect.

One of these friends was Dr William Maxwell (1760–1834), a medical man who had received more than his professional training in France. For the doctor was a Jacobin whose enthusiasm had led him to join the Republican army, as a member of which he found himself one of the guards in attendance at the execution of King Louis the XVI. Maxwell had dipped his handkerchief in the unfortunate monarch's blood. In 1794, the doctor returned to Scotland, and began to practise at Dumfries. Although the excesses which he witnessed in France had turned him from a potentially active revolutionary into an ardent arm-chair sympathizer with the principles which gave rise to the Revolution, he was watched carefully by the authorities.

Maxwell played a leading part in the formation in Dumfries of a group known to support advanced ideas about constitutional reform. Robert's name was also associated with this group, and so was the name of one who probably became his closest male friend in Dumfries, John Syme.

John Syme (1755–1831) was the son of the Laird of Barncailzie in Kirkcudbrightshire, who was also a Writer to the Signet. Young Syme started his career in the army, intending to succeed his father in the management of the estate. Barncailzie, however, went down in the economic storm which followed the failure of the Ayr Bank; so in 1791 John Syme entered the Excise, soon afterwards getting himself appointed to the sinecure of Collector of Stamps at Dumfries. His office was situated in the lower flat of Burns's first home in Stinking Vennel.

Syme was intelligent and warm-hearted, though absent-minded and decidedly unpractical. He took a pessimistic view of the possibilities which life in Dumfries seemed to offer him, finding the society 'frivolous and dissipated'. Had it not been for his growing friendship with Burns (whom he had first met in 1788 though he did not get to know the poet really well until 1790), life in Dumfries for this kindly sentimentalist would have been well-nigh unbearable. As things turned out, the poet was often a guest at Ryedale, Syme's villa on the Maxwellton side of the river. Syme, though no Jacobin, at least shared Robert's views on the milder aspects of reform. In 1829, long after Burns's death, Syme remembered his friend's charm in the Dumfries days.

> The poet's expression varied perpetually, according to the idea that predominated in his mind; and it was beautiful to remark how well the play of the lips indicated the sentiment he was about to utter. His eyes and lips—the first remarkable for fire, and the second for flexibility—formed at all times an index to his mind . . . I cordially concur with what Sir Walter Scott says of the poet's eyes. In animated moments, and particularly when his anger was roused by instances of tergiversation, meanness, or tyranny, they were actually like coals of living fire.

The letters which passed between Syme and Alexander Cunningham from January 1789 until after Burns's death, trace the growth and development of a friendship which brought great pleasure into the life of the poet.[1]

[1] Syme recorded as his first impression of 'Bonnie Jean' that the poet must have 'exhibited his poetical genius when he celebrated her'.

There were other professional friends in Dumfries, not associated with the liberal group. Of such were the Reverend James Gray—who testified to the care which Burns bestowed on the education of his children—and Thomas White, pedagogues both. Gray was Latin master and later Rector of Dumfries Academy from 1794 to 1801, when he moved to the High School in Edinburgh. White was the mathematics master. Both men loved the poet well, and were not only loyal friends during his lifetime, but staunch defenders of his reputation after his death. Another good friend and admirer was the farmer John Clark of Locherwoods.

Alexander Cunningham (d. 1812)—Syme's correspondent—though not living in Dumfries, has some claim to be regarded as a friend of the Dumfries days, since his correspondence with Burns reached its height during the closing years of the Poet's life. Cunningham became a friend of Burns during the first Edinburgh winter, and, except for Robert Cleghorn (apparently a specialist in bawdry) and the bookseller Peter Hill, was the only friend of the Edinburgh days who maintained his contact with the poet. He, too, discharged his debt to Burns by playing a leading part in getting up the subscription for his widow and family.

Robert's immediate superiors in the Excise also became his good friends. Alexander Findlater's appointment as Supervisor of the Dumfries Excise district preceded Burns's arrival there by only six months. It was to Findlater that Burns was directly responsible. Findlater, a minister's son with a high sense of professional integrity, eventually succeeded Corbet at Glasgow—Findlater was strict in the surveillance of his junior's work. Thus, in June 1791, he took Robert to task about a faulty entry in one of his books. Robert's reply is revealing, not only because, taken with its postscript, it indicates the formal yet friendly relationship between superior and inferior; but because it also shows Robert's scrupulousness in the carrying out of his duties.

> I am both much surprised and vexed at that accident of Lorimer's Stock—The last survey I made prior to M^r Lorimer's going to Edin^r I was very particular in my inspection & the quantity was certainly in his possession as I stated it.—The

surveys I have made during his absence might as well have been marked 'key absent' as I never found any body but the lady, who I know is not mistress of the keys., &c. to know anything of it, and one of the times it would have rejoiced all Hell to have seen her so drunk. I have not surveyed there since his return.—I know the gentleman's ways are, like the grace of G—, past all comprehension; but I shall give the house a severe scrutiny tomorrow morning, & send you in the naked facts.—

I know, Sir, & regret deeply that this business glances with a malign aspect on my character as an Officer; but as I am really innocent in the affair, & as the gentleman is known to be an illicit Dealer, & particularly as this is the *single* instance of the least shadow of carelessness or impropriety in my conduct as an Officer, I shall be peculiarly unfortunate if my character shall fall a sacrifice to the dark maneouvres [*sic*] of a Smuggler.

I am, Sir, your obliged & obedient humble servant.

Robt. Burns.

Sunday even

I send you some rhymes I have just finished which tickle my fancy a little—

The gentleman was a certain William Lorimer, the father of 'Chloris' and farmer of Kemmis-hall, about two miles from Ellisland; a man who was not over scrupulous about his declarations to the Excise authorities. On this occasion, however, Burns's explanation of Lorimer's misbehaviour apparently satisfied the Supervisor.

Findlater's superior John Mitchell (d. 1804), also appreciated Burns's talents and soon became his friend. It was for one of Collector Mitchell's Excise Court dinners (according to Burns in his letter of March 1792 to John Leven, an Edinburgh General Supervisor) that he composed 'The De'il's awa wi' the Exciseman', that rollicking song which dances a verbal reel with itself.

Besides these men friends, many of whom Robert had at least got to know at Ellisland, though the friendships only blossomed under the more favourable social opportunities which Dumfries offered, there were the women friends. Mrs Dunlop remained his sheet-anchor, in spite of such temporary set-backs as the offence he

gave her on his visit to Dunlop House in 1792. On that occasion his hostess asked him to read the newly-printed poems of her latest protégé, the milkmaid Janet Little (who had already made an unsuccessful pilgrimage to Ellisland in 1790, only to find Burns suffering from a broken arm and not at all in an encouraging mood), and he had replied: 'Do I have to read all those?' in a tone which Mrs Dunlop considered to be the equivalent of a slap in the face. Sometimes, too, she suspected that he was not reading her letters as carefully as he should (her handwriting was atrocious, her punctuation decidedly weak); and on at least one occasion, she realized that Burns was plying her with insincerities. What else could he do with a shrewd old Scots lady who tried to cure him of 'undecency', and who apparently saw little difference in quality between his own Scots productions and the worthless productions of Miss Little? Yet, until January 1794, when he gave her some sort of offence which she considered unpardonable, the correspondence between them continued. She preached, she scolded, she advised, and she even tried to cool his Republican ardours, with which, being the mother-in-law of two French émigrés, she naturally had little sympathy. He, for his part, found her a safe person to whom he could let off steam. In her own strange mother-confessor way, she understood him as few others did. They were necessary to each other.

Of the women who actually entered Burns's life in the Dumfries days, Anna Park may or may not be numbered. She had borne his child—the second of his Elizabeths—just before she left Ellisland, and whether or not she went back to help her aunt at the Globe Inn, we do not know. It seems, on the face of it, hardly likely that she would risk further encounters with the man who had ruined her, though giving her a certain immortality in the process. Although Robert kept on frequenting the Globe Inn, he never mentioned Anna again. Possibly she may even have died shortly afterwards, giving birth to the child of a soldier, to whom one tradition decently married her.

Robert's original interest in Jean Lorimer, the daughter of the farmer of Kemmis-hall who gave the Excise so much trouble, was on behalf of a brother officer, John Gillespie. He was unsuccessful, however, and the eighteen-year-old Jean eloped to Gretna Green

with a young Cumberland squire called Whelpdale. But after three weeks of Whelpdale's matrimonial attentions, Jean returned to her father's roof, and Robert became interested in her on his own behalf. He soon stood to her, as he told Thomson, 'a mistress or friend, or what you will, in the guileless simplicity of Platonic love'. She had previously visited him at Ellisland and was the possessor of exceptionally fair hair, which inspired him to write 'Lassie wi' the lint-white locks', and nine other songs, one of which runs:

> Beyond thee, dearie, beyond thee, dearie,
> And oh! to be lying beyond thee;
> Oh, sweetly, soundly, weel may he sleep
> That's laid in the bed beyond thee!

That she became his mistress is possible, but on the whole doubtful, however much we may feel that with Burns 'Platonic love' was not so likely to be preserved through guileless innocence as by some temporary set-back caused by a lady's prudent obduracy. In any case, whether or not he tried to win 'Chloris' as he called her,— Jean being his wife's name and Whelpdale being conspicuous by its absence of poetic quality—is of little account.

He lost interest in her, partly perhaps because he could make no headway. So far as is known, 'Chloris' eventually entered domestic service, though whether or not she degenerated into a whore (vide Mrs Carswell) depends upon the value one places upon unauthenticated traditions.

By far the most interesting of Robert's women friends—and indeed, in many ways the best of the women he ever really knew— was Mrs Walter Riddell (1772–1808). Born in London, Maria Banks Woodley was the third and youngest daughter of William Woodley and his wife Frances Payne of St Kitts. Maria had been educated in England. In April 1788, she sailed for the West Indies, where her father was Governor and Captain-General of the Leeward Islands. In 1792, she published her experiences of the trip— which included a chase by pirates—in her book *Voyages to the Madeira and Leeward Caribee Islands; with Sketches of the Natural History of these Islands*. But she collected more than the material for a book in the West Indies, for while there she met and married

Walter Riddell (1764–1802), the feckless younger brother of Burns's friend, Captain Riddell of Glenriddell. Walter had lost his first wife, but through her had heired an estate in Antigua.

About the time of the roup of the Ellisland farm gear, Maria bore her first child, a daughter, in London. In December 1791, she probably met Burns for the first time at her brother-in-law's home, Friars Carse. The following May, her husband entered into an agreement to buy the estate of Goldielea, near Dumfries, which he renamed Woodley Park in Maria's honour. Here, her second daughter was born in November. And here, she welcomed the poet enthusiastically.

She was young, beautiful—as Thomas Lawrence's portrait of her shows—intelligent, witty and charming. She was also a woman of spirit. Burns realized this almost at once and said so to Smellie (whom she was anxious to consult about her book) in a letter dated 22nd January 1792.

> . . . To be impartial, however, the Lady has one unlucky fail-
> ing; a failing which you will easily discover, as she seems rather
> pleased with indulging it; & a failing which you will easily
> pardon, as it is a sin that very much besets yourself:—where she
> dislikes, or despises, she is apt to make no more a secret of it—
> than where she esteems or respects.

Despite all her many excellent qualities, Maria was, in fact, as Burns later discovered, a little capricious. But then she was not yet twenty.

Together, Robert and Maria took part in an excursion to the lead mines at Wanlockhead, when Maria found the poet's conversation 'fascinating', though the confinement under ground made him feel faint. A few weeks later, they began to correspond. Within six months, the situation was developing, though much more slowly, along the lines of the Clarinda affair, with Robert making veiled references to love, and Maria reminding him that her brother-in-law might not approve of the warmth of their friendship.

He waited on her—though, as with Clarinda, she seems to have been the one to invite him first—particularly after her husband, Walter, had sailed for Antigua in June 1793, where he hoped to raise the balance of the purchase price of his Scottish estate. And they exchanged poems and criticisms.

Such, then, were the friends who enriched Burns's years at Dumfries. In spite of the weight of pain and suffering which gradually bore down his gallant spirit, the Dumfries days were, until the last six months, in the main happy days; days of professional consolidation; days of artistic fulfilment when, for long stretches at a time, as he himself put it, he was 'in song'.

The record of song-work which Burns accomplished during the last five years of his life, taken in conjunction with the testimonies of his superiors in the Excise, absolutely give the lie to the slanders put about by nearly all nineteenth-century biographers, whose unctuous and unkind attitude was summed up by Henley's 'The story is a story of decadence'. There was no decadence of any sort. There was no inordinate drunkenness, as the vicious and unsuccessful Heron made out, and as it suited the reforming purposes of that temperance hot-gospeller Currie to propagate. Nor was there any venereal disease, as Currie so head-waggingly hinted. There was only the gradual submission of a great and manly heart to a cruel disease that had first laid hold of it a quarter of a century before.

II

When in February 1792, Burns was promoted to the Dumfries Third or Port Division, which could be covered entirely on foot, his Excise income was, as he told his 'Dearest Friend' Maria Riddell:

> Cash paid, Seventy pounds a year: and this I hold until I am appointed Supervisor. . . . My Perquisites I hope to make worth 15 or 20 £ more. So rejoice with them that do Rejoice.

Not long after this promotion, together with a colleague, John Lewars, Robert featured in a dramatic incident which was first of all over-written by Lockhart, and then written off by Snyder.

In the *Edinburgh Evening Courant* of Thursday 8th March, there appeared an announcement stating that on the previous Wednesday:

> the revenue officer for Dumfries, assisted by a strong party of the 3rd regiment of dragoons, seized a fine large smuggling vessel at Sarkfoot. . . . Upon the officers and the military proceeding towards the vessel, which they did in a martial and determined

manner, over a broad space of deep water, the smugglers had the audacity to fire upon them from their swivel guns, loaded with grape shot; but the vessel (owing to her construction) lay in such a situation as prevented their having a direction with effect.

This, without a doubt, was the brig *Rosamond*, and one of those who advanced in 'a martial and determined manner' upon her rebellious crew was Robert Burns.

Amongst the other Revenue Officers who took part was one Walter Crawford, a Riding Officer at Dumfries. He, it seems, first discovered what was afoot, and attempted to seize the *Rosamond* with a small party he had collected for another purpose. Being unsuccessful, he dispatched John Lewars to Dumfries to:

> bring Twenty four more Dragoons, while I went to Ecclefechan for the party there with which I patroled the roads till the arrivall of Mr Lewars with the additionall force from Dumfries.

In spite of the vagaries of his spelling, Crawford's diary account is sufficiently interesting to allow him to tell the tale of the actual encounter in his own words.[1]

> ... We approached with ... Dragoons ... in all forty four fully accoutered and on horse-back. The vessel having fallen down the Solway Firth about a mile from where she was yesterday, and being about a mile within sea mark, most of which space being covered with water and a very heavy current running between us and the vessel, we deemed it impossible to get at her, either on foot or on horseback, so we agreed to search the coast for boats in which to board her. But the Country People, guessing our design, got the start of us and staved every boat on the Coast before we could reach them; the vessel in the mean time keeping up a fire of grape shot and musquetry, we resolved as (a) last resource to attempt the passage on foot, as the quick sands made the rideing on horseback dangerous, or rather impossible.
>
> We drew up the Millitary in three divisions, determined to approach and attac(k) her if the s(t)ream was foardable, one party

[1] Burns Chronicle 1934. *Burns and the Rosamond* by H. W. Meikle. I have slightly modernized Crawford's spelling in the interests of intelligibility.

fore and aft, and the third on her broadside, the first party being commanded by Quarter Master Manly, the second by my self, and the third led by Mr Burns.

Our orders to the Millitary were to reserve their fire till within eight yards of the vessel, then to pour a volley and board her with sword and pistol. The vessel kept on firing, tho without any damage to us, as from the situation of the ship, they could not bring their great guns to bear on us, we in the mean time wading breast high, and in justice to the party under my command I must say with great alacrity; by the time we were within one hundred yeards of the vessel, the crew gave up the cause, got over (the) side towards England, which shore was for a long, long way dry sand. As I still supposed that there were only Country people they were putting ashore, and that the Crew was keeping under cover to make a more vigorous immediate resistance, we marched up as first concerted, but found the vessel completely evacuated both of crew and every moveable on board, except as per inventory, the Smugglers as their last instance of vengen(c)e having poured a six-pounder Carronade through her Broadside. She proved to be the Rosamond of Plymouth, Alexander Patty Master, and about one hundred tons burthern, schooner r(igged).

The 'Inventory of the Rosamond and Furniture' is apparently in John Lewars's hand, and contains, besides a list of fifty-three items, a draft Press advertisement announcing the sale of the ship and its contents by public roup in the Coffee House, Dumfries, on 19th April. This interval between capture and sale was made necessary because the ship had to be repaired. A note in Burns's hand tells us that two carpenters were employed for eleven days and four seamen for nine days at a cost of eight pounds eighteen shillings and then re-floated. The sale realized one hundred and sixty-six pounds sixteen shillings and sixpence. As the total expenses amounted to forty-five pounds fifteen shillings and fourpence, the profit was therefore one hundred and twenty-one pounds one shilling and twopence, part at least of which would presumably have been divided among the Excise Officers.

These papers form part of a bundle of documents relating to the

Rosamond given to Joseph Train, antiquary and Supervisor of Excise at Castle Douglas, by John Lewars's widow. In 1825, Train passed the documents to Sir Walter Scott, and Scott showed them to Lockhart, who made use of them to concoct his fanciful account of the whole business, including the unlikely tale about Burns's composing 'The De'il's awa' while waiting for Lewars to arrive with his reinforcements. The Train manuscripts came to light in the early 1930's, when the Abbotsford collection was being catalogued by the National Library of Scotland.

Unfortunately, one piece of evidence which Train claimed to have included in the bundle did not reveal itself, and has not since been traced. This was the document 'detailing the circumstances of Burns having purchased the four carronades at the sale'.

Lockhart avers that Burns paid £4 for these carronades, and the tradition is that he dispatched them as a gift to the French Convention to show his sympathy with their cause. According to Train, Sir Walter Scott tried unsuccessfully to trace the receipt of the guns in France, and thereafter 'applied to the Custom House authorities, who, after a considerable search, found that they had been seized at the port of Dover, as stated by Mr Lewars in his memorandum'.

Further researches have failed to substantiate Sir Walter's information, though in view of the proven accuracy of the rest of Train's claim, it would be rash to suppose that the carronades were never dispatched.

Of course, in a purely technical sense, there was no reason why Burns should not have sent carronades to France, since France and Great Britain were not yet then at war. But prudence should have made him question the wisdom and propriety of a Government servant dispatching arms, albeit obsolete, to a foreign Government that was already showing hostile intentions. Before very long, Burns was reminded, sharply and severely, of the limitations of his position. Meanwhile, in other ways he was receiving honours which showed that his literary merits were being more widely appreciated.

On 11th April, he was informed that the Royal Company of Archers had made him an honorary member. This coveted honour must have given him the greatest satisfaction, not only because of its intrinsic worth, but because it was proof that his name and fame

were still remembered in Edinburgh. In the same month, too, he received a letter from Creech suggesting a new edition of his *Poems*. Creech had actually advertised such an edition in 1790, but until he was stirred up by Cadell and Davies in London, who must have felt there would be a demand for a new edition in England, Creech did nothing beyond inviting Burns's aid in a vague way. Now, however, Bailie Creech—for such he had become—meant business.

Burns replied offering to add 'new materials to your two volumes, about fifty pages'. His terms: 'A few Books which I very much want, are all the recompence I crave, together with as many copies of my own works as Friendship or Gratitude shall prompt me to present. . . .'

Creech wasted no time in beginning to set the book, but thereafter delayed, so that it was not until Monday 18th February 1793 that it finally appeared. The proofs had been corrected—and not very well corrected either—by Burns's Edinburgh friend Alexander Fraser Tytler. Having secured Burns's copyright, Creech produced a Second Edition on 18th February, 1793. It included fifty pages of new poems, one of which was 'Tam o'Shanter', and was itself re-issued in 1794.

The fourth volume of the *Scots Musical Museum* made its appearance in August 1792. A few weeks later, Burns received a letter from Mr George Thomson of Edinburgh, making a proposition which was to implicate him still more deeply in the business of Scots song, and evoke some of his finest lyrics.

George Thomson (1757–1851), son of the schoolmaster at Limekilns, Dunfermline, had been educated mostly at Banff, and subsequently trained as a lawyer's clerk. In 1780, John Home, the author of *Douglas*, recommended young Thomson for a junior clerical appointment with the Board of Trustees for the Encouragement of Art and Manufacture in Scotland,[1] whose headquarters were in Edinburgh. He remained with the Board throughout his long and outwardly uneventful career, eventually becoming the Chief Clerk. His greatest triumph was that Raeburn preserved his weaksighted, inoffensive features for posterity.

[1] Set up under the terms of the Treaty of Union (1707) to promote Scottish Trade with money given by the British Parliament to compensate Scotland for losses on the Darien expedition and for assuming a share of England's national debt.

Thomson, narrow soul though he was, had one absorbing passion —music. He played in the orchestra at the St Cecilia Concerts: and he thrilled to the Italianate renderings of Scots songs which *castrati* like Tenducci indulged in when they visited Scotland. But Thomson's taste was none the less far from exceptional, for on the whole he seems to have considered the rather characterless work of Haydn's pupil Ignaz Joseph Pleyel (1757–1831) to be of more account than the music of Haydn himself, or even the music of Beethoven. But Thomson—whose long life stretched into mid-Victorian days— was, as a young man, a Victorian before his time, cursed with respect for emasculated gentility. He was also conceited (as his readiness to criticize and even alter some of Burns's work shows); sharp (as his attempts to secure the copyright of his 'crop of Burns songs' reveals); spiteful in his references to his rival Johnson; and malevolent enough to put out after Burns's death a wicked and distorted account of the supposed indulgent way of life of a man he had never even met,[1] and to tamper with the letters on his own side of their correspondence. For all these failings, however, he and his descendants paid in the end. His projects brought him little real recognition, and still less reward. Indeed, but for Burns's share in them, they would now be quite forgotten. His granddaughter became the unfortunate wife of Charles Dickens.

During the summer months of 1792, Thomson interested Andrew Erskine (younger brother of the bustling, purple-faced Earl of Kellie, a pupil of the composer Stamitz who composed overtures in his master's manner, but who 'wanted application', according to Dr Burney) in the idea of bringing out a collection of Scots tunes married to 'respectable' words. Erskine, however, was by then distractingly involved in debt as a result of gambling; and in the autumn of the following year, he ended his life by jumping into the Forth, his pockets filled with stones. So Thomson went on with his project alone. In September 1792, he asked Alexander Cunningham for a letter of introduction to the poet, which, being forthcoming, he

[1] There is no record of them ever having met. Thomson, in his later years, told a few people that he and Burns had met, many others that they had never met. The former story was probably based on wishful thinking.

sent to Burns in mid-September, accompanied by an explanation of his requirements and ideals.

> For some years past, I have, with a friend or two, employed many leisure hours in collating and collecting the most favourite of our national melodies, for publication. We have engaged Pleyel, the most agreeable composer living, to put accompaniments to these, and also to compose an instrumental prelude and conclusion to each air. . . . To render this work perfect, we are desirous to have the poetry improved wherever it seems unworthy of the music. . . . Some charming melodies are united to mere nonsense and doggerel, while others are accommodated with rhymes so loose and indelicate as cannot be sung in decent company. To remove this reproach would be an easy task to the author of 'The Cotter's Saturday Night'.

It was as the author of one of his most conventional poems that Thomson, like the Edinburgh patricians, thought of Burns. Having set forth the general scheme, he then came down to practical terms.

> We shall esteem your poetical assistance a particular favour, besides paying any reasonable price you shall please to demand for it . . . tell me frankly, then, whether you will devote your leisure to writing twenty or twenty-five songs, suitable to the particular melodies which I am prepared to send you. A few Songs exceptionable only in some of their verses, I will likewise submit to your consideration; leaving it to you either to mend these or make new songs in their stead.

Burns told him frankly, replying by return. He would cheerfully do the work, so long as he was not to be hurried.

> As to any remuneration, you may think my Songs either *above*, or *below* price; for they shall absolutely be the one or the other.—In the honest enthusiasm with which I embark in your undertaking, to talk of money, wages, fee, hire, &c. could be downright Sodomy of Soul!—A proof of each of the Songs that I compose or amend, I shall receive as a favor.

Suppressing the shudder which the word sodomy must have caused

to run through his gentle soul, Thomson was overjoyed.[1] Robert began work without delay. The idea of contributing to a well-printed and lavishly produced publication no doubt appealed to him, for the *Museum*, in spite of its many merits, could hardly be regarded as a model of typographical clarity, in spite of the copperplate process which Johnson proudly introduced to Scotland, and has sometimes been wrongly credited with having invented.

At first, Burns probably had no conception of the artistic danger into which Thomson was running with Pleyel and the other Germanic composers whom he had employed to provide the accompaniments. He did not live long enough to realize the full implications behind the unhappy marriages which Thomson so misguidedly effected between good Scots words, and florid, foreign *ritornelli* supplied by composers who were unable to understand the poems they were setting, and in some cases never even saw them. By the time Thomson made his offer, Johnson's interest in Scots song was waning, and Burns's enthusiasm alone kept the affairs of the *Museum* moving. Here, now, was a fresh chance to do further work 'for puir auld Scotland's sake'; this being so, without remuneration.

From the start, Burns made it plain to Thomson, as he had done earlier to Johnson, that he intended to abide by the editorial decision —an unfortunate admission, as things turned out, for Thomson had neither Johnson's good sense, nor his humility. By the end of the year, Burns had already sent Thomson half a dozen songs, including 'The Lea Rigg', 'My wife's a winsome wee thing', 'Auld Rab Morris', and 'Duncan Gray'. He was certainly 'in song', as he put it.

But as the tide of song surged high, so also did his feelings of revolt against the upper strata of Society. He became less guarded in his political utterances. The Caledonian Hunt concluded their annual autumn Meeting at Dumfries by patronizing a gala performance of *As You Like It* in the local theatre. At the end of the play, just before the National Anthem was played, there arose a sudden clamour in the pit for 'Ça Ira', the militant song of the French Revolutionaries. Burns may or may not have joined in that

[1] He eventually suggested to Dr Currie that some other word should be substituted for 'Sodomy', when sending Currie the letter after Burns's death. Currie, with a nice sense of moral distinction, changed it to 'Prostitution'.

quickly-suppressed call. He may or may not have risen to his feet when the National Anthem was eventually played. Relating the incident to Mrs Dunlop, he said:

> For me, I am a *Placeman*, you know, a very humble one indeed, Heaven knows, but still so much as to gag me from joining in the cry.—What my private sentiments are, you will find out without an interpreter, so, alas, could less friendly folk!

On 13th November, too, he wrote to William Johnstone, the outspoken and liberally-minded proprietor of the *Edinburgh Gazetteer*, subscribing to the paper, and urging the Editor to:

> Go on, Sir! Lay bare, with undaunted heart and steady hand, that horrid mass of corruption called Politics and State-Craft! Dare to draw in their native colours these 'Calm, ˜thinking Villains, whom no faith can fix'—whatever be the Shibboleth of their pretended Party.

That was not all. Burns later denied that he ever contributed to the paper himself, but he certainly persuaded the kindly-minded Robert Riddell to submit under the pseudonym of 'Cato' a letter setting forth the case for extending the Franchise.

In spite of these things, however, 1792 was a happy and successful year. On 21st November Jean gave birth to a daughter, the third and only legitimate Elizabeth, whom Robert greatly loved. She was, unhappily, a sickly child, destined to be short-lived and to cause her father much anguish of spirit because of her obvious frailness. But just as the year was at its close, the thunder-cloud which his outspoken radical sympathies had caused to spread gradually over his head, suddenly burst; and he was nearly swept away from his anchorage in the deluge. Someone denounced him to the Excise Board as disloyal. He was told that there would have to be an inquiry into his character.

To appreciate fully Burns's political position at the end of 1792, it is necessary to be aware of the general atmosphere of British politics immediately before and after the French Revolution. Since 1783, the Tory Government of the younger Pitt had been in office, and the Whigs, with Fox and Burke as their leaders, had been in opposition.

Pitt was not unwilling to grant such minor reforms as the political intelligence of the country at the time seemed to him to warrant. But his Ministry came near to disaster over the defeat of the Regency Bill (a defeat celebrated by Burns in a contemptuous mock-ode in the 'masquing' manner of James Thomson), and but for events in France, might reasonably have been supposed to be on the verge of dissolution.

The Whigs, however, were divided in their attitude towards the Revolution. Burke, who had been on the side of freedom when Ireland and America were concerned, had visited the French court in 1774, and been deeply impressed with the personal 'brilliancy, splendour and beauty' of Marie Antoinette and with 'the prostrate homage of a nation to her'. He had also conceived a distrust which ripened into contempt, for the Revolutionary leaders. He felt sure that in allowing these leaders to free her from the old royalist tyranny, France was in danger of putting herself under a crueller and more calculating tyranny. In 1790 he thundered out his fears in his *Reflections on the Revolution in France*, which was sharply answered by defenders of the Left, among them Thomas Paine in his *Rights of Man* (1791).

The more liberal section of the Whig party, however, saw in the Revolution the birth of a French parliamentary system, and the dawning of a mystical universal brotherhood; while Radicals saw in it at long last the breaking down of those ancient feudalistic inequalities which enabled a few men to straddle the backs of others by virtue of their social lineage. With a certain amount of liberal Whig support, radical groups in favour of domestic social reform, more or less revolutionary in temper, began to be formed in both England and Scotland. 'The Friends of the People' they called themselves, and in Edinburgh their intellectual leader was Henry Erskine, Dean of the Faculty of Advocates. Their numbers included Lord Daer, Colonel Dalrymple and the advocate Thomas Muir.

The condition of the lower orders in Scotland—especially the miners—was, indeed, deplorable, and 'The Friends of the People' had a good deal of justification for their point of view in so far as it affected home affairs. But the French Revolutionaries' creed of violence, their ruthless disregard of the means by which they

achieved at least partly laudable ends, and their excursions into Holland and the Savoy soon began to alarm the British Government.

Burke began to be proved right. Throughout 1792, brutality and bloodshed rather than liberty and equality, characterized the French leaders' behaviour. The monarchy fell, and the Reign of Terror began. In the autumn, Britain joined the European coalition against France, and on Friday 1st February 1793 war was declared.

Pitt's Government, genuinely scared—but also glad of a legitimate excuse to wipe out those, who by clamouring for too-sweeping reforms menaced entrenched Privilege—took immediate repressive measures against 'The Friends of the People'. They chose a Scotsman of whom to make their main example. Muir and several lesser lights were given 'trials' which Lord Cockburn described as 'the greatest travesty of justice since the Bloody Assizes', and sentenced to extravagant terms of deportation by the coarse and vicious Lord Braxfield. Lord Daer and Henry Erskine, to be sure, could not be touched with impunity. But the Dean of the Faculty, for having had the temerity to protest against the legal impropriety of Braxfield's trials, found himself voted out of office by a majority which included a vote from the young Walter Scott. In 1794, the Habeas Corpus Act was suspended, and kept in suspension till 1801.

Once war had actually been declared, those who remained 'Friends of the People' automatically became enemies of their own people. Thus the political schism was healed, and even the two opposing parties stood together to face the menace of French invasion.

Such, then, were the events on the eve of which some unknown person informed against Burns. His reaction was panic-stricken self-abasement. To Graham of Fintry he burst out:

I have been surprised, confounded & distracted by Mr Mitchel, the Collector, telling me just now, that he has received an order from your Honble Board to enquire into my political conduct, & blaming me as a person disaffected to Government. Sir, you are a Husband—& a father—you know what you would feel, to see the much-loved wife of your bosom, & your helpless, prattling little ones, turned adrift into the world, degraded & disgraced

from a situation in which they have been respectable & respected, and left almost without the necessary support of a miserable existence.—Alas, Sir! must I think that such, soon, will be my lot! And from the damned, dark insinuations of hellish vile, groundless Envy too! . . . I say, that the allegation, whatever villain has made it, is a LIE! To the British Constitution, on Revolution principles[1] next after my God, I am most devoutly attached!

Burns then appealed to Graham to save him 'from that misery which threatens to overwhelm me, and which, with my latest breath I will say it, I have not deserved'.

Graham replied on 5th January 1793, providing Burns with a list of the charges that had been laid against him, and probably reassuring him that, provided he was in fact innocent, the extreme horrors he had so graphically painted would scarcely be likely to overtake him. Burns replied to the charges at length, by return.

It has been said, it seems, that I not only belong to, but head a disaffected party in this place.—I know of no party in this place, Republican or Reform, except an old party of Borough-Reform; with which I never had anything to do.—Individuals, both Republican and Reform, we have, though not many of either; but if they have been associated, it is more than I have the least knowledge of: and if there exists such an association, it must consist of such obscure nameless beings, as precludes any possibility of my being known to them or they to me.—

I was in the playhouse one night, when ÇA IRA was called for. —I was in the middle of the Pit, and from the Pit the clamour arose.—One or two individuals with whom I occasionally associate were of the party, but I neither knew of the Plot, nor joined in the Plot; nor ever opened my lips to hiss, or huzza, that, or any other Political tune whatever—. . . .

I never uttered any invectives against the king.—His private worth, it is altogether impossible that such a man as I, can appreciate; and in his Public capacity, I always revered, and ever will, with the soundest loyalty, revere, the monarch of Great

[1] i.e. Protestantism and the Hanoverian succession.

Britain as, to speak in Masonic, the sacred KEYSTONE OF OUR
ROYAL ARCH CONSTITUTION.

As to REFORM PRINCIPLES, I look upon the British Consti-
tution, as settled at the Revolution,[1] to be the most glorious
Constitution on earth, or that perhaps the wit of man can frame;
at the same time I think, and you know what High and dis-
tinguished Characters have for some time thought so, that we
have a good deal deviated from the original principles of that
Constitution; particularly, that an alarming System of Corrup-
tion has pervaded the connection between the Executive Power
and the House of Commons.—This is the Truth, the Whole truth,
of my Reform opinions; opinions which, before I was aware of
the complection of these innovating times, I too unguardedly
(now I see it) sported with: but henceforth I seal my lips. . . .

Of Johnston the publisher of the Edinr Gazatteer, I know
nothing . . . If you think that I act improperly in allowing his
Paper to come addressed to me, I shall immediately counter-
mand it. . . .

As to France, I was her enthusiastic votary in the beginning of
the business.—When she came to show her old avidity for con-
quest, in annexing Savoy, &c. to her dominions and invading the
rights of Holland, I altered my sentiments. . . .

That was certainly a reasonable-sounding confession of not parti-
cularly heinous political sins, well-calculated to restore his position.
He said nothing, however, about his association with the notorious
Maxwell, and nothing about his exhortation to Johnston, or about a
certain poem he had sent him, 'Here's a health to them that's awa',
containing the lines:

> Here's freedom to him that wad read!
> Here's freedom to him that wad write!
> There's nane ever feared that the truth should be heard
> But they wham the truth would indite!

However, Robert was so completely sure his plea would be
effective that he finished it off with a suggestion that he might

[1] 1688.

replace the Supervisor of the Galloway District, a Mr McFarlane, who was ill with 'a paralytic affection'.

Graham of Fintry was certainly a loyal friend. He laid the letter before the Board, in accordance with his duty, though no doubt he pled the poet's cause. But the Board were irritated by their employee's gibe against the private worth of the King, and by his allegation that corruption did exist in the Government machine. They were therefore not disposed to let him off too lightly. So they instructed Corbet to go down from Glasgow, and in company with Mitchell and Findlater, inquire on the spot into the poet's conduct, making it plain to him that his business was to act, not to think: 'and that whatever might be Men or Measures, it was for me to be silent and obedient.' All of which was, of course, a perfectly right and proper course for them to take with a junior officer on their active list, however humiliating it might seem to a gauger who incidentally happened to be a great democratic poet.

News of Burns's indiscretions got round, and a report reached the ears of John Erskine of Mar (grandson of that Earl of Mar who took part in the rising of 1715, thereby losing the family's titles), who promptly wrote to Robert Riddell asking if the rumour were true, and suggesting that if it was, a fund should be raised to keep the poet from starvation. Riddell showed the letter to Burns who, deeply touched, wrote Erskine a reply overflowing with manly gratitude, and breaking out into a noble organ-peal of democratic assertion.

> Does any man tell me, that my feeble efforts can be of no service; & that it does not belong to my humble station to meddle with the concerns of a People?—I tell him, that it is on such individuals as I, that for the hand of support & the eye of intelligence, a Nation has to rest.—The uninformed mob may swell a nation's bulk; & the titled, tinsel Courtly throng may be its feathered ornament, but the number of those who are elevated enough in life, to reason and reflect; & yet low enough to keep clear of the real contagion of a Court; these are a Nation's strength.[1]

[1] Those who make Burns out to have been an *avant-garde* Communist will note that he is extolling an informed Middle Class.

Not surprisingly, he finished by begging the sympathetic Erskine to burn the letter. He himself copied it into the collection of his letters intended for Glenriddell.

Gruff, blunt Willie Nicol, also took the opportunity to administer a reproof. 'Dear Christless Bobby', he wrote: 'What concerns it thee whether the lousy Dumfriesian fiddlers play "Ça Ira" or God save the King? Suppose you *had* an aversion to the King, you could not as a gentleman use him worse than He has done. The infliction of idiocy is no sign of Friendship or Love. . . .' Nicol held up the Vicar of Bray as a suitable model for the times. He got a light-hearted reply, in which the poet admitted the good sense of the Latin master's dictum. But 'Christless Bobby', though he never incurred the censure of the Board again, could not entirely suppress his democratic urgings.

The humiliation of such enforced silence bore heavily upon Robert, and, indeed, burdened him during his closing years. Yet he could shake it off for long stretches at a time. It was only when an army officer or a person of title behaved badly to inferiors that it flared up again, all but uncontrollably.

Meanwhile, he threw himself into his Excise duties with renewed assiduity. Early in 1793 he suggested to the Provost of Dumfries, David Staig, a way of stopping a burgh revenue leak. Ale brewed within the town was subject to the 'twapenny' tax, but imported ale was not. Robert pointed out that by regularising the position and charging the tax all round, the town would increase its income. Needless to say, the suggestion was gratefully accepted.

In February, the members of the local subscription library, on their own initiative, decided 'by a great majority' to elect Burns as one of their number 'free of any admission money and the quarterly contributions . . . out of respect and esteem for his abilities as a literary man'.

Robert reminded the Provost of the value of his revenue suggestion the following March, when he requested that, since he had been made a Freeman in 1787, his children might go to the Burgh school without his having to pay 'the high School-fees which a Stranger pays'. His request was immediately granted.

Both these incidents suggest that, contrary to malicious tittle-

tattle multiplied by puritanical biographers, Burns was, in fact, highly regarded by many of the worthiest citizens in Dumfries, in spite of his occasional indiscretions.

In May, the Burns family moved into the more spacious house in the Mill Vennel. And at the end of July, he took a few days holiday in Galloway, in company with John Syme.

III

In February 1793, Creech had at last brought out his two-volume second Edinburgh edition of the Poems (though the author had to remind the Bailie about the gift copies) and in June, Thomson published the first part of his *Select Collection.*

Creech's volume contained over fifty pages of hitherto unpublished material, and included 'Tam o' Shanter'. Although he had bought the copyright of the old poems, he paid nothing but the cost price of a couple of dozen or so author's copies for the new poems. Truly, a good bargain for the publisher!

'Tam o' Shanter' apart, the other new poems do not greatly add to Burns's poetic stature—the work that *was* to do this, he had already given to Thomson.

The lines 'Written in Friar's-Carse Hermitage, on Nith-side' are as artificial as the garden gazebo in which they were composed.

The 'Ode Sacred to the Memory of Mrs Oswald of Auchencruive', an Ayrshire lady who died in London, and whose body was brought back to Scotland for burial at St Quivox beside her husband, is a dull, bitter production arising out of an incident which Burns described much better in prose for Dr Moore, to whom he first sent the poem.

> In January last,[1] on my way to Ayrshire, I had put up at Bailie Whigham's, in Sanquhar, the only tolerable inn in the place.— The frost was keen, and the grim evening and howling wind were ushering in a night of snow and drift.—My horse & I were both much fatigued with the labors of the day, and just as my friend the Bailie and I were bidding defiance to the storm over a smoking bowl, in wheels the funeral pageantry of the late great

[1] 1789—the poem, as already noted, was written at Ellisland.

Mrs Oswald, and poor I am forced to brave all the horrors of the tempestuous night, and jade my horse, my young favorite horse whom I had just christened Pegasus, twelve miles farther on, through the wildest moor and hills of Ayrshire, to New Cumnock, the next Inn.—The powers of Poesy and Prose sink under me, when I would describe what I felt.—Suffice it to say, that when a good fire at New Cumnock had so far recovered my frozen sinews, I sat down and wrote the enclosed Ode.

One stanza illustrates the nature of the poem:

> View the wither'd beldam's face—
> Can thy keen inspection trace
> Aught of Humanity's sweet, melting grace?
> Note that eye, 'tis rheum o'erflows—
> Pity's flood there never rose.
> See those hands, ne'er stretched to save,
> Hands that took—but never gave.
> Keeper of Mammon's iron chest,
> Lo, there she goes, unpitied and unblest,
> She goes, but not to realms of everlasting rest!

'Humanity's sweet-melting grace' is not a conspicuous quality of the poem. In spite of the disagreeable nature of the whole incident, the unfortunate corpse, even of one who, when alive, was, Burns claimed, 'detested with the most heartfelt cordiality', could hardly be held to blame for it, so Burns's satire misfires.

Mr Crawford urges the merits of the 'Elegy on Captain Matthew Henderson', which owes its form, no doubt, to Milton's 'Lycidas' and Fergusson's 'Elegy on the Death of Scots Music'. English and Scots contrast and blend effectively, and the concluding stanza's valediction contrasts with that passed on Mrs Oswald:

> Go to your sculptur'd tombs, ye Great,
> In a' the tinsel trash o' state!
> But by thy honest turf I'll wait
> Thou man of worth!
> And weep the ae best fellow's fate [one
> E'er lay in earth!

There is something very honest and satisfying about this. As Burns claimed in the accompanying 'Epitaph', Matthew must indeed have been 'a rare man'.

Nothing need be said about the 'Epistle to Robert Graham of Fintry', a conventional exercise in a medium in which Burns formerly excelled. 'The Lament for Mary Queen of Scots, on the Approach of Spring', written under the influence of a study of Percy's 'Reliques of English Poetry', is interesting because of the ballad atmosphere which Burns caught from Percy, and which does not often appear in his work. The 'Lament for James, Earl of Glencairn', an unequal poem, nevertheless rises to a splendid peroration, which sums up the fullness of Burns's gratitude to his noble patron:

> The bridegroom may forget the bride
> Was made his wedded wife yestreen;
> The monarch may forget the crown
> That on his head an hour had been;
> The mother may forget the child
> That smiles sae sweetly on her knee;
> But I'll remember thee, Glencairn,
> And a' that thou hast done for me!

'Tam o' Shanter', 'The Whistle' and 'On Captain Grose's Peregrinations thro' Scotland' have already been discussed. Of the rest, the lines to Sir John Whitefoord, 'On Seeing a Wounded Hare', the 'Address to the Shade of Thomson' (written for a superfluous crowning with bays of the poet's bust at Ednam, his birthplace in Roxburghshire, devised by the Earl of Buchan), the autograph-book piece for the daughter of the Edinburgh schoolmaster William Cruikshank, the tiny song, 'Anna, thy Charms my Bosom fire' (inspired by a sweetheart of Alexander Cunningham) and, 'On the Birth of a Posthumous Child', are all *trivia*. The remaining pieces— the neo-classical 'Humble Petition of Bruar Water to the Noble Duke of Atholé', 'On Scaring some Waterfowl in Loch-Turit', 'Written with my Pencil over the Chimney-Piece in the Parlour of the Inn at Kenmore, at the outlet of Loch Tay', and the lines 'Written with a Pencil, standing by the Fall of Fyers, near Loch Ness'—date from the tours of 1787, and are all the rather forced efforts of an

itinerant poet to commemorate a scene that had pleased him; or to leave a poetic morsel behind him at a Great Man's home as a token of gratitude for generous hospitality. They could have been produced by any of a dozen of his minor English contemporaries.

Such, then, were the extra poems which filled out the pages of Creech's two-volume edition.

The first part of Thomson's first volume, which came out in June, contained Burns's promised twenty-five songs. The publisher sent the poet a copy, enclosing a five-pound note, which he accompanied by an explanation:

> I cannot express to you how much I am obliged to you for the exquisite new songs you are sending me; but thanks, my friend, are a poor return for what you have done. As I shall benefit by the publication, you must suffer me to enclose a small mark of my gratitude, and to repeat it afterwards when I find it convenient. Do not return it, for, by Heaven! if you do, our correspondence is at an end.

By then Robert was already beginning to feel the first privations of the war, caused, so far as he was concerned, by the cutting down of imports and consequent loss of his duty perquisites—indeed, only a few weeks before he had been lamenting the fact that a friend of his had 'fallen a sacrifice to these accursed times.' In spite of this, Thomson's payment roused him to indignation.

> I assure you, my dear Sir, that you truly hurt me with your pecuniary parcel.—It degrades me in my own eyes.—However, to return it would savour of bombast affectation; But, as to any more traffic of that Dr and Cr kind, I swear, by that HONOUR which crowns the upright Statue of ROBT BURNS'S INTEGRITY! —On the least notion of it, I will indignantly spurn the by-past transaction, and from that moment commence entire Stranger to you!—BURNS'S character for Generosity of Sentiment, and Independence of Mind, will, I trust, long outlive any of his wants which the cold, unfeeling, dirty Ore can supply: at least, I shall take care that such a Character he shall deserve.

Thomson never tried to repeat his gesture, until a few days before

the end when, in an agony of desperation, the dying poet begged him for a further five pounds.

It has been argued that had Thomson known better how to cope with Burns's pride, or had someone like Henry Mackenzie drawn up a proper settlement as in the affair with Creech, the difficulty of song-payment need never have arisen. Possibly so. But at that time, the value of literary property was considerably less than it is now, and Burns reaped so much vexation from the Creech transaction that it might not have been easy to bring him to the point of signing another contract.

In any case, his position reasserted, he then went on to congratulate Thomson on the elegant appearance of his book. It was, indeed, the only volume of Thomson's which came out during the poet's lifetime. But the Editor, taking the measure of Robert's enthusiasm, soon decided to widen the scheme so that he could make still more use of his willing collaborator by including 'every Scottish air and song worth singing'.

Burns therefore went on supplying Thomson with songs until a few days before his death. Because Thomson freely put forward counter-suggestions, Burns had, perforce, to carry on a fairly extensive correspondence with him. Often, the poet found it necessary to justify his reasons for what he had done to an old song, or for setting a new song to a particular tune. Because of this, Burns's correspondence with Thomson gives us a fuller insight into his attitude to Scots song than even the notes in the interleaved *Museum*. Once Burns had stated his wishes—or rebutted Thomson's—the wily Editor rarely argued back. That would have risked an interruption in the correspondence, for there were obvious limits to Burns's patience. So Thomson altered, where it suited him, without consulting the Poet—who, in any case, was dead by the time the results appeared. Many of the songs sent to Thomson, Burns asked to be returned to him if unsuitable, so that Johnson might have them. So jealous was Thomson of his rival, however, that he made a practice of retaining even what he had no intention of using, merely so that Johnson would be deprived!

Writing to Thomson in April 1793, Burns cleared up the question of the ownership of the songs:

Though I give Johnson one edition of my songs, that does not give away the copy-right: so you may take—'Thou lingering star, with lessening ray', to the tune of Hughie Graham, or other songs, of mine. . . .

The point is of particular interest, because Thomson later tried (unsuccessfully) to secure the copyright of the songs Burns provided for *Select Scottish Airs*.

In August 1793, when 'Peter Pindar' (the pen-name of the English poetaster John Wolcott) withdrew his dilatory services from Thomson's project, the editor asked Burns if, in addition to the Scots verses he was already providing, he would also provide some of the alternative English words which Thomson had undertaken to publish with each air. Forgetting that he had originally told Thomson he would have nothing to do with English words, Burns replied:

You may readily trust, my dear Sir, that any exertion in my power, is heartily at your service.—But one thing I must hint to you, the very name of Peter Pindar is of great service to your Publication; so, get a verse from him now & then, though I have no objection, as well as I can, to bear the burden of the business.

Thus Burns committed himself with Thomson still further, though, as he had truly remarked the previous April:

I have not that command of the language that I have of my native tongue. In fact, I think my ideas are more barren in English than in Scottish.

A few months later, he added:

You must not, my dear Sir, expect all your English songs to have superlative merit. 'Tis enough if they are passable.

The correspondence went on, Thomson suggesting niggling 'improvements', most of which Burns very properly rejected, sometimes almost bluntly.

I cannot alter the disputed lines in the 'Mill Mill O'.—What you think a defect, I esteem as a positive beauty: so you see how Doctors differ.

Thomson's gravest error of judgement occurred over one of Burns's most stirring songs. The shameful trial of 'The Friends of the People' took place during August 1793. The fact that the frightened Government chose to make its examples in Scotland— perhaps with the 1715 and 1745 risings still in mind—rather than in England, where Reform supporters were numerically greater, may have helped to turn Burns's mind towards the historical parallel through which he chose to declare his unshaken belief in 'Liberty and Independence'. Thomson came upon the song after an epistolary introduction, dated 30th August, in which the poet explained the limitations of his musical taste.

> You know that my pretensions to musical taste, are merely a few of Nature's instincts, untaught & untutored by Art.[1]—For this reason, many musical compositions, particularly where much of the merit lies in Counterpoint, however, they may transport & ravish the ears of you, Connoisseurs, affect my simple lug no otherwise than merely as melodious Din.—On the other hand, by way of amends, I am delighted with many little melodies, which the learned Musician despises as silly & insipid. —I do not know whether the old air 'Hey, tutti, taitie' may rank among this number; but well I know that ... it has often filled my eyes with tears.—There is a tradition, which I have met with in many places of Scotland, that it was Robert Bruce's March at the battle of Bannock-burn.—This thought, in my yesternight's evening walk, warmed me to a pitch of enthusiasm on the theme of Liberty and Independence, which I threw into a kind of Scots Ode, fitted to the Air, that one might suppose to be the gallant ROYAL SCOT's address to his heroic followers on that eventful morning.

Then followed the noble 'Scots, wha hae wi' Wallace bled'. The first four verses clearly refer to the English menace which Robert the Bruce encountered and broke. The last two verses, and the accompanying comment, could also be held to refer to contemporary events.

[1] In a copy of the *Museum* found by Burns's son Robert in the house at Dumfries, crotchet and quaver misprints were corrected, the names of the proper note-value being written in by the poet's hand above the wrong note.

By Oppression's woes and pains!
By your Sons in servile chains!
We will drain our dearest veins,
 But they *shall* be free!

Lay the proud Usurpers low!
Tyrants fall in every foe!
LIBERTY'S in ev'ry blow!
 Let us DO—or DIE!!!

So may God defend the cause of Truth and Liberty, as he did
that day!—Amen!

The postscript, too, is revealing.

P.S. I shewed the air to Urbani,[1] who was highly pleased with
it, and begged me to make soft verses for it; but I had no idea of
giving myself any trouble on the subject, till the accidental
recollection of that glorious struggle for Freedom, associated
with the glowing idea of some other struggles, of the same
nature, *not quite so ancient*, roused my rhyming Mania. . . .

Thomson liked the words, but not the tune. He suggested to
Burns that the poem ought to go to the tune 'Lewie Gordon'. This
necessitated a weakening addition to every fourth line: i.e. 'But they
shall be, they shall be free'. Thomson's Edinburgh advisers took a
similar view. Reluctantly, Burns agreed, though he came nearer to
losing his temper with Thomson over this than over any other
matter. Dr Currie, however, printed the original words in his life
and edition of Burns's works, and told the story of the controversy.
Thomson thereupon tacitly admitted his error of judgement by
reprinting in his volume of 1802 the correct words to 'Hey, tuttie
tattie', the sixteenth-century tune for the old popular song 'Hey,
now the day dawes'.

[1] Pietro Urbani (1741–1816), an Italian composer and teacher, settled in
Edinburgh, and went into business in 1795 as Urbani and Liston at 10 Princes
Street. His business failed in 1809, and he died destitute in Dublin. Burns
thought that Urbani sang 'delightfully', but was 'conceited'. Thomson
thought Urbani's *Selection of Scots Songs* (Edinburgh, 1792–1804) 'a water-
gruel collection'.

The fitness or otherwise of this tune for Burns's heroic battle-song has been questioned many times since. In our own day, Francis George Scott has made a new setting of it[1] which captures the exulting tone of the poem. The fact remains, however, that the dogged determination which the old tune suggests can still bring fire to the heart and tears to the eyes of Scots folk who love their country.

'Scots Wha Hae' has, indeed, become one of Scotland's two national songs; and very properly, for it is one of the very few pieces in which Burns's conception of independence is mass rather than individual. The other is 'Auld Lang Syne', which Burns wrote at Ellisland and published in the *Museum*, matched with what he admitted was a weak tune. Thomson, probably with Burns's approval, put it to its present tune, which first appeared in Robert Bremner's *Reels* (1759), but was used for another song in the *Museum*, 'O can ye labor lea', and borrowed by the English composer William Shield to give a fashionable 'Scotch' touch to his opera *Rosina*.

However tiresome Thomson may have been, and however wrong-headed over the matter of his accompaniments,[2] he undoubtedly stimulated Burns's muse at a time when some such stimulation was probably essential to keep him going at all.

In a letter dated September 1793, wherein the poet reviews a long list of songs that Thomson had sent him, Burns explains his method of song composition.

Laddie, lie near me—must *lie by me*, for some time.—I do not know the air; & until I am compleat master of a tune, in my own singing, (such as it is) I never can compose for it.—My way is: I consider the poetic Sentiment, correspondent to my idea of the musical expression; then chuse my theme; begin one Stanza; when that is composed, which is generally the most difficult part of the business, I walk out, sit down now & then, look out for objects in Nature around me that are in unison or harmony with

[1] By far the greatest song-composer Scotland has ever produced, Scott has made many original settings of Burns's song-poems. Scott's style is based melodically on folk-song, though his harmonic idiom is that of the early twentieth century. By many he has been ranked as a song-writer with Brahms and Wolf.

[2] Beethoven constantly complained that Thomson sent him the airs but not the words.

the cogitations of my fancy & workings of my bosom; humming every now & then the air with the verses I have framed: when I feel my Muse beginning to jade, I retire to the solitary fireside of my study, & there commit my effusions to paper: swinging, at intervals, on the hindlegs of my elbow-chair, by way of calling forth my own critical strictures, as my pen goes.— Seriously, this, at home, is almost invariably my way.

That song-writing had become essential to him, he revealed in a letter sent to Thomson the previous April:

You cannot imagine how much this business of composing for your publication had added to my enjoyments.—What with my early attachments to ballads, Johnson's Museum, your book, &c. Ballad-making is now as completely my hobby-horse, as ever Fortification was Uncle Toby's; so I'll e'en canter it away till I come to the limit of my race (God grant that I may take the right side of the winning post!) & then chearfully looking back on the honest folks with whom I have been happy, I shall say, or sing, 'Sae merry as we a' hae been'.

Burns did, indeed, 'canter' his 'hobby-horse' till he came to the limit of his race. As late as February 1796, when the last fatal decline in his health had already set in, he was promising Thomson verses for twenty-five Irish airs which the editor now wanted to include in his collection.

For Thomson's first four volumes[1] Burns provided about a

[1] Thomson's *A Select Collection of Original Scottish Airs* came out, part by part, in 1793, 1798, 1799, 1801, 1805, and 1818. The Welsh volumes appeared between 1809 and 1814, the Irish between 1814 and 1816. In 1822, he published a six-volume selected edition, drawn from them all. This, and the first part of the Scottish volume, published separately in 1793, sold reasonably well. The rest were more or less complete failures financially. Haydn, Beethoven, Weber and Hummel replaced Pleyel on the musical side: Scott, Moore, Byron, Campbell and Sir Alexander Boswell replaced Burns as the providers of the words. Haydn's accompaniments are, on the whole, the best of the set. (Curiously enough, he set great store by them, believing that they would keep alive his name in Scotland!) None of the other poems are of much account, since none of the poets other than Burns found it easy to fit words to existing tunes.

hundred and fourteen songs; for Johnson about a hundred and sixty. In neither case can any exact figure be given, because in many instances songs by other people which Burns merely claimed to have polished, he so subtly and surely transformed that he clearly deserves the main share of the credit for their immortality.

When we examine the corpus of Burns's songs, it is impossible not to be impressed both by the variety of the emotional gamut through which they range, and by their extraordinary rich technical accomplishment. Folk fragments caught fresh from the lips of their singers, are polished and fixed in their final perfection: for instance, the Fife fragment, 'Up wi' the carls o' Dysart':

> Up wi' the carls o' Dysart, [*old men*
> And the lads o' Buckhaven,
> And the kimmers o' Largo, [*gossips*
> And the lasses o' Leven.
>
> Hey, ca' thro', ca' thro', [*press on*
> For we hae mickle ado;
> Hey, ca' thro', ca' thro',
> For we hae mickle ado.
>
> We hae tales to tell,
> An' we hae sangs to sing;
> We hae pennies to spend,
> And we hae pints to bring.
>
> Hey, ca' thro', ca' throw', etc.
>
> We'll live a' our days,
> And them that comes behin',
> Let them do the like,
> And spend the gear they win. [*wealth*
>
> Hey, ca' thro', ca' thro', etc.

This boat-song—the chorus represents the rowers pulling on their oars in time to the tune—was probably picked up when Burns passed through Kinross on his way back to Edinburgh after the

Highland tour. Neither tune nor poem were known to exist before he sent them to Johnson—and yet how typical the song is of the hard-headed Fifers, out of whose scant store of indigenous folk-song so few examples have survived!

The Jacobite theme also drew many a song from Burns, most famously 'Charlie, he's my darling'. Another *Museum* song the words of which are original, matching an old tune. 'It was a' for our rightfu' King' captures perfectly the tragedy of 'the Gael's last gallant battle, greatly lost'.

> Now a' is done that men can do,
> And a' is done in vain:
> My Love and Native Land farewell.
> For I maun cross the main,
> My dear;
> For I maun cross the main.

True, the poem tails off on a personal note which slightly weakens it: but it remains, to my mind, the noblest commemoration of a Gaelic people's lost endeavour.

Burns also wrote drinking-songs a-plenty. Apart from those in 'The Jolly Beggars', one thinks of 'Landlady, Count the Lawin'', and especially of 'Willie brew'd a peck o' maut'. How naturally Burns catches the sense of the poor man's release, that harmless, fuddled exultation of the drunken state! And how free the poem is from that back-slapping, roast-beefish, Christmas-card jollity which characterizes so many eighteenth-century English drinking-songs! In drink, as in sex, all men are equal.

> O Willie brew'd a peck o' maut, [*malt*
> And Rob and Allan cam to pree; [*taste*
> Three blyther hearts, that lee-lang night,
> Ye wid na found in Christendie.

> We are na fou, we're nae that fou, [*drunk*
> But jist a drappie in our e'e; [*drop eye*
> The cock may craw, the day may daw, [*dawn*
> And ay we'll taste the barley bree. [*brew*

Here are we met, three merry boys,
 Three merry boys, I trow, are we;
And mony a night we've merry been,
 And mony mae we hope to be! [*more*

 We are na fou, we're nae that fou, etc.

It is the moon, I ken her horn,
 That's blinkin' in the lift sae hie;
She shines sae bright to wyle us hame. [*lure*
 But, by my sooth, she'll wait a wee! [*a while*

 We are na fou, we're nae that fou, etc.

There are patriotic songs, the two greatest and best known of
which have just been discussed. There are also Political songs, like
'When Guilford good our Pilot stood', 'Does haughty Gaul inva-
sion threat?', when Burns became squarely British; the Election
Ballads of 1790, 1792 and 1795, all of them written to existing tunes;
and—product of the commotion of the French Revolution—that
noble declaration of the dignity of Man, 'Is there for honest
Poverty?'. Burns sent this song to Thomson on 1st July 1795,
commenting:

> I do not give you the foregoing song for your book, but
> merely by way of vive la bagatelle; for the piece is not really
> poetry.

In one sense, Burns is possibly right, for the piece is really a series
of quasi-prophetic statements. But it sums up the essential whole-
someness of Burns's attitude to the artifical divisions of class in
society.

Ye see yon birkie ca'd a lord [*fellow*
 Wha struts, and stares, and a' that
Though hundreds worship at his word,
 He's but a coof for a' that: [*fool*
For a' that, and a' that,
 His ribband, star and a' that;
The man of independent mind
 He looks and laughs at a' that.

And was ever an almost universal desire better expressed than in
the last stanza of the 'bagatelle'?

> Then let us pray that come it may,—
> As come it will for a' that—
> That Sense and Worth, o'er a' the earth,
> May bear the gree, and a' that. [*supremacy*
> For a' that, and a' that,
> It's comin' yet, for a' that,
> That Man to Man, the world o'er,
> Shall brothers be for a' that!

Supreme amongst all Burns's poems are his love-songs. Burns
touched on every aspect of love, physical and emotional; love as
between Man and Woman. For him, love was no abstract Arcadian
dilly-dallying of mincing shepherds and shepherdesses, but a passion
the satisfaction of which was at least as much physical as spiritual.
The Scottish peasantry shared Burns's view, and celebrated in their
songs the pleasures of sex in a robustly comic manner. For Johnson
and Thomson, Burns purged many of these old songs of their
grossness: for himself and the entertainment of a few intimate friends,
he improved and polished them for his manuscript collection, *The
Merry Muses of Caledonia*. This manuscript he circulated to a few
chosen cronies who shared his own hearty and perfectly natural
sense of bawdry.

To John McMurdo, the Duke of Queensberry's Chamberlain at
Drumlanrig Castle, Burns wrote in December 1793:

> I think I once mentioned something of a collection of Scots
> songs I have for some years been making: I send you a perusal of
> what I have got together. I could not conveniently spare them
> above five or six days, and five or six glances of them will
> probably more than suffice.

Early published versions of that letter (the original manuscript of
which has only recently been found by Professor De Lancey Fer-
guson) showed thereafter an additional sentence—'A very few of
them are my own'—which does not, in fact, appear in Burns's text,

and must therefore be assumed to be an attempt on the part of 'Morality' Currie to lessen Burns's crime of having celebrated his sexual pleasure so joyously and so skilfully.

The traditional story is that the manuscript of *The Merry Muses* disappeared from Burns's home at the time of his death—traditionally, on the actual evening. Who took it, or what became of it thereafter, no one knows; but somewhere about the year 1800, an anonymous chap-book bearing the same title appeared.

In *The Merry Muses of Caledonia* (London, 1965) De Lancey Ferguson deduces that this story is wholly false; that the original manuscript went to Currie with the rest of 'the complete sweepings' of Burns's 'drawers and desk'; that what happened to it thereafter is not known; and that the 1800 edition must have been compiled from the memories of others, or some different source.

The edition to which De Lancey Ferguson contributes his Preface is edited by James Barke and Sydney Goodsir Smith, and divides into five categories: (a) pieces in Burns's holograph; (b) pieces attributed to Burns from printed sources; (c) old songs used by Burns for polite version; (d) pieces collected by Burns; (e) alien modes.

The Merry Muses cannot be regarded as obscene, except by those who regard sex itself as such. The best songs in it show as sure a touch as do those in Burns's more widely published works.

His attitude to the sex act was vigorous and humorously free of smutty prurience. To him, sex was an earlier leveller than Death. In 'The Patriarch', Burns draws a picture of Jacob and Rachael in the difficulties of their first love-making, thus reminding us that for all their dignity, kings and prophets have at least that much in common with lesser mortals. A similar object with a significance nearer home was achieved with 'Geordie our King and Charlotte his Queen', in 'Poor Bodies Hae Naething but Mow' (copulation).

In others of these songs, Burns's ingenuity of imagery is remarkable. As he told Thomson, in a letter of January 1795—a letter which, once again, must have horrified that worthy man—when he was once challenged to produce 'an Ode to Spring on an original plan', he wrote an amusing take-off of the whole Arcadian literary tradition, beginning:

When maukin bucks, at early f - - s,
 In dewy grass are seen, Sir;
And birds and boughs, take off their mows,
 Amang the leaves sae green, Sir;
Latona's sun looks liquorish on
 Dame Nature's grand impetus,
Till his p - - k go rise, then westward flies
 To roger Madame Thetis.[1]

Here, as Dr Daiches points out, the levelling through contextual absurdity is achieved, not with Biblical figures, but with the classical literary paraphernalia associated with Dawn and Spring. In 'Wha'll mow me now[2] (to the tune 'Comin' thro' the Rye', which itself features in its old form in *The Merry Muses*), a servant-girl complains directly that she is punished for doing what her mistress frequently does with impunity.

O, I hae tint my rosy cheek,
 Likewise my waist sae sma';
O wae gae by the sodger loon,
 The sodger did it a'.

 An' wha'll m—w me now, my jo, [*mow*
 An' wha'll m—w me now?
 A sodger wi' his bandileers,
 Has bang'd my belly fu'.

Now I maun thole the scornfu' sneer
 O mony a saucy quine;
When, curse upon her godly face!
 Her c—t's as merry's mine, [*cunt*

 An' wha'll mow me now, my jo, etc.

Our dame hauds up her wanton tail
 As aft as doun she lie;
And yet misca's a young thing
 The trade if she but try. . . .

[1] An (a) category piece.
[2] Category (b).

There are mock-Jacobite songs, too, and songs to which the ancient folk-flavour still clings like damp soil. There are also songs like 'Godly Girzie'[1] in which Poet Burns takes a side-kick at the religious hypocrisy he flayed so mercilessly in his Kilmarnock satires.

> The night it was a holy night,
> The day had been a holy day;
> Kilmarnock gleamed wi' candlelight,
> As Girzie hameward took her way.
> A man o' sin, ill may he thrive!
> And never holy-meeting see!
> Wi' godly Girzie met belyve,
> Amang the Craigie hills sae hie.
>
> The chiel' was wight, the chiel' was stark,
> He wad na wait to chap na ca',
> And she was faint wi' holy wark,
> She had na pith to say him na.
> But ay she glowr'd up to the moon,
> And ay she sigh'd most piously—
> 'I trust my heart's in heaven aboon
> Where'er your sinful p—e be'. [*pintle*

The only other piece in *The Merry Muses* which need be quoted is 'The Court of Equity', because it is the longest of the poems,[2] as well as one of the wittiest. Dating from the days of the Tarbolton Bachelors Club, it deals with the sittings of a mock-court at which Burns, Smith and Richmond try two men, the one for denying his fornication, the other for trying to procure an abortion, both sins which 'stain the fornicator's honour'.

The passages describing the assembly of the 'Court' and the laying of the charges against the 'prisoners' give some idea of the brilliance of Burns's handling of his theme.

[1] Category (b), but a holograph which appears to confirm Burns's authorship is described in the *Burns Chronicle*, 1894.

[2] It first appeared in 1823, and a collated version of the three MSS is reprinted in full by Mrs Carswell. I have used the text of the version given in the 1965 London edition of *The Merry Muses*.

All who in any way or manner
Disdain the FORNICATOR's honor,
We take cognisance there anent
The proper Judges competent.—
First, Poet B(urns), he takes the CHAIR,
Allow'd by all, his title's fair;
And past nem. con. without dissension,
He has a DUPLICATE pretension.—

The second, Sm(i)th, our worthy FISCAL,
To cowe each pertinacious rascal;
In this, as every other state,
His merit is conspicuous great;
R(ichmo)nd the third, our trusty CLERK,
Our minutes regular to mark,
And sit dispenser of the law,

In absence of the former twa.—
The fourth, our MESSENGER AT ARMS,
When failing all the milder terms,
Hunt(e)r, a hearty willing Brother,
Weel skill'd in dead an' living leather.—

Without preamble less or more said,
We, BODY POLITIC aforesaid,
With legal, due WHEREAS and WHEREFORE,
We are appointed here to care for
The int'rests of our Constituents,
And punish contravening Truants;
To keep a proper regulation
Within the lists of FORNICATION.—

WHEREAS, OUR FISCAL, by petition,
Informs us there is strong suspicion
YOU, Coachman DOW, and Clockie BROWN,
Baith residenters in this town,
In other words, you, Jock and Sandie

Hae been at wark at HOUGHMAGANDIE;
And now when it is come to light,
The matter ye deny outright.—

You CLOCKIE BROWN, there's witness borne,
And affidavit made and sworne,
That ye hae rais'd a hurlie-burlie
In Maggy Mitchel's tirlie-whurlie.—
(And blooster'd at her regulator,
Till a' her wheels gang clittar-clatter.—)

An' farther still, ye cruel Vandal,
A tale might e'en in Hell be scandal,
Ye've made repeated wicked tryals
With drugs an' draps in doctor's phials,
Mix'd, as ye thought, wi' fell infusion,
Your ain begotten wean to poosion.
An' yet ye are sae scant o' grace,
Ye daur set up your brazen face,
An' offer for to tak your aith,
Ye never lifted Maggie's claith.—
But tho' by Heaven an' Hell ye swear,
Laird Wilson's sclates can witness bear,
Ae e'ening of a M(auchli)ne fair,
That Maggie's masts, they saw them bare,
For ye had furl'd up her sails,
An' was at play at heads an' tails.—

You COACHMAN DOW are here indicted
To have, as publickly ye're wyted,
Been clandestinely upward-whirlan
The petticoats o' Maggie Borlan;
An' gied her canister a rattle,
That months to come it winna settle.—
An' yet ye offer your protest,
Ye never harry'd Maggie's nest;
Tho' it's well-kend that, at her gyvle,
Ye hae gien mony a kytch an' kyvle.

Then BROWN & DOW, above-design'd,
For clags and clauses there subjoin'd,
We COURT *aforesaid, cite & summon,*
That on the fourth o' June in comin,
The hour o' Cause, in our Courtha'
At Whiteford's arms, ye answer LAW!

It may seem to some people almost sacriligious to proceed from a
survey of Burns's clever bawdry to a discussion of his love-poetry.
Yet, as I have already said, the two are closely related. It is, indeed,
our continual awareness of their implied sexuality which makes
Burns's love-songs so much warmer, so much more human and satis-
fying, than the love-songs of almost any other poet.

Burns ranged widely over the anatomy of love. At one extreme,
we find him portraying a young girl's fears at her first wooing:

I am my mammy's ae bairn,[1] [*only child*
 Wi' unco folk I weary, sir, [*strange*
And lying in a man's bed,
 I'm fley'd it make me irie, Sir. [*frightened, eerie*

 I'm owre young, I'm owre young,
 I'm owre young to marry yet;
 I'm owre young, 'twad be a sin
 To tak me from my mammy yet.

Hallowmas is come and gane,
 The nights are lang in winter, sir;
And you an' I in ae bed,
 In troth, I dare na venture, sir.

 I'm owre young, etc.

Fu' loud and shrill the frosty wind
 Blows thro' the leafless timmer, sir [*woods*
But if ye come this gate again, [*way*
 I'll aulder be gin simmer, sir.

 I'm owre young, etc.

[1] This version, from the *Museum*, is superior to the more polite, abbreviated
version given in the Chambers-Wallace text.

At the other extreme, there is the most touching picture of married love ever written. It was refashioned out of an old poem (two variants of which are in *The Merry Muses* describing how an insatiable wife reproaches her husband because he is no longer as efficient a lover as he once was). In Burns's song the woman, with folk-song-like directness and simplicity, expresses gratitude for all the years of married happiness she and her husband have enjoyed. This seems to me to be remarkable evidence of the way in which Burns, who joyously embraced certain individual aspects of living, could also see life whole, and imply that natural rightness and unity of all things which is the artist's ultimate vision.

> John Anderson, my jo, John,
> When we were first acquent;
> Your locks were like the raven,
> Your bonie brow was brent; [*smooth*
> But now your brow is beld, John, [*bald*
> Your locks are like the snaw;
> But blessings on your frosty pow,
> John Anderson, my jo.
>
> John Anderson, my jo, John,
> We clamb the hill thegither;
> And mony a canty day, John,
> We've had wi' ane anither:
> Now we maun totter down, John,
> And hand in hand we'll go;
> And sleep thegither at the foot,
> John Anderson, my Jo.

In between these extremes of youth and old age, there are many songs celebrating the splendid exultation of the moment's passion: songs of sheer satisfaction like 'It was upon a Lammas night', already quoted; songs charged with longing for the absent beloved, like 'Mary Morison': songs of protective male tenderness and pride, like 'My wife's a winsome wee thing', or 'O wha my babie-clouts will buy', in which the lover's feelings are subtly accentuated by the placing of the words in the woman's mouth.

And did ever lover, vowing human constancy in terms of eternity, swear more movingly than Burns, who apparently knew so little of the meaning of constancy where woman's love was concerned?

> O my Luve's like a red, red rose,
> That's newly sprung in June;
> O my Luve's like the melodie
> That's sweetly play'd in tune.
> As fair art thou, my bonie lass,
> So deep in luve am I;
> And I will luve thee still, my dear,
> Till a' the seas gang dry.

There are humorous songs depicting marriages which have failed because of the ill-nature or ill-disposition of one or other of the partners, like 'Whistle owre the lave o't' and 'Willie Wastle'; songs like 'The tailor fell through the bed' and 'Merry hae I been teethin' a hackle', full of broad country humour. The variety is endless.

Burns wrote, or revised in such a manner as to give him claim to authorship, nearly three hundred and seventy songs, all of them designed for particular airs. The rhythmic variety of the measures he employs, the skill with which he matches the mood of a poem to the temper of an air—words and music should always be considered to-gether—and the wide emotional range which his songs embrace, are so remarkable that one leaves off studying Burns's songs scarcely able to believe that any single man could have accomplished so much.

In a sense, of course, Burns was not, as a song writer, one man: rather he was the heir of dozens of folk-poets, grave and gay, whose traditions he bent to the mould of his own genius. He came on the Scottish scene at a time when Scots song had already fallen into dangerous decline. Anglified willy-nillyings were being preferred by a London-conscious gentry, and the vernacular was becoming a vulgar handicap. Ramsay, its earliest eighteenth-century creative champion, had neither the taste to distinguish between English neo-classical falseness and genuine Scots homespun, nor enough skill to enable him to renovate and preserve without Anglifying, or other-wise weakening, the rude force of his ancient originals. Fergusson

had little or no interest in song, and the folk-collectors lacked song-tailoring equipment. It is thus not too much to say that Burns saved Scots song from virtual annihilation.

Others who came after deserve some small share of credit—the host of his contemporaries and imitators who, though most of their work was purely derivative, often succeeded in striking off one or two songs possessed of living, original qualities: James Hogg, whose 'Jacobite Relics' added a few valuable pages to our song-treasury: and Lady Nairne, who put at least half a dozen songs in the traditional manner on the lips of her country-folk. But neither Hogg nor Lady Nairne—nor any of the lesser songsters—could have achieved what they did achieve had it not been for the song work of Burns.

Nowadays in Scotland there are no peasants; and ours is not a singing age. The tradition in which Burns wrought died out in the Lowlands during the latter part of the nineteenth century, lingered out a brief decadence in the form of the Bothy Ballad in the relative seclusion of the North-East, and is now gone for ever. We cannot make folk-songs any more,[1]

> The laurels are all cut
> The bowers are bare of bay
> That once the Muses wore.

But at least we ought to have enough regard for the heritage which Burns played so large a part in saving for us, to condemn the be-tartanned Scotchery which kilted glamour-boys drool out over the footlights of Scottish—and English—music-halls! Surely a nation which possesses 'Ca' the Yowes to the Knowes', 'O were I on Parnassus Hill' and 'Of a' the airts the wind can blaw' in its store-chest of song, should not need to have recourse to such feeble song-rubbish as 'The Bonie Wells o' Wearie', 'O'er the Hills to Ardentinny', or 'The Highlandman's Umbrella'?

[1] To call the contemporary 'workers-break-your-bonds' ditties of the extreme Left modern folk-songs, as collectors like Hamish Henderson and Ewan McColl do, seems to me to be a misuse of the term. They derive, not from the real traditional songs of the Scots people, but from their later music-hall corruptions. Nor are they usually in any sense by 'the people', most of them being the indifferent products of professional writers. The same is true of the compositions of the so-called pop-folk revivalists.

IV

During the autumn of 1793, Walter Riddell was in the West Indies, trying to raise the balance of the purchase money (£1,600) still due to the previous owner of Woodley Park. Maria therefore did not receive Burns at her home; but they met at other people's houses, or in her box at the theatre during the interval. It was on one of these theatrical occasions that Robert, finding Maria in the company of some young officers, turned away in disgust. When later she chided him for not appearing, he wrote a note explaining that the sight of the 'lobster-coated puppies' guarding the 'Hesperian fruit' had been too much for him.

In spite of this incident, however, their friendship developed, and probably reached its zenith during these autumn months. Burns's letters to her became fuller and franker. He wrote a love-song, 'The Last Time I came o'er the Moor' and sent it to Maria accompanied by a thinly-veiled disclaimer of personal reference. Yet the second stanza exactly describes his relationship with this spirited upper-class young woman who could be friendly, even coquettish, with a gifted gauger, but—unlike Lizzie Paton, Jean Armour, Anna Park, and the others—would always know how to prevent him going too far:

> Love's veriest wretch, despairing, I,
> Fain, fain my crime would cover:
> The unweeting groan, the bursting sigh, [*unwitting*
> Betray the guilty lover.
> I know my doom must be despair:
> Thou wilt nor canst relieve me;
> But, O Maria, hear my prayer,
> For pity's sake, forgive me.

Robert was soon to have occasion to repeat this appeal for forgiveness under more serious circumstances which really wounded him deeply.

The exact nature of the incident which led to his rupture with the Riddell family is, to some extent, hidden in mystery. During Christmas week 1793, Burns was dining at Friars Carse and perhaps wining

rather more well than wisely. The traditional story places the dinner at Woodley Park, but that seems unlikely, in view of certain evidence to the contrary presently to be mentioned. At any rate, once the ladies had retired, the conversation somehow got round to the Rape of the Sabine women by the Romans, and the men, bemused with too much drink, apparently decided to stage a mock Sabine Rape on their return to the drawing-room. Once the horse-play had started, Robert, who apparently went further in his Roman simulation than the others, caused his hostess intense anger, for she had been selected as his particular 'victim'. A stormy scene ensued in which the kindly Robert Riddell naturally took the side of his wife; and, although some of the ladies present did their best to make light of the whole affair, the poet was ignominiously shown the door and told not to return. Next day, soberly appalled by the recollection of his conduct, he wrote an apology to his hostess, 'Mrs Riddell'.

I daresay that this is the first epistle you ever received from this nether world. I write you from the regions of Hell, amid the horrors of the damned. The time and manner of my leaving your earth I do not exactly know, as I took my departure in the heat of a fever of intoxication, contracted at your hospitable mansion; but, on my arrival here, I was fairly tried, and sentenced to endure the purgatorial tortures of this infernal confine for the space of ninety-nine years, eleven months, and twenty-nine days, and all on account of the impropriety of my conduct yesternight under your roof. Here am I, laid on a bed of pityless furze, with my aching head reclined on a pillow of ever-piercing thorn, while an infernal tormentor, wrinkled and old, and cruel, his name I think is *Recollection*, with a whip of scorpions, forbids peace or rest to approach me, and keeps anguish eternally awake. Still, Madam, if I could in any measure be reinstated in the good opinion of the fair circle whom my conduct last night so much injured, I think it would be an alleviation to my torments. For this reason I trouble you with this letter. To the men of the company I will make no apology.—Your husband, who insisted on my drinking more than I chose, has no right to blame me; and the other gentlemen were partakers of my guilt. But to you, Madam, I have much to

apologize. Your good opinion I valued as one of the greatest acquisitions I had made on earth, and I was truly a beast to forfeit it. There was a Miss I— too, a woman of fine sense, gentle and unassuming manners—do make, on my part, a miserable d - mned wretch's best apology to her. A Mrs G—, a charming woman, did me the honour to be prejudiced in my favor; this makes me hope that I have not outraged her beyond all forgiveness.—To all the other ladies please present my humblest contrition for my conduct, and my petition for their gracious pardon. O all ye powers of decency and decorum! whisper to them that my errors, though great, were involuntary—that an intoxicated man is the vilest of beasts—that it was not in my nature to be brutal to any one—that to be rude to a woman, when in my senses, was impossible with me—but—

* * * * *

Regret! Remorse! Shame! ye three hellhounds that ever dog my steps and bay at my heels, spare me! spare me!
Forgive the offences, and pity the perdition of, Madam,
Your humble Slave. . . .

This is, to say the least of it, a strange letter. The image-sequence at the beginning of it is so carefully elaborated that it conveys a feeling of artificiality which, because of the context, even carries a suggestion of flippancy. Yet, clearly, the writer was labouring under genuine distress. Possibly Burns, as he sat down to write, at first hoped to bluff his way back into favour with a fine phrase; until the nature of his own apology brought home to him the enormity of his offence, and goaded him into one of those crescendos of paper hysteria which were a symptom of the condition of his heart.

The letter cannot have been written to Mrs Walter Riddell, whose good opinion Robert valued far more than he did that of Mrs Robert Riddell, because the poet states unequivocally that it was the recipient's husband who plied him with too much drink.[1] No amount of juggling with words can get over this fact. It can

[1] The correspondence between Maria Riddell and William Smellie clearly shows that Walter Riddell was not back in this country by 21st March 1794.

therefore only have been written to Mrs Robert Riddell, the prim and proper Elizabeth, whom Burns seems never to have liked. In a letter of apology, however, he could hardly do other than claim to value her 'good opinion', whatever he thought about her privately.

Apparently, then, Mrs Robert Riddell was the victim of Robert's mock-assault (which, in view of the poet's references to 'beasts' and 'brutality', must surely have been somewhat more outrageous an affair than the mere stealing of a kiss); and presumably therefore it took place at her 'hospitable mansion' of Friars Carse. This would explain Captain Riddell's siding with his wife—he could hardly do anything else. It would also explain why the grass widow Maria should also take umbrage, since her brother would have thought it more than a little strange if his sister-in-law wantonly defied a rebuke he thought fit to administer to a man who had misbehaved in his house.

The complications which prevent us asserting this solution as the final one ought not to be given undue weight. When Currie published his *Life* and included a copy of the letter—presumably taken from Burns's own draft or duplicate copy—Maria expressed astonishment that he should have got possession of it, because she had 'somehow mislaid it and it was certainly not among those I delivered for your perusal'. But it cannot really be inferred from this remark of hers that she was the original recipient of the letter.

Nor does the evidence of Miss Kennedy, Elizabeth Riddell's sister, bear as much weight as it has sometimes been made to carry. She told Currie, in 1798, that the letter referred 'to some circumstances of improper conduct of Burns to Mrs Walter Riddell and which he (Robert Riddell) thought in his brother's absence, he ought to resent and therefore declined taking any further notice of Burns'. No evidence exists to show that Miss Kennedy was at the party where the Sabine Rape occurred. Presumably, she only heard her 'outraged' sister's account of the matter. But in any case her whole manner of writing is so vague—'*some* circumstances of improper conduct'—as to suggest hearsay.

Be that as it may; Mrs Robert Riddell did not reply to the poet's appeal, half genuine, half histrionic. Worse still, Maria also ignored a letter, and on meeting him a few days after the event, gave him a

look that 'froze the very life-blood' of his heart. She, too, remained
deaf to his appeals. So on 12th January 1794 he returned her
Commonplace Book, since it seems 'the Critic has forfeited your
esteem'. Maria's harshness made him genuinely unhappy; but it also
stirred his smouldering class hatred.

> It is however some kind of miserable good luck; that while
> De-haut-en-bas rigour may depress an unoffending wretch to the
> ground, it has a tendency to rouse a stubborn something in his
> bosom, which, though it cannot heal the wounds of his soul, is at
> least an opiate to blunt their poignancy.

The 'wounds of his soul' caused by Maria's support of her sister, hurt
Robert so deeply that he directed the full force of his anger against
her, and—to a lesser extent—against her absent husband. Burns
never seems to have liked him much, and apparently regarded him as
little more than a genteel ne'er-do-weel. Burns's attitude evidently
was that Maria at least ought to have known better.

No amount of suffering, however, excuses the means he took to
revenge himself. The 'Epistle from Esopus[1] to Maria'—which, in
spite of recent attempts to prove that it may have been the work of
another hand, does seem to have been written by Burns—is a vulgar
attack on Maria Riddell written in flat imitation of Pope's satirical
style. It is sorry stuff, the work of a man on the edge of a nervous
breakdown and beset with worries of many sorts. Little better is the
equally ill-natured 'Monody on a Lady Famed for her Caprice', the
'Epitaph' of which runs:

> Here lies now, a prey to insulting neglect,[2]
> > Who once was a butterfly gay in life's beam:
> Want only of Wisdom denied her respect,
> > Want only of Goodness denied her esteem.

There were also some contemptuous lines on Walter Riddell, and

[1] Esopus was a famous Roman tragic actor, and an intimate friend of
Cicero's.

[2] From the correspondence between Currie and Maria Riddell it appears that
she did not see this until after Burns's death, and in any case failed (not un-
naturally!) to recognize herself as its subject.

the caddish 'Extempore, Pinned to a Lady's Coach', which Burns described to Patrick Miller as a 'clinch'.

> If you rattle along like your mistress's tongue,
> Your speed will outrival the dart:
> But, a fly for your load, you'll break down on the road
> If your stuff be as rotten's her heart.

If Maria Riddell's twenty-one-year-old heart had really been as rotten as Burns alleged in his epigram, she would never have forgiven him these rhymed assaults upon her. Yet, when his need was greatest, she did forgive him and comfort him, and in the end serve him better after his death than many of his 'good-hearted' friends.

In February 1794, Robert lamented to Cunningham:

> For these two months I have not been able to lift a pen. My constitution and frame were, ab origine, blasted with a deep incurable taint of hypochondria, which poisons my existence. Of late a number of domestic vexations, and some pecuniary share in the ruin of these d - mned times—losses which, though trifling, were yet what I could ill bear—have so irritated me, that my feelings at times could only be envied by a reprobate spirit listening to the sentence that dooms it to perdition.

The domestic vexations were probably not unconnected with the precarious health of little Elizabeth. The pecuniary worries were the loss of many of his perquisites caused by the curtailment of imports during the war with France. Even for song-writing, Burns could find very little time or energy during these depressing months.

Walter Riddell returned from Jamaica in March, having failed to find the necessary money to complete the purchase of Woodley Park. It was therefore re-possessed by the previous owner, and Walter lost his £1,000 deposit, as well as the £2,000 he had spent on improving the estate. But he and Maria remained in the neighbourhood of Dumfries, staying first at Tinwald House, between Dumfries and Lochmaben, and after May 1795 at Hallheaths, to the east of Lochmaben.

They might have had Friars Carse, for on 21st April 1794 Robert

Riddell suddenly died.[1] Under the terms of his will, Friars Carse could have been offered by Robert's trustees to Walter, who would thereupon have had to pay an annuity to Robert's widow from the revenue of the estate. But although this would probably have been more profitable to Elizabeth Riddell, she chose the alternative, apparently to spite her brother-in-law. The estate was therefore sold, the proceeds being divided between Elizabeth and Walter.

In spite of his wretched health, Robert continued to strive conscientiously at his Excise duties. He even found energy to recommend the abolition of an Excise Division resulting in 'an economy in public monies', a suggestion which was accepted by the Excise authorities, and put into effect.

A second offer tempted Burns to abandon the Excise in favour of journalism. Patrick Miller junior had a friend in London, a Mr Perry, who edited the *Morning Chronicle*. No doubt under persuasion from the Millers, senior and junior, the Editor, through young Miller, offered Burns, in May 1794, a job as 'occasional correspondent' for which he would be paid a regular five guineas a week, in addition to more for poems and extra contributions. The job, however, involved residence in London. But Burns's old distrust of living by his pen made him turn the offer aside, though he undertook to provide Mr Perry with 'little Prose Essays' and 'any bagatelle' that he might write. For Robert, his 'prospect in the Excise' was 'something at least', and being encumbered with 'near half-a-score of little ones', he was unwilling to exchange a safe though humble certainty for a dazzling but more dangerous chance.

About midsummer, 1794, Burns once again set out with Syme on a short tour of Galloway, during which the mere sight of a mansion-house was enough to start the poet raging against the rich. According to Syme's remembered account of the trip, they rode to Kenmure the first day; then on to Gatehouse-of-Fleet, Kirkcudbright and St Mary's Isle, where they were happily entertained by Lord Selkirk. Again according to Syme: 'The poet was delighted with his company, and acquitted himself to admiration. . . .'

There was a fresh outburst of song-writing in the autumn, and

[1] Burns wrote a stylized but sincere poem on the death of a man he dearly loved and respected, in spite of their estrangement.

another son was born to Jean on 12th August. He was named James Glencairn Burns after the poet's earlier patron.

Robert's democratic enthusiasm was once again severely tested when the Caledonian Hunt descended on Dumfries during October, and behaved abominably. According to Syme, one of their members so insulted Walter Riddell that the dispossessed laird pursued the offender to Durham to make him ask pardon; while the Honourable Ramsay Maule of Panmure earned some scathing lines from Robert's pen by playing a leading part in plastering a servant's hair with mustard and sticking it full of toothpicks 'by way of hedgehogging him'. Rashly, too, while in the house of the Dumfries lawyer, Samuel Clarke junior, the poet gave a toast, 'May our success in the present war be equal to the justice of our cause'. As Burns fairly remarked afterwards, 'the most outrageous frenzy of loyalty' could not object to this sentiment; yet it upset the susceptibilities of a certain Captain Dods, who tossed down words which usually 'end in a brace of pistols', as Burns related to Clarke next day in his letter of apology for having been drunk. Burns claims to have been held back from duelling because of his wife and family. Dods would probably not have considered Burns his equal, and therefore would not have duelled with him in any case.

The humiliation of Robert's position, and the continuing need to muzzle his sentiments, inevitably brought about an emotional tension which, like so many other of his tensions, found relieving expression in a letter to Mrs Dunlop. But, though the writing of it no doubt did him good, it was an unlucky document all the same, that anti-Royalist letter of 12th January 1795; for after receiving it she broke off a friendship which gave Burns a good deal of comfort, and for all her occasional tiresomeness, was also the means of bringing him up against a kind of shrewd common sense from which he had often benefited.

So far as we know, what caused the rupture was Burns's description of Louis XVI as a perjured blockhead and his queen, Marie Antoinette, as an unprincipled prostitute, both of whom had met the fate they deserved at the hangman's hands.

Some writers have questioned whether this reference alone could have given enough offence to cause Mrs Dunlop to break off a

friendship so valued and of such long standing. Yet the remark could not fail to have been interpreted by Mrs Dunlop as a deliberate insult to her, though it was not meant that way. Burns must have known her political sentiments; he ought to have realized that, having one son still in the army, and two French refugee sons-in-law, the threat of a French invasion had a different significance for her than for the members of the Dumfries circle of theorizing parlour-revolutionists; and he certainly ought to have had enough tact to anticipate her feelings and consider her reactions.

Just before Christmas 1794, Alexander Findlater took ill, and had temporarily to relinquish his duties. Burns was appointed Acting Supervisor of Dumfries, and for nearly four months got a taste of the exacting day-long devotion to duty which a Supervisor was expected to give. For the Supervisors, who received between £120 to £200 a year, bore the main burden of responsibility, being not only in charge of the gaugers, but under the necessity of checking all their books. When Burns looked for promotion that would give him 'a life of literary leisure and a decent competence', he was thinking of the rank of Collector, the next senior rank to Supervisor. The moment a man became a Supervisor, he became eligible to be placed on the Collectors' list. A Collectorship, as he told Patrick Miller in a letter dated March 1795, could be worth anything from two hundred pounds a year to a thousand. Such was Burns's conscientiousness in the service that without any doubt he would have gone far in it had he lived.[1] But the increasing severity of his bouts of what he took to be hypochondria clearly foreshadowed the collapse of his sick heart.

V

The privations of the War pinched Burns still more closely at the beginning of 1795. He told William Stewart, factor to the local estate of Closeburn and an admirer of Robert's broader verse, in a 'painful, disagreeable letter' of 15th January wherein he asked for the loan of 'three or four guineas':

[1] Evidence exists to prove that his promotion, though not as nearly in the offing as he supposed, was only prevented by his illness and death.

These accursed times by stopping up Importation, have for this year at least lopt of a full third part of my income: and with my large Family, this is to me a distressing matter.

Apparently he had fallen behind with the rent, for on the 29th of the month, he confessed to Captain John Hamilton, his landlord:

It is needless to attempt an apology for my remissness to you in money-matters: my conduct is beyond all excuse.—Literally, Sir, I had it not.—The distressful state of Commerce at this town, has this year taken from my otherwise scanty income no less than 20£.—That part of my Salary depended upon the Imports, & they are no more, for one year.—I enclose you three guineas: and shall soon settle all with you.

The Captain not only made light of the default, but sent the Poet a card asking why he was avoiding coming to his house, to which Robert replied promising to pay a visit on his 'first leisure evening'.

That month, too, the breach with Maria Riddell showed first signs of healing. Robert had sent her a poem on her birthday, 'Canst thou leave me thus, my Katy?' which at least indicated that he would welcome a reconciliation. Maria sent him some verses of her own in return, assuring him that her feelings for him were still friendly. In January, she followed up this gesture with the loan of a book, which Robert acknowledged formally, as if unwilling to let down his guard too quickly until she had further demonstrated her friendly intentions.

When he returned the book, his letter of thanks picked up their correspondence in the old manner. He told her of Thomson's difficulties in communicating with Pleyel because of the war; he sent her some indifferent songs he had just set to three of Thomson's Irish airs; and he let her know that he had been sitting to 'Reid in this town for a miniature', opining, 'I think he has hit by far the best likeness of me ever was taken'.[1]

While the wound in this friendship he so greatly valued was healing, he had meanwhile put yet another burden upon his failing heart. In the very month he had told Maria Riddell that 'every hour

[1] See Frontispiece.

of the day' was being taken up with his work, he enlisted in the Dumfries Volunteers, a company of which was then being formed. His landlord was a Captain in the Volunteers, and for their commander they voted a genial retired American soldier who had married the daughter of a former provost of Dumfries, Colonel Arent Schuyler de Peyster (1736–1822). The Colonel, an active man who retained his faculties to an advanced age, was an efficient commander, and twice a week Burns drilled in his military uniform—'a short blue jacket, half lapelled, with red cape cuffs and gilt engraved buttons, a white kerseymere vest and buckled breeches and half gaiters, white stockings, a black velvet sock, shoes tied with black ribbon, and a round stiff hat, turned up one side with a gilt button and surmounted by a cockade and black feathers'.[1] A letter to Colonel de Peyster dated 18th May, of which Burns was one of eighteen signatories, protesting against the undignified begging devices which the Secretary of the Volunteers had apparently employed to raise money, shows that the poet also played his part in the administration of the Corps.

But the strain of these extra exertions soon began to tell upon him. In a letter to Maria Riddell dated 'Spring, 1795', he tells her that he is 'so ill as to be scarce able to hold this miserable pen to this miserable paper'. His daughter Elizabeth had become so weak that he had her taken to Mossgiel, hopeful that the healthier hill air there might arrest her decline. But she died the following September. Her father was so heavily involved in inescapable Excise duties that he was unable to go to the poor child's funeral. The shock grieved him deeply. To Maria, he sent a short note ending: 'That you, my friend, may never experience such a loss as mine, sincerely prays, R.B.'

Thereafter, he himself went down with another and severer attack of what he took to be rheumatic fever, but what was more probably angina pectoris. In any case, as he told Cleghorn, the attack was so severe that it brought him 'to the borders of the grave'.

Just before these catastrophes overwhelmed him, Burns had sent both Thomson and Johnson further song-packets. Now, he was unable even to make songs. By sheer force of will, he drove himself

[1] According to Mrs Carswell.

through his Excise duties. But he had been nearer the borders of the grave than he really knew, and for the last half year of his life, he never again escaped from its terrible shadow. Still his gallant spirit would not admit defeat.

On 31st January 1796 he made one more attempt to win back the friendship of Mrs Dunlop, enclosing with his letter, 'Does haughty Gaul invasion threat?' as an indication of his loyalty. No doubt:

> For never but by British hands
> Maun British wrangs be righted!

was unexceptionable. Yet his basic democratic feeling bursts out in the fourth stanza:

> ... But while we sing *God save the King*,
> We'll ne'er forget the People!

Quite clearly, so far as he was concerned, her treatment of him was inexplicable. His letter should have touched anyone whose heart had not become petrified with indignant anger.

These many months you have been two packets in my debt.— What sin of ignorance I have committed against so highly a valued friend I am utterly at a loss to guess.... Will you be so obliging, dear Madam, as to condescend on that my offence which you seem determined to punish with a deprivation of that friendship which once was the source of my highest enjoyments? —Alas! Madam, ill can I afford, at this time, to be deprived of any of the small remnant of my pleasures.—I have lately drunk deep of the cup of affliction.—The Autumn robbed me of my only daughter & darling child, & that at a distance too & so rapidly as to put it out of my power to pay the last duties to her.—I had scarcely begun to recover from that shock, when (I) became myself the victim of a most severe Rheumatic fever, & long the die spun doubtful; until after many weeks of a sick-bed it seems to have turned up more life, & I am beginning to crawl across my room, & once indeed have been before my own door in the street....

I know not how you are in Ayr-shire, but here, we have actually famine, & that too in the midst of plenty.—Many days

my family, and hundreds of other families, are absolutely without one grain of meal; as money cannot purchase it.—How long the *Swinish Multitude* will be quiet, I cannot tell; they threaten daily.—

To that pitiful cry of a suffering heart, bravely struggling against the terrors of approaching dissolution, Mrs Dunlop chose not to reply.

In Dumfries, the 'Swinish Multitude' suddenly ceased to be quiet, and there were alarming food riots in the town from the 12th to the 14th of March.

The dying poet struggled on, sending 'song-cargoes' to Thomson and enlisting the support of new subscribers. But gradually his Excise duties became too much for him, and by the end of April, he was almost certainly unable any longer to perform his rounds.

To Thomson that month he wrote depressingly.

> Alas! my dear Thomson, I fear it will be some time ere I tune my lyre again! 'By Babel streams' &c.—Almost ever since I wrote you last, I have only known Existence by the pressure of the heavy hand of Sickness; & have counted time by the repercussions of PAIN! Rheumatism, Cold, & Fever have formed, to me, a terrible Trinity in Unity, which makes me close my eyes in misery, and open them without hope.

In May, he was a little more hopeful, writing to thank Thomson for the present of a new seal made on a 'Highland Pebble', and incorporating his own unregistered Arms design:

> On a field, azure, a holly-bush, seeded, proper, in base; a Shepherd's pipe and crook, Saltier-wise, also proper, in chief.—On a wreath of the colors, a woodlark perching on a sprig of bay-tree, proper, for Crest. Two mottoes: Round the top of the Crest—'Woodnotes wild'. At the bottom of the shield, in the usual place,—'Better a wee bush than nae bield'.

This design, which he had worked out with Maria Riddell, shows something of his knowledge of the science of Heraldry. 'Beautiful seal' though it was, he was not to have much opportunity of using it. At the same time, he wisely refused to assign the whole copyright of his songs to the Editor, altering the agreement drawn up by

Thomson's lawyer in favour of a more limited agreement of his own, which Thomson never publicly produced, and is now lost. Burns went on:

> When your Publication is finished, I intend publishing a Collection, on a cheap plan, of all the songs I have written for you, the *Museum*, &c.—at least of all the songs of which I wish to be called the Author.—I do not propose this so much in the way of emolument, as to do justice to my Muse, lest I should be blamed for trash I never saw, or be defrauded by other claimants of what is justly my own.

But there was not enough time left for dreams of that sort. Jean was pregnant again. To help her with both the housework and the nursing of her husband, she had secured the services of John Lewars's eighteen-year-old sister, Jessy. Robert fancied himself in love with Jessy. One day, according to Dr Chambers (who had the story from Jessy herself), Robert hobbled into her father's house and told her that if she would play her favourite air to him, he would make a song for it. She played a seventeenth-century air, 'Lennox Love to Blantyre', several times over on the harpsichord until he had made himself familiar with it. Very soon afterwards, he produced the promised song: his last great lyric and one of the tenderest expressions of love he ever wrote.

> Oh, wert thou in the cauld blast,
> On yonder lea, on yonder lea.
> My plaidie to the angry airt, [*quarter*
> I'd shelter thee, I'd shelter thee.
> Or did Misfortune's bitter storms
> Around thee blaw, around thee blaw,
> Thy bield should be my bosom [*shelter*
> To share it a', to share it a'.
>
> Or were I in the wildest waste,
> Sae black and bare, sae black and bare.
> The desert were a paradise,
> If thou wert there, if thou wert there,

> Or were I monarch o' the globe,
> Wi' thee to reign, wi' thee to reign;
> The brightest jewel in my crown,
> Wad be my queen, wad be my queen.

By the beginning of June, Robert himself began to suspect that his end was near. Because he urgently wanted a copy of the *Museum* to give to Jessy, he took his farewell first of James Johnson.

> How are you, my dear Friend? & how comes on yr fifth volume?—You may probably think that for some time past I have neglected you & your work; but, Alas, the hand of pain, & sorrow, & care has these many months lain heavy on me!— Personal & domestic affliction have almost entirely banished that alacrity and life with which I used to woo the rural Muse of Scotia.—In the meantime, let us finish what we have so well begun.—The gentleman, Mr Lewars, a particular friend of mine, will bring out any proofs (if they are ready) or any message you may have.—
>
> <div align="center">Farewell!</div>
>
> <div align="right">R. BURNS.</div>

Unaware of the serious nature of Robert's illness, Maria Riddell, her husband being again abroad, invited Robert to accompany her in uniform to the King's Birthday Ball in Dumfries. He replied in the lowest of spirits:

> I am in such miserable health as to be utterly incapable of shewing my loyalty in any way.—Rackt as I am with rheumatisms, I meet every face with a greeting like that of Balak to Balaam—'Come, curse me Jacob; and come, defy me Israel'. . . .[1] I may perhaps see you on Saturday Night, but I will not be at the ball. 'Man delights me not, nor woman either!' . . .[2]

By this time, even his friend and medical adviser Dr Maxwell was becoming alarmed about him. For a patient suffering from any serious illness in the eighteenth century to fall into the hands of a

[1] Numbers Chap. 23, v. 7.
[2] *Hamlet*, Act II, Scene 2.

doctor was usually tantamount to being handed over to an execu-
tioner. It was not that Maxwell was anything other than well dis-
posed towards Burns, or any less skilled than the average doctor of
the day; but real medical knowledge was very nearly non-existent.

Maxwell diagnosed the stabbing agonies of angina as 'flying
gout', and prescribed sea-bathing in country quarters and horse-
riding for the remainder of the summer.

On 3rd July, so weak that he could scarcely stand, Robert took
himself over to Brow, a tiny clachan on the Solway Firth, nine
miles south-east of Dumfries. The place had a reputation as a spa
because of the purely imaginary properties of the chalybeatic Brow
Well. He was unable to afford a horse, but every day he waded far
out over the shallow Solway sands until he stood armpit-high in the
cold sea-water. The effect of this barbarous treatment on a man
suffering from heart trouble does not bear thinking of.

Burns himself had little belief in the cure. The day after he arrived
at Brow, he told Thomson:

> I recd your songs: but my health being so precarious nay
> dangerously situated, that as a last effort I am here at sea-bathing
> quarters.—Besides my inveterate rheumatism, my appetite is
> quite gone, and I am so emaciated as to be scarce able to support
> myself on my own legs.—Alas! is this a time for me to woo the
> Muses? However, I am still anxiously willing to serve your work;
> & if possible shall try:—I would not like to see another em-
> ployed, unless you could lay your hand upon a poet whose
> productions would be equal to the rest. . . .

Now, another terror came to haunt Robert: the fear of poverty
which had clouded his father's dying days. An Exciseman unable
over a long period to carry out his duties, normally received only
half-pay. This reduction, in addition to the loss of his import
perquisites which he had already sustained, would, of course, have
brought starvation upon the home in Mill Vennel. On 7th July, he
set out his plight to Cunningham in Edinburgh:

> Alas! my friend, I fear the voice of the Bard will soon be heard
> among you no more! For these eight or ten months I have been

ailing, sometimes bedfast & sometimes not; but these last three months I have been tortured with an excruciating rheumatism, which has reduced me to nearly the last stage.—You actually would not know (me) if you saw me.—Pale, emaciated, & so feeble as occasionally to need help from my chair.—my spirits fled! fled!—but I can no more on the subject—only the Medical folks tell me that my last & only chance is bathing & country quarters & riding.—The deuce of the matter is this; when an Excise-man is off duty, his salary is reduced to 35£ instead of 50£.—What way, in the name of thrift, shall I maintain myself & keep a horse in Country-quarters—with a wife & five children at home, on 35£? I mention this, because I had intended to beg your utmost interest & all friends you can muster, to move our Commiss^{rs} of Excise to grant me the full salary.—I dare say you know them all personally.—If they do not grant it me, I must lay my account with an exit truly en poëte, if I die not of disease I must perish with hunger.

Five days later, Cunningham had not replied. So Robert sent him a copy of a new song 'the last I made or probably will make for some time', 'Here's a health to ane I lo'e dear', adding, 'I shall be impatient to hear from you—As to me, my plan is to address the Board by petition, & then if any friend has thrown in a word 'tis a great deal in my favour'.

Years afterwards, Alexander Findlater stated in a newspaper letter that Graham of Fintry, not being empowered to restore Burns his full salary, had sent him a private gift of five pounds, which nearly made up the loss. On the other hand, the traditional story, first put about by Currie, is that a young expectant, Adam Scobbie, did Burns's work for nothing, thus allowing the poet to draw his full salary. One thing remains clear: right up to the end Burns must have enjoyed the loyal affections of his Excise colleagues.

There was one last gleam of pleasure to lighten the cold, bleak twilight of Robert's life. Maria Riddell, who had herself been ill, was convalescing not far from Brow Well. On the afternoon of 7th July, she sent her carriage for Burns. When he made his appearance, she was horrified at the physical change in him; but before she had

time to recover from the shock, he greeted her: 'Well, Madam? And have you any commands for the next world?'

According to Maria, they talked of his approaching end—for he would not be put off by her gallant reassurance that she still expected him to write her epitaph. It must have been an immense satisfaction to him to be able to relieve the anxieties of his anguished mind to this intelligent and generous-hearted woman who, for all her caprice, was the only woman he ever knew well who was his equal in mind and spirit. He was anxious about his family, of what should become of them when he was not there to provide for them; and he was anxious for his reputation, lest ill-meaning persons should make capital out of his many indiscretions by reviving 'every scrap of his writings' against him. When these two friends said farewell, and the poor, weak poet hirpled out to the coach that was to take him back to the dismal sands of the Solway, both of them must have been aware that this, indeed, was their final parting.

Having mended his friendship with Maria, three days later he sat down to bid farewell to Mrs Dunlop, the other woman who had withdrawn a friendship which had meant much to him:

> Madam,
>
> I have written you so often without rec.g any answer, that I would not trouble you again but for the circumstances in which I am.—An illness which has long hung about me in all probability will speedily send me beyond that bourne whence no traveller returns.—Your friendship with which for many years you honored me was a friendship dearest to my soul.—Your conversation & especially your correspondence were at once highly entertaining & instructive.—With what pleasure did I use to break up the seal! The remembrance yet adds one pulse more to my poor palpitating heart.
>
> <div align="right">Farewell!!!</div>

On the same day, he wrote to his father-in-law at Mauchline, begging him to send Mrs Armour—then away in Fife—to Jean's aid, as Jean thought she could only 'reckon upon a fortnight', and he himself could not be with her. He also gave James Armour a thinly-veiled warning of his own approaching death.

I have now been a week at salt-water, & though I think I have got some good by it, yet I have some secret fears that this business will be dangerous if not fatal.

Then he sat down to write to his brother Gilbert.

Dear Brother,

It will be no very pleasing news to you to be told that I am dangerously ill, & not likely to get better.—An inveterate rheumatism has reduced me to such a state of debility, my appetite is tottaly gone, so that I can scarcely stand on my legs. —I have been a week at sea-bathing, & I will continue there or in a friend's house in the country all the summer.—God help my wife and children, if I am taken from their head!—They will be poor indeed.—I have contracted one or two serious debts, partly from my illness these many months & partly from too much thoughtlessness as to expense when I came to town that will cut in too much on the little I leave them in your hands.—Remember me to my Mother.

Such was Robert's farewell to the brother who, at so great a personal cost, he had enabled hold Mossgiel together, and to the mother who had first planted in his consciousness a love of the folk-songs of the country people.

Two days later, while he was still trying to persuade himself that he was feeling a little better, he received a letter that struck fresh terror into his failing heart. The tailor from whom he had bought his Volunteer uniform was apparently dissolving a partnership. His lawyer, one Penn, had therefore set about collecting outstanding debts. Burns owed the tailor seven pounds four shillings. In his disordered state, the sudden demand for payment of this relatively small sum flooded his mind with visions of dishonour and death in a debtor's prison. It was the last humiliation he was called upon to bear, and it was too much for him. In an agony of spirit, he cried out to his dearest cousin, James Burness, the Writer at Montrose, and to George Thomson. To his cousin he wrote:

When you offered me money-assistance little did I think I should want it so soon.—A rascal of a Haberdasher to whom I

owe a considerable bill taking it into his head that I am dying, has commenced a process against me, & will infallibly put my emaciated body into jail.—Will you be so good as to accommodate me, & that by return of post, with ten pound.—O, James! did you know the pride of my heart, you would feel doubly for me! Alas! I am not used to beg! The worst of it is, my health was coming about finely; you know & my Physician assures me that melancholy & low spirits are half my disease, guess then my horrors since this business began.—If I had it settled, I would be I think quite well in a manner.—How shall I use the language to you, O do not disappoint me! but strong Necessity's curst command.—. . . Forgive me for once more mentioning by return of Post.—Save me from the horrors of a jail! . . . I do not know what I have written. The subject is so horrible, I dare not look over it again.

To Thomson he appealed more calmly.

After all my boasted independance, curst necessity compels me to implore you for five pounds.—. . . Do, for God's sake, send me that sum, & that by return of post.—Forgive me this earnestness, but the horrors of a jail have made me half distracted.—I do not ask all this gratuitously; for upon returning health, I hereby promise and engage to furnish you with five pounds' worth of the neatest song-genius you have seen.—I tried my hand on Rothiemurche this morning.—The measure is so difficult, that it is impossible to infuse much genius into the lines.—They are on the other side. Forgive me!

Nine days before his death, Burns was still song-making. On 'the other side' of that letter was 'Fairest Maid on Devon Banks', a song perhaps inspired by his old love Peggy Chalmers, and—hardly surprisingly—not one of his best.

Two days later he wrote to tell Jean of his condition.

My dearest Love,

I delayed writing until I could tell you what effect sea-bathing was likely to produce. It would be injustice to deny that it has eased my pains, and I think has strengthened me; but my appetite

is still extremely bad. No flesh nor fish can I swallow: porridge and milk are the only things I can taste. I am very happy to hear by Miss Jessy Lewars that you are all well. My very best and kindest compliments to her, and to all the children. I will see you on Sunday.

Your affectionate Husband.

He had decided to come home because the next week was not 'a tide-week'. On Saturday 16th July, he wrote to his farmer friend, John Clark of Locherwoods, asking if he could borrow his gig.

On the 15th, Syme had visited him bearing Cunningham's answer to the two appeals. Nothing had been settled with the Excise, and Cunningham could only promise to go on doing his best. On Monday 18th, Robert, in the borrowed gig, arrived at Mill Vennel, for the last time. Jean was as alarmed at his altered condition as he himself was dismayed to find that Mrs Armour had not yet arrived. In a shaky hand, he wrote another urgent appeal to his father-in-law at Mauchline.

> Do, for Heaven's sake, send Mrs Armour here immediately. My wife is hourly expecting to be put to bed. Good God! what a situation for her to be in, poor girl, without a friend! I returned from sea-bathing quarters today, and my medical friends would almost persuade me that I am better; but I think and feel that my strength is so gone that the disorder will prove fatal to me.

It was the last letter he was able to write. And the last letter he could read was a note from Mrs Dunlop, expressing forgiveness, yet frigid and aloof in its general tone.[1]

Syme came to see him the next day, Tuesday, and left convinced that there was now no hope. Robert was probably too ill to be able to appreciate that both Thomson and James Burness had immediately sent the money they were asked for. On his last night, tradition avers that he rallied, drew himself up in his bed, and was able to say

[1] So says tradition. Currie is the authority for the existence of this note, though he is confirmed by a mention of it in a letter which John Lewars wrote to Mrs Dunlop after Burns's death.

farewell to his family in the old Scots manner.[1] It would certainly be in keeping with his indomitable spirit. Thereafter, he lapsed into unconsciousness, and by the first light of the new day, July 21st, the proud, sick heart that had for so long driven on the worn-out body, had faltered into the stillness of death.

Syme organized the funeral. The man who had hated war, but who had joined the ranks of the defenders of his country when foreign invasion threatened, was given a military funeral. His coffin was borne to the Town Hall on 25th July. Between ranks of soldiers drawn not only from the Volunteers, but also from two regular regiments that happened to be stationed in the town, the body of Robert Burns was carried in sombre procession to the strains of the Dead March from Handel's 'Saul'. Over his grave, a sharp volley of farewell cracked out into the stillness of the air, while at the house in Mill Vennel, Jean Burns, not yet thirty, lay in labour producing her ninth child, a son whom she named Maxwell after the doctor whose unfortunate advice had unwittingly hastened her husband's end.

[1] The details of Burns's death-bed have been argued about for so long that it is hard to know what to accept and what to discount. Probably most of them had best be discounted as romantic fiction.

The Immortal Memory

I

AFTER the funeral, Maxwell, Cunningham and Syme set about ensuring that the poet's widow and children should not go unprovided for. As if conscience-stricken for the little they had done for their poet whilst he was alive, the people of Scotland poured their money into the Trustees' charitable hat as it came their way, though a few, like Dr Hugh Blair, simply passed it on without putting in anything. The Trustees announced a forthcoming edition of Burns's 'poetical remains', asking owners of manuscripts not tò publish them in newspapers, thus prejudicing the success of the proposed volume, but instead to send the manuscripts to them. An appeal to the Royal Literary Fund of London by Thomas White, teacher of mathematics at the Academy of Dumfries, drew from that body £25 on 20th October, 1786, and a further £20 in November, 1801. Within a matter of months, a generous sum had been subscribed.

Indeed, not for a single moment was the welfare of Robert's widow and children ever in any danger. The family lived on in the house in Mill Vennel where Jean eventually died. Of the three sons who survived into adult life, Robert junior, became a civil servant in the Stamp Office in London, and died in 1857 at the age of seventy. William Nicol and James Glencairn were both East India Company cadets, the former becoming Colonel of the 7th Native Infantry Regiment in the Indian Army, surviving until 1872; while the latter, also an Indian Army Colonel, died in 1865. The early success of these young men enabled Mrs Burns to hand back an annuity of fifty pounds a year tardily granted by Lord Panmure's grudging Government in 1817, a gesture which must have highly delighted her poet's Elysian shade. Until her own death in 1834, Jean lived out her days in modest quietness, patiently answering the questions of tourists who came to worship at her husband's shrine.

Though his flesh-and-blood relations were well cared for, Robert's reputation and the creations of his Muse were less kindly handled. True, ten days after his death, Maria Riddell published her *Memoir* of the Poet in the *Dumfries Advertiser*,[1] the clearest and fairest of all the contemporary accounts, though less full than Heron's *Memoir*, which was in fact the first formal biography. But, unfortunately, she was apparently never seriously considered as a possible editor of the proposed 'poetical remains' volume. Dugald Stewart would not undertake the task: Maxwell, Syme and Cunningham could not. Their choice therefore fell on Dr James Currie, a Liverpool physician who had met Burns for a few moments in 1792. Currie at first pretended to refuse until the other candidates were eliminated, though he readily agreed when he was asked a second time.

He proved to be an unfortunate choice, for he was neither a skilful editor nor a scrupulous one. With a reformed drunkard's enthusiasm stronger than his regard for the truth, he used poor Burns's life story as an illustrated object lesson to further the cause of temperance.

For three years he laboured—willingly and without financial reward it is true, but not well—engaging in correspondence with, amongst others, Maria Riddell, Syme and Gilbert Burns. Syme collected all the available 'remains' and induced many of the poet's friends to produce their most precious Burns relics to Currie, whose family thereafter lost or destroyed most of them. The quantity and the disorderliness of the material which eventually reached Currie's desk astonished him. As he later recorded to his son:

> Instead of finding, as I expected, a selection of [Burns's] papers, with such annotations as might clear up obscurities

—clearly Syme had been minimizing the labours involved in order to persuade Currie to agree to undertake the work—

> I received the complete sweepings of his drawers and of his desk (as it appeared to me), even to the copy-book on which his little boy had been practising his writing. No one had given these papers a perusal, or even an inspection. . . .

The basis upon which Currie shifted, altered, and wrote was that:

[1] Both Maria Riddell's and Heron's *Memoirs* are reprinted in full in *The Burns Encyclopedia* (second edition 1968), edited by the present author.

'All topics are omitted in the writings, and avoided in the life of Burns that have a tendency to awake the animosity of party.' On such a basis, of course, the life of a man like Burns written by one so totally different in temperament from him as Currie, could not be anything other than a travesty. Currie's most serious fault was that he deliberately put about a picture of Burns as a decadent drunkard who consorted with whores and suffered from venereal disease; all of which accusations were, of course, utterly untrue.

> Perpetually stimulated by alcohol in one or other of its various forms . . . in his moments of thought he reflected with the deepest regret on his fatal progress, clearly forseeing the goal towards which he was hastening, without the strength of mind necessary to stop, or even to slacken, his course. His temper became more irritable and gloomy; he fled from himself into society, often of the lowest kind. And in such company, that part of the convivial scene in which wine increases sensibility and excites benevolence, was hurried over, to reach the succeeding part, over which uncontrolled passion generally presided. He who suffers the pollution of inebriation, how shall he escape other pollution? But let us refrain from the mention of errors over which delicacy and humanity draw the veil.

Such preposterous impertinence is hard to stomach, even after the lapse of a century and a half. But Currie has been dealt with so roughly during the last fifty years that here we may as well let 'humanity draw the veil' over his manifold literary and ethical errors.[1] At least his efforts brought in a further twelve hundred pounds to the Trust Fund.

Currie's picture of Burns as the besotted womanizer was passed down the nineteenth century. True, in 1815, Alexander Peterkin attempted to correct it in his biography by publishing testimonies as to Burns's abilities and sobriety from, amongst others, Alexander Findlater, James Gray and Gilbert Burns. But Peterkin thereafter merely reprinted Currie's errors without further qualification.

[1] That he was basically an interesting, even a kindly, character is shown by R. D. Thornton's *James Currie, the Entire Stranger, and Robert Burns* (1963), though these qualities are irrelevant so far as his Burns editorship is concerned.

By 1820, Currie's work had gone through seven editions, and the publishers offered Gilbert Burns two cheques, each for £250, to prepare an eighth edition. But honest, hard-working, timid, dull Gilbert was more concerned about not offending Currie's relations than with defending his dead brother's reputation.[1] He failed to speak out the truth, even in an appendix about his brother's habits. He also failed to get his second cheque, for the edition would not sell.

In 1926, the Scottish surgeon Sir James Crichton-Browne published his valuable book, *Burns: From a New Point of View*. For the first time, the medical evidence regarding Burns's health and decline was collected and examined by an expert. The verdict of this expert —and of some half-dozen other medicos on both sides of the Atlantic who have undertaken similar independent surveys since— was that Robert Burns died neither of drink nor of V.D. but of some form of endocarditis. In an age when heavy drinking was part of a gentleman's every-day behaviour, Burns no doubt took his share; and there were, especially in the last years, occasions when he took rather more than was wise. But to drink according to the temper of your age and occasionally to get drunk, is one thing: to drink yourself to death is quite another. Well justified, indeed, was Sir James in calling Currie 'the arch calumniator' who 'has tainted the pages of all who have written about Burns since his time'.

Burns's literary fame fared little less strangely than his personal reputation. Immediately after his death, poetasters like James Maxwell of Paisley and 'Peebles frae the water-fit' sought to prove much of his work immoral, and did their best to discredit him. Nor were Scott and Jeffrey, the dominant Scottish literary figures of the succeeding generation, other than moderately approving. Carlyle rumbled condescension. Yet within his widow's lifetime, the flood of editions and biographies (all more or less bad) had begun steadily to rise. The first Burns Club was founded at Greenock in 1801. Burns celebrations were held in Ayr in 1844. In 1859, the centenary celebrations, which produced the Henley-Henderson edition of the *Works*, also produced a spate of eulogy, bad verse, and a large

[1] It has to be admitted that the publishers warned him not to cast any aspersions on Currie's work.

increase in the number of Burns Clubs which have continued to multiply ever since.

For Burns has long since ceased to be merely a Scottish poet, so far as Scots folk are concerned. He has become *the National Bard*, a figure of spiritual dimensions as mythical as the preposterous physical dimensions attributed to Wallace by the poet Blind Harry. And in the popular mind, the myth has become more important than the poetry.

II

Draped against the intellectual background of the twentieth century Scot are the stories of Wallace and Bruce, who saved Scotland from English conquest at a time when our southern neighbours employed more direct and less subtle methods towards achieving our reduction as a nation than they have done since; Mary, Queen of Scots, who was beautiful and unfortunate, and therefore a suitable memory upon which to drape garlands of harmless romance; John Knox, who saved the country from Mary, Queen of Scots; Bonnie Prince Charlie, who nearly saved the country from John Knox, but who, like Mary, failed, and so is a safe and suitable receptacle for romance; and, lastly, Robert Burns, who saved his country's literature.

A country which has lost its literature cannot long survive. But for Burns, Scots poetry would almost certainly have trickled out of sight after the death of Fergusson; but for Burns, Scots folk-song would certainly have remained a minor subject for sterile collectors like David Herd and Joseph Ritson to study and primly record on paper for the archives.

Burns, however, caught and fixed the texture of life in the old agrarian Scotland which was already passing away in his own day, in verse so warmly glowing and so technically accomplished that, in a real sense, he went a long way towards making our past permanent. It was not, however, in his power to revitalize the Scots literary tradition beyond his own use of it; for the decline had been allowed to go too far before he set about his work of restoration. His successors used and re-used his technique and themes long after the

emphasis in Scotland had shifted from the country to the towns. And in our own day, the attempts of 'Hugh MacDiarmid' and others who have tried to carry forward his ideal of restoring Scots as a language equipped to deal with all the nuances of contemporary life, are, in one sense at any rate, failing partly because of lack of public support, but mainly because it is now too late in the day to hope to push back the steady inrush of the English tongue. The best that may be achieved is the preservation of what still exists.

With folk-song, Burns was certainly more successful; for not only did he produce a store-house of perfectly-fashioned pieces refurbished or created out of the achievements of the past, but he so fertilized the tradition itself that it lived on and flourished for more than thirty years after his death.

Burns must therefore be considered a political as well as a poetical figure, at any rate so far as Scotland is concerned. For his work more than the work of any other single person has kept Scotland in mind of her ancient nationhood, traditions and identity, throughout more than a century and a half of relentless buffeting towards that spiritual oblivion which total submersion in the culture and way of life of England or America must inevitably mean.

That is, in my view, the main reason why Burns has been and still is, idolized throughout the Lowlands of Scotland: as a Scottish symbol rather than as a Scottish poet. There are, of course, other reasons. Most men, though they might hate to admit it, subconsciously admire a man whose powers with women were so remarkable and so successful. Other people worship at the Burns shrine for no better reason than because they like good fellowship, and quite frankly enjoy an excuse for a comfortable annual 'Scotch' binge round about the 25th of January. The speeches may be boring, the food indifferent: but after all, there is always the heart-warming presence of John Barleycorn!

The sad fact is, however, that when a great poet is also a National Hero and the Saviour Of His Country, people soon become less interested in his poetry than in his legendary properties. That is precisely what has happened in the case of Burns.

I do not believe that a writer can properly be considered without the tradition of which he forms a part. The continuing relevance of

that tradition must therefore have some impact on his influence and reputation. The influence of poets like Ovid and Virgil becomes weaker with every decade, not only because the tradition in which they wrote has for long been enshrined in a dead language, but also because Latin is becoming a less essential ingredient in present-day systems of study.

It seems to me doubtful if even Gaelic, Scotland's oldest language, having its own central syntax, can in the long term survive as a living spoken force. If this is so, then Scots, without the bolstering benefits of a wholly separate syntax, must surely be even more vulnerable, subjected as it is to the inevitable Anglifying pressures of radio, television and the cinema (influences, incidentally, now beating in so strongly from America as to suggest that what is currently regarded as 'standard' or Southern English may, indeed, soon also be under serious pressure).

What, you may say, has this to do with Robert Burns? Unfortunately, everything. Scotland is the only nation in Europe within whose schools the national literature is not systematically taught. The alarming truth of the matter is that unless Scottish literature is introduced into the curricula of Scottish schools, Primary as well as Secondary, on an organized basis, then before many more generations have come and gone few Scots will be able to read the poems of Burns except against a glossary, as they construe Caesar's *Gallic Wars*. Unless the Scottish children of the future are to be brought up to understand and enjoy that part of their heritage which is the Scots Literary Tradition—the poems of the Auld Makars and the work of the twentieth-century Lallans Makars included—then the rich vernacular glory (so essentially Scottish) of Burns's finest work will be unintelligible to them. At best they will be left only with his inferior poems in the English neo-classical manner: those poems that ape a chaste literary gentility the counterpart of which in real life was to Burns anathema.

Such is the Burns Dilemma which confronts us in the late-twentieth century, reluctant though the sentimentalists may be to recognize it. For the short term at least, the omens are not all doom-laden. Two hundred and nine years after Burns's birth, the first definitive edition of his poems, edited by Professor James Kinsley,

was published by the Oxford University Press. Some secondary schools in Scotland have introduced the study of contemporary Scottish literature into their fifth and sixth form classrooms, albeit at the individual teacher's discretion, and suitably-priced texts have begun to appear on the schools market. Several European universities, together with the Carnegie Trust, have given financial backing towards the editing and publication of David Murison's *National Scottish Dictionary*, now nearing completion. From Alexander Scott's pioneering lectureship in Scottish literature at the University of Glasgow, an awareness of the subject has now spread to the other Scottish universities.

More than a hundred and fifty thousand schoolchildren annually enter for the Burns Federation's essay competitions. There are now just under four hundred active Burns Clubs throughout the world, although the tally of annual Burns Suppers must amount to thousands.

These short-term signs may give some ground for hope. But the long-term dilemma cannot be left to take care of itself. Its practical solution lies almost entirely in the hands of Scottish educationalists, modified, perhaps, by whatever strength of determination to preserve their national identity in an international context future generations of Scots folk may show.

Burns will certainly survive in Scots sentiment as the National Saviour, his work of salvation commemorated by an annual festival, and by countless statues and memorials up and down the country. Nor will Burns's name readily be forgotten outside Scotland for, as the American Professor Robert T. Fitzhugh has said: 'While only Scots now read much of Burns, and they the wrong poems for the wrong reasons, the world is still fascinated by the man.'

But while the force of Burns's warm-hearted personality may keep 'the world' interested in him, surely the Scots have a deeper duty: a duty which puts upon them the responsibility of preserving and passing on, if not enriched, at least intact, the living heritage of Scots poetry and song for which he laboured so long and so tirelessly?

INDEX